INUIT ART

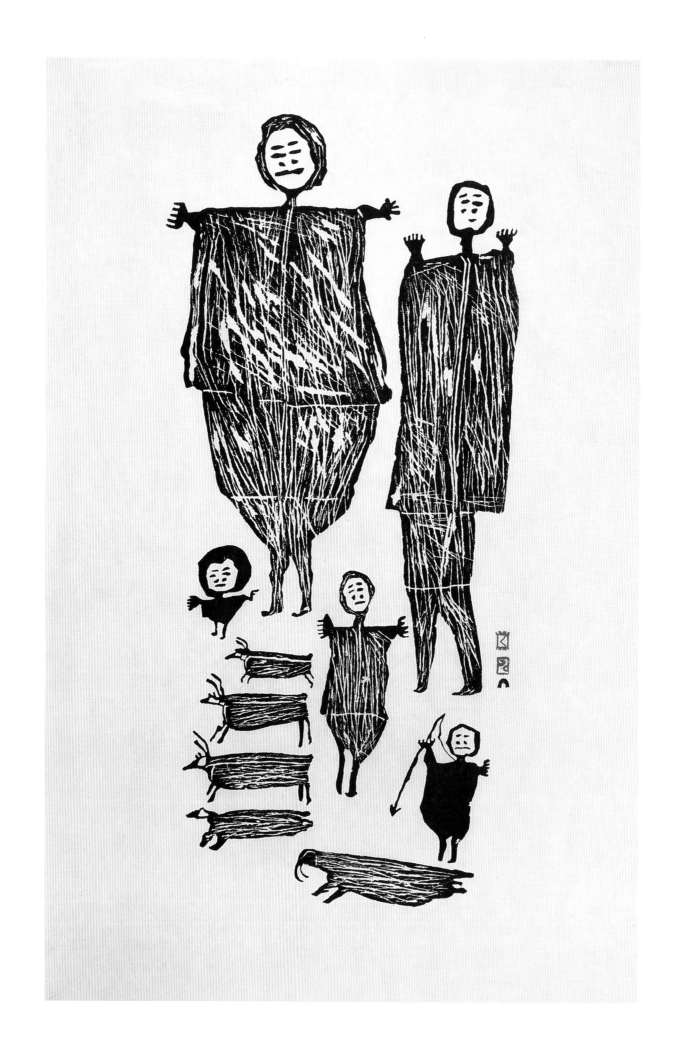

INUIT ART

AN INTRODUCTION

INGO HESSEL

PHOTOGRAPHY BY DIETER HESSEL
WITH A FOREWORD BY GEORGE SWINTON

HARRY N. ABRAMS, INC., PUBLISHERS

This book is dedicated to the memory of Alma Houston

Library of Congress Cataloging-in-Publication Data

Hessel, Ingo.
 Inuit art : an introduction / Ingo Hessel ; photography
by Dieter Hessel ; foreword by George Swinton.
 p. cm.
 Includes bibliographical references and index.
 ISBN 0-8109-3476-0 (hardcover)
 1. Inuit art—Canada. I. Hessel, Dieter. II. Title.
E99.E7H493 1998
704.003´9712—dc21 98-3410

First published in Canada by Douglas & McIntyre Ltd.

Printed and bound in Hong Kong

Harry N. Abrams, Inc.
100 Fifth Avenue
New York, N.Y. 10011
www.abramsbooks.com

Editing by Saeko Usukawa
Design by George Vaitkunas

1 (Frontispiece)
Parr m. (1893–1969), Cape Dorset
Printmaker: Lukta Qiatsuk m. (b. 1928)
My People, 1961 #82
Stonecut, 50.5 × 76.0
Musée canadien des civilisations / Canadian Museum of Civilization

Parr's earliest drawings are reminiscent of those by young children,
but he quickly gained a surer hand and a sense of spatial organiza-
tion. This image presents the themes that obsessed his whole artis-
tic life: family, animals and the hunt. His scratchy, schematized
drawing style is translated admirably in this stonecut print.

CONTENTS

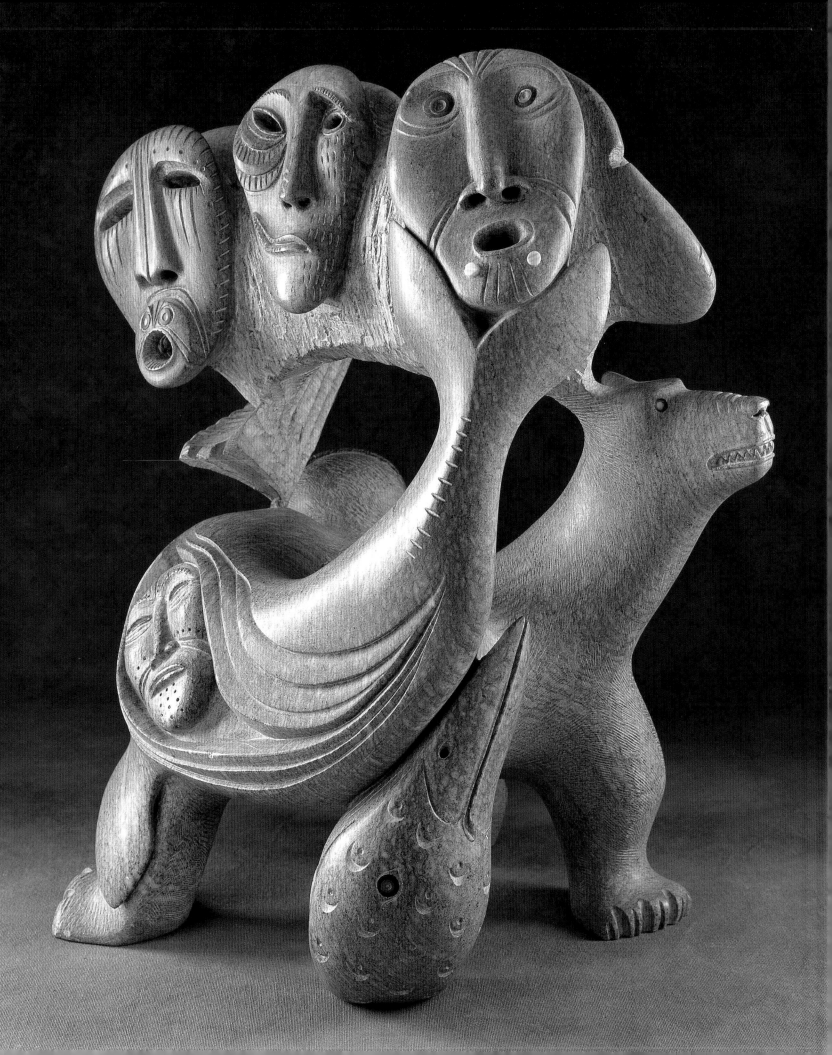

FOREWORD

BY GEORGE SWINTON

I FEEL VERY FORTUNATE to be writing a foreword to Ingo Hessel's *Inuit Art: An Introduction*. When Ingo first told me that he planned to produce an illustrated book on Inuit art as art (in the sense of our traditional Western concept of quality achievement) and not as a folksy, promotional, illustrated coffee-table book, I immediately asked him to allow me to write a foreword to it. Ingo has always represented to me the kind of enthusiastic interest and attitude which have been so regularly neglected by many who were involved in the promotion of Inuit art. When he and I think of Inuit art, we think about the best and the most significant of what we see coming out of the Arctic. We honestly do. We appreciate the pleasure we get from it.

Value judgments are, of course, a most delicate matter, probably as much of opinion as of knowledge, and certainly, I hope, not merely of taste. This issue has become especially contested now. Many non-native opinions and preferences are being challenged by those who advocate and extol the virtues of purely ethnocentric prerogatives. Others, including me, stand by the preference for quality over ethnicity in art, even while we truly recognize and admire the importance of the latter as one of the motivating forces behind Inuit art. Yet, I am keenly aware that, for all our admiration, our sense of quality is based by necessity on traditional humanistic Western values of art and aesthetics.

Even though *Inuit Art: An Introduction* is based on these traditional Western values—which operate somewhat differently from those of Inuit who were brought up within their largely egalitarian, nonjudgmental, native lifestyles—the book succeeds in bringing about an almost universal awareness and appreciation of what so often and so loosely is called "Inuit art," beyond the mere exploration of its historical and cultural context and the evolution of Inuit society. For, precisely, this is the reason why Inuit art from its very beginning received so much appreciation and recognition in the south. And, indeed, Ingo's perception and comprehension of Inuit art are located as much in the direction of quality as in its ethnic nature.

I well remember that a quarter century ago, when I discussed the work of four Puvirnituq artists of whom I was particularly fond (Davidialuk Amittu, Josie Papialuk, Charlie Sivuarapik and Joe Talirunili) in an article for a Winnipeg Art Gallery exhibition catalogue, I called it "The Povungnituk Paradox: Typically Untypical Art." Today, I could still write articles about Inuit artists under the same title. But, thank goodness, I no longer need to do so, for the understanding and recognition of Inuit art and artists as presented by Ingo in this book does exactly that. Very concisely, too. And while it provides a sensitive overview of what Inuit art means to the author, and does so honestly and convincingly in the written text, the illustrations give powerful witness to Ingo's sense for the varying kinds of quality which are typical for individual Inuit artists but do not typify Inuit art in general. I applaud such a stand, but I also realize that it is contrary to some widely held opinions for which Inuit art is popularly known, admired and bought. Yet, on the other hand, it is this special quality of the ethnic aspect that has brought to Inuit art its recognition—nationally and internationally—from art collectors, from several art museums and from a surprisingly possessive Canadian cultural consciousness.

2
David Ruben Piqtoukun (born 1950), Paulatuk / Toronto
Spirit World of the Inuit, 1984
Grey Brazilian stone, ivory, red Arizona pipe stone, black African wonderstone, antler inlay, 45.6 × 36.4 × 29.6
Art Gallery of Ontario, Gift of Samuel and Esther Sarick, 1996

"An old shaman is telling stories of how the Inuit people, animals and spirit world co-exist. Images of ceremonial masks, animals and people appear and the powerful bear-spirit supports the whole sculpture," says the artist (Wight 1989:61). He believes that shamans, although their powers are gone, live through artists like himself.

The strange aspect of this recognition of Inuit art as a major Canadian cultural achievement is that this very recognition is now considered by some as an "act of cultural appropriation in complete disregard of Inuit value systems and cultural prerogatives." In several ways, of course, it is more or less just that, as the examples illustrated have not been chosen on the basis of egalitarian principles but on the basis of selectivity and a knowledgable consciousness of art that is at the same time aware of and sensitive to context. We should remember that knowledgable selectivity is another of the reasons that Inuit art was so enthusiastically recognized in the first place. And in that sense, *Inuit Art: An Introduction* is much more than a mere overview. It is a celebration of fifty years of contemporary Inuit art. I would assert that it is also a celebration of the Inuit act of contributing so powerfully to the culture of Canada. I know that Ingo thinks that way and, indeed, so did I, when, some forty years earlier on my first visit to the north, I discovered that there was no such thing as "Eskimo art." There was only art, art made by Inuit—the art which is now called "Inuit art" and which this book celebrates so convincingly.

PREFACE

I am an Inuk
one whose ancestors sheltered
in the winter igloo of the great arctic;
One whose future is free
like the wild animal
of the arctic spirit.
I am an Inuk
who was given a place in the tundra so
I could remember the cold winter
darkness and the bright spring day.
I am an Inuk
and I know that my heart is free
to go where all animals are free.

—SIMIONIE KUNNUK, "My Past, My Future"

THIS BOOK IS A GENERAL INTRODUCTION to the art of the Inuit (formerly called Eskimos) who live in Canada's Arctic. It is not an exhaustive survey—more than a million artworks have been produced by some 4,000 Inuit over the past five decades—but it provides an overview of some of the major regional, community and individual artists' styles in three important areas: sculpture, graphic arts (drawings and prints) and textiles. It also presents the cultural, historical and socio-economic background to Inuit art-making.

In looking at Inuit art, it is best to leave our preconceptions behind, for it does not always conform to European or American notions about art and art-making. There are those who argue that the art of a culture should be judged only by members of that society. But Inuit art, which is produced primarily for "export," surely speaks not only of its own culture but also to the recipient one.

Contemporary Inuit art has made its creators and their culture famous throughout the world. Were it not for the tremendous outpouring of artworks, the Inuit might possibly be just another interesting anthropological footnote in the history of the world's cultures. Memories of life on the land are still fresh, especially for older Inuit, and the past is very much alive in Inuit culture. Although much of the art does dwell on the past for inspiration, it is important to remember that Inuit society is not "frozen in time." Given the spontaneous nature of the art, however, perhaps we may be forgiven if we are occasionally seduced into believing that Inuit continue to live the life that they portray, and often glorify, in their sculptures, graphics and textiles.

While much Inuit art is "about" traditional culture and values, it is also very much an expression of the experiences, values and aesthetics of individual artists who have had to come to grips with profound and rapid change in the second half of the twentieth century. Inuit art is often "autobiographical," even if specific events are not always depicted, and it reflects the life histories of its makers as well as their artistic talents.

By combining cultural and biographical elements with an appreciation of the communicative power and beauty of individual works, we may begin to truly understand and appreciate the complexity—and the miracle—of Inuit art.

ACKNOWLEDGEMENTS

THIS BOOK WOULD NOT HAVE BEEN POSSIBLE without the help and support of a number of people and institutions.

For their many personal and professional courtesies, Dieter and I owe a special debt of gratitude to the following curators of Inuit art: Cynthia Cook at the Art Gallery of Ontario (Toronto), Christine Lalonde, Acting Curator at the National Gallery of Canada (Ottawa), Darlene Wight at the Winnipeg Art Gallery, and Odette Leroux at the Canadian Museum of Civilization (Hull, Québec). We are also greatly indebted to Shannon Bagg, Roger Baird, Kelly Cameron, Kitty Bishop-Glover, Ann Rae and Pat Sutherland at the Canadian Museum of Civilization; Faye van Horne at the Art Gallery of Ontario; Susan Campbell at the National Gallery of Canada; and Dyane Cameron and Margot Rousset at the Winnipeg Art Gallery, as well as to numerous other staff members at these institutions.

I am most grateful to Stephen Rothwell, Lori Cutler, Joanne Logan and Frederica Cameron at the Department of Indian Affairs and Northern Development for their kind assistance and support.

I wish to thank Terry Ryan and John Westren of Dorset Fine Arts, David Wilson and Heather Beecroft of Canadian Arctic Producers, Jim McDonagh of La Fédération des Coopératives du Nouveau-Québec, Sally Qimmiu'naaq Webster of Baker Lake Fine Arts and Harold Seidelman of Images Art Gallery for their help in obtaining artists' permissions, and other assistance.

Special thanks are owed to Robert McGhee at the Canadian Museum of Civilization for his kind help, and for his book *Ancient People of the Arctic*, which furthered my understanding of Dorset culture and art. A special thank you also to Deborah Hickman, Manasie Akpaliapik, Jimmy Manning at the West Baffin Eskimo Co-operative, Dennis Hillman and Denise Gagnon at the North West Company, Martin Legault at the Geological Survey of Canada, Toivo Roht, Eric Leinberger and Simionie Kunnuk, for their advice and assistance.

Marie Routledge, Curator of Inuit Art at the National Gallery of Canada, deserves particular mention for the many years of discussion and collaboration in our search to develop a framework for understanding Inuit sculpture. I will always be grateful to Jean Blodgett, who introduced me to and encouraged me to pursue my studies in the field of Inuit art. And I owe a very special debt to George Swinton for his advice, comments and suggestions, as well as his foreword to this book, but more importantly, for inspiring much thought and reflection over the years. Thank you, George.

We wish to thank our publisher Scott McIntyre for his faith in this project, and for his hard work in helping to make it happen. Thanks to Saeko Usukawa, Editorial Director at Douglas & McIntyre, for her guidance, patience and excellent advice, and to George Vaitkunas for his beautiful design of the book.

We would like to extend our warmest thanks and appreciation to our wives, Dieter to Colleen Clancey and I to Kumiko Murasugi, for their advice, support and hard work.

And finally, I would like to thank Canada's Inuit artists, who have enriched my life and the lives of so many others with their vision and their art.

INUIT ART

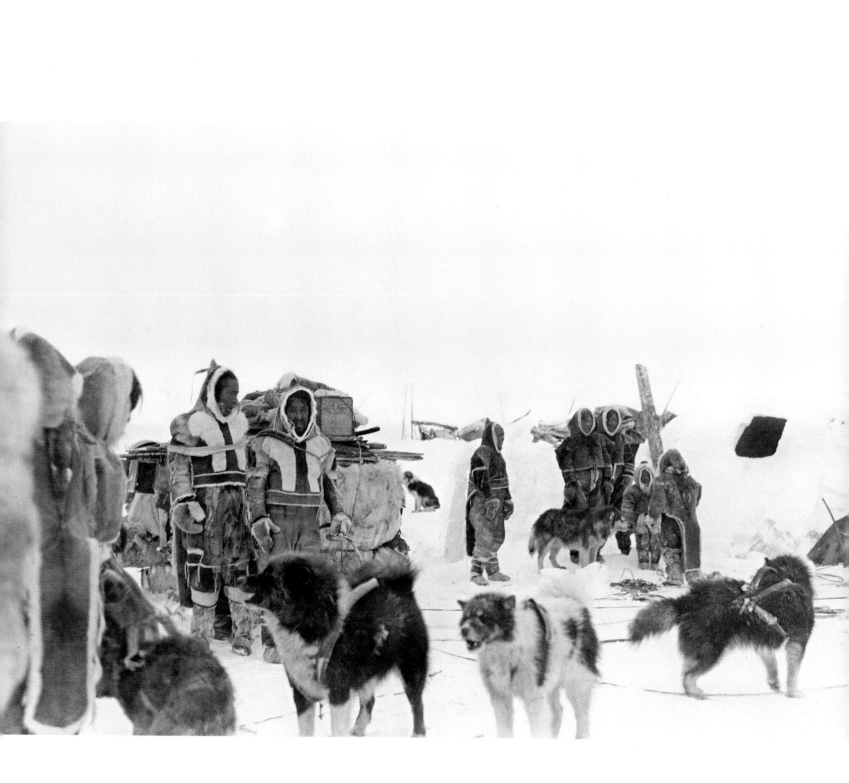

THE ARCTIC AND THE INUIT

WHAT HAPPENS when two cultures collide? When a traditional, small-scale culture encounters one that is much larger, more "advanced" and powerful? Many small societies, in North America and around the world, have been crushed or swept aside with the advance of European "civilization," and the culture of the Inuit, who inhabit the northern regions and communities of Canada's Arctic, is presently in the throes of unprecedented change under the heavy influence of the southern "Euro-Canadian" way of life.[1] Although some of the culture has been lost and forgotten, Inuit have so far managed to retain key aspects of their language, values and beliefs, as well as their deep respect for *nunatsiaq* ("the beautiful land") and its riches.

Contemporary Inuit art is just one by-product of the collision of traditional Inuit and modern Western cultures. A full understanding and appreciation of Inuit art can best be achieved by exploring both its historical and cultural context and the evolution of Inuit society.[2]

THE LAND, SKY AND SEASONS

This land of ours is a good land and it is big, but to us Inuit it is very small. There is not much room. It is our own land and the animals are our own and we used to be free to kill them because they were our animals. We cannot live anywhere else, we cannot drink any other water. We cannot travel by dog-teams in any other place but our land.

—INNAKATSIK, BAKER LAKE (Brody 1987:7)

The Inuit homeland is vast, covering nearly three million square kilometres (over one million square miles) of the most northerly and coldest part of Canada.[3] While the Arctic mainland is punctuated by lakes and rivers, the eastern islands and the Labrador coast are dominated by mountains and fiords. Much of the land is tundra, a windswept and stony plain where trees cannot survive, stunted plants grow slowly, and lichens cling tenaciously to rocks. The oceans are frozen for much of the year, and permafrost keeps the ground frozen except at the height of summer, when the top few centimetres thaw. Surprisingly, precipitation is limited, and winter blizzards are caused by high winds rather than by heavy snowfall.

The Arctic winter is cold, dark and long, lasting six to seven months of the year, with temperatures in January falling to a chill -30° C to -40° C (-22° F to -40° F) and occasionally -60° C (-75° F). In the most northerly regions, the sun disappears completely for three months, and the

3
Copper Eskimo Packed Up and Prepared to Leave Snow Village
Bernard Harbour (north of Kugluktuk), 1915
Photo by J.R. Cox, Canadian Arctic Expedition 1913–1916, courtesy Geological Survey of Canada (39707)

In winter, several bands of Copper Inuit would join forces to construct sizable snow-house villages on the sea ice. When the local supply of seals was exhausted, the camp would move on to a new source.

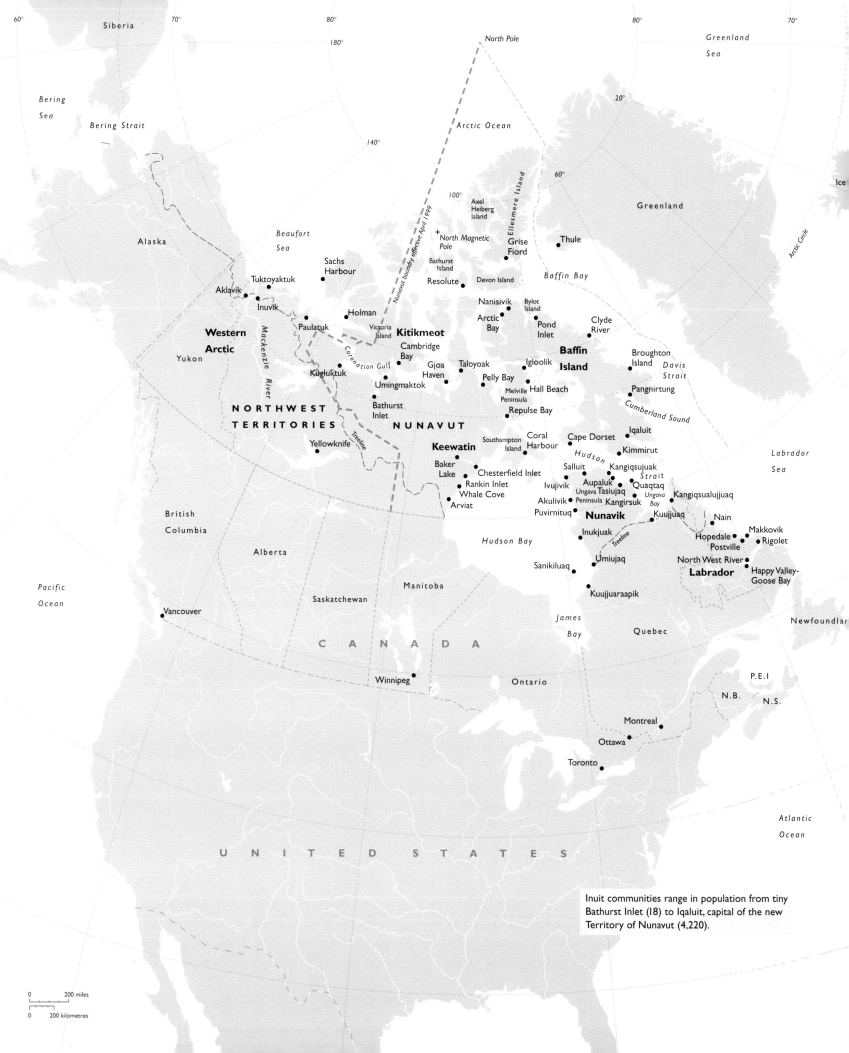

Inuit communities range in population from tiny Bathurst Inlet (18) to Iqaluit, capital of the new Territory of Nunavut (4,220).

The Inuit across Canada's Arctic shared most aspects of their culture, but there were regional differences. The tribal groups (and smaller bands) each associated themselves with a particular geographic area or lifestyle, and were identified with the suffix *miut* ("people of").

The **Mackenzie Inuit**, who had close cultural links with nearby Alaska, had a rich and varied supply of food (including moose, beaver and muskoxen) as well as access to wood. They lived in relatively large communities but by 1900 were almost wiped out by epidemics. (The majority of today's Western Arctic Inuit, who are descended from fairly recent Alaskan immigrants, refer to themselves as Inuvialuit rather than Inuit.)

The **Copper Inuit** made use of native copper deposits in their region and traded it with other groups. They hunted muskoxen and caribou in the summer and sea mammals in winter.

The **Netsilingmiut** ("people of the place where there is seal") relied on marine mammals, especially seals, and were renowned as practitioners of magic.

The **Caribou Inuit** were mostly inland people who depended almost totally upon the spring and fall migrations of caribou herds.

The **Sallirmiut** were so distinct from other groups that it is thought they might be descendants of Dorset peoples. Sadly, they were completely wiped out by disease in 1902–3.

The **Iglulingmiut** hunted a variety of game including marine mammals (especially walrus and whales), caribou and birds.

The **South Baffin Inuit**, whose lives resembled those of their Iglulingmiut neighbours, were the first group to have regular contact with Europeans.

The **Ungava** and **Labrador Inuit** who, like the Mackenzie Inuit, had access to wood as well as trade ties with Indian groups, hunted caribou and marine mammals (including bowhead whales).

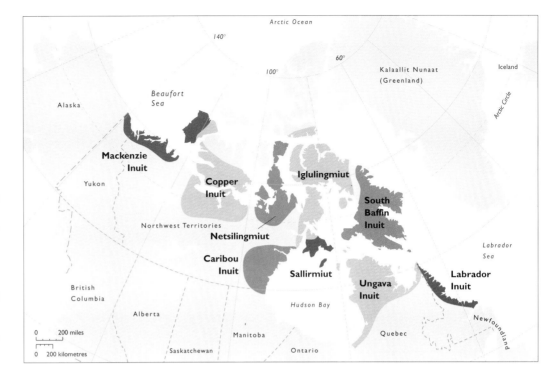

world is lit only by the dim light of the Aurora Borealis and the moon reflected on snow. The Arctic summer lasts only one to two months, with average temperatures ranging from 5° C to 15° C (40° F to 60° F), but continuous daylight and the appearance of tiny, beautiful flowers make it a special time of year.

Despite the harsh climate, the Arctic supports over eight hundred species of plants, several hundred animal species and a few dozen bird species.

TRADITIONAL LIFE

The traditional Inuit were a seminomadic hunting people divided into several regional tribal groupings. These were further divided into small bands and extended families who travelled together, combining their knowledge and resources to survive. The sharing of food and other necessities, in times of plenty and in times of dire need, was an integral part of Inuit society. Although the eldest male was generally considered to be the head of the camp, there were no elected or hereditary leaders. Most important decisions, such as resolving disputes, were made by elders or co-operatively by the group. Their goal was to maintain harmony and not to determine guilt or innocence, or to mete out punishment.

Kinship ties were extremely important, as most people were related to one another through blood, marriage, adoption and ritual partnerships. Marriages, generally arranged in childhood, were very stable, although spouse-sharing and polygamy were occasionally practised. Elders were respected for their knowledge and wisdom, and children were doted on and rarely punished. Even so, in times of great hardship it was considered necessary to kill the old and sick, or the very young—especially baby girls—so that the others might survive.

Men went out to hunt, while women stayed behind to take care of the camp. Hunting required a number of specialized skills: weather forecasting, landmark and celestial navigation, dogsledding, tracking, knowledge of animal behaviour, making weapons, butchering and

caching, and constructing shelters. Running a camp and a home also required numerous skills: butchering and preparing skins, rendering fat, sewing clothing and tents, making tools, preparing food, tending lamps, caring for children and gathering plant foods.

In winter, Inuit lived in snowhouses on the sea ice and hunted animals such as seals and walruses (Figure 3); in summer, they split up into smaller groups and moved inland, setting up skin tents at fishing spots and caribou-hunting grounds (Figure 4). In autumn, Inuit caught large numbers of fish in stone weirs; fish and meat were dried or cached in preparation for the winter months. The diet of meat and fish was supplemented by plants and bird eggs gathered in the warmer months.

Long considered masters of technological adaptation and improvisation, Inuit depended upon animals for food as well as the raw materials for clothing and shelter, tools and weapons, fuel and transportation. Furs and skins from caribou, seals and polar bears—sometimes even birds and fish—were made into clothing and footwear. Skins were also used for tents, blankets, ropes, kayaks and larger boats called *umiaks*. Bones, antlers and ivory were carved into a variety of tools such as needles, knives and harpoon heads. Even a *komatik* (dogsled) could be fashioned from strong yet flexible antler and bone. Sinew was used as thread and twine, and animal fat, primarily from seals, was rendered into oil for fuel. Rare materials such as copper and soapstone (for cooking pots and *qulliit*, or oil lamps) were usually acquired through trade; driftwood was occasionally found along beaches.

The best-known and most ingenious example of Inuit technological adaptation is the winter *igloo*, or domed snowhouse (*igloo* means simply "house"). A small, simple igloo made of blocks of packed snow could be pieced together in less than an hour. Although most igloos consisted of a single room, more permanent structures could be fairly large (4 metres/12 feet in diameter and almost 3 metres/9 feet high) and have several chambers. The sunken entrance tunnel protected the interior from fierce winds and helped prevent cold air from entering. Inside, a raised sleeping platform covered with furs provided further comfort. Each winter camp had one large ceremonial igloo for games or festivals.

To pass stormy days and long winter evenings, Inuit developed many forms of entertainment: drum dancing and singing, throat singing, storytelling, contests and games. Contests such as wrestling and arm, leg or mouth pulling were tests of strength, while *ayagak* (similar to cup and ball) and other games required agility and hand-eye co-ordination, and often involved gambling.

Storytelling was a favourite pastime. Although there were tales of the hunt or Aesop-style morality fables, most were myths, legends, songs and stories about gods, heroes and spirit beings. Through this rich oral tradition, the Inuit conveyed to successive generations their history and heroic accomplishments, as well as ideas about creation, kinship and taboos, hunting and magic, and spirit worlds. The details of a myth might vary from region to region and no doubt altered over time, but the myth's relevance and meaning remained clear.

With its tradition of oral history, Inuit culture is inseparable from its language, Inuktitut. The word *Inuit* simply means "the people" in Inuktitut, with *Inuk* being the singular noun "person." Inuktitut belongs to the Eskimo-Aleut family of languages, which are classified as polysynthetic: a single word consisting of numerous roots, prefixes and suffixes can express ideas that require several words in a language like English. Six distinct regional dialects exist today.

The importance of the land and its animals to the Inuit was reflected in their traditional spiritual beliefs, which constituted a form of nature worship. Powerful gods and spirits were

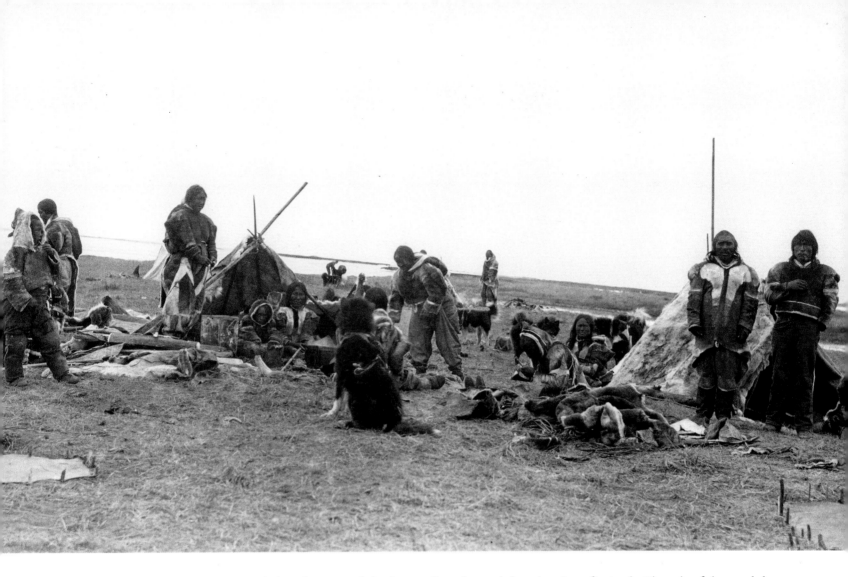

*Eskimo Camp at Mouth of
Coppermine River*
(near present-day Kugluktuk),
1916
Photo by J.J. O'Neill, Canadian Arctic
Expedition 1913–1916, courtesy
Geological Survey of Canada (38663)

When spring arrived, Copper
Inuit moved off the sea ice,
caching their winter gear and
dispersing into smaller family
groups. They travelled to inland
hunting grounds in search of
caribou, muskoxen and fish.
Summer life was more
nomadic, with tents and other
belongings carried on the
backs of Inuit and their dogs.

believed to control the forces of weather and the migration of animals. The role of the *angakok*
(or shaman, male or female) was to act as an intermediary with the supernatural world to
favourably influence these forces. Shamans were invested with tremendous strength, the power
to fly and the ability to endure great pain; they were much relied upon to heal the sick, but were
also feared. Inuit also believed that the spirit of every human and animal lived on after death;
moreover, each person could rely on at least one "helping spirit." They protected themselves
from harm with magic charms or amulets, and avoided sickness or disaster by observing strict
taboos. Many taboos related to observing the separation of land and sea. For example, seal and
caribou meat were not eaten together or even cooked in the same pot, and walrus skins were not
to be sewn during caribou-hunting season (McGhee 1988a:10).

CULTURAL CHANGE

The Norse were the first Europeans to reach the Canadian Arctic, landing in Labrador before
A.D. 1000 and even attempting to colonize along the coasts of Baffin Island, Ungava and
Labrador. The first post-Norse contacts between Inuit and Europeans took place in the late six-
teenth century with the arrival of explorers Martin Frobisher in 1576, John Davis in 1585, and
Henry Hudson in 1610,[4] but there was no sustained contact until the late eighteenth century.

After 1818, explorers began searching in earnest for the Northwest Passage, a sea route through the Arctic to link Europe with Asia.

European and American whalers began arriving around the same time. For about a hundred years, starting in the mid-nineteenth century, Inuit worked for and conducted a brisk trade with whalers on a regular basis.[5] Fur trading also brought Inuit across the Arctic in contact with outsiders, and by the early twentieth century, trading posts, operated mainly by the Hudson's Bay Company, were situated within reach of most groups. Inuit came to depend on these permanently established posts, both in times of prosperity (when fur prices were high) and in times of hunger (when they could be assured of some assistance). This was a period of transition for Inuit society, which gradually was moving away from a subsistence economy and becoming increasingly dependent on foreign trade goods and the new barter economy.

The Europeans had a tremendous impact, influencing Inuit technology and lifestyle as well as affecting traditional customs and belief systems. Moravian missionaries arrived in Labrador in the 1750s and set up their first permanent mission in Nain in 1771. By the mid-nineteenth century, Anglican and Roman Catholic missionaries were travelling throughout the eastern and western Arctic; and in the early twentieth century, permanent missions began springing up near trading posts. Missionaries usually offered medical assistance and basic education as well, gradually undermining Inuit dependence on shamanism and traditional spirituality. By the 1950s, even the most isolated Inuit had been baptized or at least nominally converted to Christianity.

No written form of Inuktitut existed until Moravian missionaries in Labrador developed a Roman orthography in the late eighteenth century. A hundred years later, Methodist missionary Rev. Thomas Evans invented a system of syllabics for the Cree Indians, which was adapted for Inuktitut in 1876 by Rev. Edmund Peck of the Anglican Church; it is still in use in the eastern and central Arctic. Missionaries helped to instill a "quasi-literacy" (Ipellie 1992:46) in Inuktitut by teaching Inuit to read the Bible and hymnals.

This time of change when people from the outside world[6] began to intrude on and influence Inuit society is called the "Historic Period." In 1903, the Canadian government set up detachments of the Northwest Mounted Police (now called the Royal Canadian Mounted Police) to enforce the rule of law and ensure Canada's sovereignty over the Arctic.

Traditionally, Inuit had given names rather than first names and surnames. Many, however, were given Christian "first" names by missionaries. These names were sometimes altered to make them sound more Inuit. For example, Thomas became Thomasie or Tumasi; Matthew became Matiusi, and Elizabeth was changed to Elisapee. The RCMP made a census of the Inuit population in the 1940s, assigning every person an identification number stamped on a small disc. These "disc numbers" were used in the hope of avoiding confusion with Inuit names, and were actually used as signatures by many carvers in the 1950s and 1960s. The numbers were dropped when "Operation Surname" was established. Surnames (usually the given Inuktitut names of the male heads of households) were officially adopted by Inuit in 1969. So, for example, the carver Osuitok (whose disc number was E7–1154), took his father's given name Ipeelee as his surname; it would therefore be less than precise to call Osuitok simply "Ipeelee." (Paradoxically, Osuitok's wife and children adopted "Osuitok" as *their* last name.)

When the Canadian government assumed responsibility for Inuit welfare at the end of the Historic Period in the late 1940s, the pace of change in Inuit culture accelerated tremendously.[7] Throughout the 1950s, the government established small villages and towns equipped with

Δ i	▷ u	◁ a
Λ pi	> pu	< pa
∩ ti	⊃ ti	C ta
P ki	d ku	b ka
ᒉ gi	J gu	U ga
Γ mi	⅃ mu	L ma
σ ni	ᓄ nu	ᓇ na
ᒉ si	ᒉ su	ᓴ sa
⊂ li	⊐ lu	⊏ la
ᔨ ji	ᔪ ju	ᔭ ja
ᕕ vi	9 vu	ᕙ va
ᕆ ri	ᑭ ru	ᕋ ra

Inuktitut Syllabics Chart
The system of syllabics is still used widely in the Eastern and Central Arctic. Artists often inscribe syllabic signatures and texts on drawings, prints and the bottom of sculptures.

schools and nursing stations around the existing trading posts and missions. Its decision to relocate scattered Inuit families into permanent settlements coincided with a time of widespread hunger and disease in many parts of the Arctic, giving people little choice but to comply.[8] However, settlement life not only severely disrupted the old nomadic hunting and trapping economy but created an immediate dependence on a cash economy and government relief.

As a way to wean Inuit off welfare, the Canadian Guild of Crafts and the Hudson's Bay Company, with the encouragement of the Canadian government, began in 1949 to purchase carvings for export on a large scale and to promote their sale. The production of art quickly became an integral part of the new cash economy, and by the early 1960s, Inuit-owned co-operatives had been formed in most northern communities to assist with economic development in arts and crafts, as well as fishing and fur harvesting. Carving, printmaking and textile arts have been a vital part of the Inuit economy and Inuit culture ever since.

CONTEMPORARY LIFE

> I know I have had an unusual life, being born in a skin tent and living to hear on the radio that two men have landed on the moon.
> —PITSEOLAK ASHOONA, CAPE DORSET (Eber 1971)

Today, approximately 35,000 Inuit live in about fifty small communities scattered through northern Canada in Labrador, Nunavik (Arctic Québec), the Northwest Territories and the new Territory of Nunavut.[9] The region stretches almost 4000 kilometres (2400 miles) from east to west—or the distance from London to Cairo.

The modern Inuit village (Figure 5), populated by 300 to 1,500 people, is connected to southern Canada by scheduled or charter flights several times a week. Huge diesel generators provide electrical power, and most people have moved from their first flimsy "matchbox" houses to government-subsidized energy-efficient homes. Many families own one or two snowmobiles and a couple of all-terrain vehicles, though a few people still own dog teams, mostly for fun or racing. Every home has a television set and a VCR, and northern residents watch TVNC (Canada's Arctic television network), which broadcasts programs in Inuktitut and English, or southern Canadian and U.S. television stations via satellite. Since "southern" food is imported, it is very expensive, and most Inuit families supplement it with "country" food (meat and fish) whenever possible.

Over 90 per cent of the population in these communities is Inuit; the rest are "southerners" who are teachers, government administrators, nurses, store managers, mechanics and RCMP officers. A number of Inuit, too, are teachers or civil servants, or have maintenance or construction jobs; others are employed at the local co-op, hotels or a branch of the Northern Store chain. Unemployment is rampant, but people would rather stay in the community than seek work elsewhere, though some have moved to the nearest regional capital and a very few have gone south.

In each settlement, there is an Anglican and a Roman Catholic church, and sometimes a Pentecostal or Baptist church as well. Since most Inuit are devout Christians, Sundays are fairly quiet. In some places, drum dances are held once or twice a week; others have not seen one for years. These days, community dances featuring jigs and reels (learned from the whalers) or rock music are more common.[10]

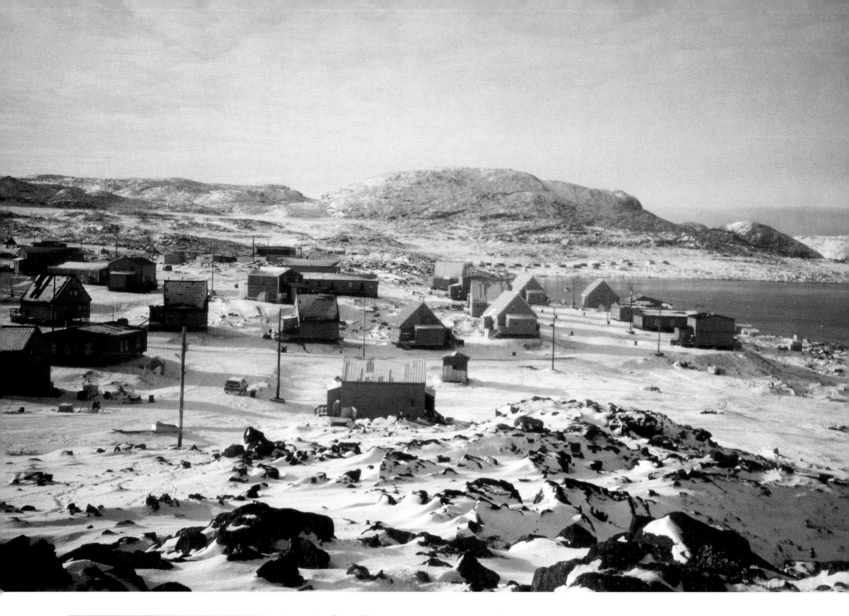

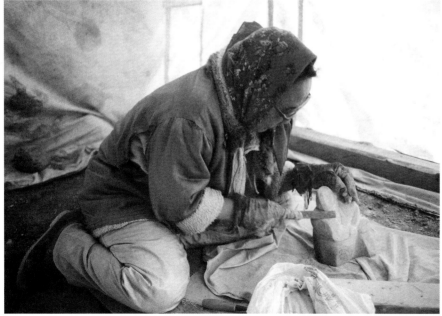

5 (top)
View of Cape Dorset, 1992
Photo by Ingo Hessel

Cape Dorset (population
1,100), situated on tiny Kingait
Island off the coast of southern
Baffin's Foxe Peninsula, is
Canada's most famous Inuit
art-producing community.
Cape Dorset's sculptures, draw-
ings and prints have attracted
as much tourism as the area's
wildlife and spectacular
scenery.

6 (bottom)
Artist Suzanne Kriniksi in Her
Carving Tent
Arviat, 1995
Photo by Ingo Hessel

Carving stone is messy work,
so artists prefer to do it out-
doors, even in winter, often in
tents pitched beside their
homes. While some carvers use
small power tools to speed up
the early roughing out stages
of their work, others continue
to work exclusively with hand
tools such as axes, files and
chisels.

Most villages have voted themselves officially "dry," but a few residents find ways to obtain alcohol and drugs. Half the Inuit population is of school age, but many have dropped out, and a large percentage of Inuit live on welfare. Teenage pregnancy is widespread, the threat of AIDS is real, and suicide and family violence are prevalent. These contemporary social problems, and not the traditional culture of igloos and shamans, form the backdrop to Inuit art-making in the 1990s. Until recently, government and administration were in the hands of outsiders, but the emergence of community councils, Inuit politicians, land claims settlements and the establishment of the new Territory of Nunavut provide new opportunities and challenges.

Many Inuit carve, draw or sew, and in some villages half of the adult population are artists (Figure 6); some work full time, while others carve occasionally for extra cash. Although most of the carvers are men, women dominate the graphic and textile arts. Producing art has enabled many Inuit to pursue a relatively traditional lifestyle; the income allows them to buy rifles and ammunition, boats and motors, snowmobiles and gasoline, so that they can continue to hunt and fish for food.

While Inuit artists have been prompted and influenced to produce art by southerners and southern institutions, they have nonetheless managed to imbue their art with traditional values and memories of life as it once was; furthermore, their art-making has been affected by—and has even helped to instill—a new pride in being Inuit. No one could have predicted how Inuit would react to the challenge of making art in a nontraditional context for an outside market. The fact that contemporary Inuit art is now about fifty years old and continues to hold a vital place in the world of art is a testament to the tenacity of Inuit culture, and the artistic gift of the Inuit people.

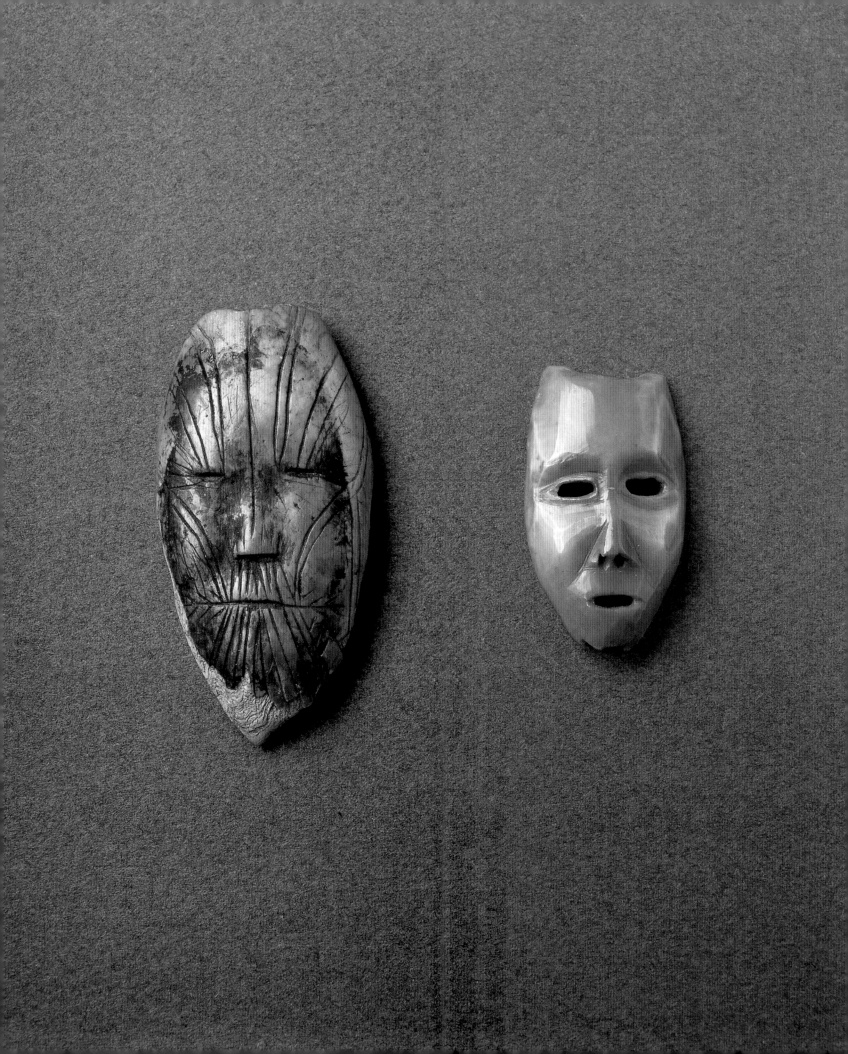

ART OF THE PREHISTORIC PERIOD

7 (left)
Early Palaeo-Eskimo
(ca. 1700 B.C.)
Devon Island (True Love
Lowlands)
Miniature mask
Ivory, 5.4 × 2.9 × 0.8
Musée canadien des civilisations/
Canadian Museum of Civilization

7 (right)
Early Dorset culture
(500–1 B.C.)
Hudson Strait (Tyara site)
Miniature mask
Ivory, 3.5 × 2.2 × 0.7
Musée canadien des civilisations/
Canadian Museum of Civilization

The pattern of lines on the maskette at left represents tattooing (or possibly advanced age). This object is the oldest known depiction of a human from Canada's Arctic. The famous "Tyara maskette" (*right*) found near Salluit, was made almost two millennia later and may represent animal-human transformation.

FIVE THOUSAND YEARS AGO, hunters from northern Asia crossed Bering Strait and settled in what is now Alaska. Their descendants, the first Palaeo-Eskimos, migrated eastward across Canada's Arctic, as far east as Greenland and as far south as Newfoundland. From these people evolved the Dorset culture, whose carvers created some outstanding sculptural works. A final wave of immigrants from Alaska, known as the Thule,[1] arrived in Canada about a thousand years ago. The Thule are the true ancestors of Canada's Inuit, whose culture developed five to six centuries later.

THE OLDEST ARCTIC ART

The first early Palaeo-Eskimo archaeological remains, discovered almost simultaneously in 1948 in Alaska and Greenland, were strikingly similar, and comparable artifacts were eventually found in Canada as well. The Stone Age people who made the tiny, exquisitely worked flint microblades, burins, arrowheads and other tools that characterized all of the finds are known as Arctic Small Tool tradition. They probably used kayaks, may have invented the igloo, and possibly passed on the use of the bow and arrow to Labrador Indians. Art is rare, however: one small ivory maskette with striking tattoo marks, carved over 3,500 years ago, is the oldest Palaeo-Eskimo human likeness (Figure 7 left). The tiny tools and weapons they made are so perfectly fashioned that they could be considered works of art in their own right.

THE ART OF THE DORSETS

Archaeological evidence of a later Arctic culture that began around 800 B.C., named "Cape Dorset" after the community near where the first few specimens were found, was identified in 1924 by the noted anthropologist Diamond Jenness. Dorset culture, as it is now called, ranged across most of Arctic Canada to eastern Greenland and south to Newfoundland.[2] The Dorsets made a wide variety of small tools, utilizing not only stone but also ivory and bone; they favoured the spear over the bow and arrow, did not use dogsleds, and seldom used kayaks. Their economy was based primarily on the hunting of marine mammals and trade with neighbouring peoples.

The most intriguing aspect of Dorset culture is its art. The discovery of hundreds of animal and human figures, amulets, masks, maskettes and ritual objects, carved from ivory, bone, antler and occasionally stone, as well as petroglyphs, has given rise to considerable speculation concerning the use and significance of art within Dorset cosmology, religion and society. Based on the artistic evidence, archaeologist William Taylor and artist George Swinton are convinced that much of Dorset art has a magico-religious basis, and they suggest that many Dorset art objects formed parts of "shaman's kits."[3] Based on the assumption of a similarity to the more recent Inuit practice, Dorset shamans would have been able to attract and influence helping spirits, travel to other worlds, heal the sick, and foretell the future. Swinton also believes that the specialized nature of many objects, and their carved precision, indicate that most were made by "professional" shaman-artists (Taylor and Swinton 1967:39).[4]

Depictions of animals and humans, particularly single figures, account for the majority of Dorset artworks. Some human figures, occasionally incorporating animal characteristics, appear to be fertility symbols, while others have been ritually "killed" with slivers of wood. The meaning of small, delicately carved ivory maskettes (Figure 7 right) from the Early Dorset period is unclear, but later, full-size driftwood masks were probably worn during shamanic rituals.

Polar bears, long considered the human's chief rival in the Arctic, hold a pre-eminent place in the Dorset bestiary. Sometimes they are depicted in naturalistic styles and poses, but more often are abstracted or stylized in some way. Most fascinating are the ivory "flying" or "floating" bears, with distinctive skeletal markings and "×" and "+" marks on skull and joints. Bears were probably the spirit helpers of shamans; these powerful carvings would have had a special significance, perhaps assisting the shaman on "spirit flights" (Figure 8). Slivers of wood inserted into cavities may have invested bear figurines with even more force. Bear amulets, on the other hand, were probably worn for protection by ordinary people. Of the other Arctic animals, falcons, seals and walrus are the most common subjects, seals being carved naturalistically, and walrus and falcons often stylized. Caribou often are represented by their hoofs or lower legs alone, realistically carved and pierced for use as amulets. Different animals were carved for different reasons: some possessed power, while others brought good luck or protection. Perhaps the more the Dorsets feared or respected an animal, the more closely they linked it to shamanism, and the more likely it was that they would represent it in a schematized or formalized manner.

Most enigmatic are the clusters of human faces carved into pieces of antler which have been found at numerous Late Dorset sites (Figure 9). Do they represent ancestors or actual people, or are they perhaps ghosts or spirits? Equally intriguing are the human faces carved into living rock on islands off the coast of Québec in Hudson Strait.

Ritual implements form another fascinating category of Dorset art. Almost certainly shaman's tools, these powerful objects, often decorated with animal and human motifs, have meanings that we can only guess at. Bone or ivory cylinders may have functioned as "sucking tubes" to release sickness (symbolized by miniature harpoon heads) from patients.[5] Ivory containers with human and animal motifs may have been used to store smaller implements, or served as ceremonial rattles (Figure 10).

The Dorsets manufactured ordinary objects such as harpoon heads with extraordinary skill, investing them with great beauty. Decorative engraving is very rare; theirs was essentially a figurative art, and despite its small size, it was very much sculpture in the round—carved and

8
Middle Dorset culture
(A.D. 1–600)
Igloolik area
Floating or flying bear
Ivory, 13.8 × 3.6 × 2.9
Musée canadien des civilisations/
Canadian Museum of Civilization

Dorset bears are carved in a very naturalistic fashion, or in a highly schematized manner that has symbolic meaning, or in a style that combines the two, as in this example: a fairly realistic figure in a standardized pose, incised with symbolic skeletal marks. These "flying" bears were probably the spirit helpers of Dorset shamans.

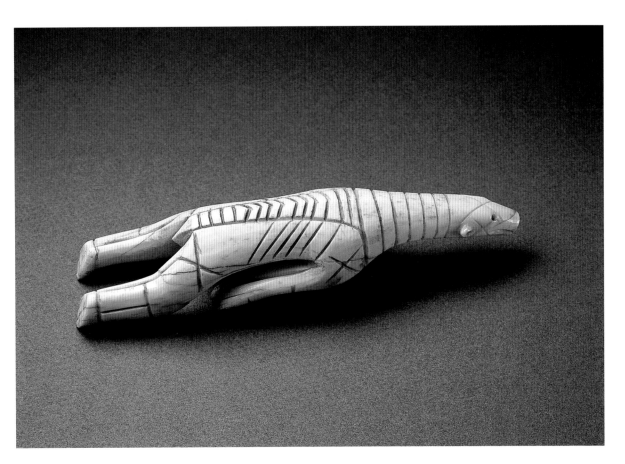

9
Late Dorset culture
(A.D. 600–1300)
Bathurst Island
Wand with faces
Antler, 19.5 × 5.1 × 3.3
Musée canadien des civilisations/
Canadian Museum of Civilization

Perhaps the most remarkable Dorset artworks are antlers carved with face clusters that were used as wands by shamans. They may represent the spirit helpers of a shaman or whole community, or the ancestors or members of a community or clan. The variety of facial types and expressions is astonishing; animal faces or characteristics seem absent.

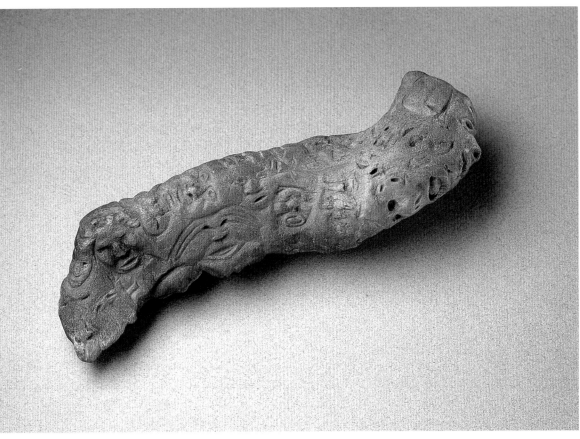

gouged, three-dimensional, and tactile. Swinton claims that of all the prehistoric Arctic art in North America, Dorset art in all its aspects—animals, human figures, ritual implements—"exudes intensity and power" like no other (Taylor and Swinton 1967:32).

THE ART OF THE THULE

After a period of expansion and cultural florescence that lasted from about A.D. 500 to 1000, during which many great artworks were carved, Dorset culture in Canada was suddenly overrun and replaced by a new wave of immigrants from Alaska. The two groups may have fought, but Inuit oral history suggests that the Dorsets often simply fled. Isolated Dorset groups survived relatively intact until the thirteenth century, but by the sixteenth the culture had vanished in Canada.

The first archaeological evidence of the new culture, which was ancestral to that of modern Inuit, was discovered by the Danish Fifth Thule Expedition of 1921–24, led by Knud Rasmussen, which travelled west from Greenland to Alaska. Archaeologists on the team uncovered the remains of a maritime culture several hundred years old, which they named Thule culture, after Thule in northwestern Greenland, where the first remains were found. Noting the similarity to artifacts from Alaskan cultures of the same period, the archaeologists speculated that Alaska was the homeland of the Thule.

The Thule hunted caribou and muskoxen, and used dogsleds in winter, but the foundation of their prosperous economy was the hunting of sea mammals, chiefly the bowhead whale. They chased down whales in kayaks and large skin boats, and killed them with float harpoons. Perhaps in pursuit of whales, the Thule began to migrate eastward around A.D. 1000 and spread to Greenland within a few generations. They learned to build igloos from the Dorsets and, like them, developed trade contacts with neighbouring groups and outsiders, which soon included early European explorers. But by and large, the Thule retained their Alaskan lifestyles and technologies.

Thule art was influenced little by that of the Dorsets, as the main purpose their art was not to appease spirits and the forces of nature but, rather, to ensure efficient hunting and to enrich everyday life. Indeed, Thule art may have had little connection with shamanism. It seems to have been a more personal art form, but with definite symbolic overtones.

Thule art has been described as "essentially graphic in emphasis," characterized by an interest in "line, geometry, and surface plane" (Vastokas 1971/72:72). The Thule made extensive use of the bow drill to create dot patterns, but also engraved the occasional hunting scene (Figure 11). The geometric and figurative graphic embellishments—border lines, dot, hatch and "Y" marks, as well as schematized figures—of hunting weapons, women's implements (combs, needle cases) and articles of adornment made mostly of ivory, are certainly a trademark of the Thule style (Figure 12) and differentiate it from the more rugged incising of magical symbols and marks in Dorset sculptural art. Though rooted in Alaskan traditions, Thule designs differ considerably from Alaskan ones. The Thule probably used a symbolic vocabulary of ornament that we have not yet learned, and it would be a mistake to assume that their art was "merely" utilitarian, decorative, and secular.

Thule sculptural art consists of a few small ivory pendants and figures, mostly female, and wooden dolls. Conspicuous for their cursory or even absent facial features (in strong contrast to

10 (top)
Late Dorset culture
(A.D. 600–1300)
Axel Heiberg Island
Decorated container
Ivory, 4.7 x 3.3 x 1.8
Musée canadien des civilisations/
Canadian Museum of Civilization

These enigmatic objects have
been found in many Dorset
sites, but their meaning and
use have yet to be deciphered.
Hollow, they all have a double-
walrus motif at the top and
perforated human faces below.
Some have another animal
carved in relief on the fore-
head. They may be rattles, or
containers for miniature
shaman's utensils.

11 (bottom)
Thule culture
(A.D. 1100–1700)
Baffin Island (near Arctic Bay)
Bow-drill handle
Ivory, 42.9 × 5.1 × 0.4
Musée canadien des civilisations/
Canadian Museum of Civilization

A fine example of Thule
graphic art. The narrow shape
of the ivory obliged the maker
to use the edges as ground-
lines; these were carefully
incised. The artist even created
a framing pattern on the left. In
the series of hunting, camp and
battle scenes, the figures are
somewhat schematized, but the
result is remarkable for its clar-
ity of meaning.

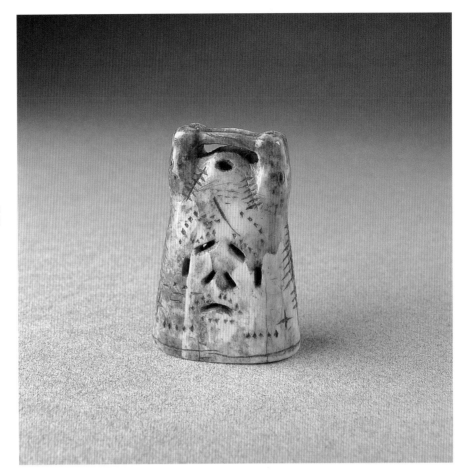

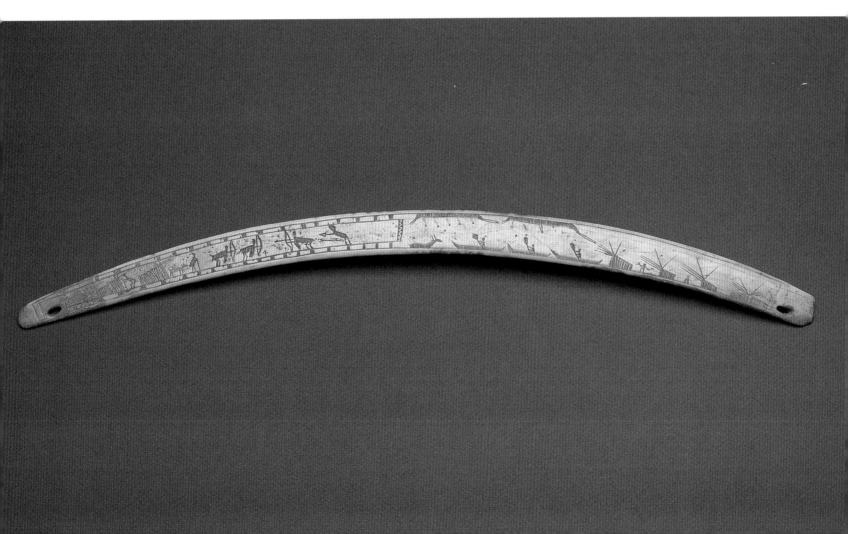

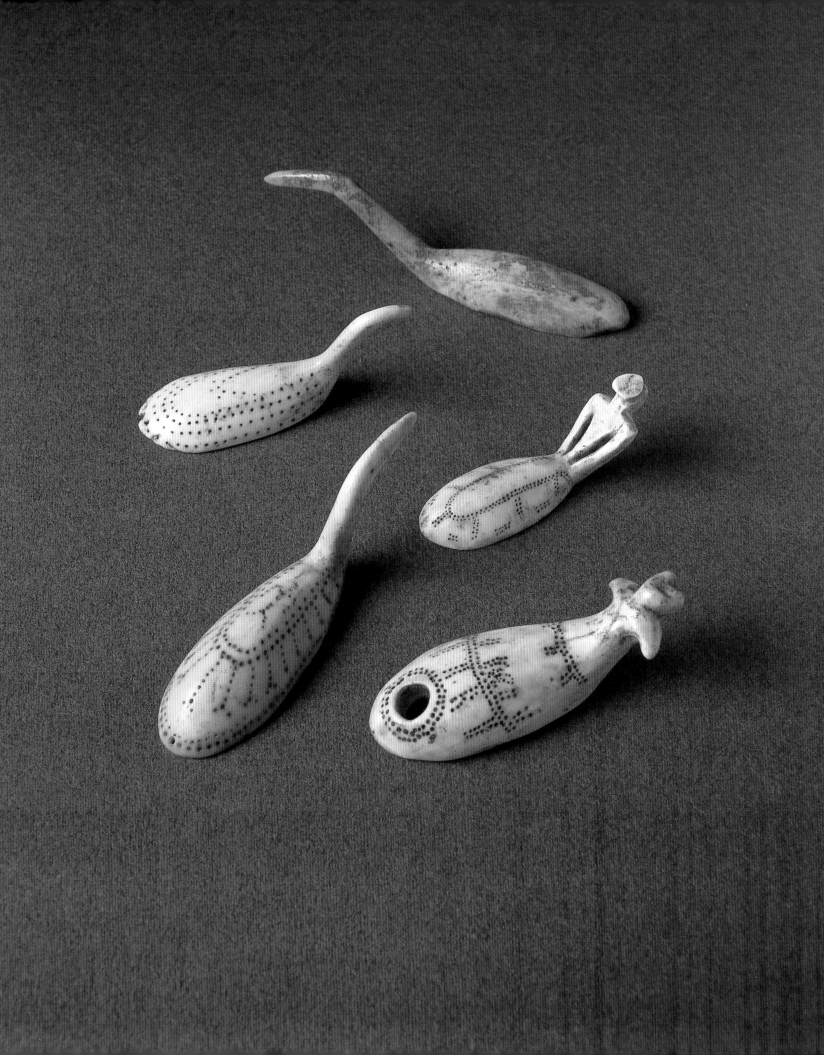

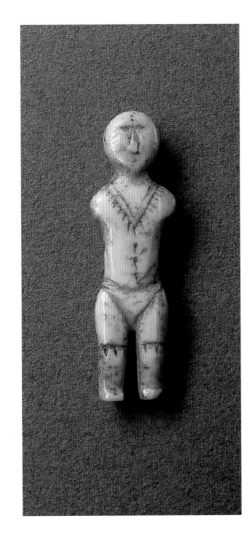

12 (facing page)
Thule culture
(A.D. 1100–1700)
Eastern Arctic
Swimming bird and bird-
woman figures
Ivory, 6.2 × 1.7 × 0.9 (front left figure)
Musée canadien des civilisations/
Canadian Museum of Civilization

These elegant little figures,
carved so that they appear to
be swimming, are often deco-
rated with stylized dot pat-
terns. They were used as
gaming pieces in later times,
but their exact use during the
Thule period has not been
determined. Some, like the one
at the bottom, may have been
worn on a cord as amulets.

13
Thule culture
(A.D. 1100–1700)
Coronation Gulf
Human figure
Ivory, 3.7 × 1.1 × 0.6
Musée canadien des civilisations/
Canadian Museum of Civilization

Thule figural sculpture is
notable for abbreviated arms
and the absence of facial fea-
tures. Larger female wooden
figures, used as dolls, have sex-
ual characteristics. This small
ivory is unusual for its clearly
defined face, its depiction of
clothing, and what appears to
be an amulet necklace. It may
represent a (female?) shaman.

Dorset art) and often abbreviated arms, these works have sometimes been described as standard-
ized and routine. Danish archaeologist Jørgen Meldgaard (1960:27) suggests that the co-opera-
tion required to hunt large whales led to an overriding uniformity in Thule society and art. The
meaning of the pendants and small figures is unclear—they may have been made as gifts, or
purely for personal adornment (Figure 13). Perhaps the most famous Thule artworks (and practi-
cally the only ones that feature animals, apart from a few whale effigies) are the small, delicate
so-called "swimming" figures of birds and bird-women, fashioned out of ivory and decorated
with patterns of drilled dots (Figure 12). These ubiquitous little objects, which are the perfect
synthesis of Thule graphic and sculptural styles, must have had a symbolic function; perhaps
they were worn as amulets or some type of decorative attachment to clothing. The bird-woman
figures may have been fertility charms.[6]

The Little Ice Age (A.D. 1600 to 1850) caused the early or complete freeze-up of open
waters and was a disaster for the Thule whaling economy, forcing them to switch to the less
reliable and productive hunt for seals, caribou, muskoxen and fish. By the time the Thule met
European explorers in the sixteenth and seventeenth centuries, their once uniform, sophisticated
culture had already begun to disintegrate and fracture into the regional cultural patterns known
to us as traditional Inuit society.[7]

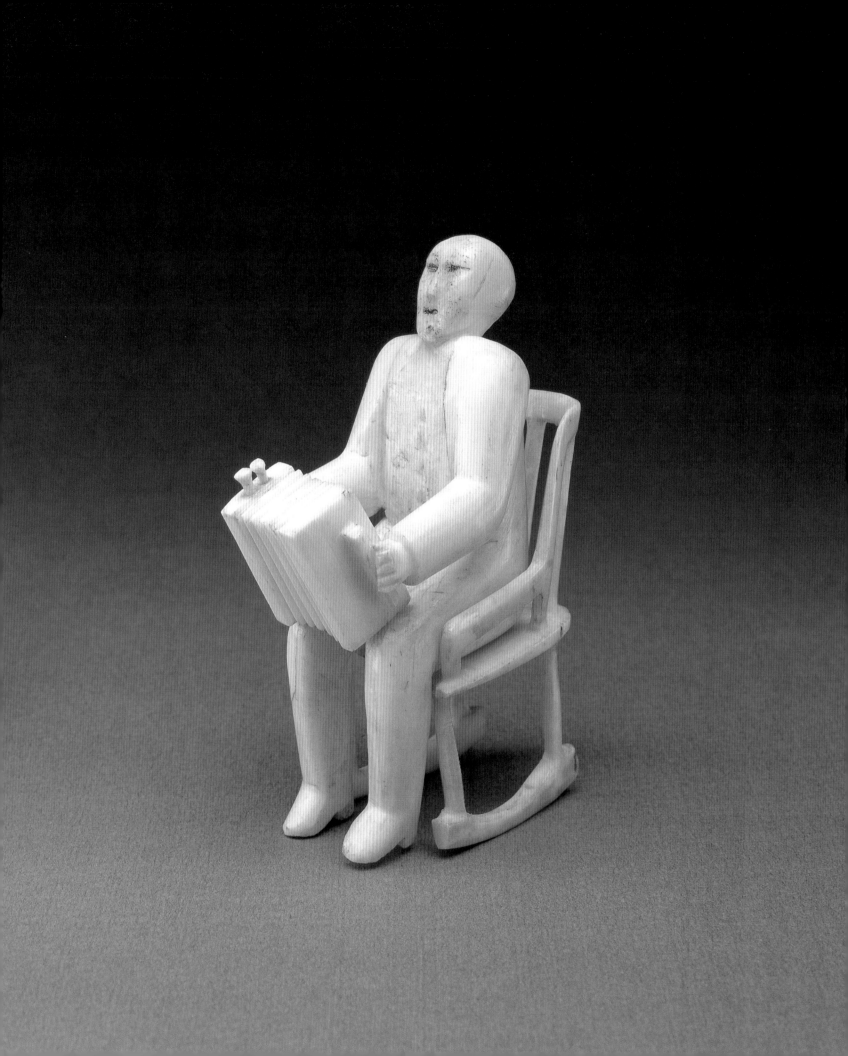

CHAPTER 3

ART OF THE HISTORIC PERIOD (1770s TO 1940s)

D URING THE FIRST FEW CENTURIES of technological and cultural decline after the Thule period, Inuit continued producing traditional weapons, tools, toys, games and clothes. In some regions, however, the umiak boat and much whale hunting technology were all but abandoned, and the kayak was modified to hunt caribou on inland lakes. The gradual introduction of European technologies (metal implements, for instance), may also have had a negative impact on traditional tool-making and carving skills. Many art forms disappeared, perhaps because Inuit were forced to spend all of their time coping with their new circumstances.

The 1770s mark the beginning of the Historic Period in Inuit art, when Moravian missionaries settled in northern Labrador and began preaching to—and trading with—the local Inuit.[1] Throughout this era, which ended in the late 1940s, Inuit works of art and artifacts were collected by explorers, whalers, missionaries, traders and others.

At first, any well-made or unusual traditional weapons, tools, games, amulets, boots, mittens and toys (especially model kayaks, sleds and igloos) satisfied the Historic Period souvenir hunters. The more realistic the model and the more detail it showed about Inuit lifestyle and technology, the more desirable it was. But three factors gradually transformed nineteenth-century Inuit art production. The first, a drastic change in the function and meaning of art objects, brought about a change in the choice and presentation of subject matter, as well as a steady transformation in the appearance of the artworks themselves.[2]

The function of many art objects switched from traditional tool, amulet or toy, to trade commodity. This change in the status of an object was often sudden. One moment, a toy or decorated tool was part of a household, and the next, after having perhaps been traded for a knife or some tobacco, it was the property of a foreigner. Inuit were willing to trade away many of their belongings, secure in the knowledge that they could make more, but the effect of trading away an amulet or a harpoon head imbued with hunting magic, even if another could be made, was a gradual secularization of the art, and to some extent, the culture in general. To meet the growing demand for carved objects, particularly models, Inuit began creating certain items in quantity purely for trade.

Hunting or camp scenes and portraits of animals (bears, caribou, muskoxen, whales and many others), in addition to the ever popular models, became valuable trade commodities (Figures 15 and 16). Some works were commissioned, but others were no doubt invented by

14
Josephee Angnako (possibly)
m. (1900–66), Pangnirtung
Historic Period (collected by
R. J. Kidston ca. 1929–31)
Man in rocking chair playing
concertina
Ivory, 9.0 × 3.0 × 5.5
Musée canadien des civilisations/
Canadian Museum of Civilization

In the Historic Period, Inuit artists were sometimes inspired (or prompted) to produce images (tiny rifles, saws, traps, even primus stoves) outside traditional themes. This work may represent a *qallunaaq* ("outsider") musician, though by this time many Inuit played Western instruments such as accordions and fiddles.

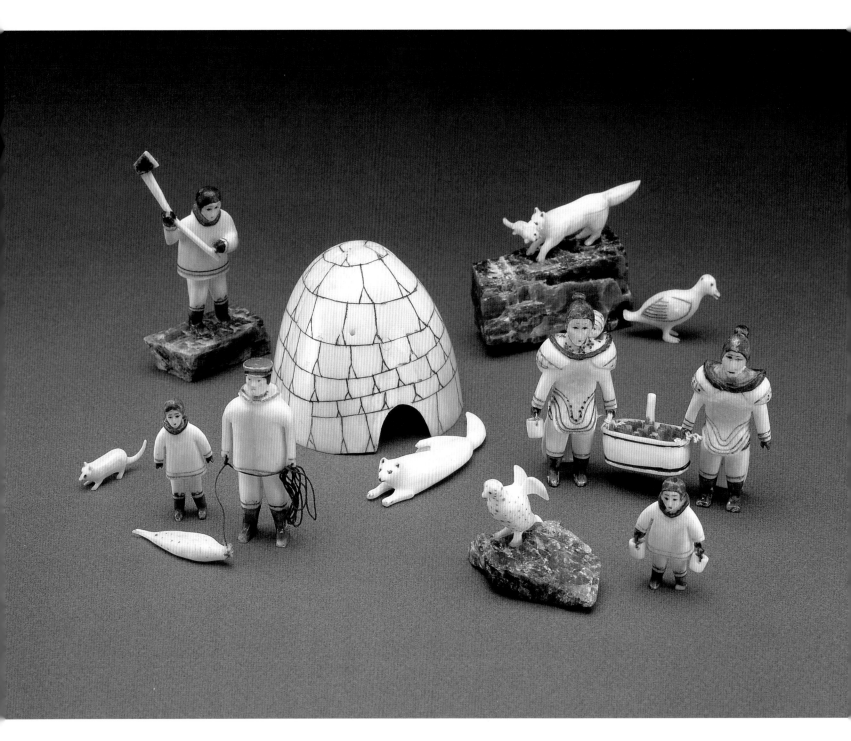

15
Unidentified Artist, Labrador
Historic Period (collected by
James Alma Wilson ca.
1874–92)
Winter camp scene
Ivory, string, colouring: women carry-
ing tub 5.4 × 7.7 × 1.5, igloo 4.8 × 5.9
× 6.0
Cotter Collection, Winnipeg Art
Gallery

Part of a collection of ivories
acquired by a Hudson's Bay
Company trader in Rigolet,
Labrador, these are typical of
the work produced there in the
heyday of Historic Period art.
The painstaking and loving
detail with which they were
carved and decorated makes
these ivories folk art of the
highest order.

16
Unidentified Artist, Eastern
Canadian Arctic
Historic Period (collected by
A. P. Low late 1880s–90s)
Muskox
Ivory and horn, 4.5 × 7.5 × 2.0
Musée canadien des civilisations/
Canadian Museum of Civilization

It is unlikely that Inuit would
have carved objects like this
beautiful muskox for them-
selves, without the influence of
European contact. The subject
matter is northern, but a deli-
cate carving like this one
would not have survived the
rigours of children's play or
constant travel between summer
and winter camps. It is very
much a "table-top" display piece.

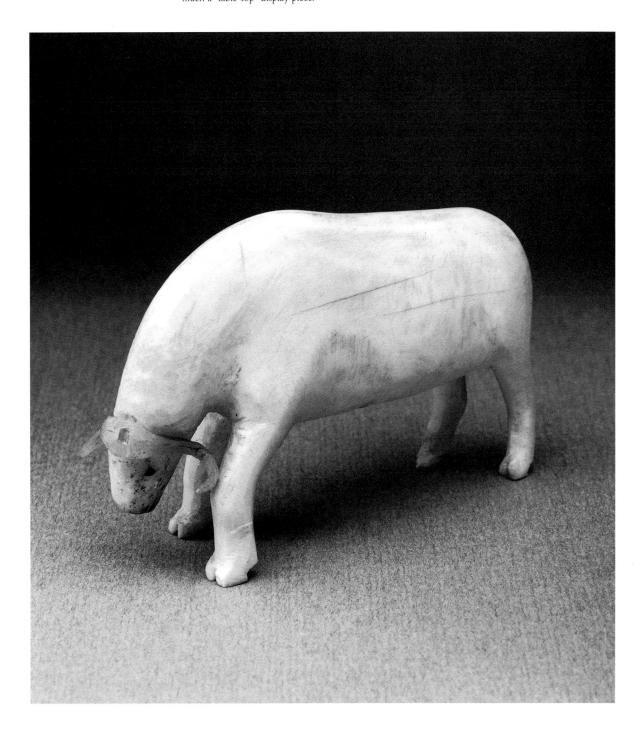

17
Unidentified Artist, Inukjuak
Late Historic Period (ca. 1943)
Incised tusk
Ivory and colouring, 29.6 × 7.0 × 3.0
Musée canadien des civilisations/
Canadian Museum of Civilization

A group of Inuit hunters and trappers brings furs to a trading post. Paris-based Réveillon Frères opened a post in Inukjuak in 1909, followed in 1920 by the Hudson's Bay Company, to which it sold out in the 1930s. The HBC bartered for furs and the occasional carving; after 1949, Inuit found art an increasingly viable alternative to the volatile fur trade.

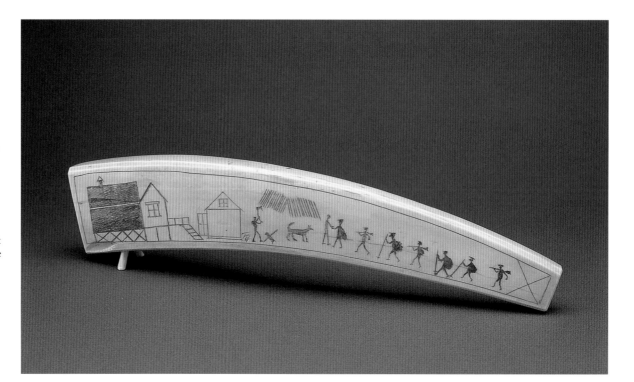

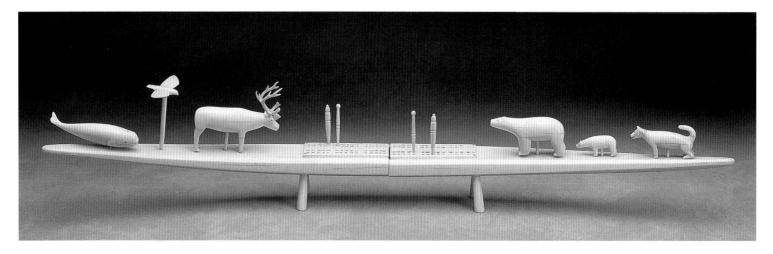

18
Koviak m. (dates unknown)
Repulse Bay
Late Historic Period (1942–45)
Cribbage Board
Ivory, grey stone inlay, 16.0 × 87.0 × 12.0
Art Gallery of Ontario, Gift of Samuel and Esther Sarick, 1996

Ivory cribbage boards were favourite trade objects during the Historic Period and into the early contemporary era. While the scale and intimate sensibility of each miniature animal is maintained, they cannot be handled separately, and so are "trapped" on a large display/entertainment object made expressly for outsiders.

19 (facing page)
Peter Pitseolak (1902–1973),
Cape Dorset
Late Historic Period (1940–42)
The Eskimo Will Talk Like the White Man, 1940–42
Watercolour and collage on paper, 78.0 × 68.5
Musée canadien des civilisations/
Canadian Museum of Civilization

Pitseolak experimented with watercolours twenty years before Houston introduced printmaking to Cape Dorset. His title may have been prophetic—perhaps he felt it was inevitable—but for the time being he amused himself by dressing Clark Gable (the man holding the saw and shovel) and other southerners like Inuit.

quick-thinking artists. So while Historic Period art still relied largely on traditional life and themes for its content, artists were selecting and presenting that content in an illustrative manner to appeal to an outside audience. Inuit artists also began experimenting with foreign subject matter: European rifles, tools, boats, musical instruments and other technologies, which were being embraced increasingly by Inuit themselves, were lovingly rendered in ivory miniatures (Figure 14). Whalers created a demand for items such as decorated cribbage boards and carved or incised walrus tusks (Figure 17), while missionaries encouraged the depiction of Christian imagery. By the mid-nineteenth century, most of the art created by Inuit was aimed at the new "tourist" market, and artists took their direction in large part from it.

With entirely new types of objects being solicited or invented, the look of the art changed rapidly. Inuit art objects had always been small, portable, simplified and compact. Many of the new objects, however, were freestanding or pegged to a base—in other words, they were "table-top" display pieces. Though still conceived on a small scale, they often took up considerable space—a cribbage board decorated with miniature figures might be over 60 centimetres (two feet) long (Figure 18). In other examples, the size of the figures themselves grew. But stylistic changes are apparent too. Since European taste valued naturalism above all, Inuit artists imbued art objects with realistic detail, forgoing the relative stylization of symbolic content. As the work became "busier" and more elaborate, compactness was replaced by openwork carving. Ivory, an exotic and relatively precious material to Europeans, was still the preferred Inuit carving medium well into the twentieth century, and was ideal for this kind of work. Stone, antler, wood and bone were sometimes used as well.

Explorers and anthropologists, particularly in the past century, occasionally solicited maps and drawings from Inuit. Maps were especially useful to explorers, who were impressed by their accuracy. Descriptive drawings (of wildlife, for example) also were collected and published at various times. Robert Flaherty, the maker of the famous Arctic docudrama *Nanook of the North*, collected a series of drawings by Nungusuituq (ca. 1890–ca. 1950) of southern Baffin Island in 1913–14 and published them privately in a portfolio.[3] Perhaps the most striking of the two-dimensional artworks of the Historic Period date from late in the era. Peter Pitseolak, also from south Baffin, received watercolours and paper from a Hudson's Bay Company trader in 1939 and went on to produce dozens of drawings over the next three years, until photography captured his interest (Figure 19).[4] Other examples of graphic art include ivory scrimshaw engraving, probably introduced by the whalers, as well as the more traditional engraving of implements carried over from Thule times.

Inuit did not have a concept of art in the European sense; the buyers of Historic Period objects did not consider them to be "art" either, but rather trinkets and toys. In fact, many Europeans had a certain disdain for the work they were purchasing, considering it to be primitive and crude (Martijn, 1964, 1967; Blodgett, 1988b; Swinton 1992:119–22). And a number of observers today consider Historic Period carving to be an art in decline from Thule traditions. One thing is indisputable about the art of this period: it marked an important transitional phase. The design and manufacture of traditional Inuit artifacts had been governed by convention, and the Historic Period represents an era of innovation and experimentation (Driscoll 1988:221). Building on late Thule traditions, and influenced by European tastes and the concept of art as commerce, Historic Period artists very definitely paved the way for a new era of art production.[5]

The Canadian Handicrafts Guild in Montreal (now known as the Canadian Guild of Crafts Québec) became interested in marketing "Eskimo handicrafts" in the 1920s and mounted an exhibition in 1930. Encouraged by Canadian government officials, the Guild revived its efforts to stimulate Inuit crafts production in the late 1940s. To that end, it circulated a one-page "Suggestions for Eskimo Handicrafts" in 1947, asking for ivory models and "carvings suitable for brooches, pendants . . . small boxes . . . napkin rings," in addition to stone bowls and ash trays "in the manner of their own cooking pots and lamps." The Hudson's Bay Company was also quite actively involved in Inuit art at that time, though its efforts to market ivory carvings in the 1930s had been cut short by the Depression. Shortly, however, events would provide a fresh impetus to these marketing efforts and alter the course of Inuit art.

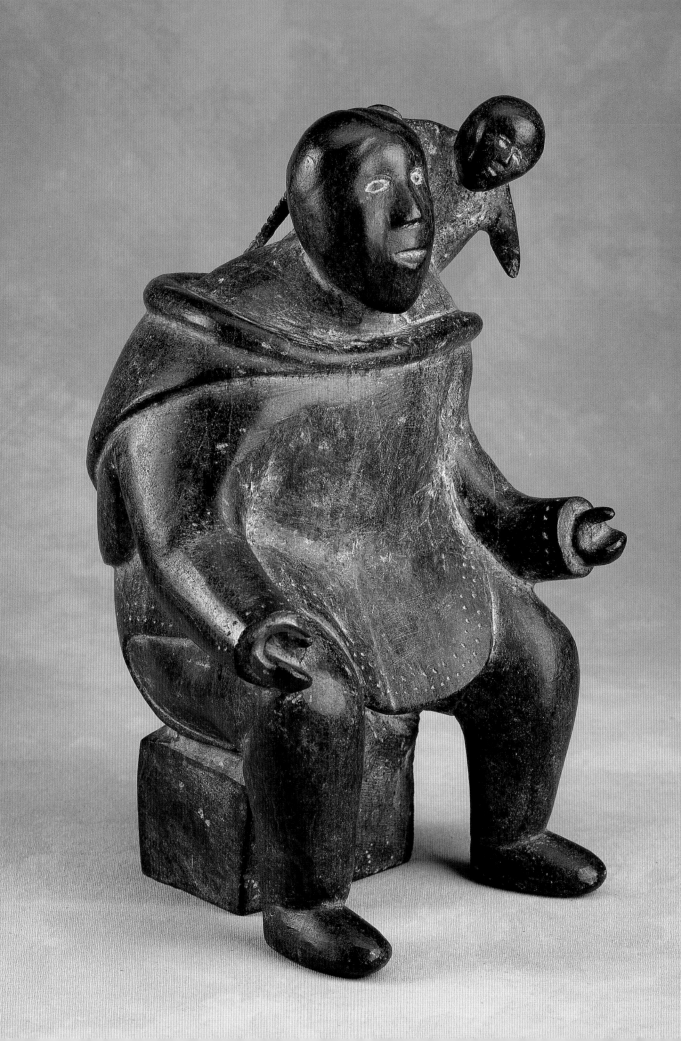

THE DAWN OF CONTEMPORARY INUIT ART (1949 TO 1955)

WHILE THE PREHISTORIC AND HISTORIC PERIODS of Arctic art are measured in the hundreds or thousands of years, contemporary Inuit art is only about fifty years old. Its earliest phase, a brief era that spans only a few years, is almost as noteworthy for the way in which the art was "discovered" and promoted by outsiders as it is for the artistic achievements of Inuit. As with many so-called discoveries, it was not the "newness" of the art per se but its intrinsic power and beauty, along with exotic novelty and clever promotion, that sparked the imagination of the public, creating an interest in and a market for Inuit art.

THE "DISCOVERY" OF INUIT ART

In the summer of 1948, a young artist named James Houston, while on a northern painting trip, was offered a ride on a flight to Port Harrison (Inukjuak) in Arctic Québec. He jumped at the chance, never suspecting that he would devote the next fifteen years of his life to promoting Inuit art.[1] In exchange for the portraits he sketched of some of the people he encountered during his five-day stay, Houston was given about a dozen small stone and ivory carvings. Thinking at first that they might be old, he was surprised to learn from the local trader that they were in fact new and not considered to be particularly interesting. When Houston returned south to his home in Grand'Mère, Québec, he proudly displayed the carvings on his mantelpiece; a neighbour suggested that he show them to Jack Molson and Alice Lighthall at the Canadian Handicrafts Guild in Montreal. The Guild, which had been renewing its efforts to encourage and market Inuit art and crafts, invited Houston to go on a buying trip the next summer to help it develop a small carving industry. Molson contacted the Hudson's Bay Company to arrange a system that enabled Houston to buy works by issuing chits to carvers, who could in turn use them to make purchases at the Company's trading posts. The Guild also secured funding for Houston's trip from the federal Department of Resources and Development.[2] In the summer of 1949, with $1100 in credit,[3] Houston purchased several hundred items, including about three hundred carvings in stone and ivory.[4]

The Guild's exhibition of these Inuit carvings and crafts, which opened on November 21, 1949, was a huge success, with about 90 per cent of them selling in three days. Several of the buyers at this event went on to become prominent collectors.[5] This exhibition is generally

20
Peesee Oshuitoq m. (attrib.)
(1913–1979), Cape Dorset
Mother and Child, ca. 1955
Black stone, 33.6 × 21.3 × 22.8
National Gallery of Canada, Gift of
M. F. Feheley, Toronto, 1984

By the mid-1950s, Inuit sculptures had grown in size and complexity. Carvers were gaining confidence in their skills, but many works still had a tentative quality, so it is not easy to attribute early works based on style alone. Many carvers were still trying to find their voices as individual artists.

considered to mark the beginning of the contemporary era of Inuit art. As has so often been the case in the history of art, social, economic and political forces (and serendipity) were to play a large role in the further development of Inuit art.[6]

After a second Guild-sponsored trip to Inukjuak and Povungnituk (now Puvirnituq) in 1950, Houston travelled to the Keewatin District on the west shore of Hudson Bay to determine the potential for arts and crafts development there. Next, he and his new wife, Alma, toured Baffin Island in 1951 in lieu of a honeymoon; they were especially impressed with the carvings they saw in Cape Dorset.[7] Also in 1951, Houston wrote and illustrated the Guild publication *Sanajasak: Eskimo Handicrafts*, produced at the federal government's request. A guide for Inuit producers of carvings and crafts, the booklet contained explicit suggestions for product types, materials and craftsmanship. Widely circulated at first, it was withdrawn a short time later and "recalled" in 1958.[8] The development efforts were so successful that by 1953 the Guild was no longer able to continue retailing and marketing the artwork on its own. The Hudson's Bay Company took up the slack, and Houston enlisted the help of an American friend to market the art in the United States.[9]

Exhibitions at the Guild and elsewhere, including one in 1952 at the National Gallery of Canada and another in 1953 at Gimpel Fils in London, attracted media attention.[10] In addition, Houston wrote a series of articles on Inuit art for magazines and hit the lecture circuit; by 1952, he was referring to Inuit carvings as "art" and not "handicrafts." He was then hired by the federal Department of Northern Affairs and National Resources to continue Inuit arts and crafts development work, mostly on Baffin Island.[11] *Canadian Eskimo Art*, a promotional booklet he wrote in 1955,[12] reveals that by this time stone sculpture had clearly taken centre stage, and the most important "women's art" of the time was considered to be the "skin picture." These sealskin hangings practically disappeared as an art form a short time later, but they (along with ivory scrimshaw art) could be considered the immediate precursors to Inuit graphic and textile arts.

THE LOOK OF EARLY CONTEMPORARY SCULPTURE

Since it is unlikely that the Inukjuak carvings James Houston acquired in 1949 were much different from those produced a few years earlier, he did not discover a "new" style. Rather, he chanced upon the fully evolved and little known late Historic Period souvenir art form as practised on the east coast of Hudson Bay.[13] Changes occurred quickly, however, and the time between 1950 and 1955 was one of intense experimentation and invention that rivalled two centuries of innovations in the Historic Period.

While the small stone carvings were what captured Houston's imagination in 1949, as late as 1951 ivory was still deemed to be the more important and valuable medium. Since the supply of ivory could not keep pace with the growing demand for carvings, artists were encouraged to try their hands at carving the cheaper and more plentiful stone. Stone could be quarried in any size, and this soon led to an increase in the scale of sculptures (Figure 20), a change that was reinforced by consumer demand.[14] Stone replaced ivory as the chief carving material in most communities, with the latter being used as a secondary material for inset faces, tools, tusks, and other details (Figures 21 and 22). Incised features or decorative elements on stone and ivory carvings were occasionally filled with materials such as wax or even melted phonograph records as colour accents. The use of wood, however, was actively discouraged.[15]

21
Samwillie Amidlak m. (attrib.) (1902–1984), Inukjuak
Untitled (Totem), ca. 1951
Stone, ivory, black inlay, 27.3 × 7.3 × 9.0
Winnipeg Art Gallery, Ian Lindsay Collection, Gift of Ian Lindsay

Numerous "totem pole" carvings appeared in 1950–51, before and after James Houston's pamphlet *Sanajasak: Eskimo Handicrafts* featuring totem imagery was distributed. It is difficult to ascertain which were "copies" and which were not; even the earliest ones may have been inspired by images found elsewhere. In any case, totem imagery is not inconsistent with Inuit spiritual beliefs.

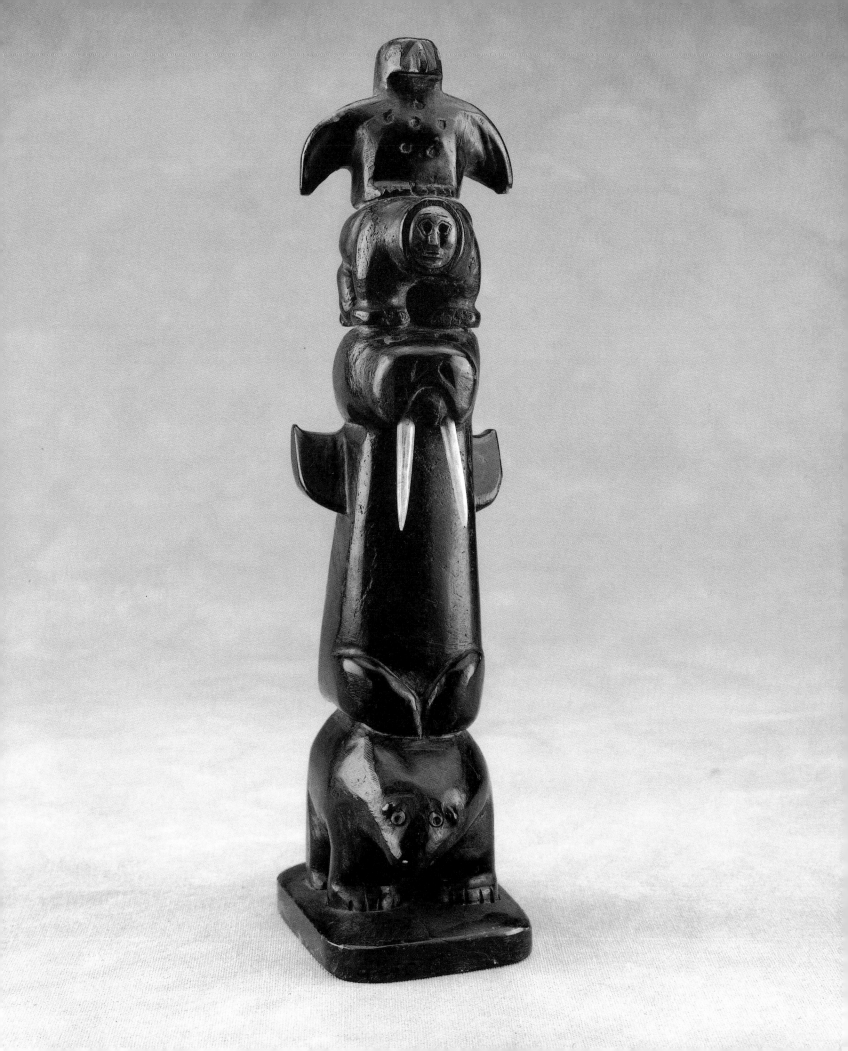

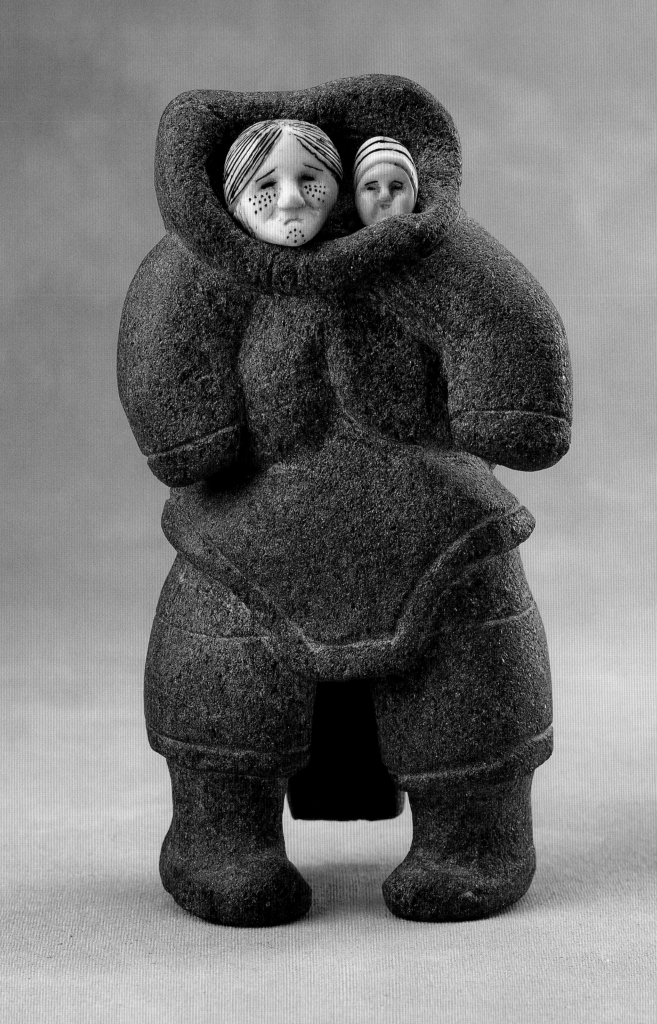

22 (facing page)
Sheokjuk Oqutaq m.
(1920–1982), Cape Dorset
Mother and Child, 1952
Stone, ivory, black colouring, 19.5 ×
10.8 × 8.5
Winnipeg Art Gallery, Ian Lindsay
Collection, acquired with funds
donated by the Volunteer Committee

Sheokjuk was an ivory carver
before experimenting in stone
in the early 1950s. The slightly
awkward stance of the figures,
carved in a coarse granitelike
rock, is a charming foil for the
sensitively carved and incised
heads. He soon mastered the
art of stone carving, becoming
famous for his elegant loons.

23
Philipoosie Napartuk (possibly)
(born 1931), Inukjuak
Untitled (Circle of Animals), 1951
Stone with soap inlay, 2.2 × 11.7 × 11.7
Winnipeg Art Gallery, Ian Lindsay
Collection, Gift of Ian Lindsay

This work is unusual in form
because it is more a plaque
than a free-standing sculpture.
It is also enigmatic, largely
because of the inclusion of
non-Arctic animals (the camel
and elephant are obvious,
but there may be others). Is
the circle a globe, or is it an
igloo? A Baker Lake print
(1971 #4) with a similar motif
is identified as a calendar, as
this may be.

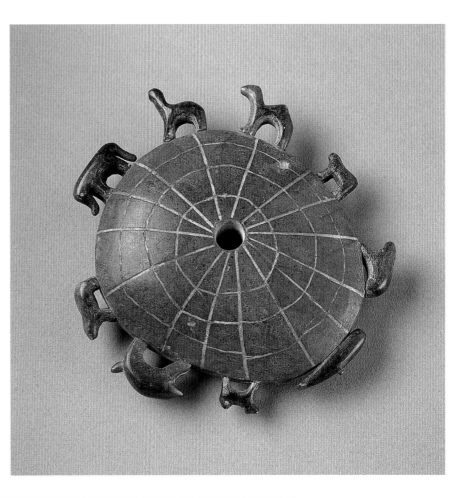

24
Unidentified artist, Eastern
Arctic
Seated Woman, ca. 1951
Black stone, clay (?), graphite, 7.9 ×
10.7 × 5.7
National Gallery of Canada, Gift of
M. F. Feheley, Toronto, 1988

Many early contemporary
works cannot be attributed, as
the names of artists were rarely
noted. The small carvings from
this period have an intimate,
tactile quality that was often
lost when Inuit art became
"sculpture." This exquisitely
carved woman, with her subtle,
sensuous curves, needs to be
cradled in the hand to be fully
appreciated.

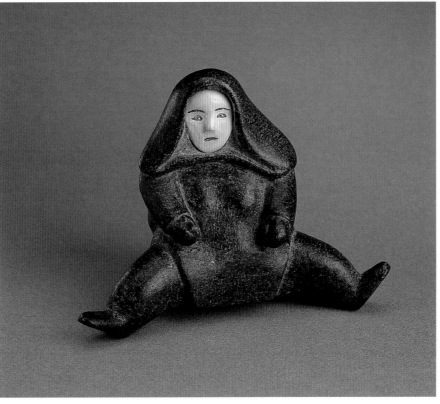

Changes in scale and presentation—from the amulet- and toy-inspired ivory miniature model to the table-top sculpted stone scene—which had begun in the Historic Period, accelerated in the early 1950s. Occasionally inspired by Houston's drawings (Figure 21), Inuit artists more often gave free rein to their own imaginations (Figure 23). Subject matter expanded, and figures of animals and hunters, as opposed to games and functional items, became increasingly important. Artists also began exploring themes such as the mother and child, which was often incorporated in details of camp life (Figure 49). The rise of the genre carving (animal portraiture, hunting and camp scenes) and the other great themes of Inuit art (the family, mythology, the spirit world) were important developments of the early to mid-1950s. Many artists were still feeling their way, but their confidence was building, and this was reflected in the work. It was at this time that observers of Inuit art began arguing over whether to label the art form carving or sculpture, tourist art or fine art.[16]

Although much Inuit art of the early 1950s still had a "primitive" or naive look, there was a continuing shift to a greater naturalism in poses, facial features, clothing and so on. This stylistic "evolution" from the Historic Period was not instant, absolute or universal, however. Compare the small-scale, tactile, almost amulet sensibility of Lucie Angalakte Mapsalak's *Bear* (Figure 86) with the more imposing nature of Sheokjuk Oqutaq's *Mother and Child* (Figure 22). And while the *Seated Woman* by an unidentified artist (Figure 24) is more naturalistically carved than Samwillie Amidlak's untitled totem (Figure 21), it retains a more intimate, hand-held quality. These contrasting sensibilities are still present in Inuit art today.

"A SPLENDID NEW ART OF ACCULTURATION"[17]

Acculturation could be described as the borrowing and blending of traits and characteristics that occur when two cultures come into continuous contact, particularly the influence of a large-scale culture on a smaller one. An art of acculturation, then, is an art in which the values and systems of the dominant culture influence the art-making of the smaller one. This can lead to the corruption of traditional art forms, the adoption of new ones, or the invention of innovative or hybrid forms. Inuit art since the early 1950s has taken the latter course, building on and accelerating changes already begun in the Historic Period.

James Houston eagerly offered suggestions to Inuit artists, often illustrating them with drawings, and there is little doubt that he influenced some of them.[18] Hudson's Bay Company traders also sent very clear messages to artists about what was acceptable or not,[19] and many other outsiders gave advice to the fledgling "carving industry." Southerners regarded Inuit art very much as "primitive" and wished to preserve what they perceived to be its uniquely naive character. While the various instigators did not consciously wish to make Inuit art conform to Western artistic styles, they attempted to elicit the "best" and "most marketable" work. As Deputy Minister, Department of Northern Affairs and National Resources R. Gordon Robertson wrote (1960), "The romantics who say that Eskimos must stare at the sky and create only what the spirits tell them with no references to commercial influences are just being unrealistic—and the Eskimo is a realist."

> Before the government came up here there was only one way of making money. People could make money from fox furs and the other things we used to bring in, but only a little money. Then it was learned that carvings here in the Arctic have a price and when there were no jobs available people

quickly learned their value. That is why they have tried so hard at it. If people hadn't started carving we'd all be supported by the government.

—OSUITOK IPEELEE, CAPE DORSET (Eber 1993:438)

Inuit artists were keenly aware that they were producing works not for their own people but for an outside market. They also learned that this market on the whole demanded traditional themes and materials, fine workmanship, realism, and an increasingly impressive scale; yet it also appreciated imaginative composition and individuality of expression. And so the artists learned about both artistic compromise and artistic freedom at the same time. Certain artists such as Akeeaktashuk, Johnny Inukpuk and Osuitok Ipeelee were singled out as special talents and became "stars," encouraging the development of individual as well as community styles.

Witnessing the destruction of their traditional way of life, Inuit artists must have felt strangely empowered by the knowledge that they could make and sell objects that the dominant outsiders could not make themselves and desired so fervently. In some communities, as much as 80 per cent of the adult male population experimented with carving in the early years. Inuit were greatly relieved to find an alternative to the volatile fur market, which had largely replaced the traditional hunting economy. Bound forever to an alien lifestyle, they had at least found another way to survive in it.

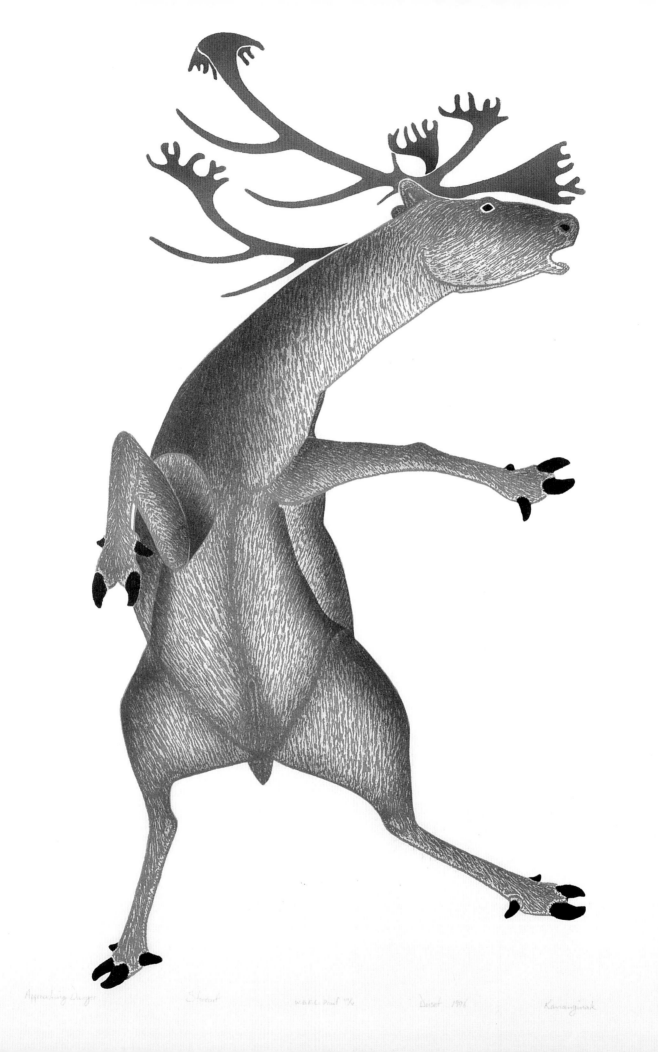

INSPIRATION FOR THE THEMES in Inuit art is intimately tied to personal experience of the land and its animals, camp and family life, hunting, spirituality and mythology. In telling the story of their people through this wide array of subjects, artists have created an almost encyclopaedic visual catalogue of traditional (and to a lesser extent transitional and modern) Inuit culture.

> We carve the animals because they are important to us as food. We carve Inuit figures because in that way we can show ourselves to the world as we were in the past and as we now are . . . There is nothing marvelous about it. It is there for everyone to see. It is just the truth.
> —PAULOSIE KASADLUAK, INUKJUAK (1976)

THE WORLD OF ANIMALS

> One reason so many Inuit become such good artists or carvers is that they come from a very visual culture. Their very livelihood depended solely on dealing with the landscape every day during hunting or gathering expeditions. They were always visualizing animals in their thoughts as they searched the land, waters and skies for game.
> —ALOOTOOK IPELLIE (1997)

Animals play a vital role in the everyday lives of Inuit, and only in the past few decades has the people's absolute dependence on them lessened. Not too long ago, procuring food and other necessities depended solely on successful hunts, which in turn depended upon proper preparation and luck, in addition to the strict observance of taboos and respect for the soul of the prey. As a consequence, animals constitute the prime inspiration for many Inuit artists, particularly in sculpture.[1]

Based on years of observing, stalking and butchering prey, Inuit wildlife art shows a keen awareness of the physical characteristics, habits and seasonal changes of animals. Some artists display a high degree of naturalistic detail (Figures 25 and 57), but others prefer to convey the animal's personality or to exaggerate certain physical attributes for effect. In general, while most Inuit artists strive for verisimilitude, they seem more concerned with capturing the essence of an animal's spirit.

Animals may be portrayed singly, in small groups, or in scenes that involve both hunter and prey. Graphic arts often show the chase leading up to the kill, while sculptures focus more on the act itself, often with considerable drama (Figure 26). The hunter may be human, or one of

25
Kananginak Pootoogook m.
(born 1935), Cape Dorset
Printmaker: Kavavaow Mannomee m.
(born 1958)
Approaching Danger, 1996 #9
Stonecut, 77.0 × 62.0
Collection of West Baffin Eskimo
Cooperative

One of Cape Dorset's founding printmakers, Kananginak is also its most highly regarded wildlife print artist and has earned the nickname "Audubon of the North." But, like many Cape Dorset artists, he sometimes mixes naturalism with theatrical twists. See Aqjangajuk's *Wounded Caribou* (Figure 125).

the great Arctic predators such as the polar bear, owl, hawk or wolf (Figure 27). Gender differences among artists are evident in wildlife art: men often emphasize the strength and ferocity of an animal adversary, while women, who do not usually have the hunting experiences of men, present animals in a more decorative, stylized or humorous manner (Figure 28).[2]

SCENES OF EVERYDAY LIFE

Scenes of everyday life, which include camp scenes, games and entertainment, are common to all forms of Inuit art, and traditional activities are far more prevalent than modern aspects of Inuit community life. Camp-related themes mostly portray women engaged in domestic chores such as preparing food and skins or sewing clothes. Games and contests involve both individuals and the community, and drum dancing is a form of entertainment that also has considerable spiritual significance (Figure 29).

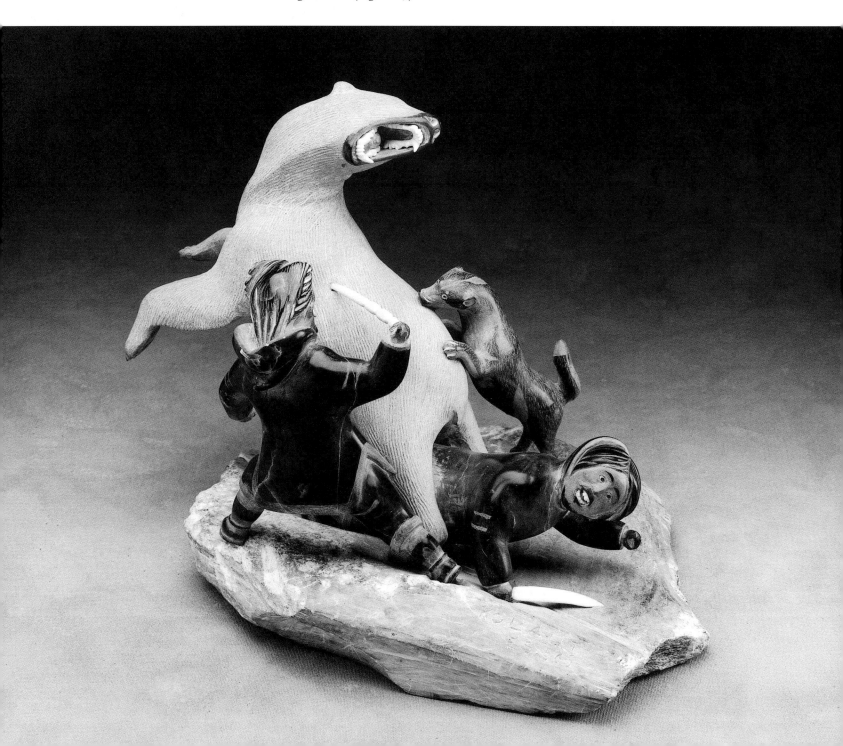

26 (facing page)
Pacome Kolaut m.
(1925–1968), Igloolik
Bear Hunt, 1967
Grey stone, ivory, 22.8 × 33.0 × 25.4
Musée canadien des civilisations/
Canadian Museum of Civilization

In Inuit sculpture (but seldom
in two-dimensional art), there
is the occasional heroic work
that could be described as
Romantic. Romanticism is
more an attitude than a style;
the subject matter or theme is
idealized and presented with a
sense of grandeur or nobility.
More than a hunt, this work
epitomizes the struggle
between man and beast.

27
Charlie Sivuarapik
(1911–1968), Puvirnituq
Caribou Attacked by Four Wolves,
ca. 1965
Grey stone, bone, 39.0 × 20.3 × 24.1
National Gallery of Canada, Gift of
M.F. Feheley, Toronto, 1984

As hunters, Inuit artists tend
not to sentimentalize or glorify
death. Sivuarapik, though, has
imbued this scene with a cer-
tain amount of pathos. It is
carved not with graphic vio-
lence but with an elegant natu-
ralism. George Swinton
(1977:23) credits Sivuarapik as
the major influence on the
highly naturalistic Puvirnituq
carving style.

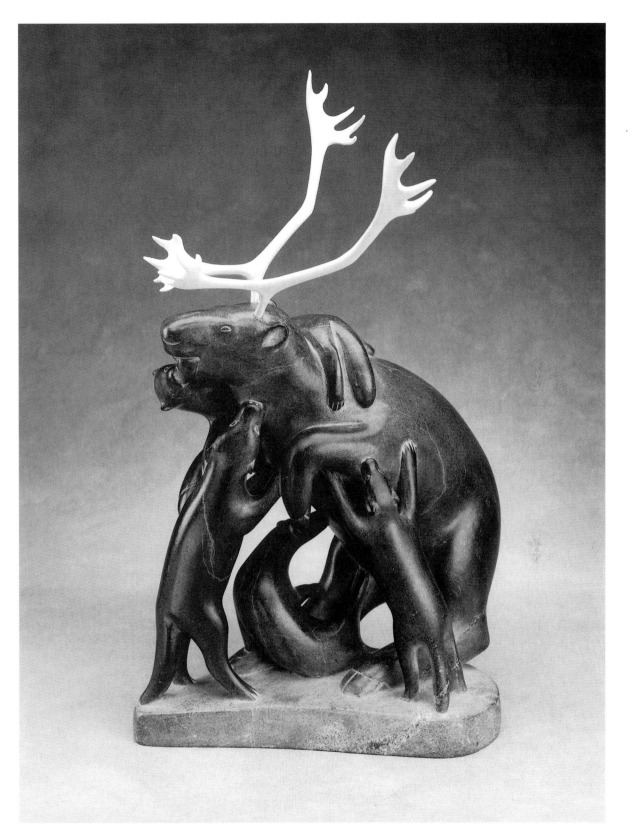

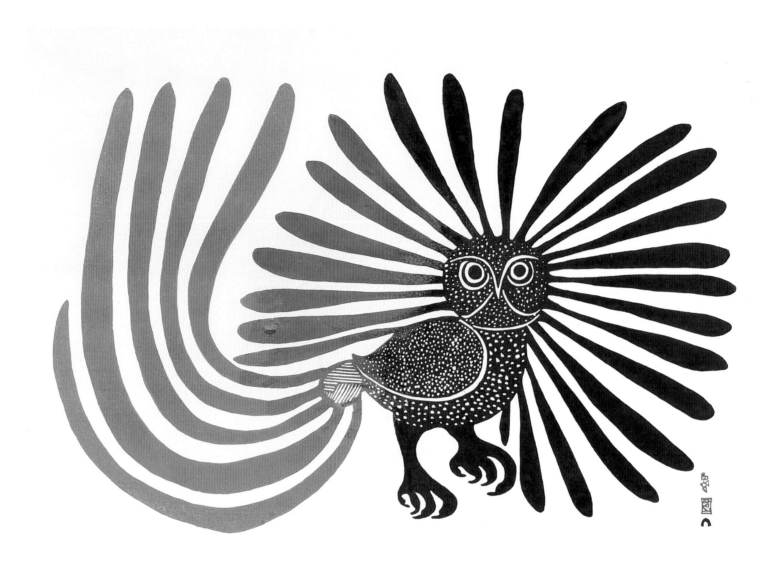

28
Kenojuak Ashevak f. (born 1927), Cape Dorset
Printmaker: Eegyvudluk Pootoogook m. (born 1931)
Enchanted Owl, 1960 #23
Stonecut, 38.5 × 59.0
Musée canadien des civilisations/ Canadian Museum of Civilization

Based on a graphite drawing, this print is the best-known image in Inuit art, and it launched Kenojuak's career and fame. She is a consummate designer of pictorial space; this image does not have the symmetricality of her later work, but it already reveals her ability to balance positive and negative space and her fluidity of line.

29
Luke Anguhadluq (1895–1982),
Baker Lake
Drum Dance, 1970
Coloured pencil and graphite, 48.3
× 61.0
Art Gallery of Ontario, Gift of Samuel
and Esther Sarick, 1998

Figures radiate from the
immense drum, and colour
reinforces the hypnotic rhythm
of the drumbeat. The pose is
schematized: frontal males
versus women with children
in profile. There is no favoured
perspective; Anguhadluq
turned the paper as he drew,
placing his signature in the
open space provided. Form and
symbolic content fuse perfectly.

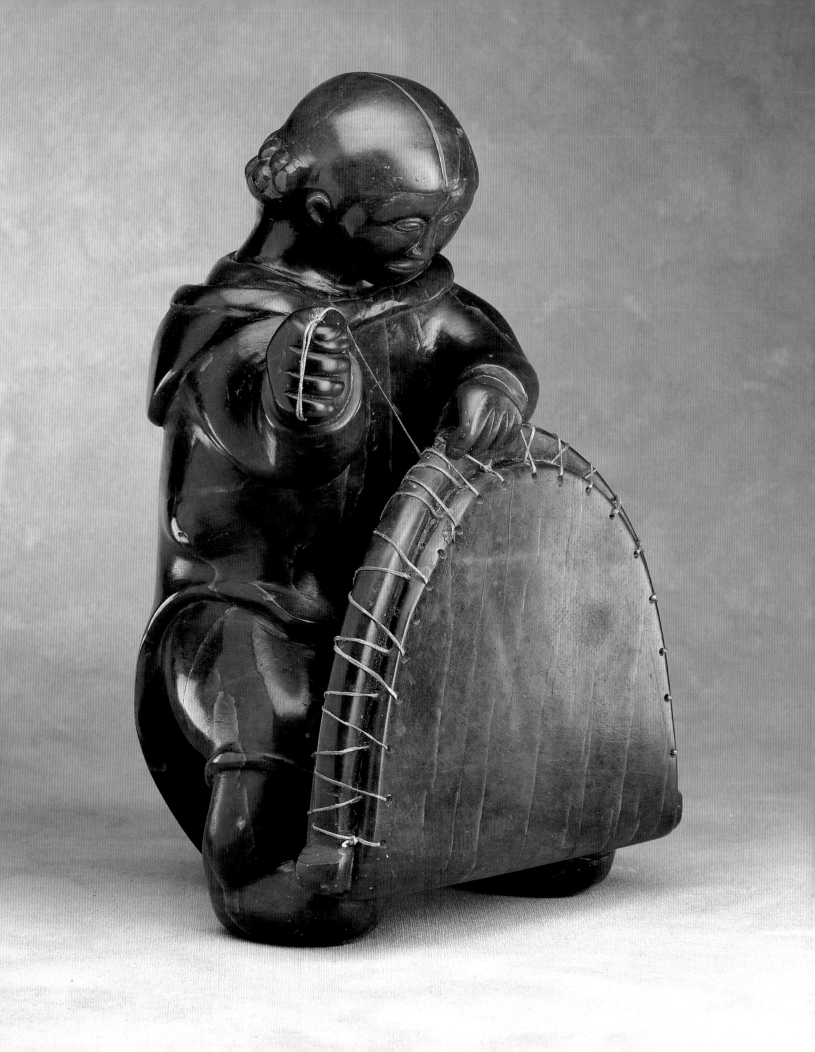

In sculpture, scenes of everyday life are most popular in the work of artists from Arctic Québec. Since works on this theme are almost purely descriptive, they tend to be quite representational (Figure 30). Just as certain artists have developed reputations for their depictions of wildlife, others specialize in "genre" works that show traditional life in painstaking and loving detail. While single activities are more easily translated into sculpture, complex camp scenes can be represented in both two- and three-dimensional works (Figures 31 and 32). A single drawing or sculpture can provide a wealth of information about traditional Inuit material culture and society.

SHAMANISM AND THE SUPERNATURAL

> I have always been concerned with supernatural things. I believe that the Spirits were not created by man and that they were very powerful. There were many Spirits in former times and they influenced the lives of the people. Although I do not want to believe or follow the old ways which involved these Spirits, I feel that we should reveal the things which exist and perpetuate the stories which are told about them. . . . Maybe as I do my prints and drawings I will remember them.
> —TIVI ETOOK, KANGIQSUALUJJUAQ (1980)

Inuit have embraced Christianity with fervour during their conversion by missionaries over the past two hundred years,[3] practising their beliefs more seriously than the majority of southern Canadians. As a result, many older Inuit will not talk about shamanism, although most people seem to retain some residual belief in spirits, and the supernatural world continues to play an important part in Inuit art. Perhaps the visual arts provide a safe outlet for presenting subjects that cannot be openly discussed, or for secularizing the supernatural. A number of younger artists, who did not grow up on the land, are discovering that traditional religion and stories about shamanism and the spirit world provide a rich source of subject matter.

Supernatural themes range from the representation of spirit beings to the depiction of astonishing feats of shamanic power. The exploits and rituals of shamans are illustrated in work from across the Arctic, particularly in the art of Baker Lake, in graphics from Holman, and in sculpture from Netsilik communities. These portray the healing powers of shamans as well as their more dramatic powers to transform into various animals or to fly (Figures 33, 34, 39 and 85), and their ability to injure themselves without suffering ill effects (Figure 35) or to become transparent (Figure 36).[4]

Equally interesting is the portrayal of transformations from animal-to-animal and human-to-animal. Transformational works sometimes refer to specific myths or stories (Figures 37 and 38) but more often simply visually represent, through hybrid creatures, the ability of animal and human spirits to move about and inhabit each other's bodies. The concepts of transformation, spirits and shamanism (Figures 39 and 40) allow artists the creative freedom to play with unusual juxtapositions of subject matter, composition, materials and even colours which may not necessarily reflect personal or community spiritual beliefs (Figure 2).

30
Eli Weetaluktuk (attrib.)
(?–1958), Inukjuak
Woman Stretching Skin, 1958
Dark green stone, sinew, 30.1 ×
20.4 × 16.3
National Gallery of Canada, Gift of
the Department of Indian Affairs and
Northern Development, 1992 (Gift
of Robert Kennedy, Spencerville,
Ontario, 1985)

The great Inukjuak artists have
a gift for transforming the
ordinary into the sublime. Not
only do the opulently rounded
and graceful lines of the
woman contrast with the ele-
gantly simplified plane of the
skin in its semicircular frame,
but the quiet concentration of
the woman gives this piece a
contemplative quality.

Pitseolak Ashoona f.
(1904–1983), Cape Dorset
Summer Camp Scene, 1974
Felt-tip pen, 50.8 × 65.6
National Gallery of Canada, Gift of
the Department of Indian Affairs and
Northern Development, 1989

Pitseolak could create an entire
world on a sheet of paper. Her
foreshortened landscapes are
like small islands, complete
with camps and their human
and animal inhabitants. Subtle
balance is achieved not only
through the placement of land-
scape features, tents and figures,
but also through colour.

Paul Akkuardjuk (1914–1974),
Repulse Bay
Winter Camp, 1974
Antler, ivory, stone, hide, thread,
black colouring, 16.1 × 47.0 × 40.3
Winnipeg Art Gallery, Swinton
Collection

Great skill and ingenuity are
required for a work of this size
and complexity, but its intimate
sensibility is preserved by the
small scale of individual pieces.
Paradoxically, while this carv-
ing is clearly the result of out-
side influence, it is typical of
naive, unprompted, untutored
folk art.

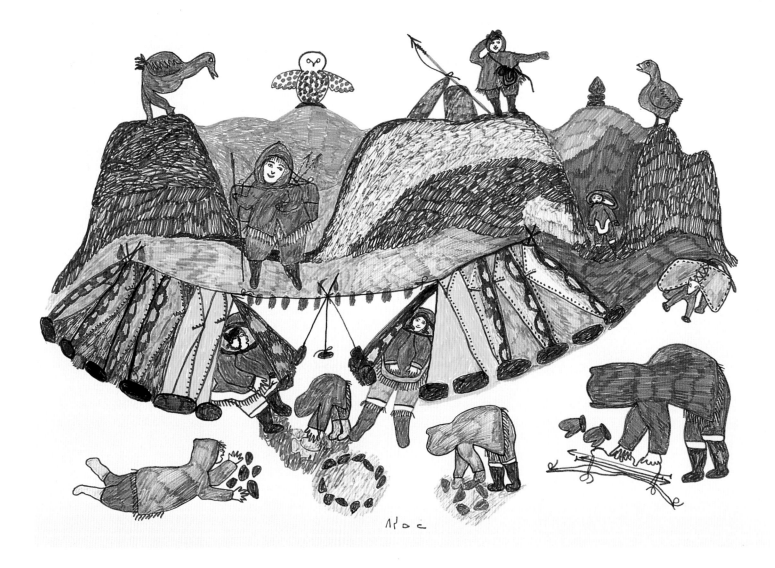

33
Irene Avaalaaqiaq Tiktaalaaq
(born 1941), Baker Lake
Mysterious Powers of the Shaman,
1974
Duffle, felt, embroidery floss and
thread, 81.8 × 162.0
Musée canadien des civilisations/
Canadian Museum of Civilization

Avaalaaqiaq, inspired by her
grandmother's stories, delves
into the supernatural, with a
light touch of humour. Her
hangings have large, strongly
defined border areas. Here,
human, animal and bird heads
surround the shaman and spir-
its, to show that human, animal
and spirit worlds are inextrica-
bly connected.

34 (facing page)
Eric Niuqtuk (born 1937),
Baker Lake
Shaman, 1974–75
Green-grey stone, antler, 18.6 ×
14.2 × 5.9
Art Gallery of Ontario, Gift of Samuel
and Esther Sarick, 1989

Inuit believed that in the dis-
tant past, animals and humans
could transform effortlessly, each
into the other. More recently,
only shamans were able to per-
form this type of transforma-
tion. In a séance, the shaman
would wear tusks, teeth or
claws, and the spirit and voice
of the animal helping spirit
would speak through him.

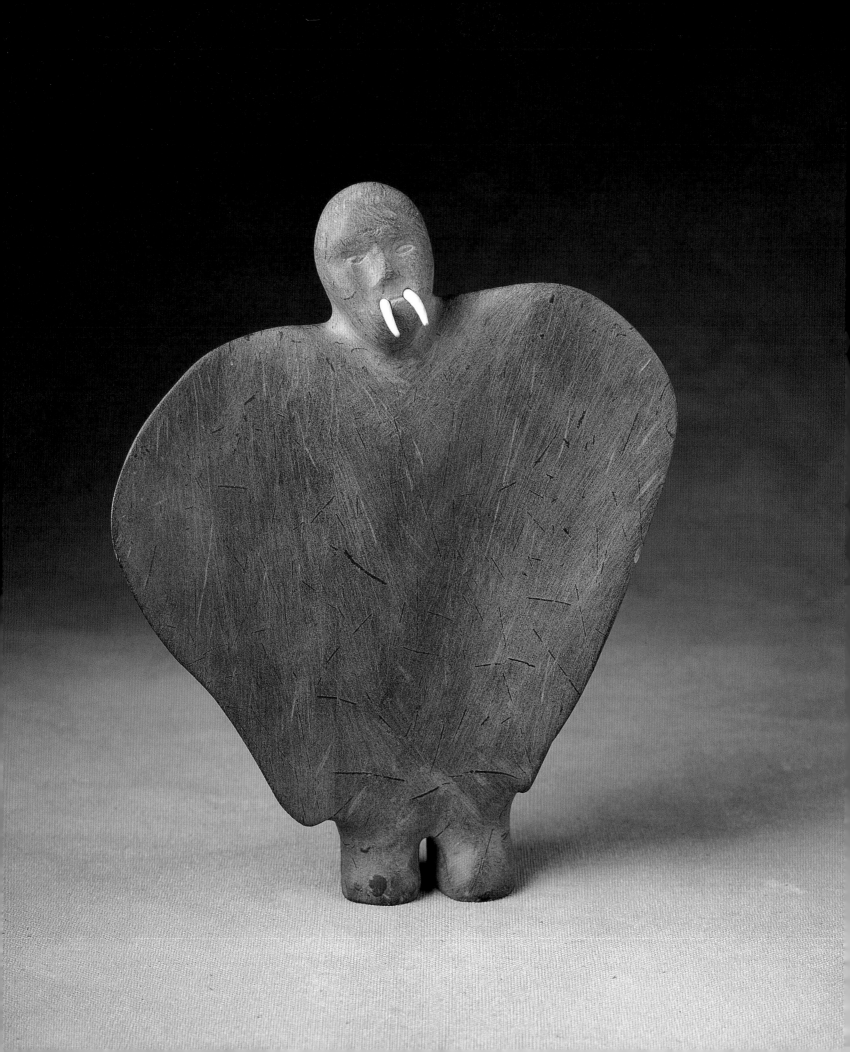

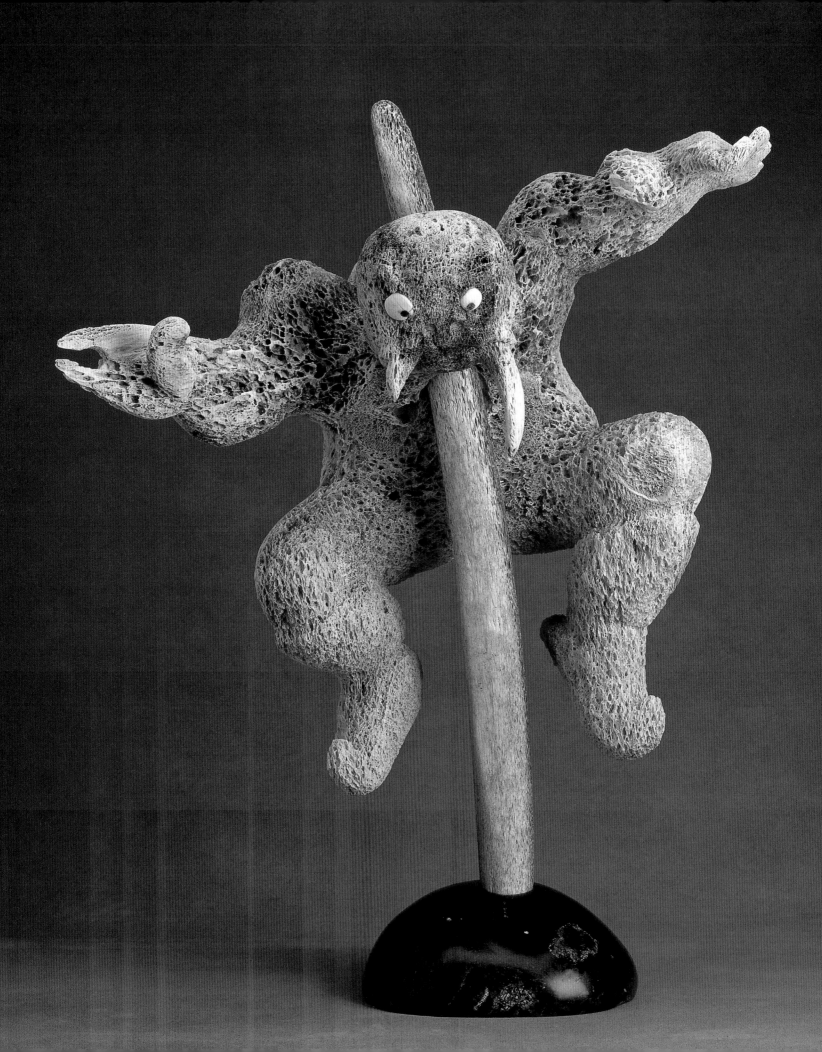

35 (facing page)
Charlie Ugjuk (born 1931),
Taloyoak
Harpooned Shaman, 1988
Whalebone, dark green stone, ivory,
63.0 × 36.0 × 28.0
National Gallery of Canada

One of the more spectacular
powers of the shaman was the
ability to receive or self-inflict
a serious injury without
suffering any permanent ill
effects. He might spear or stab
himself, throw himself upon a
harpoon, or allow himself to
be throttled. Ugjuk's shaman
appears to be possessed by an
animal helping spirit as he per-
forms his miracle.

36
William Noah (born 1943),
Baker Lake
Printed by the artist
Shaman, 1972 #24
Stonecut and stencil, 42.0 × 63.0
Musée canadien des civilisations/
Canadian Museum of Civilization
*Note: This image was labelled the
wrong way. Here it is shown posi-
tioned the way the artist originally
intended.

"Though no shaman can
explain to himself how and
why, he can . . . divest his
body of its flesh and blood, so
that nothing remains but his
bones. And he must then name
all the parts of his body, men-
tion every single bone by name
. . . [using] only the special
and sacred shaman's language,"
Knud Rasmussen noted
(Blodgett 1979:37).

37 (facing page)
Davidialuk Alasua Amittu m.
(1910–1976), Puvirnituq
Mythological Bird, 1958
Grey stone, 43.4 × 38.2 × 16.5
Winnipeg Art Gallery, Twomey
Collection, with appreciation to the
Province of Manitoba and the
Government of Canada

Davidialuk, one of the great
storyteller-artists, illustrates the
tale of a village whose women
were magically transformed
into sea gulls while their hus-
bands were away hunting. One
of his trademarks was to over-
lay powerful sculptural forms
with lighter graphic embellish-
ment, here manifested as deli-
cately incised feathers.

38
George Tataniq (1910–1991),
Baker Lake
Fox-Woman, 1970
Green-grey stone, 39.1 × 16.3 × 11.0
Art Gallery of Ontario, Gift of Samuel
and Esther Sarick, 1996

Tataniq carved several versions
of an episode of the Kiviuk
legend in which the hero, who
lived alone, found his igloo
miraculously tended and his
meals cooked for him. One day
he snuck home early and sur-
prised a fox who had shed her
skin to become a beautiful
woman. Tataniq's elegant yet
timid woman is so subtly
carved that we almost forget
she is transforming.

39
Peggy Ekagina (1919–1993),
Kugluktuk
Female Muskox Shaman, 1974
Dark grey stone, 19.8 × 9.3 × 36.0
Winnipeg Art Gallery, Gift of Sheila
and Robert Garfield

Unlike most of Ekagina's carv-
ings, which are considerably
smaller, this imposing work
resembles Baker Lake muskox
sculptures (Figure 84). But as a
transformation image, this
shaman-as-animal has a com-
pletely different sensibility
from Niuqtuk's shaman with

animal attributes (Figure 34),
also from Baker Lake. This is
not pretence but actual trans-
formation.

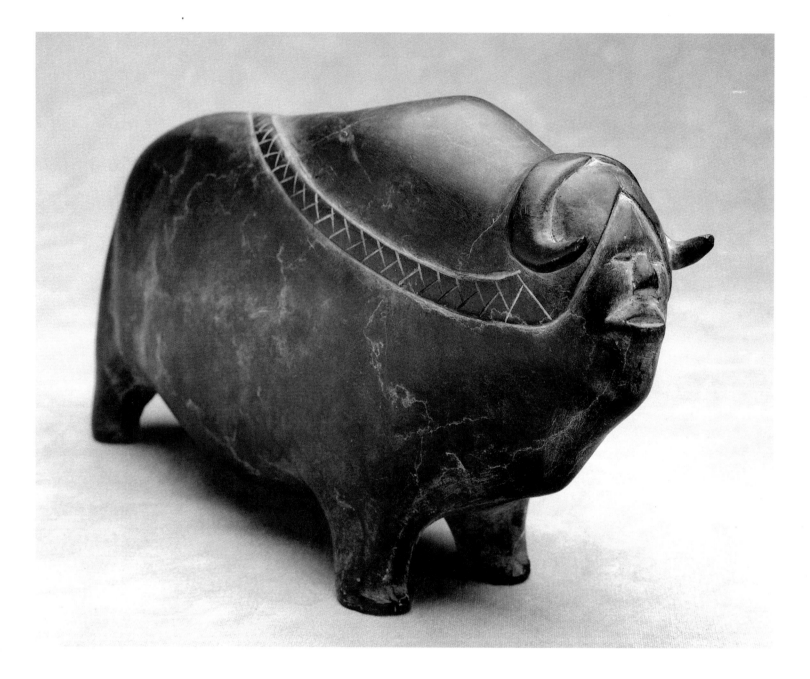

40

Simon Tookoome (born 1934),
Baker Lake
A Vision of Animals, 1972
Coloured pencil, graphite, 52.4 × 75.5
Winnipeg Art Gallery, purchased
through a grant from the McLean
Foundation

"The Inuit, especially a long time ago, used to think and to visualize—to have a vision of going out hunting, hunting wolves especially," Tookoome says (Jackson et al. 1995:109). He blends aesthetic concerns—bold pattern, symmetry and large blocks of colour—with a knack for visually communicating human thought and a love of animal-human transformation. In his drawings and prints, as in much Baker Lake art, the world of the Inuit and the world of animals mix freely.

A few Inuit artists have explored Christian themes over the past sixty years or so.[5] Influenced by Roman Catholic missionaries who arrived in the late Historic Period, carvers in the communities of Chesterfield Inlet, Pelly Bay and Repulse Bay created a number of ivory works depicting crucifixions and other portrayals of Christ, portraits of popes, and the madonna and child. In more recent years, some works, particularly wall hangings, have been commissioned by churches in Arctic communities. The Christian content is not always overt and requires explanation to distinguish it from "traditional" imagery (Figure 132).[6] And, finally, a few artists have depicted missionaries and their influence with ironic intent.

MYTHS AND LEGENDS

Inuit myths and legends are not simply stories but are oral traditions that describe the origins of humans and animals, provide justifications for taboos, explain the forces of nature, and generally bring a sense of purpose to an otherwise strange and chaotic world. Myths about the sea goddess, the hero Kiviuk and Lumaaq the Blind Boy, to name just a few, are a rich source of inspiration for artists, whose interpretations range from single famous scenes or episodes to entire story cycles (usually drawings).

The Legend of the Sea Goddess

The sea goddess, the most famous and powerful being in Inuit mythology, is known by many names, including Sedna, Nuliajuk and Taleelayu. The myth of the sea goddess exists in different versions in various regions of the Arctic, and this brief retelling is based on one of the better known accounts from northern Baffin Island:

> A young woman (Sedna), after refusing the offers of many suitors, eventually married a fulmar or petrel (sea bird). The bird, having promised her a life of luxury, took her to an island. Sedna discovered too late that she had been deceived, for her life on the island was in fact miserable. Upon hearing of her unhappy fate, Sedna's father came to the island to rescue her and killed the bird-husband. The two escaped the island in the father's boat but were pursued by the bird's friends, who created a terrible storm which threatened to swamp the small vessel. In a panic, the father threw Sedna overboard to save himself, but she clung to the side of the boat. Desperate to make it to shore, the father chopped off Sedna's fingers one joint at a time. Her severed finger joints transformed into whales and seals, and Sedna herself sank to the bottom of the sea and became a powerful spirit.

Sedna's sacrifice produced a bountiful harvest of sea mammals for Inuit, but there was a price to pay. The people were obliged to obey many rules and taboos to keep Sedna happy; if these taboos were broken, she might withhold her creatures from the community and whip up fierce storms, which would lead to starvation. One of the chief tasks of the shaman was to appease Sedna and to intercede with her in times of crisis. An annual Sedna Festival was held in some regions as an indication of the people's appreciation and respect.

Sedna's general appearance is quite similar to that of a mermaid; she is usually depicted with the upper body of a woman and the tail of a whale or other sea creature (Figure 41). Another physical characteristic is her hair. A shaman could curry Sedna's favour by travelling to the bottom of the sea to comb and braid her tangled hair (Figure 42).[7]

Taleelayu and Family Stencil '80 Ananaisie Alikatuktuk / Thomasie Alikatuktuk Pangnirtung 1976

41
Ananaisie Alikatuktuk m. (born
1944), Pangnirtung
Printmaker: Thomasie Alikatuktuk m.
(born 1953)
Taleelayu and Family, 1976 #13
Stencil, 38.5 × 58.5
Musée canadien des civilisations/
Canadian Museum of Civilization

The sea goddess Taleelayu (also
known as Nuliajuk and Sedna)
embodied the idea of fertility.
She was regarded as the giver of
life and a symbol of abundance,
but could withhold her animals
when angered. Ananaisie's
idyllic depiction of her as a
mother figure has been en-
hanced by Thomasie's delicate,
almost ethereal, stencilling.

42
Natar Ungalaq m. (born 1959),
Igloolik
Sedna with Hairbrush, 1985
Grey stone, fur, bone, 18.0 ×
21.5 × 20.0
National Gallery of Canada

When angered, the sea goddess
would withhold the animals,
causing starvation. One of the
duties of the shaman was to
appease Sedna by combing and
braiding her tangled hair.
Natar's thoroughly modern
work depicts Sedna as a grimac-
ing prima donna who doesn't
enjoy being kept waiting.

The Legend of Kiviuk

This complex legend, or legend cycle, has been compared to Homer's *Odyssey* as it involves an immortal hero's exploits during a lengthy journey through strange lands. The story exemplifies the traditional Inuit belief in the constant intersection of the human and animal worlds, with many examples of transformation, intermarriage and regeneration. This is a very concise rendition of some of Kiviuk's more interesting adventures:

> A young boy who lived with his widowed grandmother was constantly ridiculed in camp. Of all the men, only Kiviuk was kind to him. The boy's grandmother, who was a powerful shaman, avenged the cruelty of the men by luring them far out to sea and churning up a great storm. Kiviuk's life was spared, but he was carried off to a distant land. There, he came to the house of an evil shaman and barely escaped being eaten by her. After wandering for a time, Kiviuk arrived at the house of an old woman and her widowed daughter. He and the daughter married, but the mother soon became extremely jealous. She murdered her daughter, skinned her and donned the skin herself, hoping to fool Kiviuk. He quickly discovered her treachery and escaped.

> Several other adventures include encounters with a Spider Woman, a Bee Woman, giant caterpillars, bears and yet another cannibal sorceress who kept the heads of her victims (Figure 43). Kiviuk also married a fox who transformed into a beautiful woman (Figure 38), escaped from more cannibals and then married a goose (Figure 44). Finally, he returned home and was reunited with his original family.

> Kiviuk's many escapes from death were due to more than mere luck; he himself was a shaman of some considerable power, although he hid that fact whenever he could. He was also immortal, yet very human in his frailties. Always giving in to temptation, he was forever relying on his wits to get himself out of terrible trouble.[8]

The Story of Lumaaq

Like many Inuit legends, the story of Lumaaq the blind boy is about cruelty and vengeance. This is one of the more common versions of the legend:

> Lumaaq lived with his mother and sister. One winter, he had the misfortune to become snowblind. When a polar bear ventured near the family's camp, Lumaaq's mother knew that only he was strong enough to kill the creature. With his mother guiding his hand, Lumaaq killed the bear with his bow and arrow. He clearly heard the bear's howl of pain, but his mother lied to him, telling him he had missed and killed a dog by mistake. The mother and daughter moved a short distance away and cut up the bear for themselves. Lumaaq's sister, however, would sneak him food whenever she could.

> Lumaaq's prayers for deliverance were answered by a loon, who instructed him to hang on to its neck while it dove deep beneath the water three times. At the third descent, Lumaaq's sight was completely restored (Figure 45). He decided, however, to hide this from his mother. By now it was summertime, and whaling season. Lumaaq made a strong harpoon and suggested to his mother that they go whale hunting. He tied the harpoon line around his mother's waist, telling her that when they caught a whale, he would help pull it in. Ready to guide her son's hand on the harpoon, she waited for a small whale to appear. Lumaaq, however, harpooned the largest whale he could see, and found his revenge was complete as the whale pulled his hapless mother out to sea.

In Inuit mythology, it is sometimes difficult to know when one legend ends and another begins. In some versions of the Lumaaq story, he and his sister marry and/or wander into the wilderness, meeting the "long-clawed people" and the "bottomless women." In other tellings,

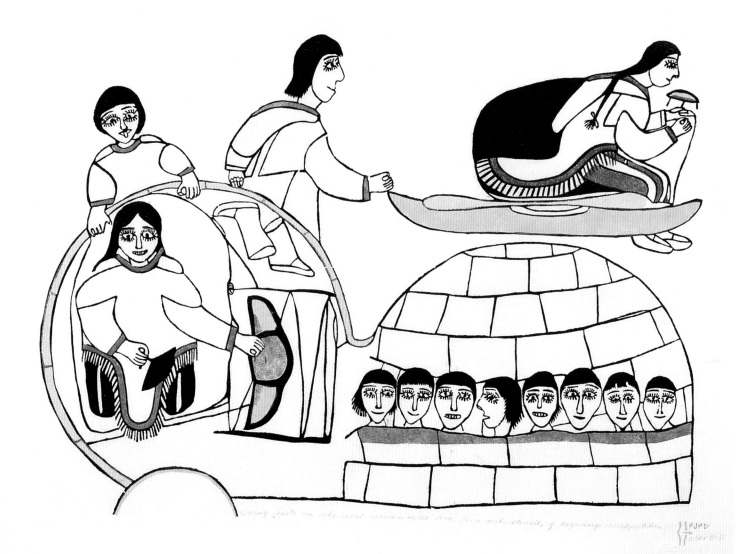

43
Janet Kigusiuq (born 1926),
Baker Lake
Printmaker: Magdalene Ukpatiku
(born 1931)
Qiviuq Spits on the Evil Woman,
1979 #13
Stencil, 47.5 × 63.5
Musée canadien des civilisations/
Canadian Museum of Civilization

In this episode of the Kiviuk
story, he is invited into the
igloo of the cannibal sorceress
Igutsaq. While she prepares a
fire to cook the unsuspecting
hero, he notices a pile of heads
in the corner. One head speaks,
warning Kiviuk to escape while
he can. The key players appear
several times in a kind of "time
lapse" sequence.

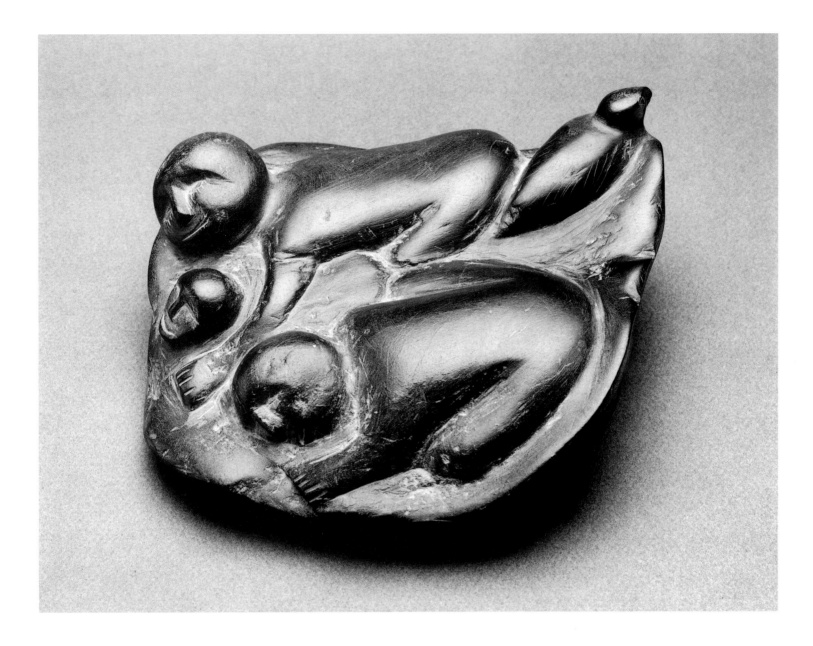

44
Miriam Marealik Qiyuk (born
1933), Baker Lake
Sleeping Family (Kiviuk legend),
1980
Black stone, 7.0 × 16.4 × 17.7
Winnipeg Art Gallery

In this episode of the Kiviuk
legend, he marries a bird-
woman; the couple have several
bird-children. Mother and
children can transform at will
and eventually fly away, but
Kiviuk chases after them. The
sculpture also works well on
the level of an intimate family
scene.

the two attend a village feast where Lumaaq inadvertently kisses or makes love to his sister in a dark igloo. Having marked her lover's face with soot, the sister is overcome with shame when she discovers it is her brother. She races away, pursued by Lumaaq, and the two rise up into the sky, where she becomes the sun, and he the moon.

Since very little Inuit literature has been written down and published, the visual arts have become a valuable permanent record of oral history and myths: a carving or drawing of a legend becomes the equivalent of its telling in words. Sadly, many thousands of artworks illustrating myths and legends have gone undocumented; however, much more would surely have been lost were it not for the efforts of storyteller-artists across the Arctic.[9]

THE HUMAN FIGURE

In Inuit art, the human figure is usually shown in cultural contexts such as hunting and daily activities, but occasionally the solitary human figure or partial figure appears divorced from those contexts. While a figure may be identifiable as Inuit because of its clothing, it does not rely on its "Inuitness" for meaning.

Although details of animal musculature and fur are often carefully treated, the human figure is generally fully clothed and thus largely hidden. Frequently, only the face is visible. Hints of an articulated body inside the bulky clothing are gestural rather than anatomical. The beauty of human anatomy, with some notable exceptions (Figure 46), is usually not significant. As in the depiction of animals, the spirit or psychological impact is paramount (Figures 47 and 48).

THE FAMILY

The family unit, particularly the mother and child (or children), is one of the most important themes in Inuit art. There is a very physical closeness between a mother and her infant children, due to the harsh climate which necessitated the invention of the *amaut* (back pouch) and the oversized hood. In many scenes of Inuit life, the small child peeking out from the mother's hood is almost an appendage (Figure 49), but in other works, the maternal bond is more overtly stated (Figures 50 and 51). The mother-and-child theme is particularly evident in sculpture; in two-dimensional art, it usually forms only part of the larger context of daily activities. Sometimes this theme bears a resemblance to the Christian motif of madonna and child; although the two themes are not related iconographically, there is a comparable emotional intensity (Figures 52 and 104). Expressive content is concentrated in the mother's face and in her tender, sheltering gestures, with considerable power and little sentimentality (Figure 53).

45
Agnes Nanogak (born 1925),
Holman
Printmaker: Harry Egutak (born 1925)
The Blind Boy, 1975 #29
Stonecut, 22.5 × 42.0
Musée canadien des civilisations/
Canadian Museum of Civilization

This print illustrates a pivotal
episode in the story of
Lumaaq. According to one
Copper Inuit version of the
tale, Lumaaq remained blind
for four years. One spring, a
loon spoke to him, offering to
restore his sight. After the

first dive, he could see some
light; after the second, his
eyesight was overly acute.
After the third, it was perfect.

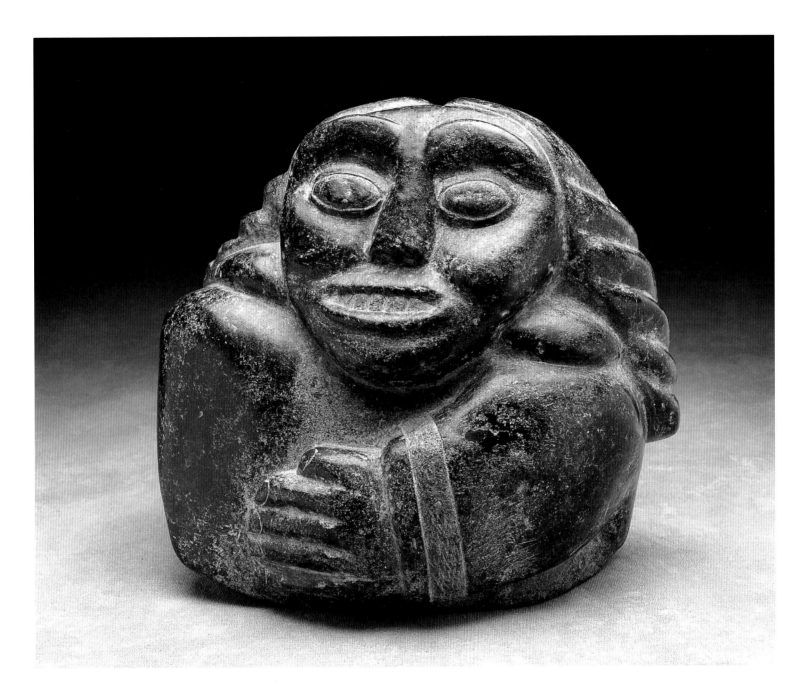

46 (facing page)
Oviloo Tunnillie f. (born
1949), Cape Dorset
Torso, 1994
Dark green stone, 23.5 × 9.3 × 3.6
National Gallery of Canada

In contrast to Oviloo's
flamboyant *Taleelayu* (Figure
69), this small *Torso* is quietly
elegant. While Oviloo has
carved nudes for years, she has
only recently begun experi-
menting with fragmentary
human figures. These invite
comparison with similar figures
in the European tradition,
about which this artist is no
doubt becoming aware.

47
Qaqaq Ashoona m.
(1928–1996), Cape Dorset
Bust of a Woman, 1956
Green-black stone, 21.3 × 24.7 × 14.8
Musée canadien des civilisations/
Canadian Museum of Civilization,
Gift of the Department of Indian
Affairs and Northern Development

What is remarkable about this
sculpture is how forcefully,
how resolutely, it is carved.
Qaqaq's mastery of three
dimensions is complete. All ele-
ments—arms, cheeks, even
eyes and eyebrows—are strong
sculptural shapes in their own
right, yet they combine to form
a successful whole.

48
Pitaloosie Saila f. (born 1942),
Cape Dorset
Printmaker: Lukta Qiatsuk m. (born
1928)
Eskimo Leader, 1972 #11
Stonecut, 62.2 × 85.0
Musée canadien des civilisations/
Canadian Museum of Civilization

"I don't know Picasso, myself,"
says Pitaloosie (Leroux et al.
1994:169). She often has had
to fend off questions about the
superficial resemblance of her
print to Picasso's imagery. The
figure is not a mustachioed
man, but a tattooed woman.
According to what she learned
as a child, women were tat-
tooed only when they had dis-
tinguished themselves as
leaders.

49 (facing page)
Johnny Inukpuk (born 1911),
Inukjuak
Woman and Child, 1954
Dark green stone, ivory, 20.0 × 20.5 ×
28.0
Musée canadien des civilisations/
Canadian Museum of Civilization

Johnny Inukpuk's works from
the 1950s exemplify the rapid
evolution of early contempo-
rary sculpture from small-scale,
tentative efforts to larger, more
ambitious and individualistic
artistic statements. The ripe,
voluptuous, rhythmic forms of
the mother tending her *qulliq*
(oil lamp), carved in the lus-
cious Inukjuak stone, imply
abundance and well-being.

50
Napatchie Pootoogook f. (born
1938), Cape Dorset
Printmaker: Pitseolak Niviaqsi m.
(born 1947)
My Daughter's First Steps, 1990
#9
Lithograph, 56.3 × 86.2
Musée canadien des civilisations/
Canadian Museum of Civilization

Napatchie inherited her mother
Pitseolak's interest in depicting
Inuit traditions from a personal
perspective, but recent attempts
to depict landscape settings
indicate a generational
difference. Napatchie, who
worked on the lithographic
stone herself, expressed frustra-
tion at the changes she was
obliged to make from the orig-
inal drawing (Leroux et al.
1994: 154).

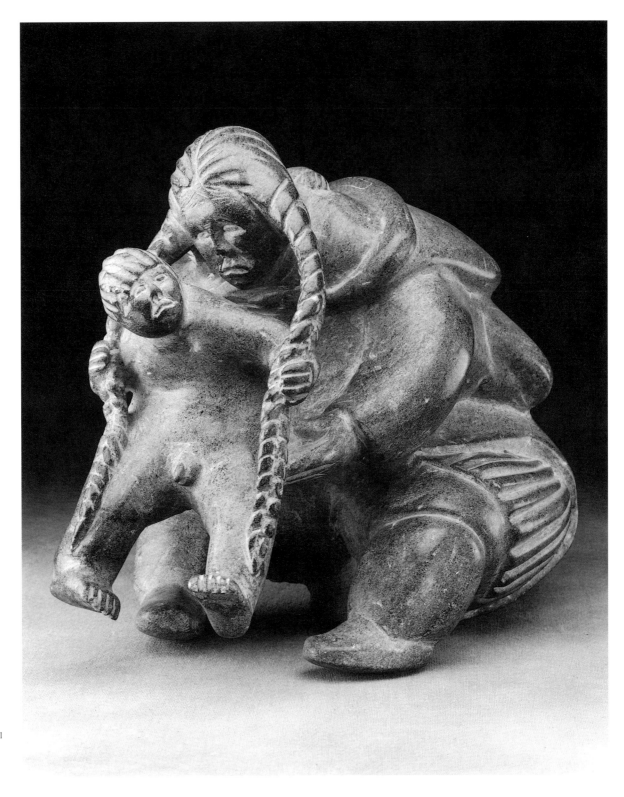

51
Paulosikotak Alaku m.
(1923–1971), Salluit
Mother and Children, ca. 1959
Grey stone, 26.9 × 32.0 × 22.4
Art Gallery of Ontario, Gift of Samuel
and Esther Sarick, 1990

Domestic and family themes
were the most popular in
Salluit art of the 1950s, with
carvers revelling in the simple,
unheroic aspects of everyday
life. This mother has probably
taken her son out of her *amaut*
"rear pouch" to let him urinate;
he does not seem too sure of
the situation.

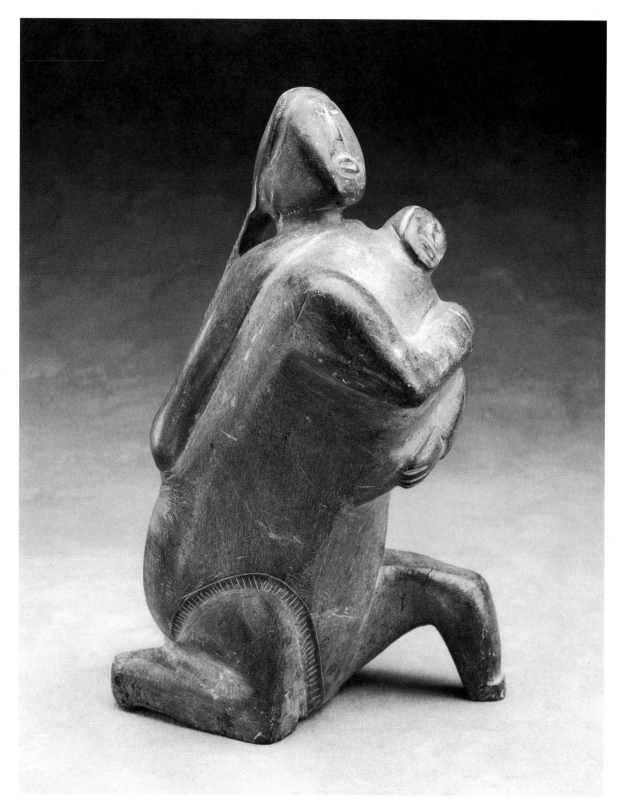

52
Margaret Uyauperq Aniksak
(1905–1993), Arviat
Mother and Child, 1971
Grey stone, 28.6 × 12.3 × 17.5
Winnipeg Art Gallery, Twomey
Collection, with appreciation to the
Province of Manitoba and the
Government of Canada

Unlike many of her Arviat
peers, Uyauperq aimed for a
measure of realism. Not only
did she open up negative space
somewhat with her figures'
gestures, she also carved and
carefully delineated details of
clothing. But her themes are
pure Arviat, centred almost
exclusively on highly expres-
sive images of maternity.

53
Peter Sevoga (born 1940),
Baker Lake
Family Group, 1972
Darkened green-grey stone, 25.2 ×
22.7 × 22.5
Art Gallery of Ontario, Gift of Samuel
and Esther Sarick, 1996

The best Baker Lake stone is
black and hard, polishing to a
satin sheen. In many of Sevoga's
sculptures, a family huddles
together in the mother's pro-
tective embrace. He juggles bulk
and delicacy, creating surface
rhythms through the interplay
of sensuous curves and vol-
umes, while leaving the central
mass of the stone intact.

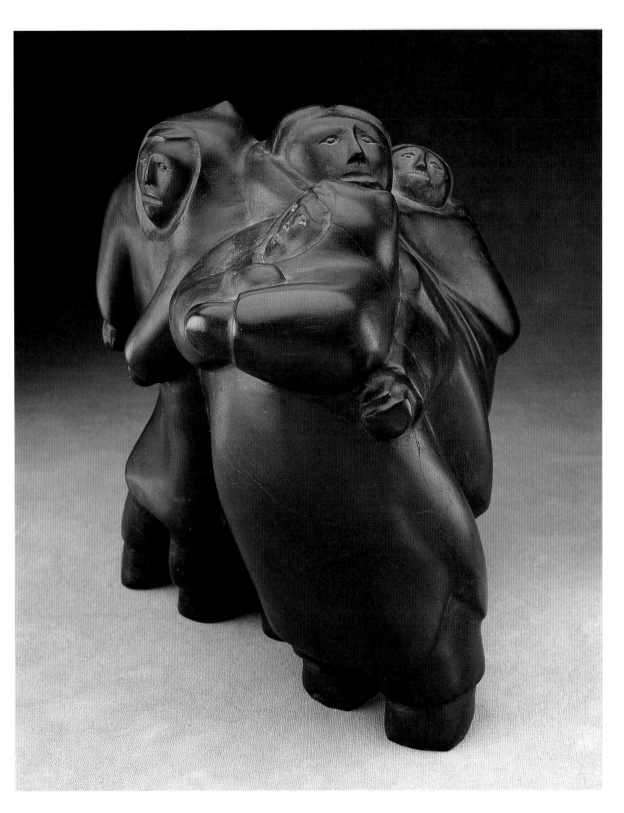

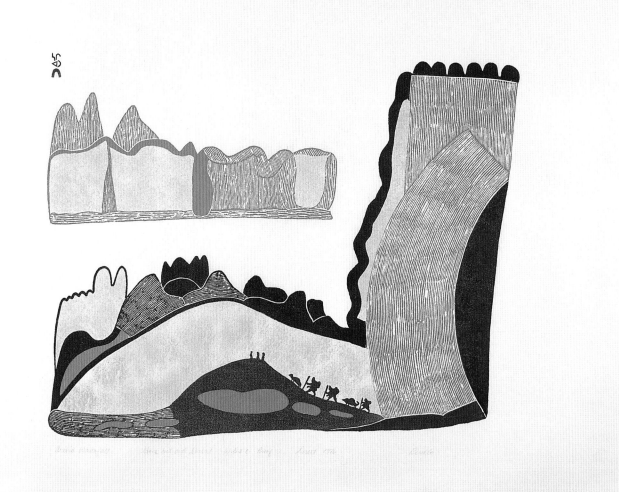

THE ARCTIC LANDSCAPE

As it was just thirty to forty years ago that the Canadian government permanently settled the Inuit in villages, only the younger generations of artists have been raised off the land. Many Inuit, however, divide their time between the community and the land, often spending the entire summer at a semipermanent camp site. For them, the land and sea are not merely hunting grounds but the places where spirits live, where generations of ancestors lie buried under stones, and where animals and plants flourish according to the seasons.

Despite the importance of the physical environment, it does not figure prominently in Inuit art. Even in the graphic and textile arts, which are more amenable to depicting landscape than sculpture, the land is a background element or is completely absent. Graphic and textile artists who have experimented with showing true landscape in their work include Pudlo Pudlat, Janet Kigusiuq and Ruth Qaulluaryuk (Figures 54, 112 and 145). The younger generation of graphic artists is adopting Western conventions of perspective and landscape.

THE INFLUENCE OF THE SOUTHERN MARKET

In the Historic Period, many works were specially commissioned by Europeans; these ranged from depictions of animals and models of traditional Inuit implements to miniature replicas or ivory models of European objects such as rifles, traps and boats. Today, the wide variety of themes in Inuit art indicates that artists enjoy relative freedom in choosing their subject matter, although they are greatly influenced by the southern market. After all, they are producing works for that market and not for sale or use within Inuit society; furthermore, they rely on art production for their livelihood or as a source of spare cash. More recently, the front-line purchasers of Inuit art (usually just the first in a series of buyers) have also exerted a considerable amount of influence. The rejection by buyers of particular subjects often means that an artist will choose to portray a more acceptable one in the next work, and some exploit popular themes because they sell well. However, independent-minded or important artists feel freer to experiment, and they influence the market as well as their fellow artists. Moreover, the art-buying public appears to be curious and imaginative enough to collect the variety of works produced by the artists.

Inuit art is relatively conservative and is rarely political: very few artists deal with present-day social issues. On the other hand, themes in contemporary Inuit art such as mythology and shamanism still have the power to evoke shock and surprise. At present, the art continues to celebrate Inuit traditions, but sweeping social changes are bound to have an effect on Inuit identity; both artists and the outside world will have to learn to appreciate and accept the inevitable evolution of Inuit art as it begins to reflect that new identity.

54
Pudlo Pudlat m. (1916–1992), Cape Dorset
Printmaker: Sagiatuk Sagiatuk m. (born 1932)
Arctic Waterfall, 1976 #15
Stonecut and stencil, 62.2 × 86.3
Musée canadien des civilisations/ Canadian Museum of Civilization

"Now in my drawings I draw land," Pudlo says, "because everybody in this world sees land every time they get up . . . I really love making landscapes—the sky and everything" (Routledge and Jackson 1990:27). By the mid-1970s, Pudlo, like many of his Cape Dorset peers, had become interested in depicting landscape. The tiny row of figures at the bottom is dwarfed by the grandeur of the scenery. In this image, Pudlo, unlike Pitseolak (Figure 31), seems more interested in the formal, almost abstract potential of landscape.

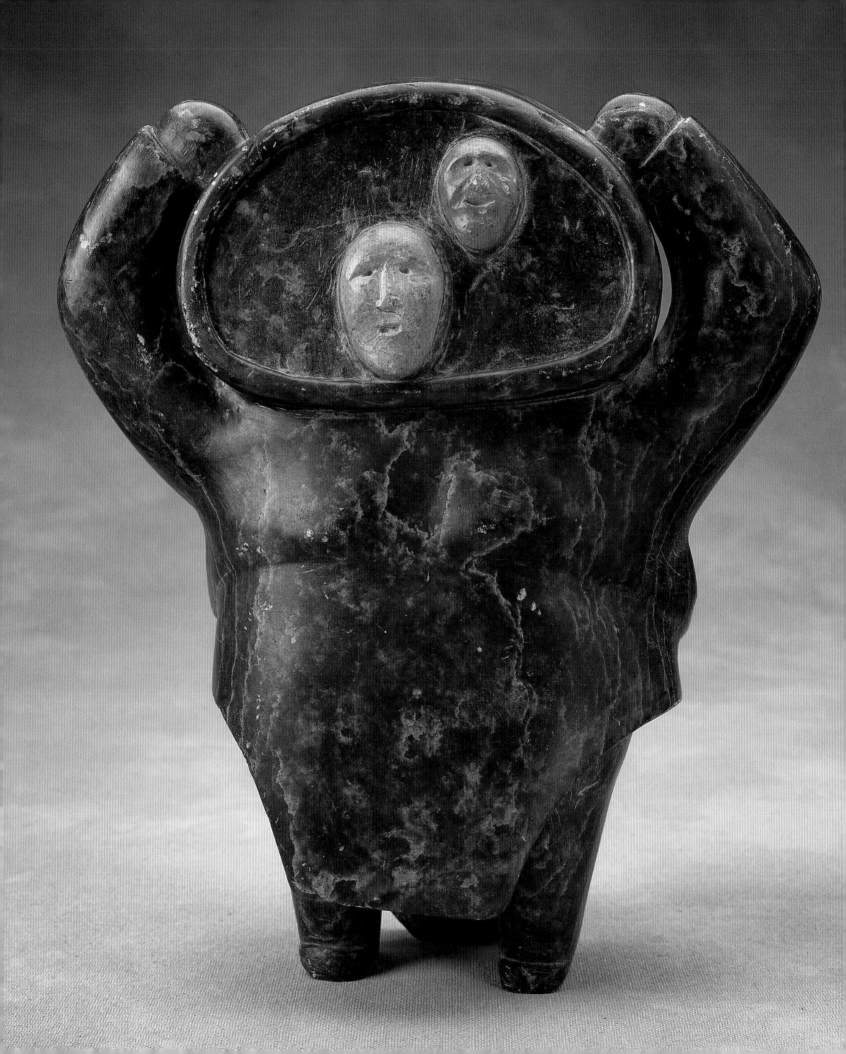

SCULPTURE: TRADITIONS AND NEW DIRECTONS

55
Syollie Weetaluktuk m. (attrib.)
(1906–1962), Inukjuak
Mother and Child, ca. 1957
Dark green stone, ivory, 25.0 ×
20.0 × 10.0
Musée canadien des civilisations/
Canadian Museum of Civilization,
Gift of the Department of Indian
Affairs and Northern Development
(Gift of Robert Kennedy)

The mother is pulling up her
spacious hood to protect the
infant emerging from her *amaut*
("rear pouch"). Like many
Inukjuak figures, they engage
the viewer with calm yet
expressive gazes. The subtle,
broad volumes of this work,
with the upraised arms framing
the oval form of the hood, lend
it an archetypal quality.

WITHIN A DECADE of James Houston's visits to Arctic Québec, the west coast of Hudson Bay and Baffin Island, the Inuit carving industry was booming across the Arctic, with projects initiated by government administrators, contracted arts advisors, missionaries and even schoolteachers.

Beginning in the late 1950s, Inuit-owned co-operatives were organized with assistance from the federal government, first in northern Québec, then in the rest of the Arctic, to market arts and crafts, fish products and other commodities. These days, the co-operatives operate businesses such as stores and hotels, as well as wholesaling sculptures, prints and other arts. The Hudson's Bay Company's Inuit art marketing division has become an arm of the North West Company, which still purchases sculpture and other arts and crafts through its chain of Northern Stores, wholesaling them in the south. Inuit art (primarily sculpture) is now a multimillion-dollar industry, with dozens of companies and individuals selling to a network of retail galleries and shops in Canada, the U.S. and Europe. Unlike the early 1950s, Inuit sculpture is now generally promoted as fine art, although many artists and communities continue to produce work for the popular art and tourist markets. Carvings, which constitute about 80 per cent of Inuit art production, are considered the pre-eminent art form in most communities and the one with which Inuit art is most readily associated.

Two defining features of contemporary Inuit sculpture are its physicality and relatively modest scale. The raw materials of Inuit sculpture are tactile, natural materials—stone, bone, antler and ivory—taken from the earth and its animals. Artists use the human or animal body as their starting point and relate them directly to the physical or spiritual world rather than to abstract political or philosphical ideas. Like most small-scale sculptures, Inuit carvings create their own world and draw us into their space. Reactions to Inuit sculpture are visceral and emotional, rather than intellectual.

Although the terms "carving" and "sculpture" are used almost interchangeably, they have different connotations. The word "carving" often refers to smaller-scale work and may be used to denote so-called "lesser" arts such as folk art or tourist art. It also sometimes implies the working of wood. "Sculpture" frequently refers to larger, more "impressive" work that is serious "fine art" and, by implication, produced by one of the "major civilizations" or a recognized artist.

All Inuit sculptures are carved in the sense that they are hewn or cut, and not modelled (with the exception of ceramics). While many works are assembled from individual elements made from different materials, even these separate elements are individually carved. Despite the connotations and the fact that Inuit works which are modest in scale, execution and conception may be referred to as "carvings," and those that are larger and more ambitious as "sculptures," there is no actual qualitative distinction between the two terms. Inuit artists, if they speak English, generally call themselves carvers, but some of the younger generation prefer to be called "artists."[1]

METHODS AND MATERIALS

> Before I make a carving I think about women, how they used to live a hard life before, how they were always cold. I always talk to the stone: "What are you going to be? I know you won't answer, so I will do what I want." I always have strong feelings before I make a carving.
> —ELIZABETH NUTARALUK AULATJUT, ARVIAT (Nutaraluk 1989)

In Inuit sculpture, the relationship of artists to material is a special one. The carvers are inspired by shapes, textures and colours, and have an uncanny ability to look at the raw material and visualize the final sculpture. They may sometimes search for a piece of raw stone, bone or antler to accommodate a general theme, but more commonly they study the available material until it suggests a suitable idea or composition. As a consequence, Inuit carvers have no need to make maquettes or preparatory drawings.

Perhaps it is the great respect for and sensitivity to the materials they carve that allows many Inuit artists to produce wonderful images which go far beyond the mere representation of subject matter. Inuit sculptors—market forces notwithstanding—have great freedom in their choice and combination of materials, carving methods and size of sculptures. Their open dialogue with the materials allows for a corresponding freedom of choice in composition, style and subject matter. Inuit sculpture is full of examples of startling originality of conception, breathtaking simplicity and raw vitality.[2]

> Carving means many things to us. One has to find stone in order to make carvings. Summer or winter, each brings its own difficulty in obtaining the stone. This is something which I believe the people in the South do not understand. You have to think of where the stone comes from and the problems one goes through getting it out. The problem of locating it in the first place and the distance one has to carry it.
> —PAULOSIE KASADLUAK, INUKJUAK (1977:21)

Inuit and their ancestors have been obliged to hunt or scavenge for their traditional carving materials: ivory, bone, antler and driftwood. Stone was shaped into oil lamps and cooking pots, but rarely used for art until the Historic Period. Today, in most communities, stone has supplanted organic materials as the primary carving material. While it is more plentiful and versatile than other materials, locating, quarrying and transporting good quality carving stone is time-consuming and difficult, and some quarries are almost exhausted. True soapstone, or steatite (*qullisaq*, the stone traditionally used for carving *qulliit*, or oil lamps) is used mostly in Arctic Québec; the much harder green serpentine and serpentinite are more common on southern Baffin Island. Other stones used include limestone, argillite and, most recently, marble (also found on southern Baffin). Occasionally, southern stone has been imported by communities with chronic shortages, but poor market acceptance tends to discourage this practice.[3]

Walrus ivory, once the mainstay of Inuit carving, is still being utilized, but now mostly for miniatures and details or inlay work, as well as jewellery. In contrast, whalebone is favoured by many carvers because of its unusual shapes and textures, and because it allows them to work on a relatively large scale.[4] Unfortunately, international trade restrictions concerning marine mammal products have limited the marketability of works in ivory and whalebone.[5] Caribou antler, which is a renewable resource as the animals shed their antlers each year, offers an alternative to ivory and is often used for work that is mostly assembled or "constructed."

Although many contemporary carvings are small enough to fit in the palm of a hand, there has been a general increase in the size of works as carvers learned that larger works brought considerably more money for relatively little extra effort. Stone and whalebone sculptures can attain heights of 60 to 90 centimetres (two to three feet). The only restriction seems to be the ability to quarry and transport large pieces of stone, or to scavenge large pieces of aged, weathered whalebone on Arctic beaches. Although works on a larger scale were initially encouraged, the art market has not been able to absorb an unlimited supply of bigger, more expensive works, obliging artists to alternate between larger and smaller pieces.

Inuit carvers utilize an assortment of hand tools, either purchased or improvised. In stone carving, they use small axes and sometimes adzes to rough out the initial shape. An improvised hatchet can be made by lashing or welding two worn files together into a T and grinding one of them to form a blade. Softer stone can be cut with a saw. A few Inuit carvers have adopted European chisel-and-mallet techniques; much more popular are small power tools such as diamond-disc grinders and flexible-shaft rotary grinders. These electric tools considerably shorten roughing out and shaping time. Files and rasps are used to shape the stone to its final form. It is then smoothed and polished with emery cloth, sandpaper and sometimes even liquid metal polish. Fine incisions are made with knives or nails, usually after a stone has been finished. The stone may be heated and rubbed with beeswax, which forms a protective, shiny surface. As the natural colour of stone is brought out when it is polished or wet, sometimes lard, margarine or other substances are used to maintain the dark natural look. Even shoe polish is occasionally used to artificially darken grey stones. Ivory, antler or contrasting stone details are added at the very end.

Carving methods must be adapted for working on organic materials such as ivory, bone and antler, whose qualities of hardness and brittleness differ considerably from that of stone. Ivory can be worked with small grinders and knives; antler, like wood, can be sawn, filed and pegged or glued together. Because of its varying hardness, textures and brittleness, whalebone can be tricky to carve; power tools tend to scorch the bone, so carvers use axes or mallets and chisels, switching to knives and files for finer details.

AESTHETICS AND REGIONAL STYLES

George Swinton (1992:129–30) has noted that Inuit did not traditionally have a term for "art." To describe carving or the making of art, they use the Inuktitut term *sananguaq*, which translates as "carved in the likeness of (replica)." While Western artists use the same language as critics and art historians, Inuit artists, especially those of the older generations, are "difficult" to interview about their work as they are unfamiliar with "artspeak."

Most Inuit have a decidedly craftsmanlike rather than an aesthetic approach to carving: a realistic, well-made object is considered more important than a "beautiful" one, and the subject

56 A and B (two views)
Manasie Akpaliapik m. (born 1955), Arctic Bay/Toronto
Respecting the Circle, 1989
Whalebone, ivory, dark grey stone, antler, baleen, rust stone, horn, 52.0 × 71.4 × 40.0
Art Gallery of Ontario, Gift of Samuel and Esther Sarick, 1996

"Everything in the world is connected, people and the animals, the entire food chain. When you disturb the circle, the chain, you disturb everything," says Manasie. His gift for naturalistic representation in the challenging material of whalebone is remarkable; the character and integrity of the bone remain absolutely intact. He does not simply carve bone, he animates it.

of the carving is more meaningful than its form (Swinton 1992:130). As Kananginak Pootoogook observed (1979:33–34): "A white man, if he is going to buy a carving, buys it purely by the appearance of the carving. The white people do not consider the meaning of the carving, simply the appearance of the carving."[6]

The anthropologist Nelson Graburn chose the Inuktitut term *sulijuk* ("it is true or real") for identifying realism as the overriding aesthetic approach among Inuit artists.[7] The close connection between realistic form and content in Inuit sculpture is not as restrictive as it seems, however, for "realism" can manifest itself in many ways. It can refer to the portrayal of imaginary or supernatural beings and events as if they were real, often in highly naturalistic expressions (Figure 56); very precise depictions of people, animals and objects in the natural world (Figure 57); somewhat more naive, less anatomically perfect, more expressionistic illustrations of activities or actual events (Figure 63); and depictions of actual beings in a stylized manner that conveys their essence (Figure 107). As Paulosie Kasadluak has said (1977:21): "No matter what activity the carved figure is engaged in, *something about it will be true*" (italics mine).

57
Osuitok Ipeelee m. (born 1923),
Cape Dorset
Standing Caribou, 1988
Mottled dark grey-green stone, antler
49.8 × 42.2 × 25.1
Art Gallery of Ontario, Gift of Samuel
and Esther Sarick, 1996

Osuitok, already a renowned ivory carver in the late 1940s, is perhaps the foremost Inuit sculptor of naturalistic "wildlife art." When James and Alma Houston visited him in 1951, they found the ceiling of his igloo plastered with animal and bird illustrations cut out of books (Houston 1979).

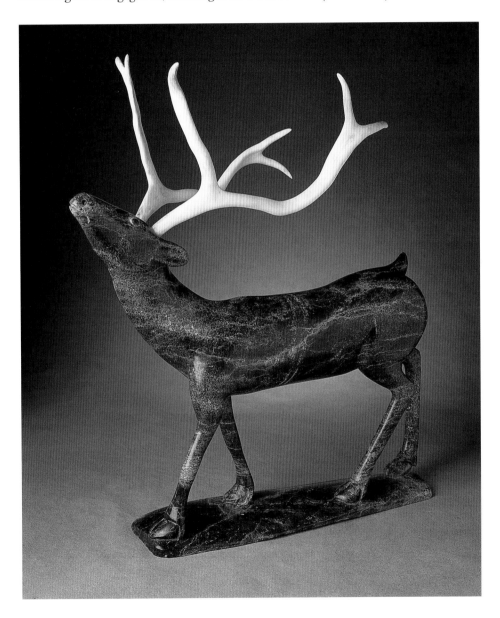

The inseparability of form and content in Inuit sculpture cannot be stressed enough. Inuit sculpture is always *about* something; while the meaning of a particular work may be obscure due to the viewer's lack of knowledge, the forms themselves are almost always intended to relay or enhance meaning. Pure abstraction does not exist in Inuit sculpture or in Inuit art in general; even when form is radically simplified (Figure 58), it is seldom an end in itself. Likewise, there is little pure decoration; Inuit artists either leave carved surfaces unadorned, or apply texture, incising or inlay to enhance realism or add symbolic content.

Interestingly, contemporary Inuit sculpture is characterized not by its homogeneity but rather by its great stylistic diversity, which is due to many factors. First, the disintegration of the relatively uniform Thule culture into regional patterns discouraged a single artistic style; this was compounded by the fact that regions experienced different and varying outside influences in the Historic Period. Second, the episodic nature of the introduction of carving activity to widely scattered communities in the 1950s and 1960s, and the personal tastes of the advisors and entrepreneurs who worked with artists, encouraged diversity. Third, the considerable variety in the availability and type of carving materials across the Arctic made a uniform style impossible and promoted artistic invention. Finally, Inuit carvers are talented individuals who have an acculturated and rapidly changing lifestyle, producing art for an outside audience that values, promotes and rewards personal expression. They have developed personal artistic styles even in settlements where the "community style" is especially strong, and even among artisans who specialize in carving tourist or souvenir art.

Today, at least thirty-five of the fifty or so Inuit communities are recognized as centres of sculpture. Ironically, Labrador, which produced the first Inuit export ivories for Moravian missionaries in the late eighteenth century and which was considered the foremost art-producing region in the Historic Period, was sadly neglected; it has only recently attempted a carving revival.

The following survey of regional and community styles in Inuit sculpture discusses both the broad general stylistic characteristics and the favoured subjects of each region and key communities.[8] This is not an attempt to categorize the work of communities or artists, especially since it seems that the exceptions outnumber rather than prove the rules, as can be seen by comparing and contrasting the work of individual artists within, as well as outside, regional and community boundaries. Moreover, a number of aesthetic approaches cut across those boundaries, and a few of these are also examined.

Nunavik (Arctic Québec)

"What we show in our carvings is the life we have lived in the past right up to today. We show the truth," says Paulosie Kasadluak (1977:21). He is from the community of Inukjuak, and his sentiments are echoed throughout the Nunavik region, which encompasses more than a dozen communities dotting Arctic Québec's coastline. The importance of depicting the reality of everyday Inuit existence, as well as events described in Inuit oral history, mythology and personal recollection, is a current that has run through fifty years of Nunavik sculpture. The region's carving is strongly narrative and strives for naturalistic and realistic representation. Dominated by the styles of two communities, Inukjuak and Puvirnituq, Nunavik work was the first contemporary Inuit art presented to the public and it has coloured perceptions about the art form ever since. Tradition is favoured over innovation, and styles which matured in the late 1950s and early 1960s are still practised today.[9]

58
John Pangnark (1920–1980),
Arviat
Mother and Child, 1973
Grey stone, 31.3 × 28.2 × 23.0
Musée canadien des civilisations/
Canadian Museum of Civilization

Pangnark, the greatest practitioner of Keewatin "minimalism," focussed on the single human figure. His instinctive interest in the underlying geometry of the human body was evident from the beginning. By the late 1960s, he had begun stripping away detail; soon only the barest vestiges of humanness remained (see face at topmost point).

 "It's the imagination of the shape that I like. It does not look just like a real thing. If it looked like a real person, you would simply see a copy of what is alive," says fellow Arviat carver Lucy Tasseor (1989).

Most Nunavik sculptures are carved from grey steatite (soapstone). This soft stone is easily carved, but as it also breaks and scratches easily, it must be worked with care. Carvers often darken the stone to a black colour, then scrape or incise the surface to enliven it with realistic details such as facial features and patterns of clothing or fur, or to create a colour contrast between ground and figures.

Inukjuak

Inukjuak (formerly Port Harrison), located on the east coast of Hudson Bay, was the "birthplace" of contemporary Inuit art and rapidly developed as an art-producing community in the 1950s.[10] Inukjuak sculptures, carved mainly from a dark green serpentine, the most beautiful stone in the region, illustrate and celebrate the everyday life of times past. Subject matter includes wildlife, the human figure and occasionally mythology, but it is the depiction of the family and traditional female camp activities (Figures 30 and 55) that are most closely associated with Inukjuak sculpture, although very few of the community's carvers (indeed, few Nunavik carvers), in contrast to other regions, are women.

Inukjuak sculpture evolved from the experiments of the early 1950s (Figures 21 and 23) to a mature style that features broad, rounded volumes. This found full expression in the work of Johnny Inukpuk, a camp leader and one of the early "stars" of Inuit art, who had developed a strong personal style by 1955 (Figure 49). Overall, classic Inukjuak sculpture appears rooted to the ground, self-contained and somewhat static; the works exhibit a quiet, somewhat reserved tone, and yet the faces—the eyes more than anything (still sometimes inlaid with ivory)—often divulge a certain expressionism (Figures 59 and 60). It has been suggested that the people of

59
Noah Echaluk (born 1946)
Inukjuak
Woman Stitching a Skin Closed,
ca. 1985
Grey-green stone, hide, antler, ivory,
colouring, 22.9 × 25.1 × 20.1
Art Gallery of Ontario, Gift of Samuel
and Esther Sarick, 1996

Echaluk adds hide and other materials to his sculptures, and also follows the older convention of inlaying facial features with contrasting ivory. He uses these materials for greater realism, but also expressively for psychological impact. Compare this work with Eli Weetaluktuk's serene treatment of a similar theme (Figure 30).

60 (facing page)
Abraham POV (1927–1994),
Inukjuak
Mother and Two Children, 1981
Grey stone, 32.4 × 15.7 × 31.5
Musée canadien des civilisations/
Canadian Museum of Civilization,
Gift of Beverly and Irwin Bernick

Son of artist Joe Talirunili, Abraham moved to Inukjuak from Puvirnituq; his last name, derived from the abbreviated name of his home community, is pronounced P-O-V. Just as the child hugs his mother's back, so POV's lines and sculptural forms hug the original shape of the stone; he needs to remove little to reveal essential forms.

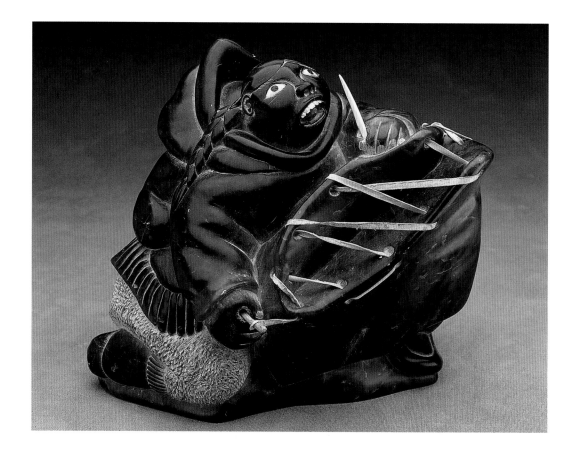

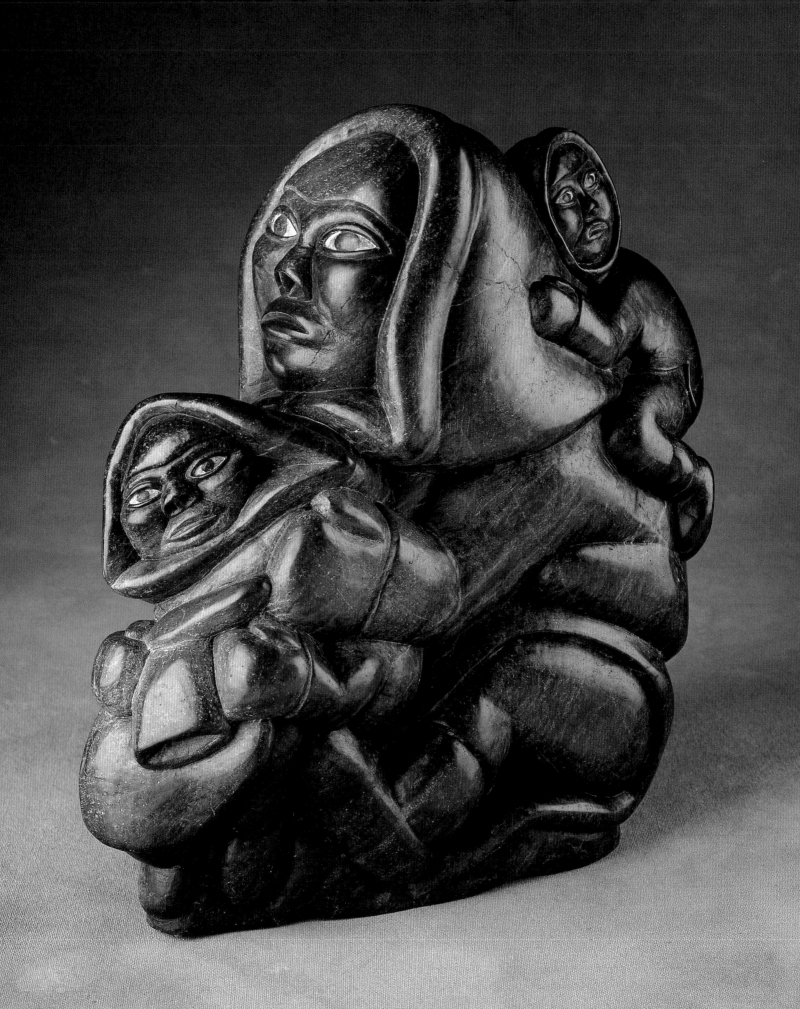

Inukjuak lacked confidence in their relationship with southerners, tending to hold back somewhat and keeping their thoughts to themselves. Perhaps this reticence is embodied in their art.[11] In recent years, Inukjuak sculpture, influenced by the art of its northern neighbour Puvirnituq, has become less restrained, more energetic and gestural.

Puvirnituq

Puvirnituq (Povungnituk, or POV) developed around a Hudson's Bay Company trading post in the 1950s. The community's sculpture, hardly distinguishable from that of Inukjuak in the early years, had developed a robustly realistic style by the end of the 1950s, and now dominates the art of the entire region. Compared with the art of Inukjuak, Puvirnituq sculpture is more exuberant, confident and even aggressive.[12] In the male-dominated carving profession, technical proficiency is valued as highly as hunting prowess, and competition among carvers is evident. The themes are male-oriented as well, rarely portraying domestic scenes; instead, the sculptures pay tribute to the exploits of hunters, both human and animal, and illustrate mythological and personal narratives.

The Puvirnituq style, although realistic, is not a photographic realism. Rather, it epitomizes Graburn and Swinton's concept of *sulijuk*.[13] The Puvirnituq brand of sulijuk realism can apply to different combinations of truthful or experiential content, and/or realistic form. It can vividly depict myths and stories (Figure 61) or the surreal world of dreams (Figure 62), and it varies from elegant naturalism (Figure 27) to somewhat coarser forms of expressionism (Figure 63).[14] Puvirnituq realism does not shy away from the depiction of violence or bodily functions, and carvers have even experimented with erotic subject matter.[15]

Swinton (1977:21) fittingly describes Puvirnituq art as a "typically untypical" paradox, having a definite community spirit but refusing to let itself be pigeonholed into a single stylistic category. The two most famous Puvirnituq artists, the cousins Davidialuk Alasua Amittu (Figures 37 and 61) and Joe Talirunili (Figure 63), exemplify this paradox; both had absolutely individualistic rugged carving styles and were driven in their desire to chronicle traditional and personal stories. Davidialuk, widely considered to be one of the last great Inuit myth-makers,[16] was never a great hunter; he built a career out of recounting myths and legends in sculptures and prints, and wrote down and recorded hundreds of traditional and personal stories for posterity.

Salluit

Salluit (formerly Sugluk), on the northern tip of Ungava Peninsula, began its art project in 1952, and by 1955, 70 per cent of the 110 adults in the community were carving regularly. The ensuing years were the heyday of Salluit art; by 1957, its carving production was the second highest in Canada's Arctic. Interestingly, fully half of the Salluit carvers were women, and themes were divided more or less along gender lines. Women carved female-oriented domestic and family scenes almost exclusively; men appeared to have more freedom, usually carving scenes of the hunt, but occasionally depicting female subjects as well (Figure 51).

The coarsely textured grey Salluit stone allowed the shaping of negative space but did not permit much detailed incising or polishing. Making the best of their material, carvers created works that are monumental in their simplicity, if somewhat stiff and formal at times (Figure 64). Salluit works of the 1950s, with their archaic sensibility, are reminiscent of certain examples of European Romanesque art. Sadly, by the late 1950s, the art market had lost interest in the static,

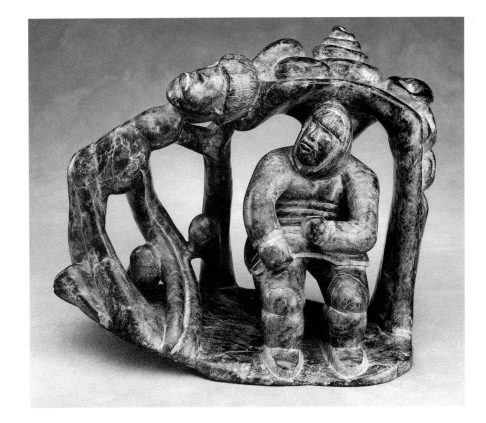

61 (top)
Davidialuk Alasua Amittu m.
(1910–1976) Puvirnituq
*The Aurora Borealis Decapitating
a Young Man,* 1965
Dark grey stone, 23.2 × 29.0 × 14.0
National Gallery of Canada

One night, three companions
went outside and one of them
started whistling. The
Northern Lights began to roar
and whip up a violent wind,
but ignoring the warnings of
his friends, the young man
kept whistling. The Aurora
swooped down, decapitated
him, and played football with
his head. Since then, no one
whistles outdoors at night.

62 (bottom)
Eli Sallualu Qinuajua (born
1937), Puvirnituq
Untitled (Mythology Sculpture),
1970s
Grey stone, 27.1 × 18.0 × 11.0
Musée canadien des civilisations/
Canadian Museum of Civilization

Encouraged in 1967 by an
anthropologist to depict things
never before seen, a group of
Puvirnituq carvers began creat-
ing works of a fantastic, even
surreal, nature. The similarity
to some of the imagery of
European artists such as Bosch,
and modern surrealists like
Dali and Tanguy, is startling.

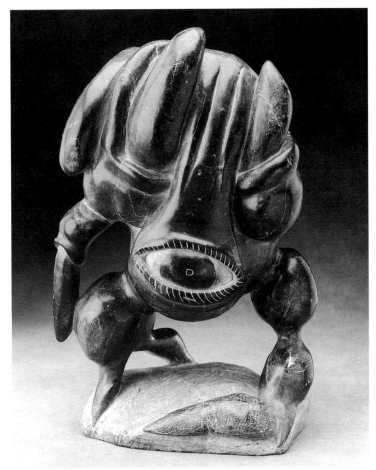

63
Joe Talirunili (1893–1976),
Puvirnituq
Migration, ca. 1975
Grey stone, skin, black wool, wood,
34.5 × 29.0 × 20.6
Musée canadien des civilisations/
Canadian Museum of Civilization

In his later years, Talirunili
became obsessed with recount-
ing the details of a harrowing
childhood adventure: survivors
of a shipwreck crowded into a
hastily constructed *umiak,* in an
attempt to reach safety. He
carved a dozen versions in the
last year of his life, occasion-
ally even including a list of
those involved.

64 (facing page)
Sammy Kaitak (born 1926),
Salluit
Woman Combing Her Hair,
ca. 1955
Grey stone, 19.5 × 15.0 × 24.0
Musée canadien des civilisations/
Canadian Museum of Civilization,
Gift of the Department of Indian
Affairs and Northern Development

The slightly coarse grey Salluit
stone resists polishing but has
not deterred carvers from
attempting realistic detail.
Kaitak's mother and child,
with their large, massive bod-
ies, small, delicate faces and
carefully delineated hair,
exhibit a blend of monumen-
tality, awkwardness and charm.

traditional look of Salluit sculpture; experiments with southern stone were not successful, and by the early 1960s the project had begun to falter. Sculpture is still produced in Salluit, but the style is now less distinct from that of other Nunavik communities.[17] The art of Kangiqsujuaq (Wakeham Bay) and Ivujivik paralleled to some degree the development of Salluit sculpture.

Kangirsuk

Kangirsuk (Payne Bay) on the west coast of Ungava Bay has forged a reputation as a source of small, quirky, often crudely carved folk-art style stone carvings, dominated by the unique and eccentric style of Thomassie Kudluk (Figure 65). Emphasis is not on realism or the depiction of traditional life but on the more incongruous details and foibles of human existence. The rough grey stone is often blackened with shoe polish.

Kangiqsualujjuaq

Kangiqsualujjuaq (formerly George River) on the eastern shore of Ungava Bay was little known as an art-producing community until the 1970s, when its artists began specializing in antler sculpture. The works range from small spirit and wildlife pieces to antler segments or even entire racks decorated with bas-relief carving of animal themes, as well as ingeniously assembled scenes (Figure 98). Carvers make a special effort to utilize the natural curves and branchlike shapes of antler to lend a sense of movement to their work which, like that of Kangirsuk, has a lively folk-art sensibility.

The Baffin Region

A short time after James Houston's 1951 trip across southern Baffin Island to develop the fledgling carving industry, the Baffin Region became Canada's primary source of Inuit art,

65
Thomassie Kudluk m.
(1910–1989), Kangirsuk
This Man Is Carrying the Naked Woman Home to Make Love 1977
Stone, 12.7 × 19.6 × 4.7
Winnipeg Art Gallery, Ian Lindsay Collection

Kudluk's eccentric, earthy, often self-deprecating humour, apparent not only in his choice of themes but also in his carving style and lengthy titles or inscriptions, often poked fun at human foibles. This quirky carving, less fact than fantasy, is in the tradition of Kudluk works such as *She Says Her Boy Friend Is Always Going to the Pool Hall, and She Is Bringing Him Back.*

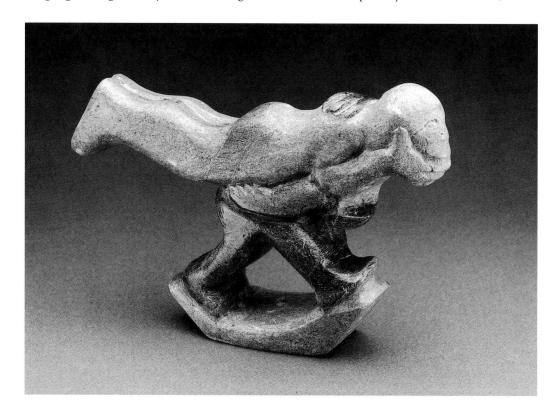

eclipsing both Inukjuak and Puvirnituq.[18] The cultural diversity of this vast area has resulted in a variety of styles, the most famous being those of Cape Dorset and the other southern Baffin communities.

This area boasts the widest variety of high-quality carving stone in the Arctic. The many shades of green serpentine and serpentinite are jadelike in appearance and carvability; the integrity of the stone permits bold use of negative space, thin shapes and high polish. Argillite, marble and other stones are also quarried in the region.

The hallmarks of southern Baffin sculpture, which are evident to a greater or lesser extent across the region, are an elegant and somewhat stylized naturalism, dramatic composition, careful balance, high finish, and a general sense of confidence and flamboyance. In contrast to the sculpture of the Nunavik region, which prides itself on following carving traditions, the art of southern Baffin is marked by experimentation and innovation; themes such as wildlife and mythological subjects appear in a multitude of personal styles. The sculptures of the smaller, far-flung Baffin communities, however, tend to be somewhat more conservative and less refined.

Cape Dorset

James Houston (1979:9–11) recalls that ivory carvers like Osuitok Ipeelee were already famous before his visit to Cape Dorset in 1951. From such promising beginnings, Cape Dorset soon became the Arctic's foremost art community, with its strong, well-managed art projects and co-operative,[19] the energy and talent of independent, competitive and highly professional artists, both male and female, as well as access to beautiful carving stone.[20]

Cape Dorset sculpture is ambitious, perhaps more calculated and self-conscious than art made elsewhere in Canada's Arctic. It is also very much an individual pursuit, and Cape Dorset carvers take pride in their signature styles.

Three generations of carvers have taken their inspiration largely from animal subjects; caribou, bears and delicately carved birds figure prominently, and anthropomorphism is prevalent, with animals adopting heroic or humorous humanlike poses (Figures 66, 67 and 102). Supernatural themes are also popular, incorporating various animal and sometimes human forms fusing and transforming in endless combinations (Figures 68 and 149). In contrast to the sculpture of Nunavik, domestic, family and hunting themes are less important.

Cape Dorset sculptors have not merely taken full advantage of their carving material (chiefly stone), they have stretched the boundaries of what is possible. They take pride in coaxing amazingly thin forms out of stone; these bladelike polished shapes do not merely reflect light, some actually become translucent. Osuitok, who is perhaps the foremost Inuit wildlife sculptor, exerts complete control over his materials, almost defying them to break (Figure 57). Not satisfied with being able to create a perfect likeness, however, he has also experimented with more stylized, slightly abstracted animal and bird forms.

Although some small, intimate works are still produced, most of the important Cape Dorset carvers have worked on a fairly large scale since the 1960s. Their sculptures are bold, dramatic compositions, in which the manipulation of elegant natural form, sinuous line, space and light rival content in importance (Figures 69 and 70). The vibrant and often decorative Cape Dorset drawings and prints are sometimes credited with influencing the community carving style towards a certain linearity. Yet the sculpture is not merely pretty; a strong undercurrent of spirituality saves it from superficiality.

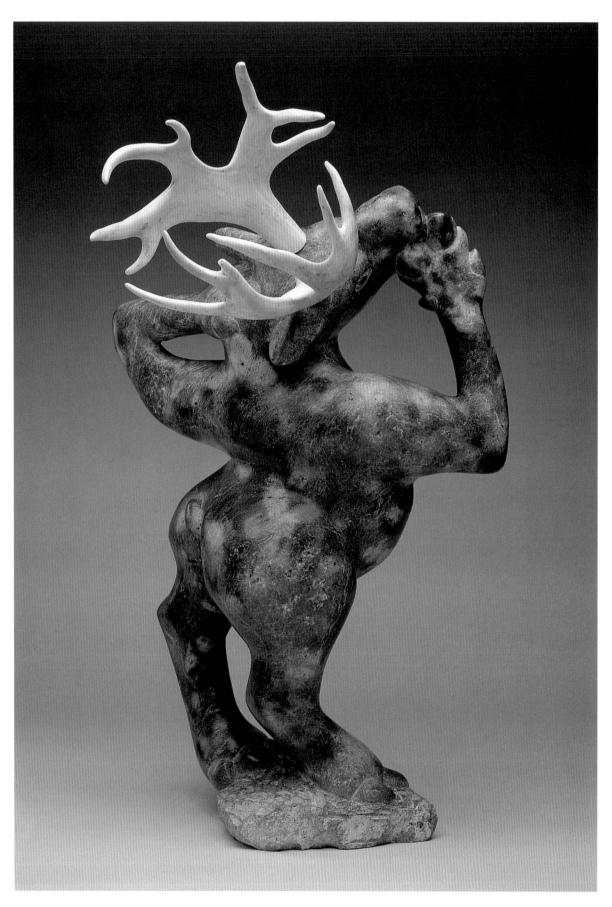

66
Aqjangajuk Shaa m. (born 1937), Cape Dorset
Caribou Standing on Hind Legs, 1984
Mottled grey-green stone, antler, 64.0 × 37.8 × 36
Art Gallery of Ontario, Gift of Samuel and Esther Sarick, 1990

Aqjangajuk's work stands in stark contrast to the sleek elegance of Osuitok's caribou (Figure 57). Aqjangajuk embraces some elements of the Cape Dorset aesthetic—dramatic pose, balance, anthropomorphism—and rejects others. The contorted stance of his caribou is aggressively carved, almost satyrlike in its brutish power.

67
Latcholassie Akesuk m. (born
1919), Cape Dorset
Bird (Owl), 1973
Mottled white stone, 41.6 ×
43.0 × 16.8
Art Gallery of Ontario, Gift of Samuel
and Esther Sarick, 1989

Latcholassie, who inherited his
love of owls from his father,
Tudlik, has the caricaturist's
flair for imparting real person-
ality and humour to his sub-
jects with a minimum of
elaboration. This owl, perhaps
a young chick, is ungainly and
lovable, like so many of his
birds and bird-humans.

68
Kiawak Ashoona m. (born
1933), Cape Dorset
Devil, ca. 1961
Mottled green stone, 37.0 × 21.6 × 13.6
Art Gallery of Ontario, Gift of Samuel
and Esther Sarick, 1989

Kiawak became known in the
early 1960s for his carvings of
demonic figures. While many
have a ferocious, gargoylelike
appearance, others are more
whimsical. The head of this
figure is detachable and mov-
able; the fact that you can "play"
with the head and give it a
quizzical tilt makes the crea-
ture less threatening.

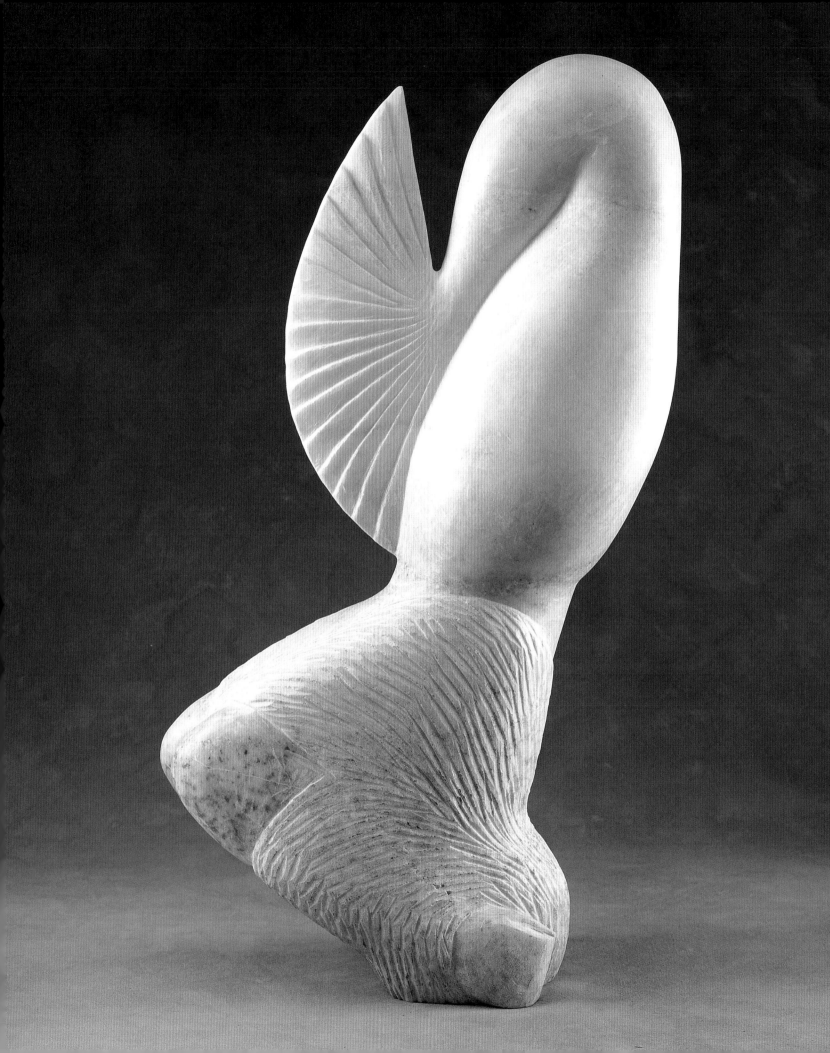

69 (facing page)
Oviloo Tunnillie f. (born
1949), Cape Dorset
Taleelayu, 1994
White marble, 68.0 × 38.0 × 14.0
National Gallery of Canada

Oviloo presents the sea god-
dess Taleelayu in an unusual
diving pose that is at once
modest and sensuous. While
her face is hidden, her wet hair
parts to reveal flushed, volup-
tuous breasts (fitting for the
giver of life). Taleelayu flexes
her lower, sea mammal body
of gleaming white marble, dis-
playing her bladelike, fan-
shaped tail.

70
Iyola Kingwatsiak m. (born
1933), Cape Dorset
Bird, 1981
Mottled dark grey-green stone, 55.3 ×
22.9 × 18.0
Art Gallery of Ontario, Gift of Samuel
and Esther Sarick, 1990

Cape Dorset sculptors have a
flair for combining naturalism
with dramatic and theatrical
composition. While marvelling
at the beauty of Iyola's bird,
we are also seduced by its ele-
gant, somewhat stylized forms.
Perhaps returning to the sur-
face after a dive, the body
of this bird has the languid
fluidity of fronds of seaweed.

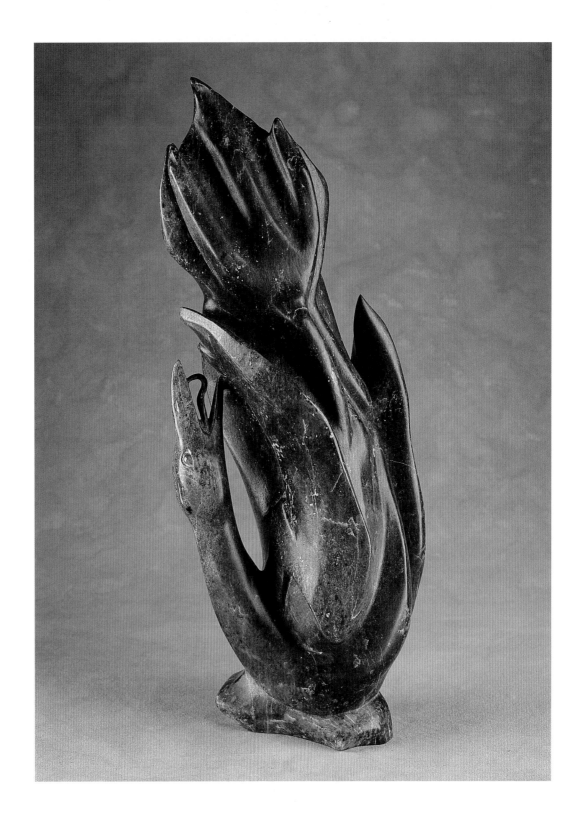

71
Davidee Itulu m. (born 1929),
Kimmirut
Incised walrus tusk, 1964
Ivory with colouring and green stone,
53.4 × 11.0 × 9.4
National Gallery of Canada, Gift of
M. F. Feheley, Toronto, 1988

Itulu carries on the venerable
scrimshaw tradition in a con-
servative, naturalistic style little
changed for decades. Innovation
is not important; the careful ren-
dering of Baffin Island clothing
and the realistic poses are.
Although scrimshaw pieces are
three-dimensional objects, their
art is one of engraving, not
carving.

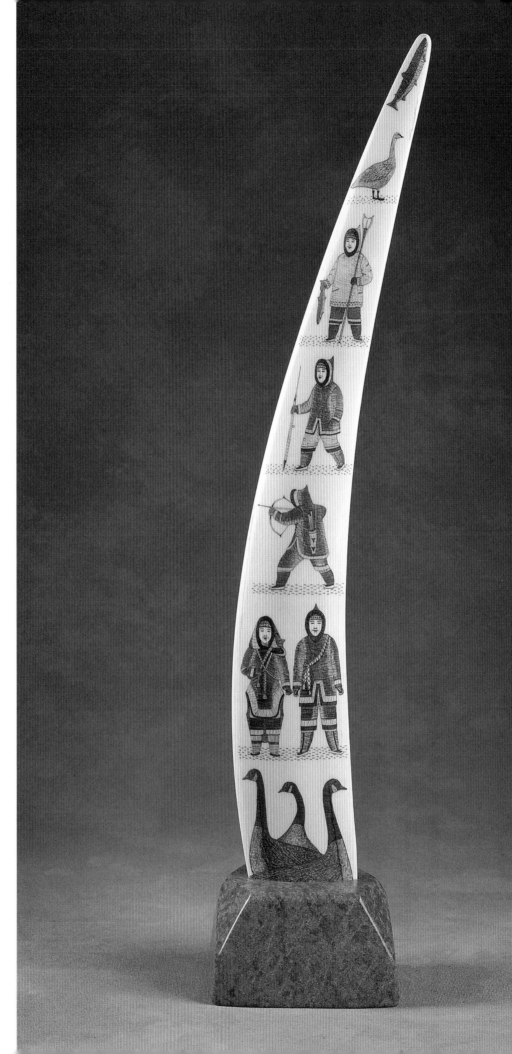

Kimmirut

Kimmirut (formerly Lake Harbour) was the site of one of south Baffin's thriving whaling stations in the nineteenth century, and many Inuit who worked at or lived near the station traded ivory carvings to the newcomers. The community's fame as an ivory-carving centre extended into the late 1940s, when the presence of American military personnel in neighbouring Iqaluit provided a ready market that necessitated the regular importation of ivory from other places. Some works recall that of late Historic times (Figure 71), but in the mid-1960s Kimmirut earned a new reputation for the naturalistic carving of animals and spirit beings (Figure 72).

72
Shorty Killiktee m.
(1949–1993), Kimmirut
Spirit with Young, 1969
Mottled green stone, ivory, 24.5 ×
14.3 × 14.4
Art Gallery of Ontario, Gift of the
Klamer Family, 1978

Killiktee has paraphrased the familiar mother-and-child theme to create a pair of likable devils. Note the curious inverted claws; possibly the artist experimented with a way to avoid the tedious insetting process. An accidental break in the stone might have inspired him to rework the left leg into its amusing scratching pose.

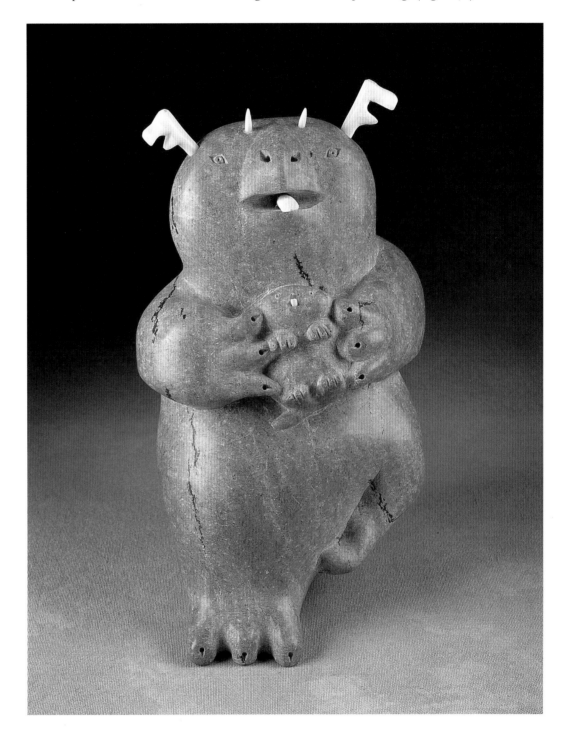

Pangnirtung

Pangnirtung, located on Cumberland Sound just south of the Arctic Circle, has, like Kimmirut, a long history of carving production due to the booming whaling industry in the region. Later, an "industrial home" established by the Anglican Church in the 1930s encouraged its elderly and infirm residents to produce carvings and handicrafts for sale. Today, Pangnirtung is recognized both for its heroic realism in the southern Baffin style and for its dynamic spirit sculptures. Although carvers work in both stone and bone, their work in whalebone has attracted the most attention (Figure 74).

Arctic Bay

Arctic Bay on northern Baffin Island produced little sculpture until the 1950s. The artists in this community utilize a fine-grained, striated grey argillite much like the Sanikiluaq stone. In the 1960s, Arctic Bay was known for its art in both argillite and whalebone—modest, naive works with simple lines, yet direct and even moving, depicting everyday life and animals (Figure 73). Carving has declined since the opening in 1974 of the nearby Nanisivik lead-zinc mine; on the other hand, the mine provided much-needed wage employment for local Inuit. Manasie Akpaliapik, one of the pre-eminent post-contemporary Inuit sculptors (Figures 56 and 109), was raised in Arctic Bay but now lives in southern Ontario.

Igloolik

Igloolik, separated from Baffin Island by the Fury and Hecla Strait, enjoys a reputation as a bastion of traditional Inuit culture but has produced art in quantity only since the late 1970s. When stone imported from north Baffin Island is not available, Igloolik artists content themselves with carving the coarse grey local stone, as well as bone. Themes vary from hunting scenes to mythological subjects, and they are carved with a gritty realism (Figures 26 and 42).

Sanikiluaq

Sanikiluaq is a community on the Belcher Islands in Hudson Bay, and its carvings resemble those of its Nunavik neighbour, Kuujjuaraapik, at least as much as they do the art of any Baffin community.[21] Carved in the local beautiful fine-grained green to black argillite, a stone that takes well to cutting, polishing and delicate incising, Sanikiluaq sculptures are usually small, with streamlined curves and crisp edges. Long dominant in the Inuit souvenir carving industry, Sanikiluaq produces large quantities of pleasant but unremarkable figures of seals, walrus and especially the many species of birds that inhabit or migrate to the Belcher Islands. The thriving tourist market has perhaps prevented Sanikiluaq artists from creating many challenging works, but some remarkable examples do exist (Figure 107). Sanikiluaq has also produced beautiful, unusual spirit pieces.

The Keewatin Region

The Inuit of the Keewatin Region are made up largely of former inland Barrenland or Caribou Inuit who now live in coastal communities along western Hudson Bay and inland at Baker Lake. While some of the coastal groups (the most northerly of which are more closely related to the Iglulingmiut) developed early and steady contact with whalers and other foreigners, the inland bands were considerably more isolated. Keewatin Inuit have endured more than their share of disease and famine; in the 1920s, Rasmussen's Fifth Thule Expedition reported

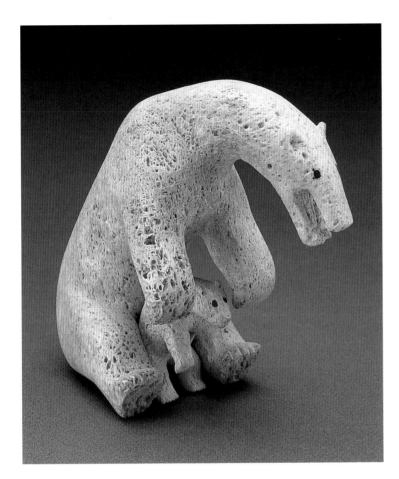

73 (left)
Elisapee Kanangnaq Ahlooloo
f. (born 1918), Arctic Bay
Bear Protecting Her Cub, 1960
Whalebone, 14.8 × 6.0 × 13.5
Winnipeg Art Gallery

Arctic Bay whalebone carvings,
modest and unpretentious in
their simplicity, can be pro-
foundly moving. Not just the
ancient whalebone but also
the work itself seems to have
a patina of age. The fact that
Inuit believe polar bears are
much like humans seems a
cliché, until a reminder such
as this.

74 (right)
Davie Atchealak (born 1947),
Pangnirtung/Montreal
Drummer, 1974
Whalebone, green stone, antler,
scraped sealskin, sinew, 66.5 × 31.5 ×
28.5
National Gallery of Canada

The drum, the only traditional
Inuit musical instrument, is
built like a large tambourine,
and is struck on its rim with a
hide-covered stick. Atchealak's
figure is stripped to the waist
because a good drummer exerts
himself by dancing and yelping
or whooping as he drums.
The style of heroic realism suits
the theme perfectly.

that almost 20 per cent of the population had starved to death because of shifting caribou migrations. The inland Caribou Inuit were finally resettled by the federal government in the 1950s because they were starving once again, as well as suffering from diphtheria and tuberculosis.[22]

These severe hardships may have influenced the Keewatin aesthetic, which tends to strip away detail, working with and even accentuating the stone's hardness, mass and texture. Occasionally soft but generally quite obdurate, much of the grey to black local stone does not lend itself to detail or a high finish, so there is an inclination to "let the stone be" and allow it to follow its natural shape. Yet there is a great variety of styles: some artists create rugged, even crude, expressionistic sculptures; others carve pristine, almost minimalist forms.[23]

The human figure, alone or in family groupings, is the principal theme. Keewatin subject matter is less recognizably "Inuit" and hence more universal, but animals, transformational themes and mythological subjects play a significant role as well, especially in Baker Lake. Even when Keewatin sculpture is more realistic, it is still sparing in detail.[24]

Rankin Inlet

The community of Rankin Inlet grew up around a nickel mine which flourished briefly before closing in 1962. The promise of wage employment had drawn Inuit to the village, and arts and crafts production intensified when the mining jobs disappeared.[25] As a regional administrative and commercial centre, Rankin Inlet has attracted numbers of non-Inuit workers and visitors who, like their Historic Period predecessors, favour hunting and animal themes in a strongly naturalistic vein. Consequently, there is pressure for artists to carve for this local market.

Two artists who chose a rather more idiosyncratic path, and who are now considered as the community's greatest talents, are John Tiktak and John Kavik. Tiktak, injured in a mining accident in 1959, began carving regularly in the early 1960s. Although he occasionally carved single figures, his two obsessions were the mother-and-child theme and the human face.[26] Stylistically, his work ranges from the serene and elegantly simple (Figure 75) to the stark and almost brutal (Figure 76). Like Tiktak, Kavik reworked the themes of the human figure and mother and child endlessly. Kavik's carving style is consistently cruder, however, as well as more direct and energetic (Figures 77 and 78).

A ceramics project was introduced to Rankin Inlet in 1963, under the guidance of Claude Grenier, and stone carvers and others experimented in the new medium until 1975. Rankin ceramics were built up using the coil method and were frequently conceived as sculptures rather than as functional vessels (Figure 79). Although some truly exceptional work was produced, problems with kilns, marketing, transportation and government support proved to be insurmountable. However, ceramic art has been revived in the 1990s with a new generation of artists.[27]

Arviat

The community of Arviat (formerly Eskimo Point) is made up mostly of Inuit from the inland Iharmiut and Pallirmiut bands who were evacuated to the west coast of Hudson Bay in the late 1950s. Carving production commenced in the early 1960s, and artists soon earned a reputation for their distinctive, rugged style. Arviat stone sculpture, while dealing almost exclusively with family and maternal themes, possesses perhaps the least "naturalistic" style in all of Inuit art.[28]

75
John Tiktak (1916–1981),
Rankin Inlet
Mother and Child, 1966
Dark grey stone, 48.0 × 21.0 × 12.0
Art Gallery of Ontario, Gift of David and Moiya Wright, 1990

George Swinton's (1966) comparison of Tiktak to the British sculptor Henry Moore is apt, particularly for this piece, arguably the greatest work by a Canadian sculptor. Here Tiktak's instinct for pure form meets content (mother and child) in profound harmony. The mother's head is large, her legs short; yet not one line or volume or cavity seems out of place. As in Qaqaq's *Bust of a Woman* (Figure 47), every shape has meaning.

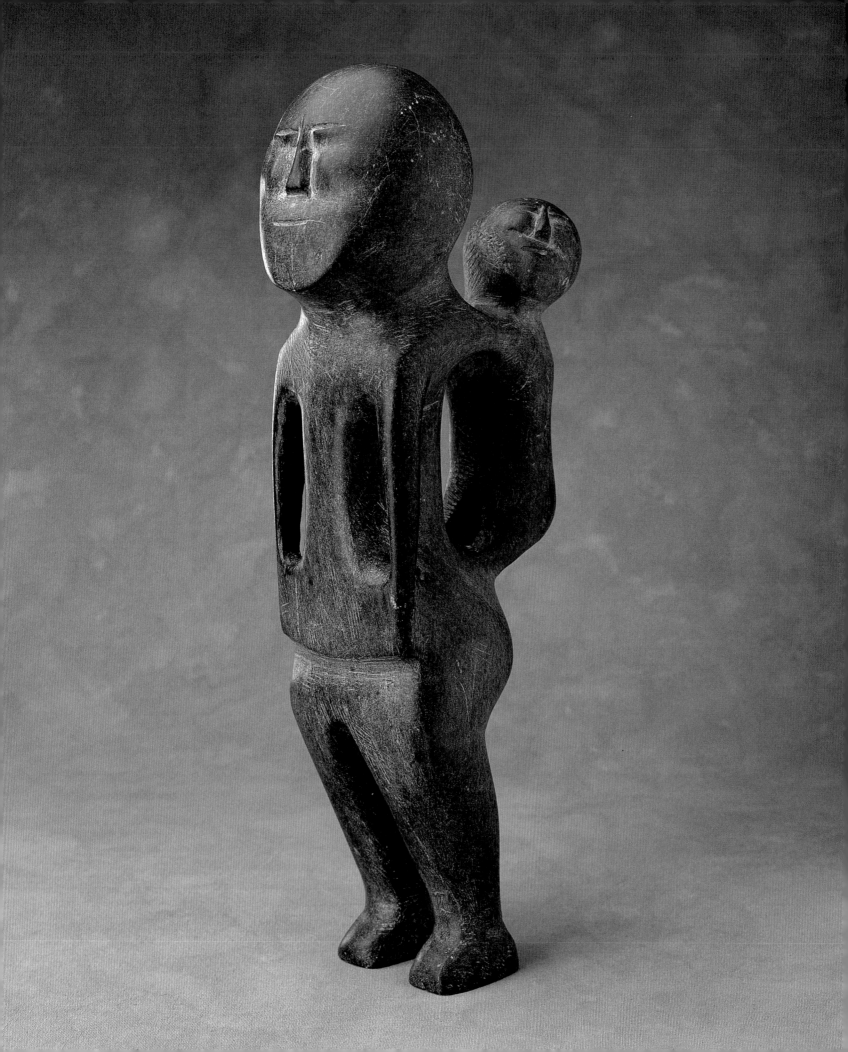

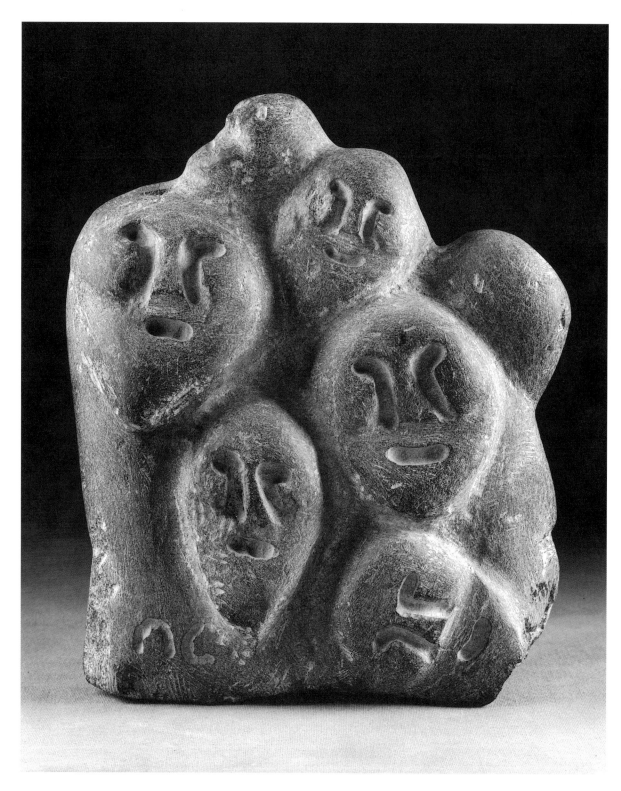

76
John Tiktak (1916–1981),
Rankin Inlet
Faces, 1973
Grey stone, 28.5 × 24.3 × 14.0
Art Gallery of Ontario, Gift of the
Klamer Family, 1978

Later in his career, Tiktak sup-
plemented his favourite sub-
jects of mother and child, the
human head and single human
figure with a new theme: the
head cluster, often carved in a
cruder, more expressionistic
style. Though not derivative,
these are hauntingly evocative
of prehistoric Dorset antler
wands (Figure 9). Note
Tiktak's syllabic signature at
bottom left.

77 (facing page)
John Kavik (1897–1993),
Rankin Inlet
Mother and Child, 1971
Dark grey stone, 23.2 × 12.1 × 9.5
Winnipeg Art Gallery, Swinton
Collection

Never pretty, Kavik's rugged
works are among the most
powerfully evocative in Inuit
sculpture. He roughly cut and
gouged the stone with saws,
chisels and files, leaving many
tool marks. There is no senti-
ment in his art, but much vis-
ceral emotion. Is the child
dead? This mother and child is
like a raw and elemental *Pietà.*

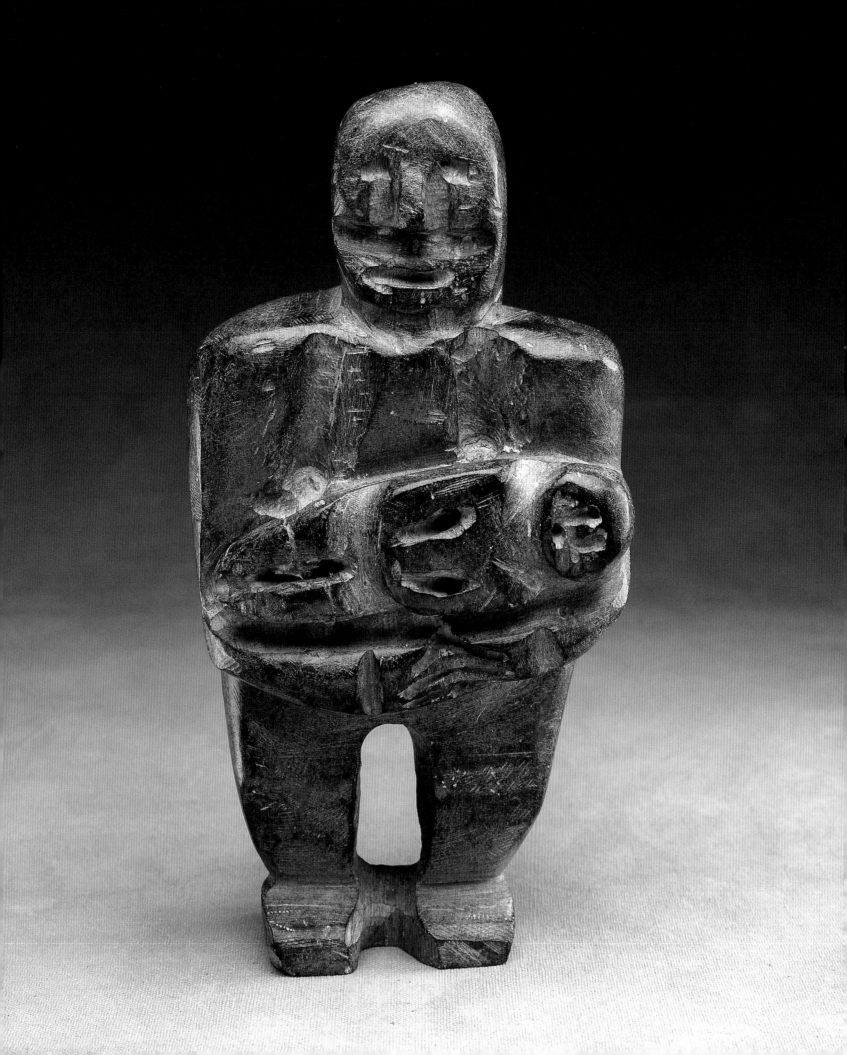

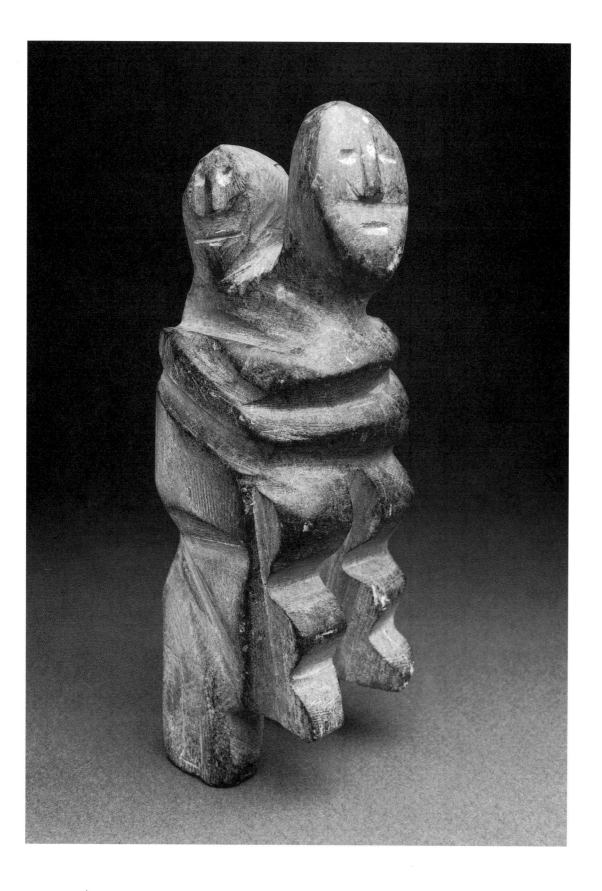

78
John Kavik (1897–1993),
Rankin Inlet
Two Figures, 1971
Dark grey stone, 13.8 × 6.0 × 5.0
Art Gallery of Ontario, Gift of the
Klamer Family, 1978

A woman is carrying another
adult, perhaps a grown child,
perhaps a husband or parent: it
is hard to tell. Like much of
Kavik's work, the scene evokes
a visceral response. The cutting
and filing of the expressive
zig-zag shapes, as well as the
faces, suit the subject. Even
without knowing the details of
the theme, we know it
expresses hardship.

79 (facing page)
Eli Tikeayak (born 1933),
Rankin Inlet
Untitled (Four Figures and a Dog),
ca. 1968
Red clay, shoe polish, 15.9 × 16.5
Musée canadien des civilisations/
Canadian Museum of Civilization,
Gift of the Department of Indian
Affairs and Northern Development

The initial decade-long ceram-
ics project in Rankin Inlet
failed because of technical and
logistical problems, but
spawned some fascinating
experimental works. Using the
coil method, artists built up
sculptures rather than vessels,
for the most part; Tikeayak's
relief may depict the building
of an igloo.

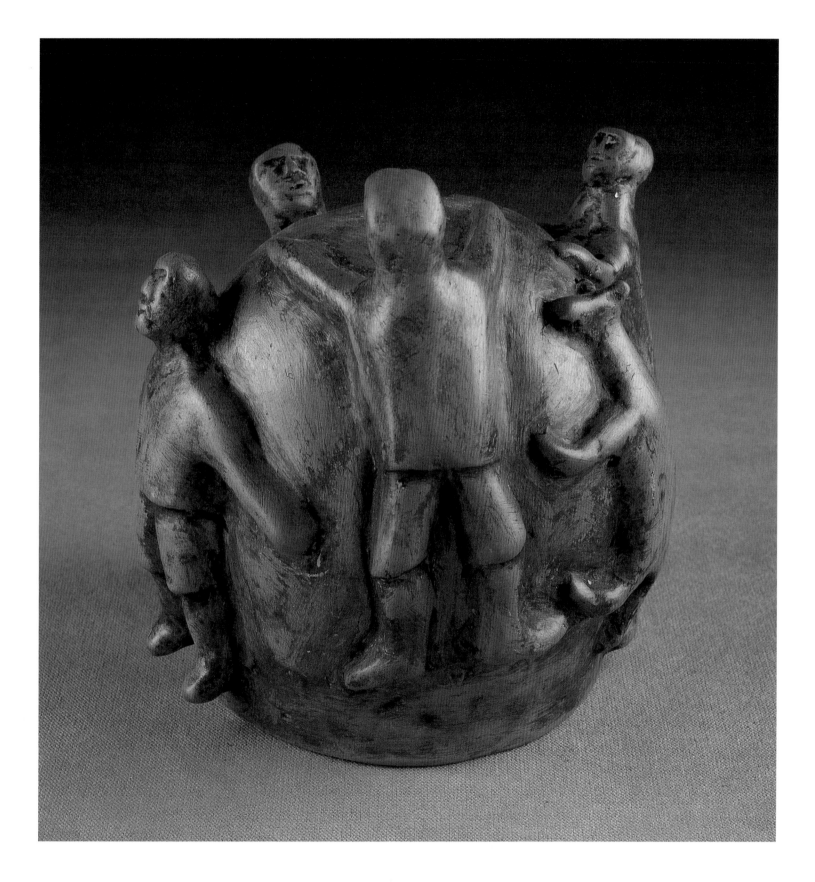

Details of anatomy and clothing are usually stripped away so that some works seem to be almost abstract in form (Figure 81). Arviat carving ranges from raw primal forms (Figure 104) to the elegant but pared-down, almost "minimalist" forms of John Pangnark (Figures 58 and 103), an artist who has been compared to the European sculptor Brancusi. Singled out as a unique talent by some critics and curators, Pangnark was, however, little appreciated in his lifetime. He is perhaps the most extreme example of a phenomenon found throughout Inuit art—the artist who works a particular theme again and again to explore its gestural and formal possibilities.

The tough, dark grey Arviat stone resists detailed work, and sculptures usually bear the marks of axes and files. Even when softer stone is found and utilized, many artists take advantage of the opportunity to simplify sculptural form rather than elaborate it (Figure 82), although others strive to an unusual degree (for Arviat) to depict naturalistic detail and poses (Figures 52 and 80). The mood of Arviat stone sculpture is serious, even sombre; emotional power is enhanced rather than diminished by the absence of detail or decoration.

Arviat antler carvings, on the other hand, are quite playful and homespun in spirit; they are generally constructed out of several elements glued or pegged together. Antler carvings also explore a greater variety of themes, including shamanism and hunting (Figure 99). A high percentage of Arviat stone sculptors are female, but antler carvings are produced mostly by men.

80
John Attok (1906–1980),
Arviat
Mother Nursing Child, 1967
Dark grey stone, 18.2 × 18.4 × 14.6
Art Gallery of Ontario, Swinton
Collection, Gift from the Volunteer
Committee Fund, 1990

Attok, like Uyauperq (Figure 52) opted for comparative realism in his work. This nursing mother, though her expression is somewhat dour, exudes plump well-being, and is a far cry from Nutaraluk's mother (Figure 104), who seems to be pleading for her daughter's life or mourning her death.

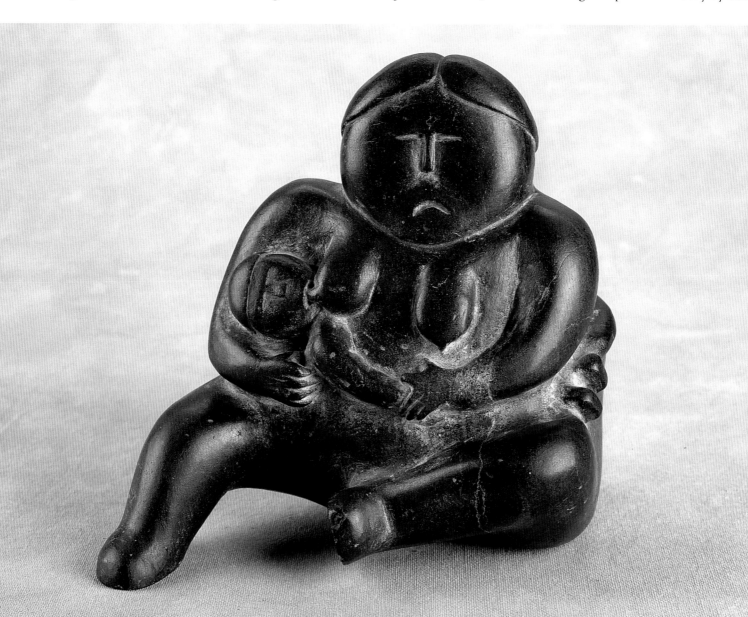

81 (top)
Lucy Tasseor Tutsweetok (born 1934), Arviat
Faces with Igloos, 1971
Grey stone, 47.0 × 15.8 × 27.8
Winnipeg Art Gallery, Twomey Collection, with appreciation to the Province of Manitoba and the Government of Canada

Tasseor, whose aesthetic resembles Pangnark's, focusses on the larger themes of family and community; hence, she cannot reduce form as radically as he did. Working very much with the existing surfaces and edges of the stone, Tasseor aligns heads and faces; usually the face and perhaps a protective arm of the mother dominates the image.

82 (bottom)
Andy Miki (1918–1983), Whale Cove/Arviat
Dog, 1960–64
Dark grey stone, 7.0 × 16.3 × 4.2
Musée canadien des civilisations/ Canadian Museum of Civilization, Gift of the Department of Indian Affairs and Northern Development

One of the great Arviat artists, Miki began carving seriously in neighbouring Whale Cove. At first he made elegant little figures in the round, but later became famous for his almost two-dimensional "cookie cutter" semi-abstractions. Carving single animals exclusively, he frequently simplified their forms into pristine geometric shapes.

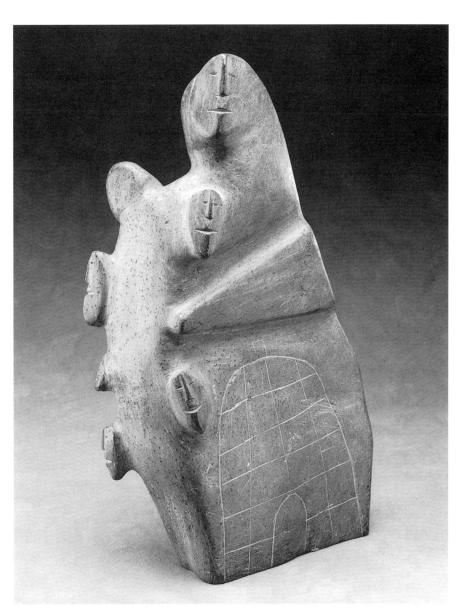

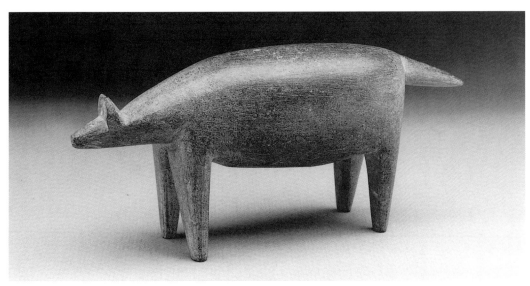

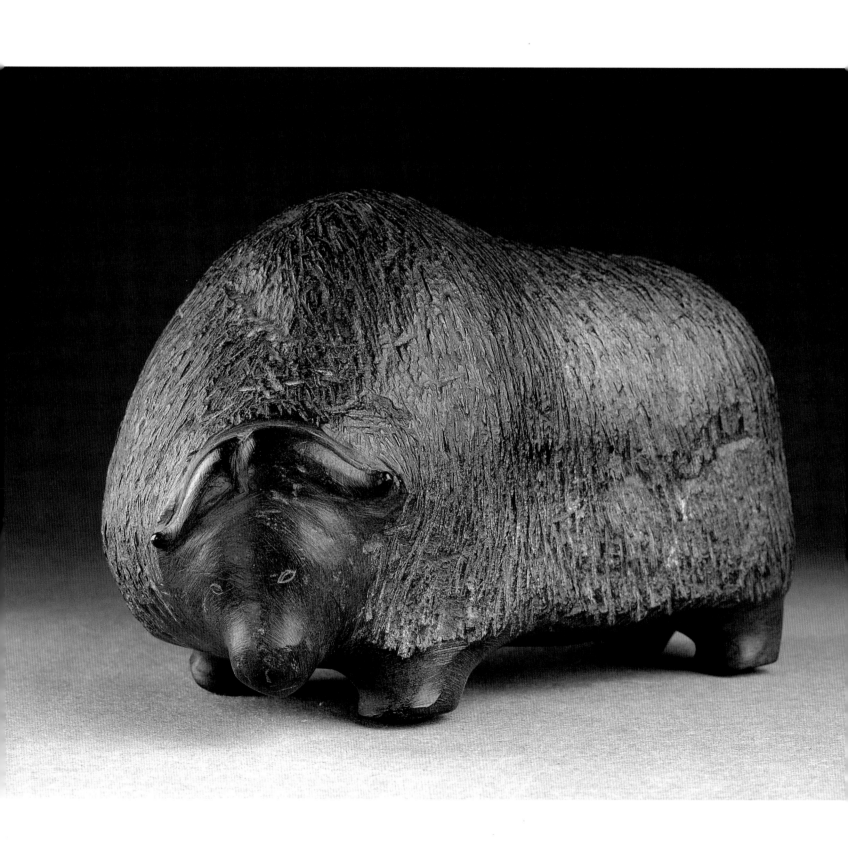

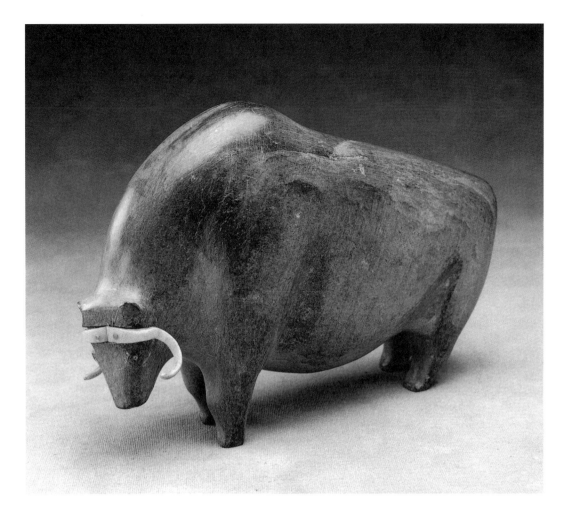

83 (facing page)
Barnabus Arnasungaaq (born 1924), Baker Lake
Muskox, 1974–75
Dark grey stone, 13.0 × 20.7 × 11.9
Art Gallery of Ontario, Gift of Samuel and Esther Sarick

The muskox (*umingmak,* or "bearded one") is a compact, massive, woolly animal related to wild sheep and goats. When shedding its winter undercoat, the muskox looks even shaggier. The heavy textural treatment concentrates attention on the muskox's coat without losing the sense of its bulk. The polished horns are a perfect foil to the texture.

84
George Tataniq (1910–1991), Baker Lake
Muskox, 1963
Stone, antler, 13.8 × 22.0 × 6.2
Winnipeg Art Gallery, Twomey Collection, with appreciation to the Province of Manitoba and the Government of Canada

In contrast to Arnasungaaq's muskox (Figure 83), Tataniq's is elegantly, even pristinely carved. Not "anatomically correct," it is simplified and streamlined instead. Arnasungaaq emphasizes shagginess, Tataniq, grace. In fact, Tataniq shares his aesthetic more with the unidentified Historic Period artist who carved the ivory muskox in Figure 16.

Baker Lake

Inuit began moving to Baker Lake, the only inland community in Canada's Arctic, in the late 1950s, forced to relocate there from the surrounding river systems because of starvation and disease. Baker Lake achieved artistic prominence quickly; by the mid-1960s, some two hundred of the five hundred inhabitants were carving. Artists work on a medium to large scale in the local dark grey to black stone which, although hard, generally accepts detail and polish. While most carvers accentuate the stone's mass and volume, their style is nonetheless considerably more naturalistic than that of their Arviat colleagues. Many Baker Lake sculptures have a massive, powerful presence because of their very size and bulk, but much of their energy seems pent up within the sculptural form. Peter Sevoga's *Family Group* (Figure 53) epitomizes the Baker Lake aesthetic, which contrasts the elemental power of the stone with a sensitivity of line and form, and even a certain delicacy of detail.

Baker Lake carvers explore family, hunting, animal, spiritual and mythic themes. The muskox, a favourite subject, is portrayed in a variety of ways. One approach is to accentuate its bulk and the texture of its shaggy coat (Figure 83); another presents the animal in a far crisper, more elegant manner (Figure 84). The keen interest in the close metaphysical relationship between animals and humans is evident in the number of transformation images (Figures 34 and 38). Perhaps 10 to 20 per cent of the carvers are women; they tend to work on a more modest, intimate scale and seem to be more interested than the men in depicting scenes from mythology (Figure 44).

In stark contrast to the massive black stone sculptures of Baker Lake, Luke Iksiktaaryuk's works in antler achieve an ethereal, otherworldly quality because of their slender shapes and their predominantly spiritual themes (Figure 85).

Central Arctic: Miniature Carving

In the late nineteenth century, the northwest coast of Hudson Bay became a key centre of miniature ivory and stone carving. Roes Welcome Sound, a narrow strait between the Keewatin mainland and Southampton Island, was a particularly rich whaling ground, and Inuit from the region (especially Repulse Bay) worked for and traded with whalers and explorers. In the twentieth century, the Inuit of Chesterfield Inlet and Repulse Bay in the Keewatin, and their neighbours from Pelly Bay (in the Kitikmeot Region, 300 kilometres/185 miles northwest overland from Repulse Bay), were encouraged by Roman Catholic missionaries to produce large quantities of ivory miniature models and figures.[29] Ivory miniatures (as well as modest works in stone and antler with a similar sensibility) are still carved in the region, harking back to the unassuming models and trinkets of the Historic Period.

Work on a very small scale is quite appealing, as it appears to be carved with greater finesse than other sculpture. While a miniature figure does require more dexterity and careful cutting, the details are not usually more precise, but are simply smaller. In fact, details are often simplified, resulting in a streamlining of form (Figure 86) or sometimes a certain "precious crudeness (Figure 87)." Ivory as a material lends itself to precision carving and has an intrinsically precious quality that enhances the overall effect of a miniature.

Repulse Bay

Although Repulse Bay, situated at the base of the Melville Peninsula, falls within the Keewatin Region politically, culturally it is related to the Iglulingmiut groups to the north.[30] Artistically, its roots are very much in the late Historic Period, influenced by decades of contact and trade with whalers.[31] In the 1940s and 1950s, due to significant encouragement from missionaries and sympathetic Hudson's Bay Company post managers, Repulse Bay artists produced small animal and human figures as well as constructing ivory, stone and antler tableaux (Figures 18 and 86). Swinton (1978:29) is right to suggest that the relatively stiff poses in the small-scale carvings, which adds to their playful and homespun charm, do not lend themselves to magnification.

Repulse Bay subject matter focusses on camp and hunting scenes (Figure 32), with considerable animal-human interaction but few overt references to shamanism or traditional spiritual beliefs. One well-known artist, Mark Tungilik, learned to carve ivory as a young man in nearby Pelly Bay, creating both traditional and Christian imagery.[32] He later moved to Repulse Bay and became famous for his quirky "micro-miniature" ivory depictions of people, animals and spirits (Figure 87).

Pelly Bay

Pelly Bay, a small village west of the Melville Peninsula, was almost completely insulated from the outside world until 1955 when its DEW Line site was built; even then, ice jams at the mouth of the bay made the community inaccessible by sea. An airstrip was constructed only in 1968, and many Inuit families did not settle in the community permanently until the early 1970s. An Oblate missionary, Father Franz Van de Velde, the only white resident in the community

85
Luke Iksiktaaryuk
(1909–1977), Baker Lake
Bird Shaman, ca. 1974
Antler, stone, caribou skin, metal, 71.0
× 41.0 × 28.5
Winnipeg Art Gallery, Peter Millard
Collection, Gift of Peter Millard

The caribou was vital to the survival of Keewatin Inuit, and Iksiktaaryuk, unlike his Baker Lake peers, works with the expressive shapes of caribou antler to create images of shamanic flight. In this transcendental piece, the shaman, wearing his amulet belt, soars to another world even as his feet are still rooted to the ground.

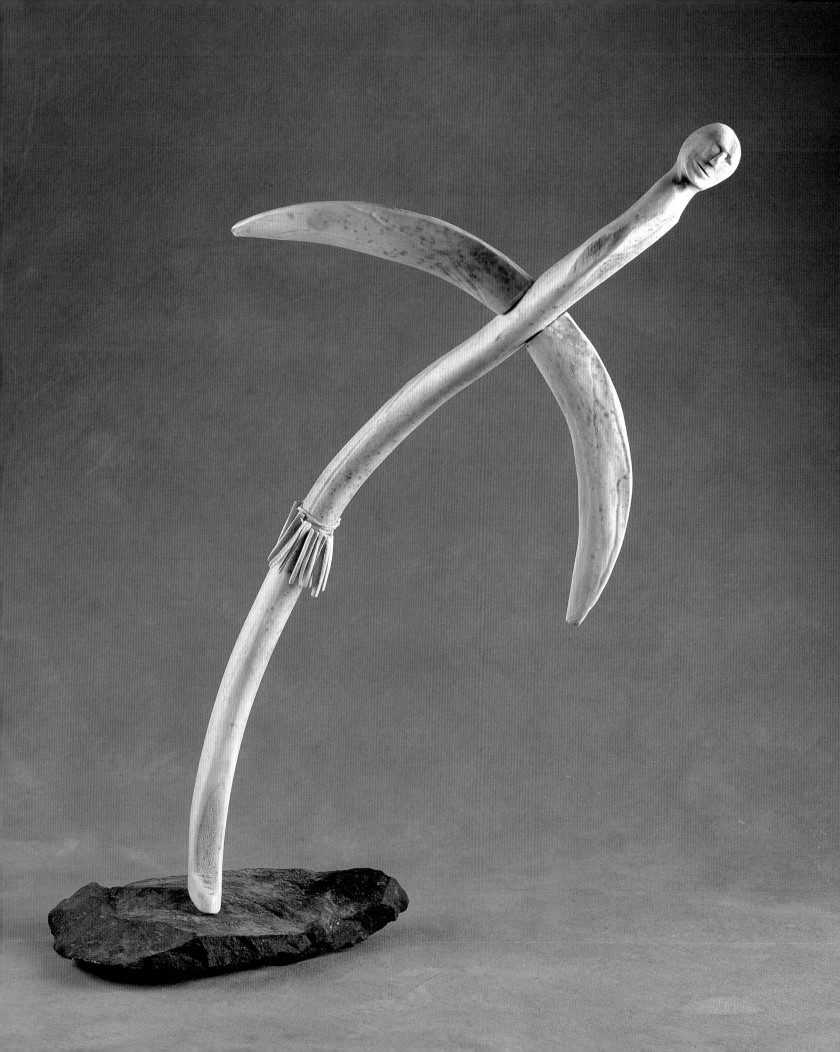

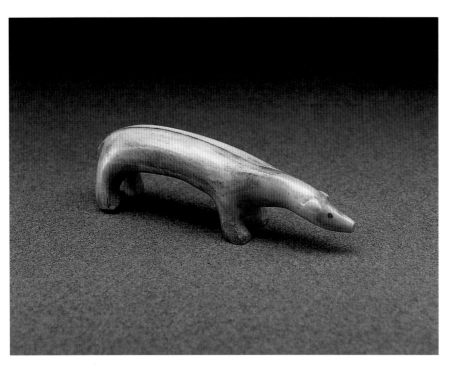

86
Lucie Angalakte Mapsalak
(born 1931), Repulse Bay
Bear, 1954
Ivory, 1.7 × 5.5 1.4
Art Gallery of Ontario, purchased
with the assistance of the Joan
Chalmers Inuit Art Purchase Fund,
1990

This work sits squarely
between two eras, the Historic
and contemporary, and illus-
trates why it is not always easy
(or advisable) to categorize
Inuit art too much by style or
period. Angalakte's "early con-
temporary" work was not a
harbinger of things to come,
but rather carried on a commu-
nity style of miniature carving
rooted in decades of tradition.

87
Mark Tungilik (1913–1986),
Repulse Bay
Totem of Faces, ca. 1980
Ivory, grey stone, 5.3 × 1.4 × 1.3
Art Gallery of Ontario, Gift of Samuel
and Esther Sarick, 1988

Tungilik began carving for
missionaries in the late Historic
Period. His "micro-miniatures,"
with their human heads and
figures measuring just millime-
tres in height, are remarkable
not only for their size and
detail but also for their sculp-
tural strength and spiritual
intensity. Towards the end of
his life, he wore two pairs of
eyeglasses while working.

between 1945 and 1961, strongly encouraged the production and marketing of ivory miniatures and scenes.[33] Like their Repulse Bay counterparts, Pelly Bay miniatures invite close inspection, literally drawing us into their little worlds. Works like Agnes Iqqugaqtuq's *Man and Woman with Dog Team* (Figure 88) are conceived more as models than as high art and are best appreciated with that modest aim in mind.

88
Agnes Nulluq Iqqugaqtuq
(attrib.) (born 1930), Pelly Bay
Man and Woman with Dog Team,
1967
Black stone, ivory and sinew, 11.0 ×
22.0 × 21.0
Art Gallery of Ontario, Gift of Samuel
and Esther Sarick, 1989

Miniatures are not only modest in scale, they are usually modest and fairly conservative in their goals as well. Sometimes they speak to the human condition, communicate ideas about Inuit spirituality, or astound with their beautiful forms or technical brilliance. But on the whole, they just try to tell a story or show a "slice of life."

Eastern Kitikmeot (Netsilik) Region

> It is a perilous visible world controlled by unreliable supernatural beings that is most characteristic of the Netsilik world view, a world of double danger.
>
> —ASEN BALIKCI, ANTHROPOLOGIST (1970:212)

The Inuit who live in the three communities of the eastern Kitikmeot Region—Taloyoak, Gjoa Haven, and Pelly Bay[34]—are primarily Netsilingmiut, or "People of the Seal." These Inuit were the last to be touched by Western civilization, having been unaffected by whaling in the last century and less influenced by the fur trade in this one. Apart from ivory miniature production in Pelly Bay, a carving industry did not develop until the late 1960s. When Kitikmeot sculpture did reach the south, it was immediately apparent that the ancient Netsilik belief system had substantially survived the population's conversion to Christianity. Depictions of shamans, spirits and mythical beings were not the exception but the rule. Fashioned primarily out of whalebone, that most expressive and suggestive of carving materials, Kitikmeot sculptures surprised, delighted and shocked the art world with their fantastic, surreal forms. Kitikmeot sculpture does not merely hint at supernatural content as much Inuit art does, it actively explores and celebrates it; the "double danger" of the visible world and the spirit world is deftly combined with Inuit humour, in all its earthiness and irony. Kitikmeot sculpture balances serious psychological impact with a lively exuberance.

Taloyoak

The community of Taloyoak (formerly Spence Bay) on the Boothia Peninsula is a blend of Netsilingmiut with a few Baffin Island (mostly Cape Dorset) families who were experimentally relocated by the Hudson's Bay Company in the 1930s and 1940s. Whalebone sculptures were first made here in 1968, encouraged by a southern sculptor contracted by the Government of the Northwest Territories.

Of the Inuit artists singled out as special talents, Taloyoak's Karoo Ashevak was destined to become the most famous, with solo exhibitions in Toronto, Montreal and New York. Tragically, his brilliant career was cut short when he and his wife perished in a house fire in 1974.[35] Karoo's work appealed instantly to those outside the established Inuit art market. His fabulous, bizarre "surreal" constructions in whalebone (Figures 89 and 90), meticulously carved and augmented with contrasting details in other materials, explored his private world of dreams and the spirit world of the Netsilik, but somehow struck a universal chord and seemed to transcend popular notions about what constituted Inuit art. Karoo's influence, which increased after his much-publicized New York show, is still strongly felt across the Kitikmeot region. A few artists have copied his style directly, but many more have adopted his playful, experimental approach to depicting shamanism and the spirit world (Figure 35). Even those Taloyoak artists who carve mostly in stone reveal a marked expressionistic quality in their work (Figure 91).

Gjoa Haven

Gjoa Haven, named after the explorer Roald Amundsen's ship, the *Gjoa*, is situated on King William Island.[36] This fast-growing but traditional Netsilik village has absorbed Inuit from several surrounding communities. Gjoa Haven carvings from the early 1970s, with their charming naiveté of conception and execution, have been compared with the earliest contemporary works from Inukjuak and Puvirnituq (Lindsay 1974).

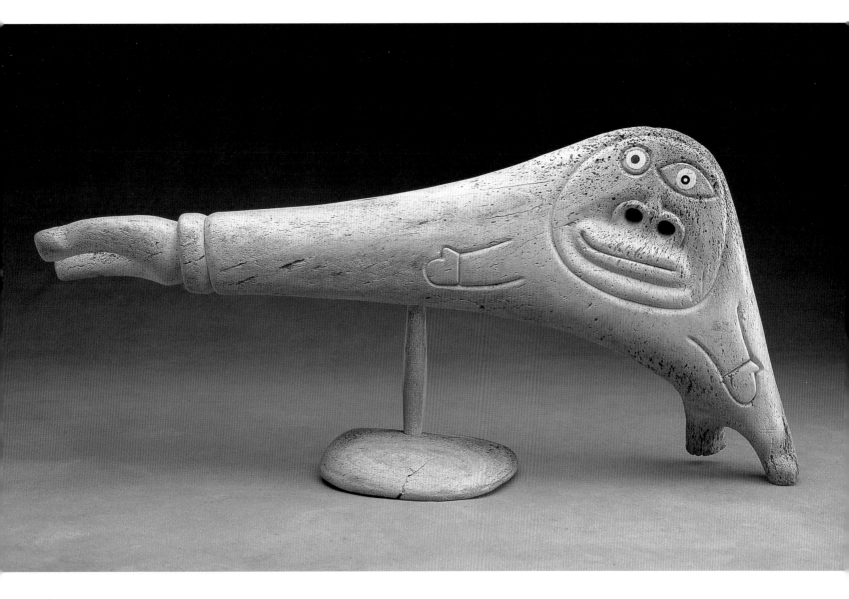

89
Karoo Ashevak m.
(1940–1974), Taloyoak
Spirit Figure, ca. 1972
Whalebone, antler, ivory, black stone,
37.5 × 78.8 × 15.5
Art Gallery of Ontario, Gift of Samuel
and Esther Sarick, 1996

The physical qualities of
whalebone have inspired many
Kitikmeot sculptors, but none
has surpassed Karoo's instinc-
tive understanding of its formal
possibilities or has his combi-
nation of technical skill and
ingenuity, spirituality and intel-
ligent humour. His work
inspired an entire generation of
Kitikmeot artists.

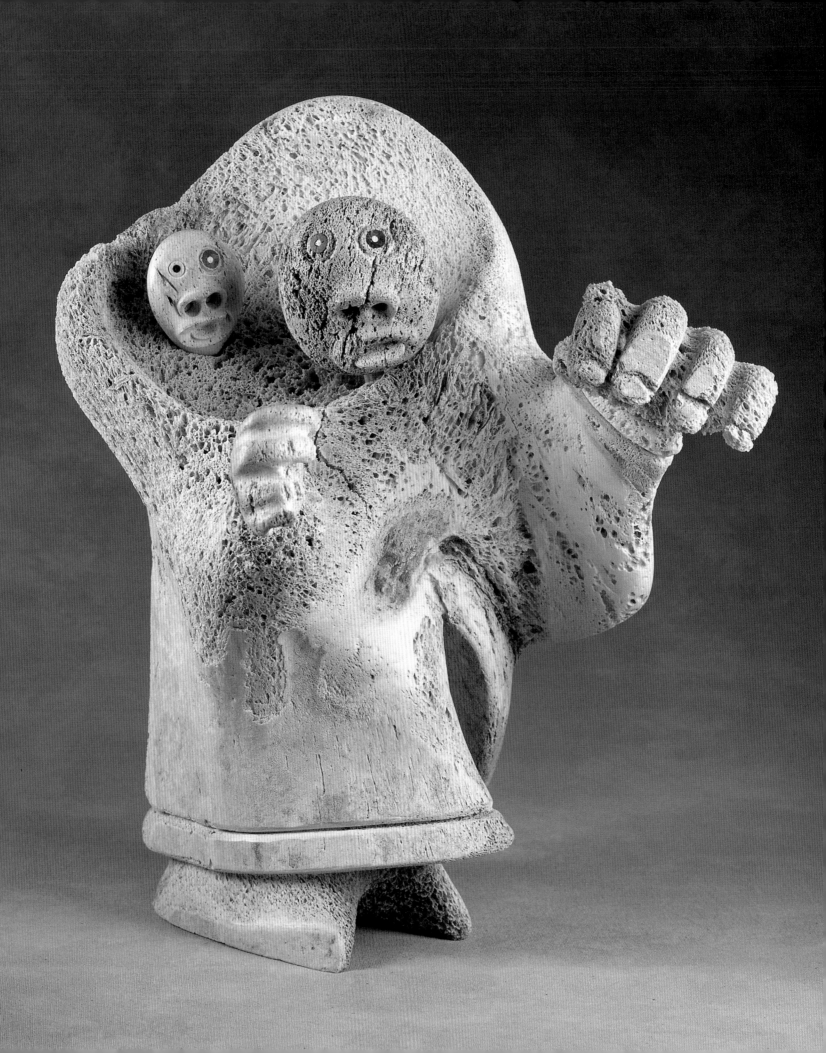

90 (facing page)
Karoo Ashevak m.
(1940–1974), Taloyoak
*The Coming and Going of the
Shaman,* ca. 1973
Whalebone, antler, stone, 38.5 ×
27.0 × 29.5
National Gallery of Canada

In presenting the mysterious
transfer of a female's shaman's
powers to her apprentice,
Karoo cleverly appropriates
imagery from the familiar
mother-and-child motif. The
deteriorating strength of the
old shaman is wonderfully
captured in the porous whale-
bone of her upper body, head
and immense hand, while
the neophyte is depicted as
an awestruck child.

91
Maudie Rachel Okittuq (born
1944), Taloyoak
Dog-Woman with Braid, 1980
Greenish-grey stone, 31.0 ×
26.7 × 17.9
National Gallery of Canada, Gift of
the Department of Indian Affairs and
Northern Development, 1989

Not working in the typical
Kitikmeot style, Okittuq still
chooses to tap the same sources
of Netsilik mythology and reli-
gion for her subject matter.
Her enigmatic *Dog-Woman* may
refer to the Netsilik version
of the sea-goddess legend in
which the girl marries a dog.
In other stories, her dog-
children become Europeans
or Chipewyan.

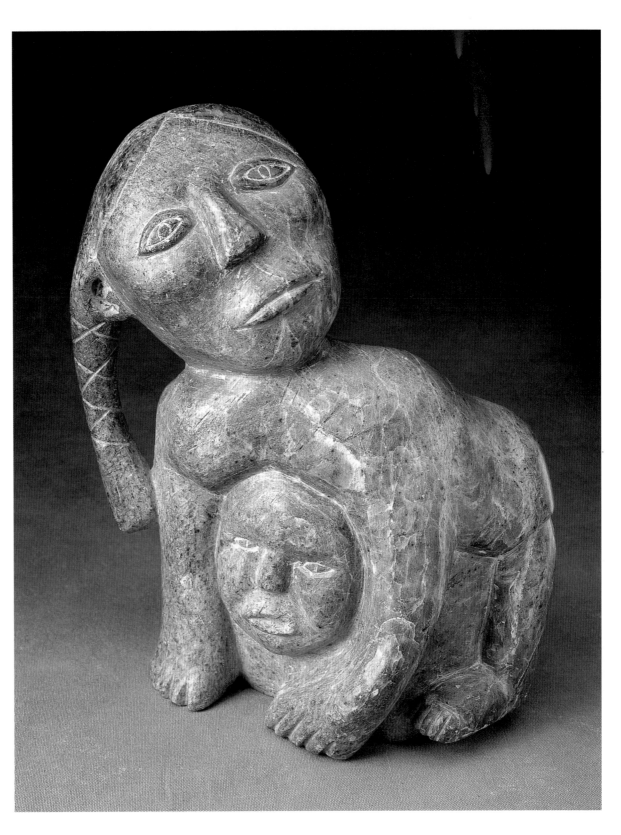

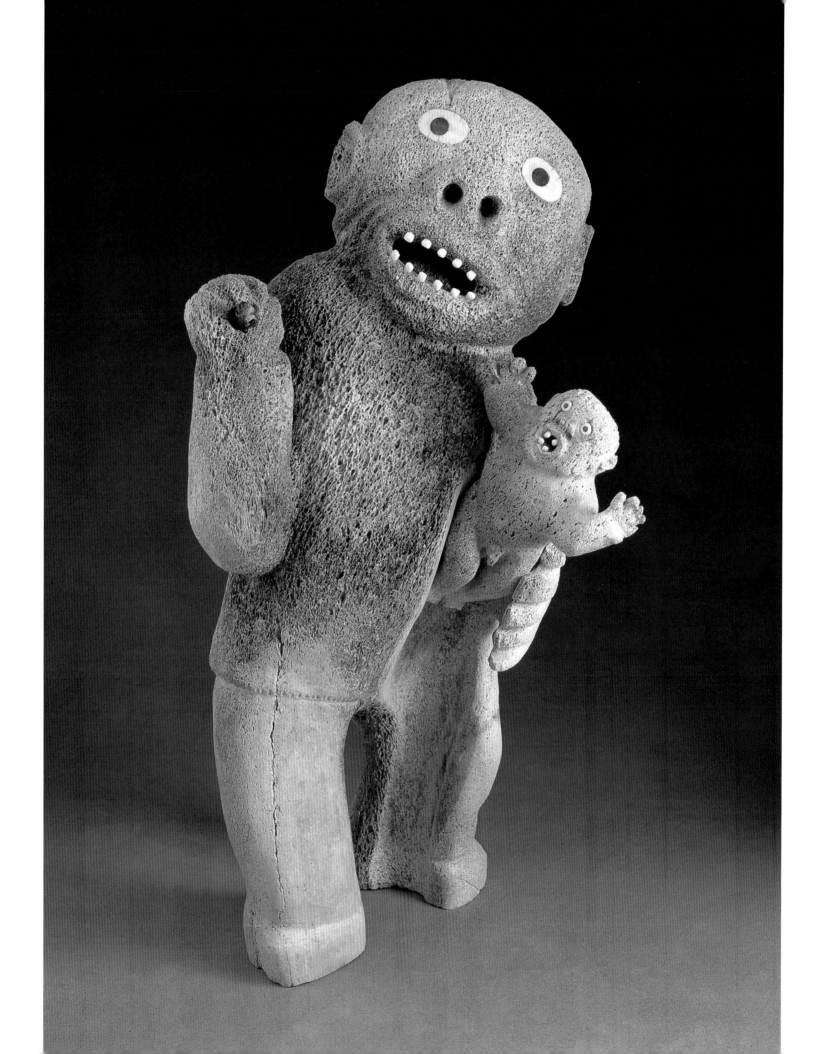

In the late 1970s and early 1980s, an influx of artists from neighbouring Taloyoak brought with them that community's style. Among the most influential of these relocated artists are Judas Ullulaq and Nelson Takkiruq, Karoo Ashevak's uncles. Gjoa Haven artists use conventions such as grotesque faces with mismatched features and have a special fondness for working with the natural shapes of materials (Figure 148), as well as a knack for making the ordinary look extraordinary (Figure 92). With their contorted shapes and startled or twisted grimaces, Gjoa Haven figures seem to exude a kind of spiritual or psychological angst, tempered with humour (Figure 93).

Pelly Bay
Pelly Bay still maintains its tradition of miniature carving, but many artists have adopted the Kitikmeot style for larger scale sculpture. The peripatetic artist Nick Sikkuark was born in the Keewatin; after being orphaned, he was raised and educated by Oblate fathers, then studied for a time in Winnipeg and Ottawa. He lived in several Inuit communities before settling in Pelly Bay and picked up the Kitikmeot style during the time he spent in Gjoa Haven. Pelly Bay assemblages are created with organic materials such as whalebone, antler and ivory (Figure 94); Sikkuark augments these materials with skulls, teeth, ivory, fur, hair, feathers and sinew (Figures 95 and 96).

Western Arctic
In the late nineteenth century, whalers moved past Bering Strait and penetrated the Beaufort Sea, bringing serious change and disease to the far Western Arctic. They did not, however, much influence the Inuit populations of Victoria Island and the Coppermine River, home of the Copper Inuit.[37] The two major Western Arctic art-producing communities, Holman and Kugluktuk (formerly Coppermine), grew up around trading posts and missions—Catholic in Holman, and Anglican in the case of Kugluktuk.

The residents of Kugluktuk were encouraged to produce carvings in the mid-1950s and have become known for their small-scale genre scenes of traditional camp life. These often feature igloos with detachable tops that can be removed to reveal the details of everyday family life. To this day, much Kugluktuk art tends to be static and relatively descriptive, although some works do reflect the spiritual life of the Copper Inuit (Figure 39).

The community of Holman on Victoria Island is best known for its prints, but it has produced sculpture in whalebone, ivory, muskox horn and occasionally stone since the early 1960s (Figure 97).

ARTISTIC CROSSCURRENTS

Stylistic approaches in Inuit sculpture are seldom restricted by borders: realism is practised to some extent in every region; abstraction or simplification occurs most widely in the Keewatin but also appears in the Baffin and Nunavik Regions; surrealism is common in Kitikmeot but is found in Nunavik and Baffin communities as well. The various approaches that determine the "look" of Inuit sculpture are constantly expanding as individual artists' styles take precedence over the earlier regional or community "schools." The differing aesthetic sensibilities of individual artists, conscious and unconscious, have resisted categorization, and rightly so. For one thing, they are not always "styles" per se, but are more like attitudes towards art-making, with some similarities among the sensibilities and attitudes of certain artists. While these artistic crosscurrents do not constitute artistic movements, certain parallels are evident in their works.

92
Nelson Takkiruq (born 1930),
Gjoa Haven
Mother Delousing Child, 1992
Whalebone, ivory, grey stone, horn,
58.8 × 35.0 × 25.2
Art Gallery of Ontario, Gift of Samuel
and Esther Sarick, 1996

Few southern artists would dream of creating an artwork that portrayed this theme. Kitikmeot carvers, however, with their earthy (and sometimes even scatalogical) sense of humour, would and do. Lice were believed to drop from the sky, hurled down by an angry spirit who was cursed with them forever.

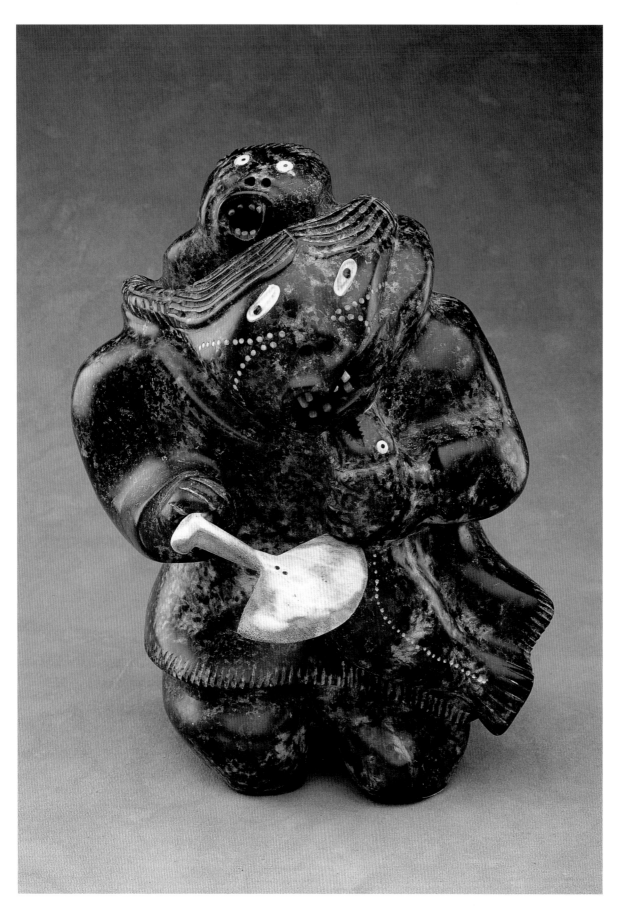

93
Judas Ullulaq (born 1937),
Gjoa Haven
Mother Killing Fish, 1990
Mottled dark green-grey stone, bone,
antler, horn, grey stone, 33.9 ×
27.2 × 23.0
Art Gallery of Ontario, Gift of Samuel
and Esther Sarick, 1996

No, not fish again! Probably
not, but Ullulaq does have a
sparkling wit. The child may in
fact be screaming *for* fish.
Thanks to Karoo, gaping
mouths, flaring nostrils and
wandering eyes are simply part
of the Kitikmeot visual vocab-
ulary, and are no cause for
alarm. While facial features in
Kitikmeot sculpture often seem
full of angst, terror or pain, the
figures often are going about
perfectly everyday activities.

94 (facing page)
Augustin Anaittuq (1935–1992),
Pelly Bay
Caribou, 1990
Whalebone, antler, bone (caribou pelvis)
and grey stone, 50.7 × 62.0 × 36.0
Art Gallery of Ontario, Gift of Samuel
and Esther Sarick, 1996

Inadequate titling is a problem
that plagues Inuit art, and this
work by Anaittuq, who for-
merly carved ivory miniatures,
is at the very least a spirit
figure, and probably a caribou-
muskox transformation as well.
The assemblage of materials,
hardly carved at all, is aston-
ishing in its simplicity, power
and quiet humour.

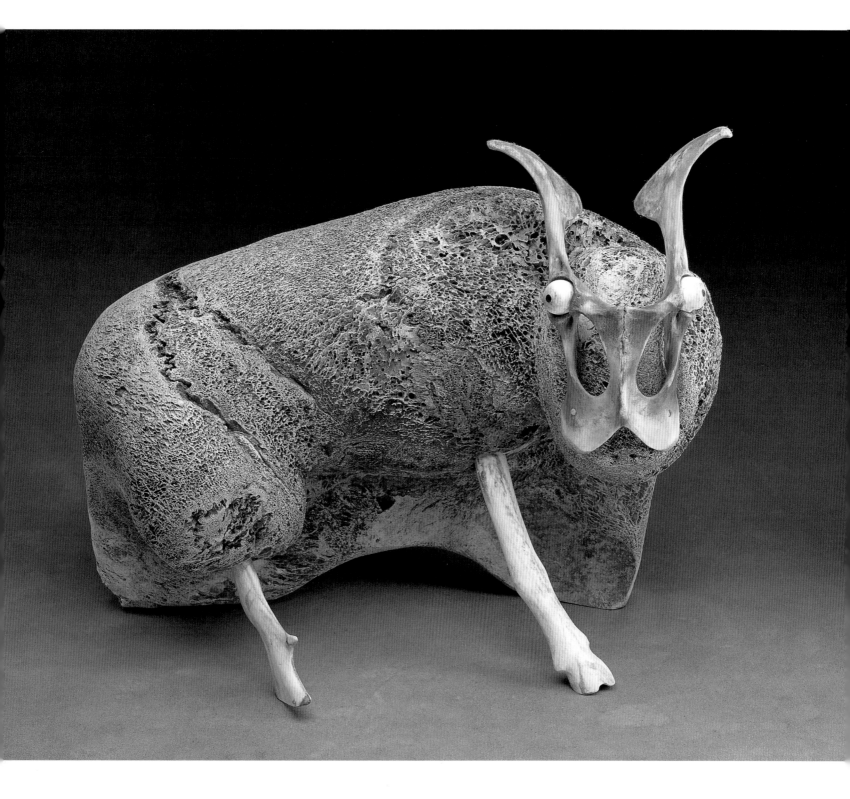

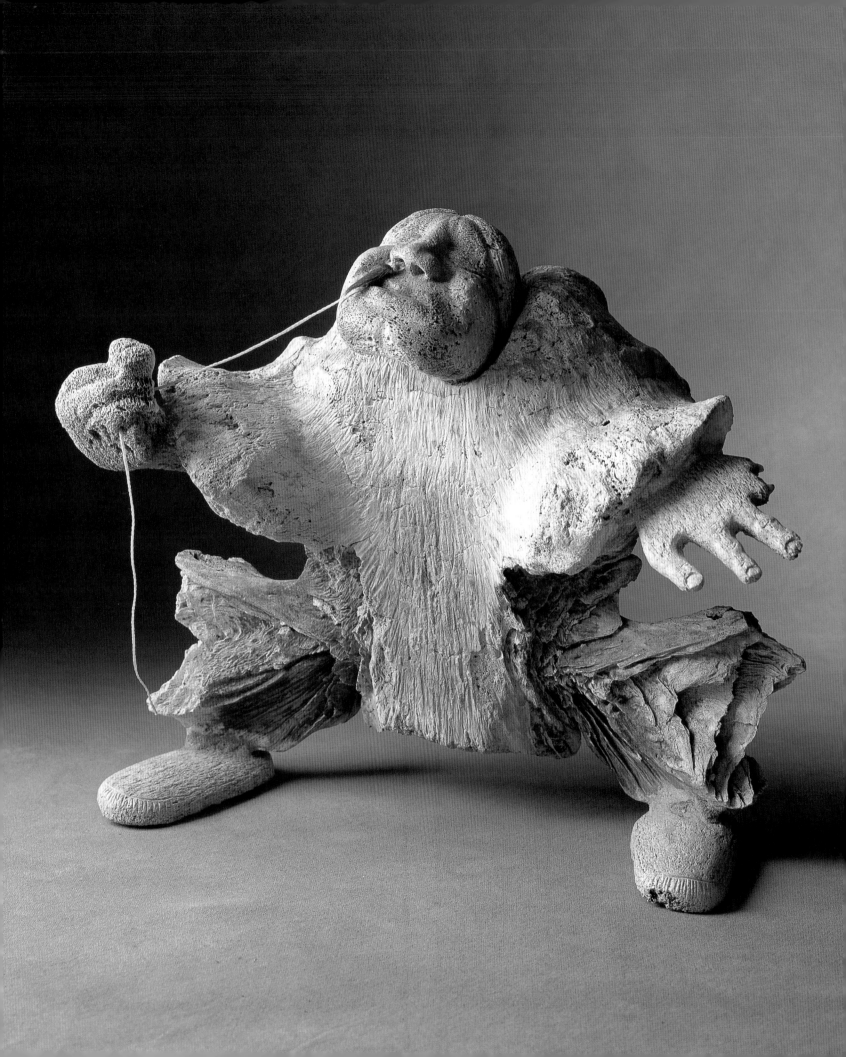

95 (facing page)
Nick Sikkuark (born 1943),
Gjoa Haven/Pelly Bay
Shaman Performing ("Cleaning Nose"), 1987–88
Whalebone, fur, sinew, 38.0 ×
46.5 × 22.5
Art Gallery of Ontario, Gift of Samuel
and Esther Sarick, 1996

Aged whalebone is probably the most expressive carving material there is; Inuit artists are fortunate to be able to scavenge for it on Arctic beaches, and Sikkuark does it full justice. He is generally very cryptic in his responses to questions, so we are left to wonder if this is a scene of hygiene or ritual self-injury

96 (right)
Nick Sikkuark (born 1943),
Gjoa Haven/Pelly Bay
Spirit Figure Swallowing Animal,
1987–88
Whalebone, bone, antler, hide, fur,
white pigment, claw, 74.2 × 19.4 × 18.9
Art Gallery of Ontario, Gift of Samuel
and Esther Sarick, 1996

In spite of his religious upbringing (he was raised by Catholic missionaries and trained for the Church), Sikkuark embraces the mystical aspects of Inuit culture in his art. Like Karoo, his forte is the manipulation of natural materials, but he seems fascinated by their slightly morbid possibilities. His is a droll, macabre wit.

97 (bottom)
Peter Aliknak (born 1928),
Holman
Woman Eating with an Ulu, 1960
Pale grey stone, 10.7 × 8.4 × 11.9
National Gallery of Canada, Gift of
M. F. Feheley, Toronto, 1996

Aliknak is better known as a graphic artist, but carved in the early 1960s. He had to begin working as a hunter as a very young boy to help his aged father. While other Holman artists are fascinated with narrating stories and myths, much of Aliknak's imagery centres around fishing, hunting and eating.

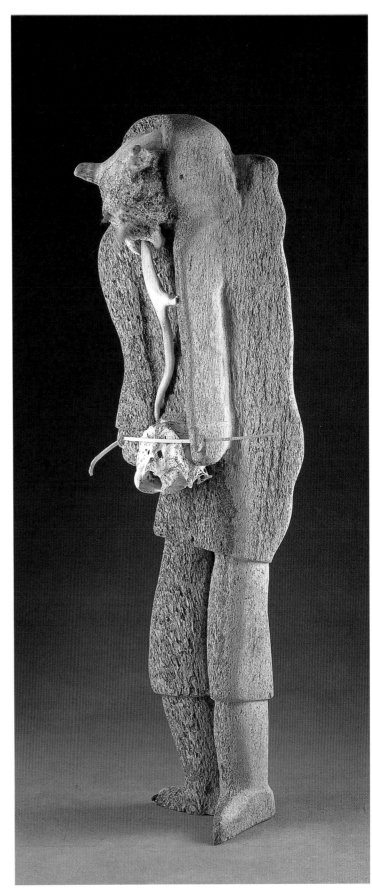

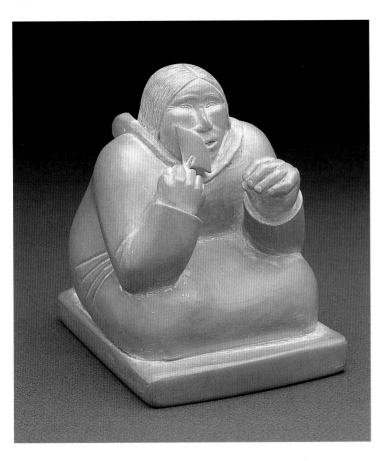

Folk Art

Traditionally, folk art has been defined as the production of arts or crafts by successive generations of untrained and usually rural artisans for personal gratification or amusement, for gifts or for special occasions. By this definition, little contemporary Inuit sculpture would qualify as folk art, since it is made for sale to outsiders. These days, however, the definition has been expanded: folk art might now be defined as art that untrained artists make for themselves, for their friends or for sale.

The traditional categories of Inuit folk art include dolls, tools and games, and certain items of clothing; to these could be added carvings or whittles. While folk art is not strictly a "style," it does conjure up images of works that are conceptually realistic and "true" in spirit if not in execution—art that has real meaning for its maker but is perhaps naive, with an honest, rustic charm. Thematically, it can range from the humorous depiction of human foibles to more serious spiritual content. The folk art sensibility fits well with the sulijuk concept.

Under the expanded definition, most Historic Period art would qualify as folk art, as would much of the production from the early 1950s. The works of some contemporary artists with eccentric and toylike qualities could be considered folk art as well. For example, towards the end of his life, Joe Talirunili of Puvirnituq was driven by a desire to chronicle as many details of the important events of his life as possible. He worked feverishly to depict over a dozen versions of his now famous "Migration" series of carvings (Figure 63), using scrap materials and any stone he could find. The resulting works were considered crude and clumsy by his fellow Puvirnituq carvers, who prided themselves on careful workmanship (Myers, 1977b:4–5).

A handful of communities seem to have fostered rather than discouraged the folk art approach, either because they had a strong Historic Period tradition or perhaps because they were outside the mainstream of early contemporary developments. The Kangirsuk artist Thomassie Kudluk, like Talirunili, disregarded the niceties of aesthetics. He nonchalantly painted areas of his small carvings and gouged inscriptions not only on the bottom but also along the visible surfaces of many works. Kudluk's decidedly crude carving style complements his eccentric subject matter. His humour was frequently scatalogical or ribald; in the context of Kudluk's work, *This Man Is Carrying the Naked Woman Home to Make Love* (Figure 65) is neither erotic nor misogynistic but probably self-deprecating.

The toylike quality of much Inuit art, described by Swinton as *pinguaq*—"toy or playful imitation" (1992:129; 1982:14)—is most pronounced in the antler and ivory constructions from various communities across the Arctic. The carvers of Kangiqsualujjuaq create quirky, charming works almost exclusively out of caribou antler. Peter Morgan's *Mother Bird Feeding Young* (Figure 98), like much Inuit folk art, is the result of a playful attitude, where ingenuity rather than style, form or even content is the driving force. While much of Arviat's stone sculpture is monolithic in conception and almost solemn in its tone, its antler carvings tend to be more spirited, and like Kangiqsuallujuaq works, are crafted to take advantage of an antler's natural shape and its ability to be pieced together easily (Figure 99).

Swinton (1978:27–30) also has characterized the general mood, scale and look of Repulse Bay carving especially as exemplifying the folk art aesthetic. Certainly, constructions like Paul Akkuardjuk's *Winter Camp* (Figure 32) qualify. To appreciate the similar sensibility, compare it with Koviak's late Historic Period cribbage board (Figure 18), also from Repulse Bay, and the much earlier ivory figures from Labrador (Figure 15).

98 (top)
Peter Morgan (born 1951), Kangiqsualujjuaq
Mother Bird Feeding Young, 1980s
Antler, bone, hide, black stone, 18.0 × 24.5 × 16.5
Art Gallery of Ontario, Gift of Samuel and Esther Sarick, 1990

Art developed slowly in this community until carvers experimented with antler, which is plentiful because of a nearby caribou migration route. Morgan makes innovative use of a caribou cranium with antlers still attached, as well as taking advantage of colour contrasts in his depiction of a mother bird and her ravenous chicks.

99 (bottom)
Henry Isluanik (born 1925), Arviat
Hunting Caribou, 1964
Antler, stone, 16.5 × 16.0 × 32.0
Musée canadien des civilisations/Canadian Museum of Civilization, Gift of the Department of Indian Affairs and Northern Development

Arviat antler carving differs from stone sculpture in style and temperament. Many artists who favour naturalism choose antler, as do those who produce playful folk-art pieces. Isluanik's hunter, while well carved, is curiously inanimate compared with the dog and the beauty and pathos of the dying caribou, done with true mastery.

The Grotesque and Fantastic

There are various reasons for depicting the grotesque, just as there are diverse opinions as to what constitutes the grotesque. Some bizarre Inuit works have been encouraged by outsiders, but others that represent demons and monsters from Inuit mythology are necessarily ugly and threatening in appearance.[38] And it is reasonable to assume that some Inuit sculptors, like a proportion of artists everywhere, struggle with their own personal demons and attempt to exorcise them through their art.

Puvirnituq carvers such as Eli Sallualu Qinuajua have produced astonishing works as a direct result of outside prompting to create something "different." To the great surprise of observers, some sculptures (Figure 62) bear an uncanny resemblance to works by proto-Surrealist European and twentieth-century Surrealist artists.[39] These "grotesque" Puvirnituq carvings not only share many formal similarities with the European works but, as Amy Adams (1994:10) has observed, they are "filled with the same ambivalence: attraction and repulsion, order and chaos, humour and horror."

Some Kitikmeot works as well are true "monstrosities" in that they depict—occasionally in gruesome detail—the horrific, the bizarre, the unmentionable and even the obscene. Charlie Ugjuk's work probes the more violent side of shamanism, the imposition of Christianity on Inuit, and the influence of "demon" alcohol; he confronts these topics forcefully and much more graphically than most of his Kitikmeot peers (Figures 35 and 100). While others like Nick Sikkuark also maximize the expressive power of bizarre themes and materials, they usually mitigate their messages with more humour, even if it is sardonic (Figure 95). The grotesque crops up even in the Keewatin, which is known for its pared-down, more pristine "abstract" sculptures (Figure 101).

A distinction should be made between the truly grotesque and Swinton's "fantastic art."[40] Much of the art of Puvirnituq, Kitikmeot communities and even Cape Dorset is fantastic and even bizarre. But grotesque art is generally deliberately ugly, not simply bizarre.

Reduction and Streamlining

Because complex subjects such as myths and transformations do not lend themselves easily to simplification, reduction (which some might call abstraction) in Inuit sculpture tends to occur in the single figure. Stripping away the extraneous focusses attention on either material or form. As noted by author Gerhard Hoffmann (1993:393–94), reduction of the body can be achieved in several ways. One is by simplifying the form and eliminating detail so that the figure incorporates, or fuses with, the elemental quality of the material. A second is a more intellectual approach whereby the artist's instinct for pure, distilled form controls and subordinates the material. And a third is through the rejection of the "monolithic" whole in favour of open space and the relationships between parts. Examples of all three approaches can be found in Inuit sculpture. While the "reductive impulse" among certain Inuit artists has probably not occurred for the same *reasons* as it has among various twentieth-century European artists (such as Brancusi, Arp and Giacometti) or artists from other times and cultures, the physical evidence (namely the works themselves) points to similar sensibilities.[41]

The first reductive approach can be achieved in more than one way. Sculptors such as Pauta, Sevoga and Latcholassie streamline form to emphasize mass, bulk and volume (Figures 53, 67 and 102), while in the work of Nutaraluk or Tasseor, for example, content seems to fuse with or emerge from the stone matrix (Figures 81 and 104).

100
Charlie Ugjuk (born 1931), Taloyoak
Devil After Birth Holding Young Devil, 1983–85
Mottled dark green-grey stone, 18.6 × 25.3 × 10.9
Art Gallery of Ontario, Gift of Samuel and Esther Sarick, 1996

The meaning of this mother and child image may be rooted in Netsilik mythology, or perhaps only in Ugjuk's imagination. Ugjuk's art is not for the faint-hearted or prudish; his images are truly and profoundly—but artfully—ugly. Nonetheless, it is a mother and child; who is to say that her emotions are not equal to Nutaraluk's (Figure 104).

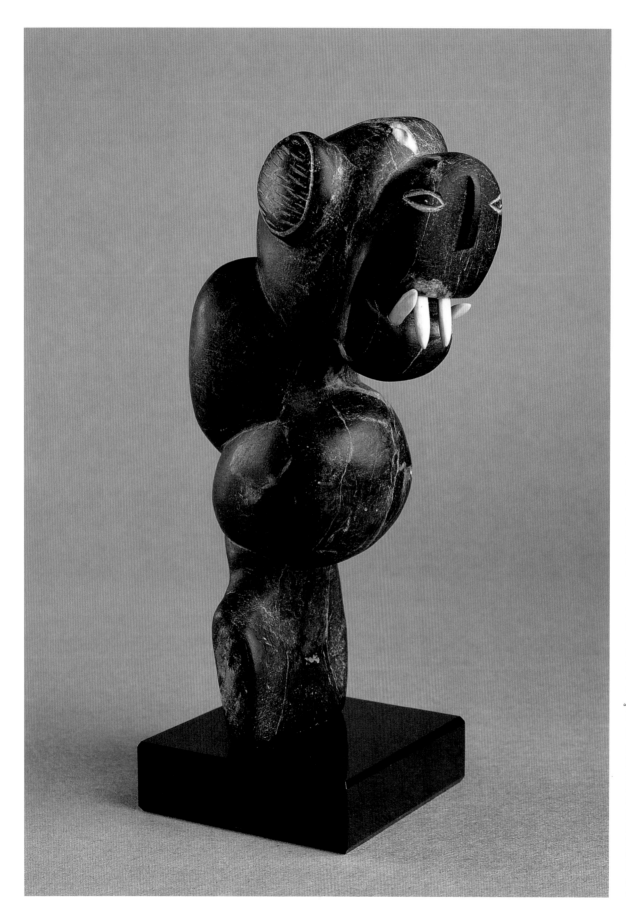

101
George Arluk (born 1949)
Rankin Inlet/Winnipeg
Shaman, prob. 1970s
Dark grey stone, bone, polished black
stone, 20.4 × 11.9 × 7.8
Art Gallery of Ontario, Gift of Samuel
and Esther Sarick, 1996

Arluk began carving at age
nine, first copying older artists
but soon finding his own
sleekly modern style, carving
the human figure with Henry
Moore-like openings. His
shamanic figures are distinctive
for their spiky projections; this
grotesque example is a won-
derful aggregate of sculptural
shapes and teeth.

102 (facing page)
Pauta Saila m. (born 1916),
Cape Dorset
Dancing Bear, 1984
Mottled dark grey stone, ivory, 51.2 ×
38.8 × 22.8
Art Gallery of Ontario, Gift of Samuel
and Esther Sarick, 1996

"Polar bears are just like people.
They can do many things that
humans do. They can stand or
sit, like us. They look around,
just as we do," says Pauta (Eber
1993:435). His love of and
immense respect for polar bears
is almost an obsession. He is
famous for his so-called "danc-
ing bears" balanced on one
foot. The bear's strength,
ferocity and uncannily human
behaviour are captured in mas-
sive, stylized forms bursting
with compressed raw energy.

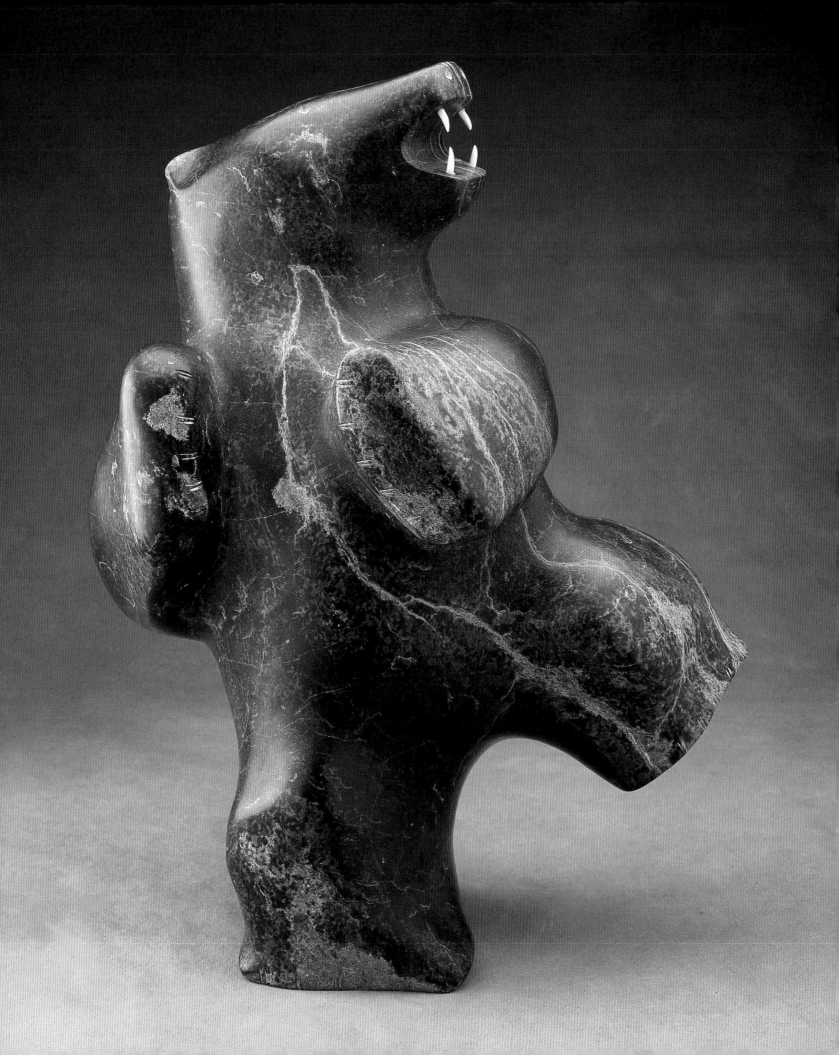

The second more "intellectual" approach can range from Pangnark's pure formal abstraction (Figure 103) to Tataniq's or Miki's pristine naturalism (Figure 84 and 106). Although most evident in the Keewatin, this second approach appears elsewhere as well (Figures 105 and 107).

The third "open-space" approach is found most often in works that are assembled rather than carved, especially in bone and antler (Figure 85).

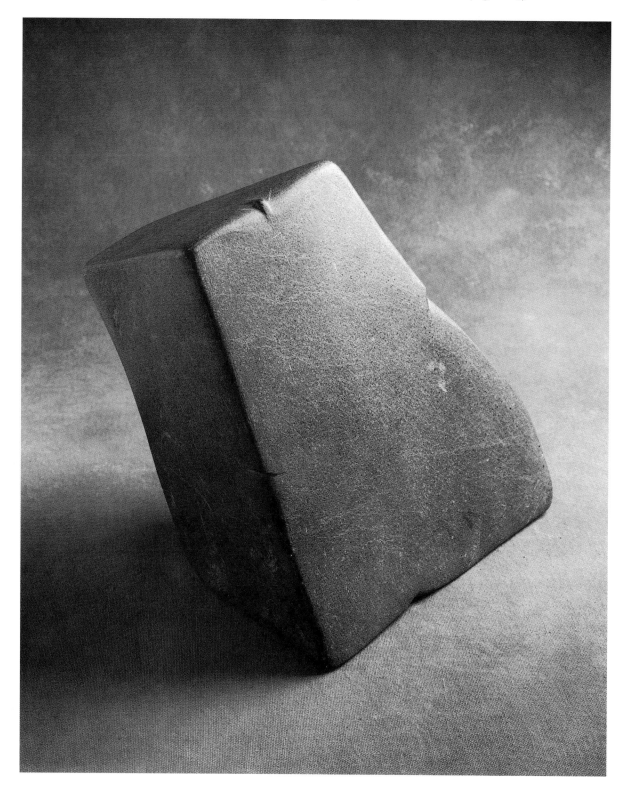

103 (facing page)
John Pangnark (1920–1980),
Arviat
Figure, 1974
Grey stone, 21.5 × 22.3 × 18.3
Art Gallery of Ontario, Gift of Samuel
and Esther Sarick, 1989

With the subtlest of indenta-
tions and the barest of slits,
Pangnark could articulate an
entire body. He had a love of
flat planes and subtle curves;
formal concerns dominated his
career. Perhaps he chose to
carve only single figures to put
content out of his mind and
concentrate, like Brancusi, on
near-abstract form.

104
Elizabeth Nutaraluk Aulatjut
(born 1914), Arviat
Mother and Child, 1972
Grey stone, 16.8 × 17.2 × 15.6
Art Gallery of Ontario, Gift of Samuel
and Esther Sarick, , 1988

A survivor of the 1950s
famines, Nutaraluk knows
hardship and death; she lost
half of her thirteen children.
She is obsessed with the
mother-and-child theme. Her
work is more autobiographical
and emotionally charged than
Lucy Tasseor's (Figure 81), and
more figurative, even though
much of the stone is left un-
carved. Braids are a distinctive
feature of her sculpture.

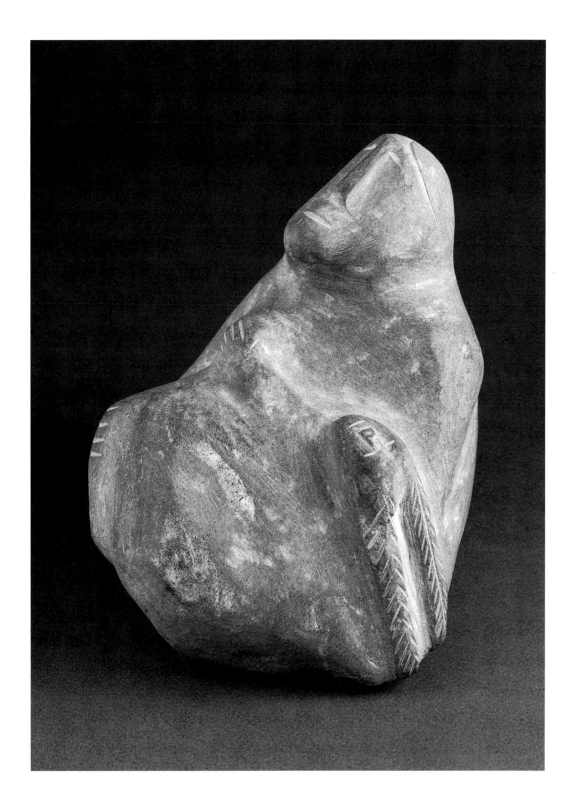

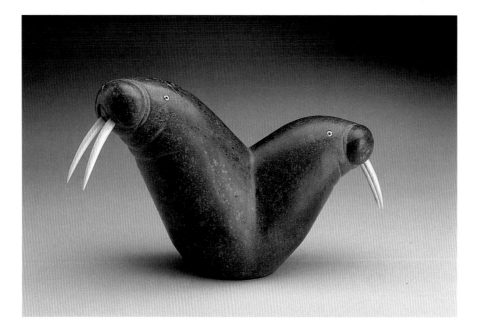

105 (top)
Tivi Paningajak (possibly)
(born 1917), Ivujivik (collected
in Cape Dorset)
Two Walrus Heads, 1956
Grey stone, ivory, 12.0 × 20.5 × 6.5
Musée canadien des civilisations/
Canadian Museum of Civilization,
Gift of the Department of Indian
Affairs and Northern Development

The successful unity of form
and content is sometimes
breathtaking in its simplicity.
These two partial walrus
figures, though quite realisti-
cally carved, blend together
so seamlessly that they create
one sensuous, almost abstract
form. Cover up the muzzle of
either one, and you have a
perfectly complete single wal-
rus form.

106 (bottom)
Andy Miki (1918–1983), Whale
Cove/Arviat
Animal, ca. 1967
Grey stone, 12.4 × 8.2 × 3.8
Art Gallery of Ontario, Gift of Samuel
and Esther Sarick, 1996

Miki created essential forms
without removing tool marks,
preferring the matte, tactile
look of a fine file or sandpaper

finish. This enigmatic little ani-
mal (it may be a caribou,
despite its pose), like many of
his figures, has a real sculptural
"presence," yet fits into the
hand like some mysterious and
beautiful stone implement.

107 (facing page)
Charlie Qittusuk (born 1927),
Sanikiluaq
Polar Bear, 1967
Stone, ivory, 17.0 × 13.0 × 9.4
Winnipeg Art Gallery, Hudson's Bay
Company Collection, anonymous gift

Qittusuk radically foreshortens
and thereby compresses the
bear's body, but this work is
very different from Pauta's
Dancing Bear (Figure 102). The
awesome power of Qittusuk's
animal is concentrated in the
imposing neck, shoulders and
chest, while its hindquarters
dwindle away. One is left
wondering if this might be a
transformation piece.

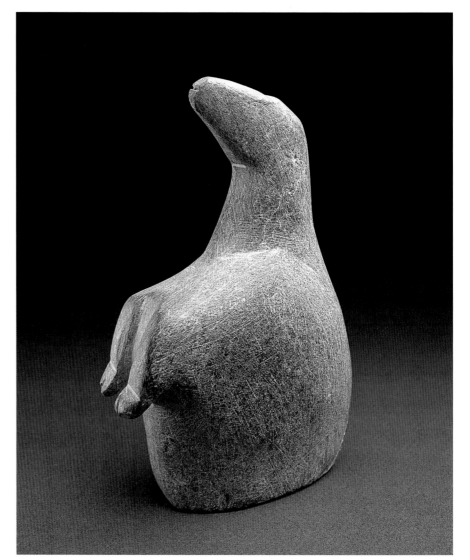

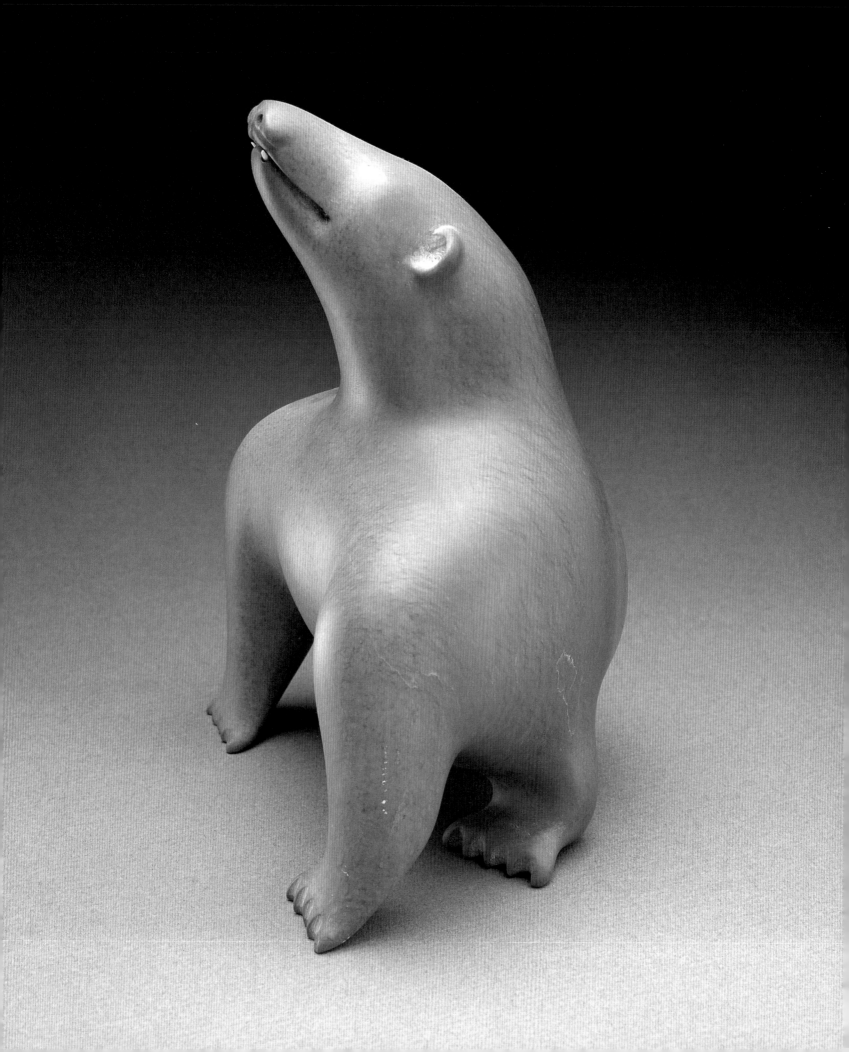

> For young Inuit artists, I think that there are a lot of possibilities . . . I think we are a storytelling, carving society and I think that will sustain us in the future. My best advice for the young artists is to travel a bit more, see more of what there is out there. That really helps your development as an artist . . . I have learned the importance of learning about my past and translating oral stories into visual form.
>
> —DAVID RUBEN PIQTOUKUN (1989:41)

There are indeed many possibilities for young Inuit artists. Although the majority of Inuit sculptors are still working within "traditional" regional, community or personal styles, some younger artists, led by a tiny vanguard who are living and working in or frequently visiting the south, have developed a more professional, articulate and experimental approach to art-making. This more Western, more thoroughly acculturated approach, which has manifested itself since the 1970s, has been identified as a post-contemporary tendency (Swinton 1992:247). Much like the artistic crosscurrents just examined, it is more an attitude than an actual "movement" or new "period" in Inuit art, yet there is a certain generational shift. The fact that many of these young artists come from smaller communities without famous stylistic traditions may be significant.

These relatively young sculptors, often with the full knowledge that their understanding of Inuit culture is somewhat more tenuous than that of their parents and grandparents, view art as a vehicle for aesthetic self-expression, as a means of getting and keeping in touch with their culture, as a viable and worthwhile profession, and occasionally as a path towards personal redemption.[42]

While a few artists are experimenting with nontraditional styles, most post-contemporary art is still rooted in sulijuk realism. In fact, the emotional intensity and superb technical execution with which these new works are often produced shows that, far from being outside the "normal" styles of Inuit art, post-contemporary sculptures are the same only more so. Many of the works represent a "mannerist" approach, in the sense of devoting a greater attention to aesthetics and having a self-conscious virtuosity and a taste for the unusual.[43]

Themes remain to a large extent traditional, though wildlife art, for one, is rare; mythological and shamanic subjects are supplemented occasionally by subject matter with very personal content. These younger artists have a strong interest in the supernatural, even if their experience of traditional spirituality is secondhand at best. All in all, some interesting parallels might be drawn between this generation of Inuit sculptors and contemporary First Nations artists.

Although Inuit artists who work in the south often use traditional materials, they do have access to different types of stone and other sculptural materials. Moreover, they have the liberty to use them, unlike northern Inuit who are still strongly discouraged by the market from working in non-indigenous carving materials. In general, post-contemporary work is larger and more elaborately structured, and some artists occasionally even hire apprentices to help in the roughing out and polishing phases.

Two leading post-contemporary artists, Abraham Apakark Anghik and his brother, David Ruben Piqtoukun, are Inuvialuit born near Paulatuk in the Western Arctic. Their grandparents had migrated from Alaska to the Mackenzie Delta area, and the brothers grew up in a mix of Inuit cultures. Educated in Roman Catholic residential schools from an early age, they lost much of their language and culture. Anghik studied for a time with the Alaskan artist Ronald

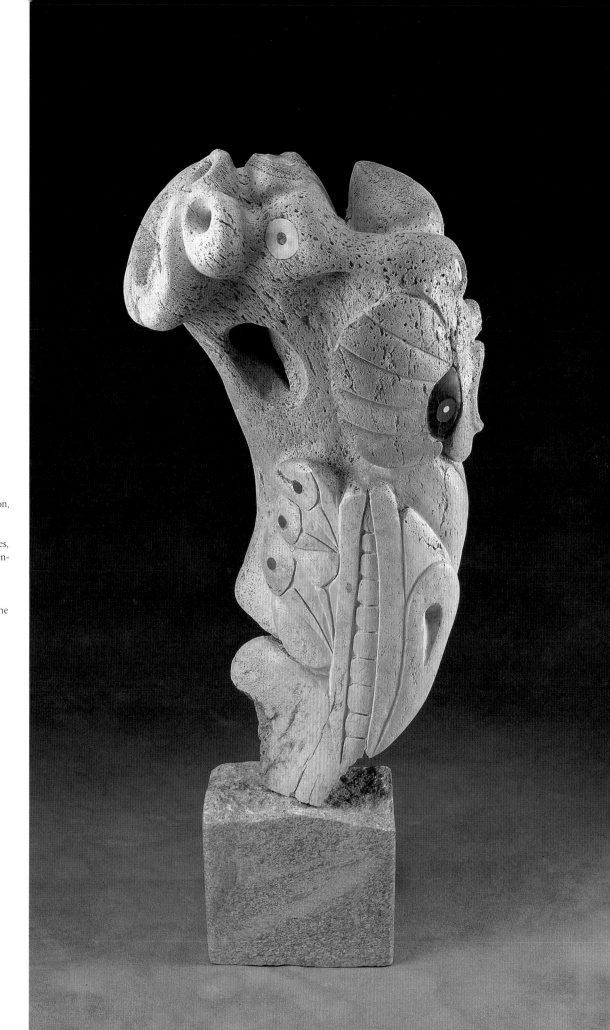

108

Abraham Apakark Anghik
(born 1951), Paulatuk/Salt
Spring Island
Spirits Along a Seashore, 1985
Whalebone, black and grey-green
stone, ivory, metal, beige and red
colouring, 64.5 × 30.5 × 21.0
Musée canadien des civilisations/
Canadian Museum of Civilization,
acquisition funded by Dr. Norman
Epstein

In "post-contemporary" fashion,
Anghik has looked around,
chosen his influences, and
reworked them. The spirit faces,
strongly carved in three dimen-
sions, derive their look from
Karoo's Kitikmeot style; the
raven and its young follow
Northwest Coast models in the
design and "graphic" relief
carving.

Senungetuk in Fairbanks, absorbing Alaskan and Northwest Coast influences. Ruben joined his brother in Vancouver in the early 1970s; by 1981, he was living in Toronto and marketing his own work. Anghik now lives and works on Salt Spring Island in British Columbia. Both artists often carve in Brazilian soapstone and other nontraditional materials, and each has produced several large-scale works. The howling spirits and grimacing raven of Anghik's *Spirits Along a Seashore* (Figure 108) reveal to some extent the influence of Karoo Ashevak but are more indebted to First Nations art styles of the Northwest Coast. *Spirit World of the Inuit* (Figure 2) is one of Ruben's most complex depictions of the relationship of humans and animals; the dance masks are a reminder of his Alaskan roots. Both Anghik and Ruben have made a special effort to study the stories and art styles of Inuvialuit and Alaskan Eskimos, and freely mix all these in their work.[44]

Manasie Akpaliapik, born in a hunting camp near Arctic Bay on northern Baffin Island, learned to carve from his grandparents Peter and Kanangnaq Ahlooloo (see Figure 73). Akpaliapik moved to Montreal in 1980, where he began to carve seriously; six years later, he moved to Toronto and has lived there or nearby ever since, though he travels home to Arctic Bay whenever he can to collect stories, to collect whalebone and to "recharge his batteries."[45] He has utilized both ivory and stone, but is most famous for his work in whalebone; he succeeds in carving ivory miniatures and colossal whale vertebrae with the same degree of sensitivity. Manasie's works often exhibit a higher degree of emotional or psychological tension than their themes would suggest; the subject of his remarkable *Respecting the Circle* (Figure 56), like Ruben's *Spirit World of the Inuit* (Figure 2), is the powerful bond between humans and animals. In *Shaman Summoning Taleelayuk to Release Animals* (Figure 109), Manasie uses the ancient whalebone to great advantage, extending its gestural sweep with the movement of the ivory sea mammals.[46]

Oviloo Tunnillie, who spent three years in southern tuberculosis sanatoria as a child, is currently Cape Dorset's most celebrated sculptor, and perhaps the only one who consciously competes with the men. Her work is remarkable for its sometimes subtle, sometimes overt, feminist content, its depiction of social problems, and its matter-of-fact representation of the nude female body. She has tackled the themes of alcoholism, rape, spousal abuse and hospitalization, as well as sports figures and the sea goddess. In Oviloo's white marble *Taleelayu* (Figure 69), we are drawn immediately to the sensuous volumes of the body which contrast beautifully with the texture of the hair and the geometric patterning of the tail. The small nude *Torso* (Figure 46) does not attempt to be flamboyant or provocative. Its success relies not on its erotic appeal but in its elegant simplicity. Oviloo's sculpture transcends commonly held perceptions about Inuit art because it does not capitalize on its ethnicity. *Taleelayu* and *Torso* are sculptures first and Inuit second.[47]

Although other northern Inuit artists may not approach new modes of art-making as consciously as Oviloo or their southern colleagues, many of their works of the past twenty years might fit into the post-contemporary category. These include Oopik Pitsiulak's *Oopik Going for Water* (Figure 110), an autobiographical work incorporating beaded cloth; Natar Ungalaq's *Sedna with Hairbrush* (Figure 42); and Matiusi Iyaituk's *The Woman Is Happy to See That Her Son Is Becoming a Good Hunter* (Figure 111). Of these artists, the Ivujivik artist Iyaituk is particularly adventurous in constantly experimenting with form and different materials and in giving his sculptures cryptic or amusing titles. It could be argued that some Kitikmeot art also is post-contemporary. Perhaps the Kitikmeot artist Karoo Ashevak (Figures 89 and 90) was the first post-contemporary Inuit artist, and perhaps Nick Sikkuark (Figures 95 and 96), with his influence on an entire community, is his successor in that region.

109
Manasie Akpaliapik m. (born 1955), Arctic Bay/Toronto
Shaman Summoning Taleelayu to Release Animals, 1989
Whalebone and narwhal ivory, 43.7 × 40.2 × 27.8
Winnipeg Art Gallery, acquired with funds from the Winnipeg Art Gallery Foundation Inc.

Normally, a shaman could summon animals himself, but in times of hunger (perhaps caused by the breaking of a taboo), the shaman was obliged to journey to Taleelayu or to summon her. The piece of ancient whalebone provides a perfect sweep, in which the shaman dances and chants to lure the sea goddess and the animals she controls.

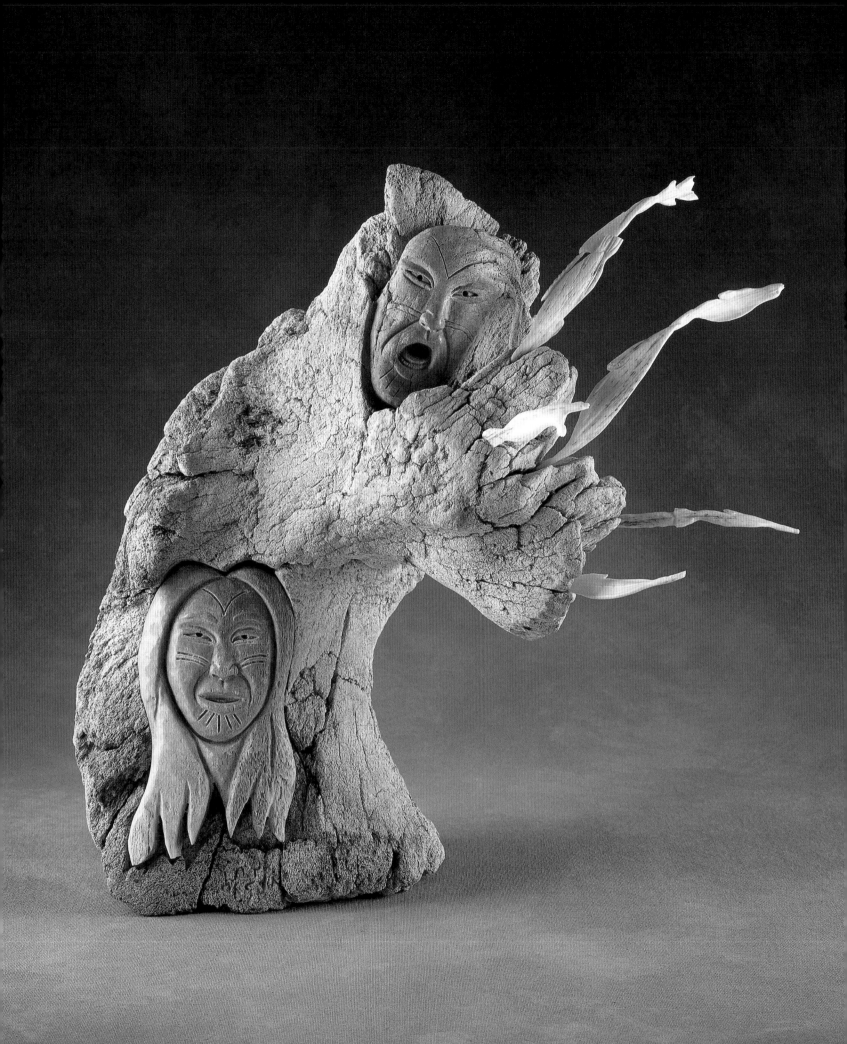

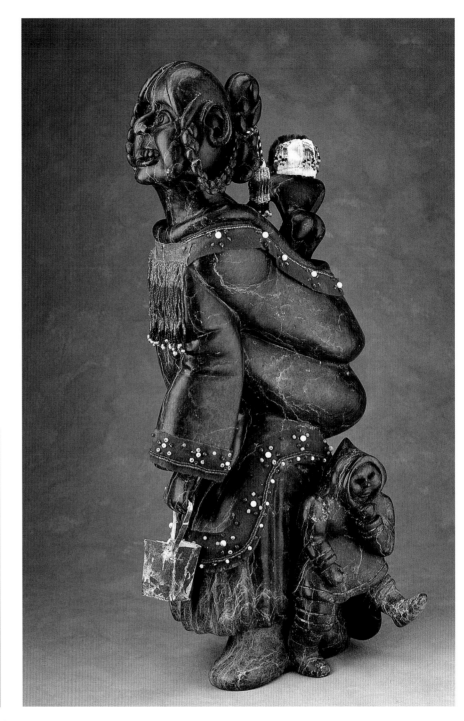

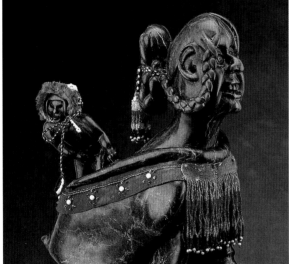

110 A and B (two views)
Oopik Pitsiulak f. (born 1946),
Cape Dorset
Oopik Going for Water, 1990
Green stone, glass beads, wool fabric,
wool cord, sealhide, tanned leather
and fur, 63.5 × 19.0 × 25.5
Musée canadien des civilisations/
Canadian Museum of Civilization

Oopik's addition of fabric and
beads (at least on a "major"
sculpture) may seem incongru-
ous and even disconcerting.
But in the context of idiosyn-
cratic Inuit "folk art" (and in
the larger context of world
sculpture, where gilding, poly-
chromy, jewels and other
embellishments are quite com-
mon), it makes perfect sense.

It is doubtful that the post-contemporary way of Inuit art-making will develop into a recognizable "style." New materials, working methods and attitudes will co-exist with more "traditional" sculptural styles for some time, and individual artists' styles will probably become even more pronounced over the next couple of decades. But the real challenge for Inuit sculptors will be to continue to move forward and innovate without succumbing completely to a southern approach, and to hang on to traditions without stagnating.

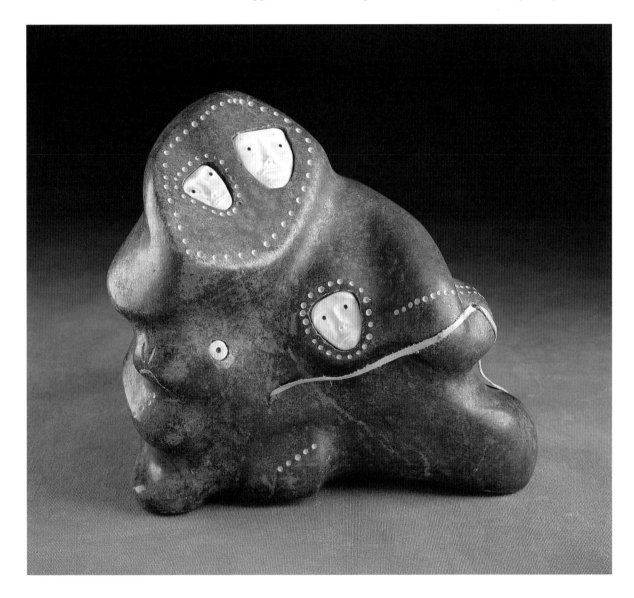

III

Matiusi Iyaituk m. (born 1950), Ivujivik
This Woman Is Happy to See That Her Son Is Becoming a Good Hunter, 1980
Grey stone, antler, hide, colouring, wood, 21.4 × 24.6 × 22.9
Art Gallery of Ontario, Gift of Samuel and Esther Sarick, 1989

Iyaituk first experimented with abstract form in 1979, when he felt "too lazy" to carve details on a figure. Pleased with the result, he has adopted a fluid style and now calls himself an abstract artist. He combines old practices such as ivory or antler inlay with constant experimentation in form and materials.

To us—my mother [Jessie Oonark] and me—we wondered why the white people would want a piece of paper with some funny drawings on them. We thought those papers were useless.
—WILLIAM NOAH, BAKER LAKE (1995:20)

Only *children* draw pictures; *men* do carving.
—PAULOOSIE KARPIK, PANGNIRTUNG, early 1960s[1]

I loved his drawings, so thoughtfully and carefully made. It would make him smile whenever I complimented his drawings. [Pauloosie] Karpik has left us a lot of memories.
—KOONOGOUSIQ NUVAQIRQ (Pangnirtung 1988:38)

ALTHOUGH THE DEVELOPMENT of Inuit sculpture can easily be traced all the way back to prehistoric times, the production of drawings and prints is a fairly recent phenomenon, dating only to the late 1950s. There was, however, a tradition of two-dimensional art-making and design among Inuit, their ancestors and their predecessors. Its first appearance was in the form of incised skeletal, joint and tattoo markings in Palaeo-Eskimo and Dorset art (see Figures 7 left and 8), though these decorated the sculptural form with realistic detail to augment the power of those carved objects rather than constituting true graphic art. Later, in Thule times, inscribed ornamentation began to play a more important role in tool- and art-making, with the occasional depiction of symbolic and figurative graphic designs (Figure 12), and even some complex narrative scenes (Figure 11).

The practice of decorating implements diminished in the Historic Period, but other two-dimensional arts flourished, such as tattooing on face, arms and legs (Figure 130), and clothing design. Like tattooing, clothing decoration was symbolic and indicated gender and regional differences. The careful arrangement of appliquéd and inlaid panels on clothing, although they were sewn and not "drawn," required two-dimensional spatial organization and an artistic sensibility; the addition of beadwork and amulets further enriched and personalized clothing. Another form of graphic art, the manipulation of string figures (cat's cradle) representing mostly animal and human figures, was an ephemeral but important visual adjunct to storytelling and oral history.

During the Historic Period, outside influences encouraged two-dimensional design. Inuit probably learned the art of scrimshaw from American whalers, and engraved tusks, cribbage

112
Janet Kigusiuq (born 1926), Baker Lake
Upiknivik—Summer Camp, 1992
Coloured pencil and graphite, 76.1 × 56.9
Winnipeg Art Gallery

While Kigusiuq sometimes draws busy scenes of traditional camp life and mythology in a cartoonlike narrative style (Figure 43), for the last decade she has been covering the paper with more solid blocks of colour. Her semi-abstract landscapes (based on childhood memories of the Back River) bear comparison with Pudlo's (Figure 54).

boards and other objects with realistic animal figures and scenes (Figure 17). And some examples of maps and drawings were commissioned or prompted mainly by explorers and anthropologists (Christopher 1987). In 1913–16, anthropologist Diamond Jenness collected drawings by Copper Inuit and wrote articles comparing the graphic art of Alaskan, Greenlandic and Canadian Inuit.[2] So while only a very few Inuit like Peter Pitseolak (Figure 19) were afforded the chance to actually sketch or paint, other opportunities to practise two-dimensional design and "draw" did exist.

PRINTMAKING: "WE COULD DO THAT."

James Houston created one of the famous legends of Inuit art with his story of how the idea of Inuit printmaking was born in Cape Dorset in the winter of 1957. According to Houston, the carver Osuitok Ipeelee had been studying the identical printed images of a sailor's head on two cigarette packages, marvelling at the skill and patience it must have required to produce the same likeness repeatedly. Houston's Inuktitut vocabulary was too limited to explain the printing process, so he rubbed ink on a tusk newly incised by Osuitok and pulled an impression of the image on a piece of toilet tissue. Osuitok declared: "We could do that" (Houston 1971:9–11).[3]

That same year, the Inuit of Cape Dorset began experimenting with various printing techniques and inks. They tried a mixture of seal oil and lamp black, but it proved to be a very poor substitute for printer's ink. They found that stencils cut from scraped sealskin were inadequate, while paper stiffened with wax made excellent stencil cutouts, a method still used today. In the absence of real printing paper, they used government stationery. Attempts at linocut printing were moderately successful, but the breakthrough came with the discovery that the beautiful green serpentine used by sculptors provided an excellent medium for the low-relief carving of images for printing.

In 1958, Houston travelled to Japan to study printmaking with Un-ichi Hiratsuka. Given the circumstances in Cape Dorset, he became convinced that the ancient Japanese tradition of *ukiyo-e*, in which printmakers translate the drawings of artists into prints, would be the most suitable one to follow.[4]

The development of Inuit graphic arts is much more orderly and better documented than the evolution of sculpture, which is produced across the Arctic. Most Inuit sculptures have disappeared into private hands, sold without visual or written records being kept, although many important works are housed in major public and private collections. In contrast, prints are documented in the catalogues of annual collections, and printmaking has been confined to just a handful of communities, the major ones being Cape Dorset, Puvurnituq, Holman, Baker Lake and Pangnirtung. In addition, community archives of drawings and paintings—with the exception of Baker Lake, which lost many drawings in a 1977 fire—have been preserved largely intact. All this makes it relatively simple to note stylistic changes and the rise of individual talents, especially as the lives and words of many graphic artists have been published in annual catalogues and artist interviews. The yearly jurying of prints until 1989 by the Canadian Eskimo Arts Council, which had been set up by the federal government to help promote and protect Inuit art, meant that Inuit graphic arts production underwent constant scrutiny and discussion by experts.

The history of Inuit printmaking is fraught with marketing problems and quarrels between communities and the Canadian Eskimo Arts Council. Art history occasionally deals with the

economics or politics of art-making, but in the case of Inuit art, and especially Inuit graphic arts, economics is always a factor. Because printmaking involves high labour costs and expensive facilities, equipment and supplies, it has depended on considerable government assistance. Various projects have waxed and waned as a result of economic development priorities as well as the vagaries of the art market. Although Inuit carvers are almost always assured a regular market for their works, the artists and printmakers associated with graphic arts programs live in constant fear of funding cutbacks, poorly received annual collections, and closure. In addition, the intervention of arts advisors and the Council not only affected artistic freedom but also the very choice of images presented to the public for almost thirty years. Because of the need to market numerous copies of a print, there has always been a temptation to stick to tried-and-true imagery and steer clear of the controversial.[5]

Inuit original prints are usually published in editions of twenty-five to fifty numbered copies, plus a few artist proofs; after the printing is done, the original stone blocks, plates, or stencils are chiselled down, defaced or destroyed.[6] Each printmaking community has developed its own printed symbol as proof of origin, and in Cape Dorset, individual artists and printmakers also developed their own signature "chops," borrowed from the Japanese ukiyo-e tradition. From 1961 to 1989, approved prints were also blind-embossed with the stamp of the Canadian Eskimo Arts Council.[7] Inuit prints are marketed as annual catalogued collections through a select group of retail galleries, and in boom years the demand for prints has been so high that collectors have camped outside galleries the night before an opening, and some dealers have been obliged to set up a lottery system.

Printing Processes and Techniques

For the most part, Inuit print shops have followed the Japanese ukiyo-e process, in which printmaking is a collaborative venture between artists and printmakers. The artists create the drawings and sell them for relatively modest amounts to the print shop throughout the year. Arts advisors, usually hired by the co-operatives, and the printmakers (who are salaried employees of the print shop), select the drawings they feel would make good salable images for the upcoming print collection. The printmaker's job is to faithfully translate the artist's vision onto stone blocks, plates or stencils; often yet another technician, the printer, actually transfers the image onto paper. Artists are not deliberately excluded; the process is simply a division of labour. In recent years, artists have often been consulted at critical stages in the printmaking process, and in the case of lithographic prints, may work directly on the stone. A few artists are also printmakers, and vice versa; while some print their own images, others prefer to leave printmaking to someone else.

Several factors affect the choice of an image for an annual print collection, including the reputation of the artist, aesthetic merit, complexity and the general appeal of the subject matter.[8] Consideration also is given to balancing the number of works by established and emerging artists, and to offering a wide range of styles and subjects. The margin for error in assessing these factors is small, as the cost of making and releasing an edition of prints is expensive because of extremely high utility charges for running printmaking facilities in the Arctic, shipping fees to and from remote areas, and payroll costs.

After a drawing has been chosen and the printing technique has been decided upon, the printmaker sometimes may be obliged to alter the image. In the early years, especially, shortages

of ink colours or paper sizes necessitated the occasional simplification of colour schemes, or the alteration, removal or rearrangement of elements in an image. Techniques such as stonecut sometimes require the original shading, texture or pattern in an artist's drawing to be simplified or schematized (see Figures 113 and 114). As artists became aware of the limitations of the various printmaking techniques, many of them began to create simplified images with the end use in mind. Artist-printmaker Kananginak Pootoogook of Cape Dorset has observed, "You really have to think carefully about what you are going to draw when it is to be used in printmaking. It has to be good, but not too difficult for carving [stonecutting]" (Kananginak 1976). The lithographic print method has to some extent resolved that issue in the communities where it is used.

The collaborative process, with its considerable participation by printmakers, raises the question of who is the true author of the print. Cape Dorset printmakers, for example, seek to convey the essence of an artist's vision and are careful not to impose their own styles. In Holman, on the other hand, printmakers exercise greater freedom, while still respecting the artist's vision. The artist has always received the most credit for the printed image, and although printmakers have signed the prints along with the artists, for many years they were not even listed in annual catalogues and were often ignored in books and exhibition catalogues. The importance of contributions by printmakers was finally addressed in a 1991 exhibition at the McMichael Canadian Art Collection.[9]

Some artists are very particular about fidelity to their original drawings, but others are grateful for the printmakers' participation. Pudlo Pudlat of Cape Dorset remarked, "I like the prints better. I never really liked my drawings, and the colours are much better looking in the prints" (Cape Dorset 1978). Pitseolak Ashoona agreed, and said of her drawings, "After they are put on the stone, they are always better" (Eber 1971:67). Although many Inuit printmakers achieve near-technical perfection, southerners are more interested in the imagery of Inuit prints than in their technical execution, and some feel that the character of a "rustic" image is enhanced when it looks a bit rough around the edges.

Inuit printmakers have employed most of the major printmaking methods, including relief, stencil, intaglio and lithography. The method most closely associated with Inuit art is the stonecut (Figure 115), which is a variation of the woodcut or linocut relief method, which also are sometimes used. Stonecut, which was invented in Cape Dorset and utilizes the skills of stone carvers, comes closest to an indigenous Inuit printmaking technique. The stone block is first flattened with an axe, then filed, sanded and painted. Next, a copy of the original drawing is transferred onto the stone, using a tracing and carbon paper. Any background or negative spaces (areas not to be printed) are chiselled away with sharpened files. The stone is then inked with a roller; several methods can be used to apply more than one colour of the oil-based inks. Paper is laid onto the stone and rubbed with a tool called a baren. The stone must be re-inked before each impression; thus, no two prints are exactly alike.

In stencil printmaking, stippling brushes are used to gently pound ink onto the paper through stiff wax paper cutouts; each colour has its own stencil. This method can be used to apply large blocks of solid colour, but it is also ideal for creating subtle effects of graduated colour and shading (see Figure 41). Stencil printing is frequently combined with the stonecut technique (see Figure 114).

In intaglio methods of engraving and etching, the image is incised into a metal plate with a sharp metal tool. In etching, the scratched image is further deepened in an acid bath. Ink is

113 (left)
Jessie Oonark (1906–1985),
Baker Lake
A Shaman's Helping Spirits, 1970
Coloured pencil and felt pen, 76.2 ×
55.6
Winnipeg Art Gallery, purchased
through a grant from BP Canada

A powerful shaman, wearing
muskox horns, attracts many
spirit helpers who surround
and inhabit his body. Oonark
masterfully combined symbol-
ism with a designer's decora-
tive impulse. Her images incline
towards symmetricality (even in
colour placement) but, tempered
by energetic pencil strokes,
they are emblematic, not rigid.

114 (right)
Jessie Oonark (1906–1985),
Baker Lake
Printmaker: Thomas Sivuraq (born
1941)
A Shaman's Helping Spirits, 1971
#9
Stonecut and stencil, 94.2 × 63.8
Musée canadien des civilisations/
Canadian Museum of Civilization

In Baker Lake, printmakers
were encouraged to come up
with the strongest images pos-
sible. They had the leeway to
change colours, vary the inten-
sity of lines, and add or remove
texture. Also, print images are
frequently reversed from the
original drawing, although it is
difficult to detect in this rela-
tively symmetrical image.

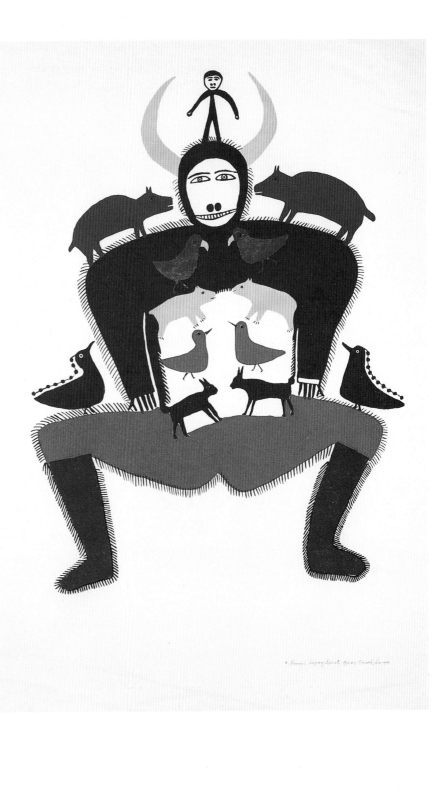

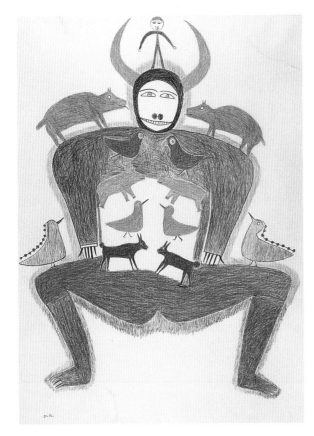

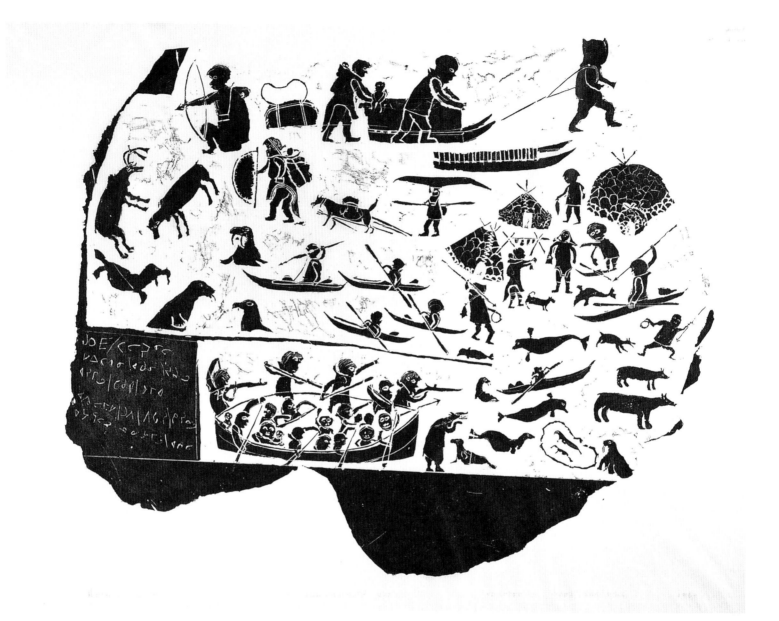

115
Joe Talirunili (1893–1976),
Puvirnituq
Printed by the artist
Hunters Who Went Adrift, 1964
#217
Stonecut, 54.5 × 68.0
Musée canadien des civilisations/
Canadian Museum of Civilization

Talirunili repeats his tale of
marine disaster (see Figure 63)
but adds apparently unrelated
scenes of hunting, camp life
and overland travel. This rustic
stonecut, carved energetically
by Talirunili himself, shows
the trademark of Puvirnituq
prints: the rough edges of the
stone block frame the image.

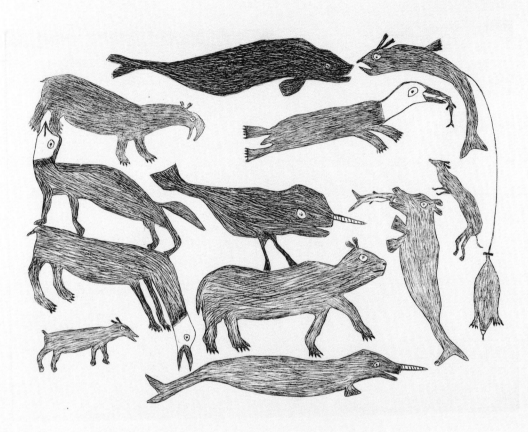

116
Kiakshuk m. (1886–1966),
Cape Dorset
Untitled, 1962 #18
Engraving, 33.9 × 48.5
Musée canadien des civilisations/
Canadian Museum of Civilization

"Because Kiakshuk was a very old man, he did real Eskimo drawings. He did it because he grew up that way, and I really liked the way he put the old Eskimo life on paper. I used to see Kiakshuk putting the shamans and spirits into his work on paper," said Pitseolak Ashoona (Eber 1971).

An old hunter like Parr (Figures 1 and 120), Kiakshuk's interests were wider ranging. Engravings, which offer artists a chance to work on prints directly, exhibit the freshness and vitality of drawings.

forced into the grooves, the surface of the plate is wiped clean, and the image is transferred onto damp paper in a press. Intaglio printing resembles the first demonstration Houston gave to Osuitok on his incised tusk. These methods have been much used in Cape Dorset, especially in the 1960s, with artists drawing directly onto the plates, and printers pulling the impressions in the studio (see Figure 116).

Lithography utilizes a limestone block or metal plate, capitalizing on the natural antipathy of grease and water. The printmaker or artist draws the image directly onto the block with a grease crayon or special inks. The block is chemically treated so that only the drawn areas of the surface absorb ink; it is then pressed with damp paper. Lithography not only allows maximum freedom of line and fine detail but can closely mimic the effects of coloured pencil, crayon and chalk (see Figure 50).

Drawings and Paintings

Drawings and paintings have a rather unusual status in the Inuit art market. For many years, drawings were collected as records of a fast disappearing way of life, and as "image banks" for the print programs; painting, for the most part, was not even attempted. Drawings by the thousands were housed in the archives of print shops, regarded as historically significant but rarely marketable. Occasionally, they were exhibited by public institutions and a few committed commercial galleries.[10] Only in the 1980s did drawings become the object of serious study and public exhibition.[11] But it was the Inuit prints that were introduced first to the public, and they continue to dominate the market for Inuit graphic arts.

In the early years, older men who had retired from the hunt joined women in producing drawings as a way to earn extra income, but today, the art of drawing is dominated by women. Less strenuous than carving, drawing is perhaps considered to be a more genteel occupation. It is certainly easier to draw than carve in a house full of children (although more than one Inuit drawing bears tea and other stains!).

In most regions, the earliest drawings were made in graphite pencil (Figure 117). Felt-tip pens were introduced into several communities in the mid-1960s (Figures 118 and 120), but it was soon discovered that the inks faded with exposure to light. Most artists now work with high-quality coloured pencils, which offer a wide range and intensity of colours while also permitting subtle shading (Figures 112 and 132).

After Peter Pitseolak's brief experience with painting in the early 1940s, that medium was relatively unexplored until the 1970s.[12] Between 1973 and 1977, about ten Cape Dorset artists made some acrylic paintings, usually in combination with coloured pencil and felt-tip pen (Figure 119). A few also experimented with watercolour (and lithography) in 1975. While the works were well received in the south, with over a dozen solo artist commercial exhibitions between 1977 and 1981, the cost of running separate studios in Cape Dorset proved to be prohibitive, putting an end to the painting endeavour.[13]

Drawings reveal the artist's hand: the sureness or hesitancy of line, the strokes of colour and shading from pencil, pen, crayon or felt-tip pen in a drawing are subtleties that are often lost when they are translated into prints. Drawings also tend to have a spontaneity and immediacy that other media cannot replicate. Inuit drawings are not quick preparatory sketches, however, but completely realized works of art.

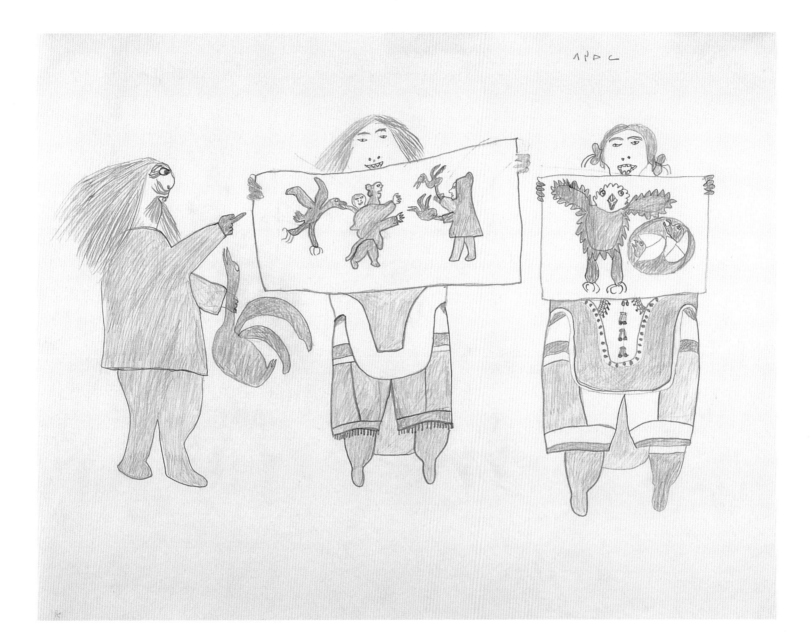

117
Pitseolak Ashoona f.
(1904–1983), Cape Dorset
The Critic, ca. 1963
Graphite, 47.6 × 61.1
National Gallery of Canada, Gift of
the Department of Indian Affairs and
Northern Development, 1989

The man (possibly Ashoona, Pitseolak's husband) is critiquing two drawings by Pitseolak, one probably held up by Pitseolak herself. This charming image is doubly noteworthy: first, true portraits and self-portraits are uncommon in Inuit art; and second, references to art-making and self-as-artist are even rarer.

Josie Pamiutu Papialuk m.
(1918–1997), Puvirnituq
Different Kinds of Birds, 1983
Felt-tip pen, 50.0 × 66.0
Musée canadien des civilisations/
Canadian Museum of Civilization

"Different kinds of animals:
Arctic tern, plover, raven, sea
gull. The birds live everywhere.
When they come back north
they lay eggs in our land."
(Translation of syllabic inscrip-
tion on the drawing.)

Papialuk was a true original,
one of the great Inuit folk
artists. Joyous, naive drawings
and prints (and occasional
carvings) celebrate animal life
and the spirit world with an

unexpected twist: sound, wind
and weather are given visual
expression. These waves, squig-
gles, stars and drops are not
merely decorative devices; they
hold true meaning.

As is often the case with folk
art, the artist's name (translit-
erated in this instance as
Papealook by the artist) figures
prominently.

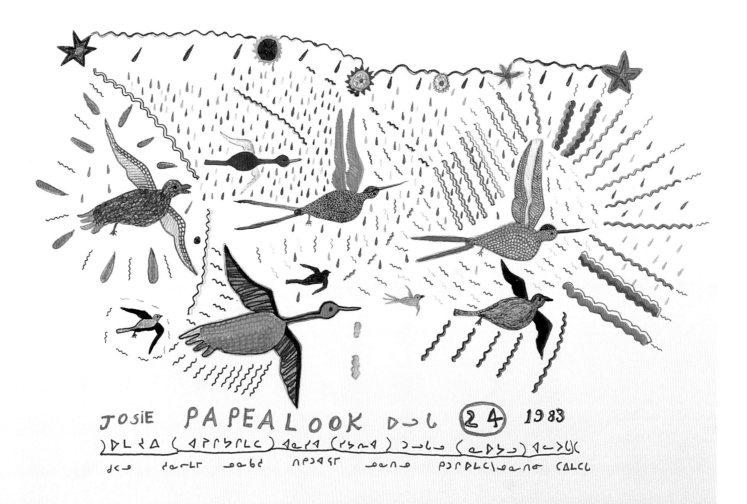

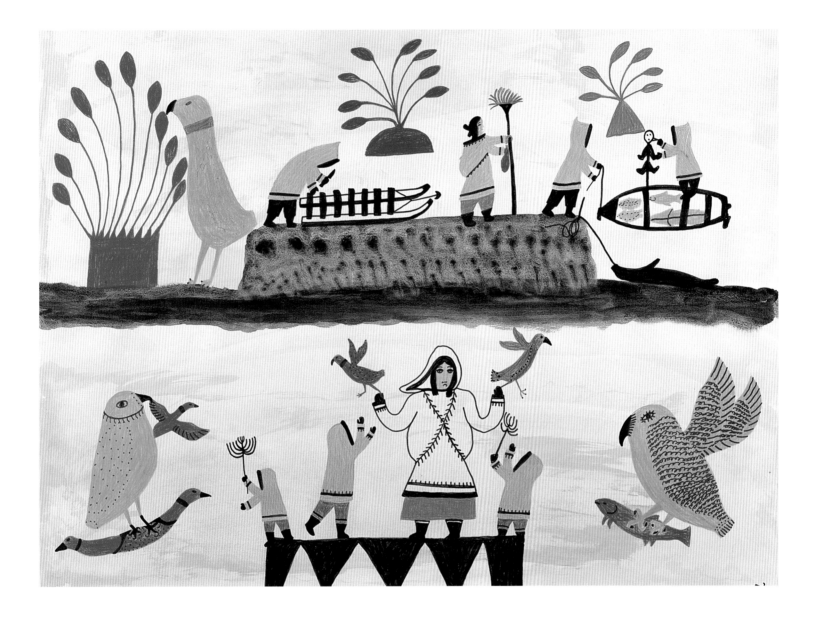

119
Lucy Qinnuayuak (1915–1982),
Cape Dorset
Scene, 1977
Coloured pencil and acrylic,
56.0 × 75.8
Art Gallery of Ontario, Gift of the
Klamer Family, 1978

"I never make my drawings
balance on both sides even
though I try to. After I finish
them, I see that they are only a
little bit balanced," said Lucy
(Cape Dorset 1978:59). In
1977, she reached the height of
her experiments with acrylic
painting, which she learned
from Toronto artist K. M.
Graham. Lucy did, in fact,
achieve a high degree of bal-
anced composition, as well as
her usual playful charm.

Meaning and Aesthetics

> When I first started drawing I would draw realistic images, but it was very difficult. Now I know it doesn't have to be like that. I've seen some drawings done by qallunaat and they are not very realistic. After having seen drawings like that, I feel more comfortable because I can draw any way I want.
> —PUDLO PUDLAT, CAPE DORSET (1991:46)

Early graphite pencil drawings resulted in either outline or filled-in black-and-white images, which may account for the bold and somewhat stark appearance of early prints based on them (Figure 1). The introduction of crayons, felt-tip pens and coloured pencils resulted in an immediate explosion of colour that corresponded to the evolution of techniques in printmaking. The differences between drawings and prints are most apparent in works from the early years, when both artists and printmakers were learning their skills and printmaking options were fewer.

Inuit drawings are often experimental; the artists tend to illustrate their immediate thoughts and change elements as ideas progress.[14] Prints, whose images have been chosen out of hundreds of possibilities, have a more coherent, "organized" appearance. They have a cleaner, crisper look; lines tend to be sharper and thicker, areas of colour more even and bolder, and textures more schematized. Prints may lack the energy and vitality of drawings, but they often have more "punch."

> The stories that are told by the prints and drawings are written well from the beginning to the end but they are condensed in meaning. If you stop and really look at them, they look like they would move. The drawing or print will tell you what the traditions of the Inuit are.
> —THOMAS IKSIRAQ, BAKER LAKE (1986)

The Inuit focus on content, meaning and history over aesthetics is especially evident in their graphic arts, which are more descriptive and narrative than sculpture. While sculpture forces artists to concentrate on a particular subject or activity, two-dimensional art allows them to incorporate larger themes and expand the image. As Iksiraq says, it is easy to tell a story. Where sculpture must often make one part stand for the whole, graphic art can depict a scene in its entirety, although, as Iksiraq points out, it might be "condensed in meaning." Not every Inuit graphic artist takes advantage of these wider possibilities, however. Elaborate camp and hunting scenes incorporating landscape and entire episodes of legends are quite common in Inuit graphics, but so are single, striking images or repetitive ones. Moreover, some artists are more interested than others in aesthetic considerations such as composition, pattern and colour.[15]

The imagery of much Inuit graphic art, particularly the drawings produced by the oldest generation born between the 1890s and 1910s and the prints translated from them, is sometimes called "memory art." Many older men recall their glory days as hunters (Figure 120), while women fondly remember traditional camp life on the land (Figure 31). Those who create simpler images often focus on animals or the spirit world, with symbolic rather than naturalistic treatment. There is usually little or slow stylistic development in the work of the oldest artists, and a tendency to depict variations of a few favourite themes (Figure 121). While it is no longer advisable to label these works as "primitive," there is no denying the primal look of drawings by elderly Inuit. Younger artists are more apt to explore a wide variety of themes, relate precise details of myths and legends, and to experiment with more aesthetic treatments of subject matter (Figures 122 and 133).

120
Parr m. (1893–1969), Cape
Dorset
Bear Hunt, ca. 1966
Felt-tip pen, 50.8 × 65.6
Art Gallery of Ontario, Gift of the
Klamer Family, 1978

Parr, an elderly retired hunter,
was bent on reliving his glory
days through his art. Moving
from graphite to coloured pen-
cil to felt pen, by 1966 he had
developed a freer, more ani-
mated narrative style. Animal

species showed differentiation
and distinct behavioral charac-
teristics. Compare this with his
earlier *My People* (Figure 1).

121
Luke Anguhadluq (1895–1982),
Baker Lake
Fishing and Hunting Birds, 1970
Coloured pencil and graphite,
56.1 × 76.1
Art Gallery of Ontario, Gift of Samuel
and Esther Sarick, 1998

Anguhadluq's hunting scenes
are broad in scope. They are
marked by the rhythmic repeti-
tion of motifs (tents, fish,
fishers with gaffs, fishers with
spears, kayaks) and often mix
aerial, profile and even tempo-
ral perspectives (the kayakers
may be the same men). Here
the focal point is not the lake
but a stone weir constructed to
trap fish.

Mary Okheena (born 1955),
Holman
Printmakers: Mabel Nigiyok (born
1938) and Susie Malgokak (born 1955)
The Strange Drummer, 1992 #21
Stencil, 56.0 × 76.0
Musée canadien des civilisations/
Canadian Museum of Civilization

Okheena is a leading light in
the third generation of Holman
graphic artists; this print ex-
emplifies George Swinton's
description of much new
Holman imagery as "extrava-
gant dramatizations" (Holman
1987). Okheena is creating
theatre: dramatic atmospheric

effects act as a backdrop, and
the fluttering clothes of
shaman and dancer become
costumes.

"THE STRANGE DRUMMER"　　　　　　　21/50　　　　　　　MARY. K. OKHEENA 1992.

One art historian, Marion Jackson (1987), proposes a "two-generation" theory to explain the general stylistic differences between first- and second-generation graphic artists. According to Jackson, many drawings by the first generation are characterized by isolated images often devoid of context, the repetition of motifs, the mixing of spatial perspectives, and the blending of physical and spiritual realities (Figure 29). Second-generation artists, on the other hand, are more self-conscious and innovative because of their early exposure to outside ideas and cultural or artistic values; they are likely to give priority *either* to the presentation of clear and accurate information (Figure 36) *or* aesthetic expression (Figures 48 and 123). Jackson claims that older generation artists, rather than choosing one of these paths, "may be located near the midpoint where content and form most closely fuse." She suggests that the culturally rooted "thinking patterns" of older Inuit explains their style, and that second-generation artists make artistic choices based on new and expanded options. The idea that the "look" of an artwork may be influenced by factors other than aesthetics is important to the study of all Inuit art (see also Lalonde 1995).

In his thought-provoking critical analysis of Baker Lake drawings, author Peter Millard (1995) has used two terms: "syncretism" (the practice of freely combining seemingly unrelated and often incongruous elements in one image)[16] and "meta-realism" (the ability to make thoughts or ideas visible). He suggests that these two practices, together with the much-discussed mixing of spatial and temporal perspectives, are major characteristics of Baker Lake graphics. Millard's concepts could be applied to Inuit drawings and prints in general (and indeed, to some extent, to all Inuit art), though they do not necessarily appear either together or in the work of all artists.

> Those who make drawings, even if they are not photographically correct, do it by recalling and feeling once more the old ways. We know that there are people who can make pictures in the Kadlunak's [white people's] way and are very good at it, but their pictures look as if they were made with a camera, they may be accurate in detail but not good to look at. We are content, we feel that perhaps our way is more difficult, but that our pictures are more sought after.
> —KANANGINAK POOTOOGOOK, CAPE DORSET (1973)

What we see in Inuit drawings and prints is not entirely unique to Inuit art; as Sheila Butler has noted, all peoples must choose how to represent the three-dimensional world on a flat picture plane. Artists have two choices: to attempt an illusion of three dimensions (the Western post-Renaissance method of shading and perspective), or to stress the flatness of the picture plane in some way. Butler observes that most cultures have opted for the latter (Driscoll 1982:13). Inuit graphic art certainly began that way, and while a number of younger artists are adopting the illusionistic approach, the "flat" look of much Inuit graphic art will continue for some time. But Inuit drawings and prints involve much more than pictorial technique; their style and imagery will continue to appear curiously "different" until the older generation dies out and acculturation moves much farther along its course.

COMMUNITY STYLES

As with sculpture, Inuit graphic art is noteworthy not for its homogeneity but rather its diversity, both between and within communities. Images can be singular, repetitive or narrative; static and frontal or "processional," with figures in profile moving across the page. Composition can be symmetrical and ordered, or free and unplanned. Styles range from crude and elemental to

123
Mayoreak Ashoona f. (born 1946), Cape Dorset
Printmaker: Niveaksi Quvianaqtuliaq m. (born 1970)
Shared Vision 1994 #26
Lithograph, 102.2 × 80.1
West Baffin Eskimo Cooperative

Mayoreak and her late husband, the carver Qaqaq, lived in an outpost camp. Her themes range from evocative records of traditional life to emblematic images of animals, of which this is the most striking. She has an ambivalent attitude towards art-making: "I have always wished I could be paid more for the things I make to sell that were valuable in our traditional culture . . . I would like to be able to make money from selling things I can make out of caribou and sealskins instead of selling the drawings I make about those things" (Ashoona 1994:204).

Flight to the Sea Lithograph 24/50 Dorset 1986 Pudlo

124
Pudlo Pudlat m. (1916–1992),
Cape Dorset
Printmaker: Pootoogook Qiatsuk m.
(born 1959)
Flight to the Sea, 1986 special
commission
Lithograph, 56.8 × 76
Musée canadien des civilisations/
Canadian Museum of Civilization

Fascinated with southern technology, Pudlo became interested in flying, as a passenger and observer. Many drawings from the 1970s and 1980s include airplanes and helicopters. But ever the innovator, he gave the aircraft imagery a unique twist by blending it with Inuit transformation iconography.

highly naturalistic; colours from black to bright primary. Themes include all of those found in sculpture and extend to landscape as well. There are community styles and techniques, and the historical development of Inuit graphic arts in a few communities is well documented, but the personal styles of artists are, in the end, more significant.

Cape Dorset

> I will never forget when a bearded man called Saumik [James Houston] approached me to draw on a piece of paper. My heart started to pound like a heavy rock. I took the papers to my Qamak [tent-house] and started marking on the paper with assistance from my love, Johnniebo. When I first started to make a few lines he smiled at me and said "Inumn," which means "I love you." I just knew inside his heart that he almost cried knowing that I was trying my best to say something on a piece of paper that would bring food to the family. I guess I was thinking of the animals and beautiful flowers that covered our beautiful, untouched land.
>
> —KENOJUAK ASHEVAK, C.C. (Ashevak 1993)

As the first Inuit community to produce drawings and prints, Cape Dorset set the standard for Inuit graphic art in the artistic quality of its imagery and the technical quality of its prints, as well as in management and marketing. The early experimental prints were exhibited in 1958, and annual print collections have been marketed since 1959. In workshops led by southern advisors, printmakers experimented with many techniques; copperplate engraving was introduced in 1961, and in recent years lithography has taken over from stonecut as the most popular printing method (Figure 123). Cape Dorset's output has been prodigious—over 100,000 drawings and more than 2,500 editioned prints, including many commissioned and special-edition works. Terry Ryan, first hired as an arts advisor in 1960 and manager of the West Baffin Eskimo Co-operative since 1962, has been credited by many with the co-op's continued success. Fears for the safety of the West Baffin archives resulted in their long-term loan in 1991 to the McMichael Canadian Art Collection in Kleinburg, Ontario, where the images are being catalogued, photographed, studied and exhibited.

Early Cape Dorset prints, based on graphite drawings, were notable for their simple, bold images of animals, spirits, humans and birds, crisply printed in stonecut and stencil against empty white backgrounds. The exuberance of the figures and their lively interaction are striking. While few of the images can be described as naturalistic—they range from the naive, almost childlike drawing style of the elder Parr (Figure 1) to Kenojuak Ashevak's fluid, balanced, emblematic compositions (Figure 28)—they convey the essence and vitality of their subjects. At first, colour was used sparingly though dramatically, but since the introduction of coloured pencils and felt-tip pens influenced drawings, colour has become increasingly important in the prints as well. Pitseolak Ashoona[17] created energetic, colourful images that celebrate traditional camp life and belie the notion that the Arctic is a desolate place (Figure 31). Several of her children, including Qaqaq (Figure 47), Kiawak (Figure 68) and Napatchie Pootoogook (Figure 50) have become well-known artists in their own right.

Pudlo Pudlat, in contrast to most of his colleagues, incorporated modern technology into his imagery. He delighted in the whimsical and incongruous, combining and even transforming airplanes and helicopters with Arctic animals. His *Flight to the Sea* (Figure 124) is an excellent example of "syncretism."

Aqjangajuk Shaa m. (born
1937), Cape Dorset
Printmaker: Iyola Kingwatsiak m.
(born 1933)
Wounded Caribou, 1961 #57
Stonecut, 32.3 × 38.0
Musée canadien des civilisations/
Canadian Museum of Civilization

Aqjangajuk's only print leaves
us wishing he had drawn more,
and begs comparison with his
Caribou Standing on Hind Legs
(Figure 66). The two images
are radically different: the
sculpture is a brutal depiction,
while the print is full of ele-
gant pathos. Yet both animals
are contorted, heroic, vital—
even if the graphic version is in
the throes of death.

Although Cape Dorset art has evolved in aesthetic "sophistication" and printmaking tech-
niques, there is a continuity in the look of the images. Even as younger artists experiment with
landscape or southern-influenced perspective, elders still produce naive yet powerfully evocative
images presented as single, bold figures floating against an empty background. Wildlife imagery
is treated in a variety of ways, from the whimsical to the elegantly stylized, highly detailed and
naturalistic (Figure 125). Cape Dorset drawings and prints exhibit flair, even flamboyance; the
theatricality and extravagance of graphic art (Figure 25) parallels the community's developments
in sculpture. Like Cape Dorset sculptors, the graphic artists are very much individual talents, and
the range of styles and subjects is broad. But unlike carvers, many of the foremost graphic artists
have been women, and their work stands out as being more festive, playful and decorative.[18]

Puvirnituq (Povungnituk)
The artists of Puvirnituq began experimenting with stonecut printmaking in 1961, encouraged
by the accomplishments of Cape Dorset and the success of their own co-operative.[19] Father
André Steinmann, who had helped establish the Povungnituk Sculptors' Society, arranged for
southern artists to teach printmaking techniques. The first Puvirnituq prints were released with
the Cape Dorset collection in 1962. After much of its second collection was rejected by the
Canadian Eskimo Arts Council's jury the following year, Puvirnituq refused to continue submit-
ting prints for review, and conflicts with the Council continued for the next twenty-five years.
In the early 1970s, Puvirnituq helped to establish printmaking in several other Nunavik commu-
nities; unfortunately, this expanded program lasted only a few years. Puvirnituq printmakers
then began experimenting with stencil and serigraphy, but after many years of economic
difficulties, the print program shut down in 1989.

ᏔᏣᎠᎷᏔ ᎷᎠᏗ ᎷᏗᏓᎷᏗᏔ ᏔᏗᏓᏗᏓ ᎷᏔᏓᏗᎷ ᏔᏓᏗᏓᏗ ᎷᏗᏗᏓ ᏔᏗᏓᏓᏗᎷ ᏔᏗᏓᏗᎷᏔᏗᏓᏗ ᎷᎠ ᏗᏗᏓᎷᏓᏗ ᏔᏗᏓᏗᏓᎷ ᏔᏗᏗᏓᏗᏔ
ᏔᏗᏓ ᏔᏗᏗᏗ ᏗᎷᏗᏔ ᏗᏓᎷ

126

Davidialuk Alasua Amittu m.
(1910–1976) Puvirnituq
*Snow House Interior with Fiddler
and Woman,* 1970–1975
Graphite, felt pen and coloured pen-
cil, 51.0 × 66.2
Art Gallery of Ontario, Gift of Samuel
and Esther Sarick, 1998

Famous for his illustrations of
traditional legends (Figure 37),
Davidialuk also made refer-
ences to European cultural
influences, as in this drawing.
The couple lives in an igloo
heated and lit with *qulliit* (oil
lamps), but the man plays a
fiddle and the woman wears
southern clothing.

Like sculpture, graphic art was a male-dominated profession in Puvirnituq, although women made important contributions as printmakers. Early prints (Figure 115) convey the nervous energy and movement of a Kiakshuk engraving (Figure 116), rather than the static, emblematic quality of a Kenojuak (Figure 28). George Swinton has described Puvirnituq prints as folk art, noting that they combine "seriousness, innocence and lack of academic skill" (1978:28). Indeed, the immediacy, vigour and ultimately the charm of Puvirnituq prints derive much from their unsophisticated technical execution, which often lacks the finesse of Cape Dorset work. The images carved into the stone blocks are left rough around the edges, and the resulting prints have the slightly imperfect quality of rubbings taken from old reliefs. The uncarved outer edges of the irregular stone blocks are often left intact, framing the images and forming part of the composition. Many of the artists were often carvers, so they cut the stone blocks themselves. In the lively stonecut *Hunters Who Went Adrift* (Figure 115), Joe Talirunili expanded the sculpted version of the saga of his harrowing experience at sea (Figure 63) to include many details of traditional hunting and camping life, even using syllabic text to describe life on the land. Artists often cut their signatures directly into the borders as well. Black and dark earth tones are the colours of choice. Despite experiments with stencil and serigraphy over the years, the rugged stonecuts remain the trademark of Puvirnituq graphic art.

Given the dominance of male artists, hunting images prevail, though scenes from mythology and camp life are also common (Figures 126, 127 and 128). Robust sulijuk realism carries over from sculpture, its predilection for narrative given full rein in graphic art. Perhaps the most individualistic artist in Puvirnituq was Josie Papialuk; in fact, he (and to a lesser extent Talirunili) might even be considered an "outsider artist."[20] Papialuk not so much rejected as blithely ignored both community and southern tastes, and developed a unique visual vocabulary (Figure 118).

127
Lukassie Tukalak m. (born 1917), Puvirnituq
Printmaker: Caroline Qumaluk (born 1913)
The "Evil Spirit" Tired After Carrying the Man, Sleeps, 1988
#2
Stonecut, 54.5 × 68.5
Musée canadien des civilisations/Canadian Museum of Civilization

"The giant's wife is collecting twigs for a fire to cook the man. Because he is tired from carrying the man, the giant falls asleep. His children try to wake him to tell him that the man is still breathing, but the giant insists that he has already checked. The man opens one eye and plans to kill the giant with the axe." (Translation of syllabic inscription on the print, Povungnituk 1988–89.)

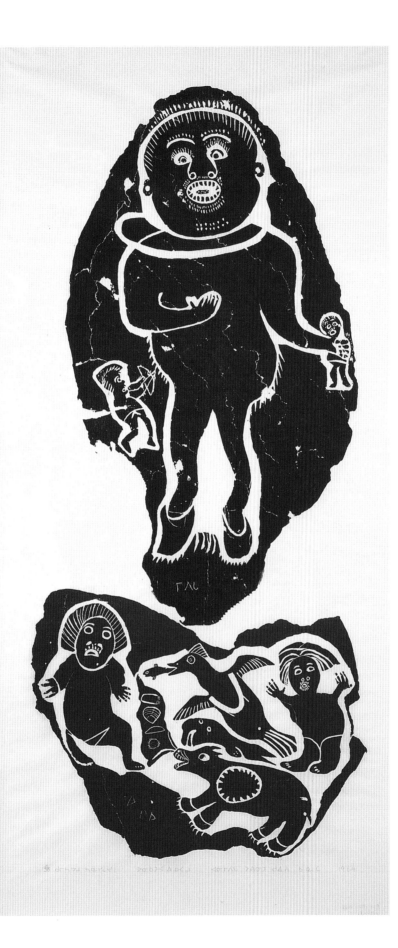

128

Annie Mikpiga (1900–1984),
Puvirnituq
Printed by the artist
The Giant, 1964 #152
Stonecut, 80.0 × 36.2
Musée canadien des civilisations/
Canadian Museum of Civilization

In contrast to Tukalak's print
(Figure 127), the humans here
are no match for the giant.
The bear carries the mark of a
torngnraq ("evil spirit") (Roch
1974:146). Mikpiga, one of the
first women to attempt stonecut
printmaking in Puvirnituq, often
created scenes of hunting and
mythology more disturbing
than those of her male peers.

Holman

Holman is the only Western Arctic community with a printmaking program. Artists began experimenting with drawing in 1960, encouraged by the resident Roman Catholic priest, Father Henri Tardy, who had helped to start the local co-operative. The earliest prints—sealskin stencils similar to those attempted at Cape Dorset—were submitted to the Canadian Eskimo Arts Council in 1962, but a catalogued collection of the prints was not released until 1965. One of the three remaining print programs, Holman has issued collections almost every year since then.

The prints of early Holman annual collections were stonecuts, but they were made by cutting through the actual drawing directly onto a limestone block, thereby destroying the original image in the process. This practice of tracing simple line drawings directly onto stone blocks without the addition of texture, and printing mostly in black or other dark colours, resulted in a reverse silhouettelike or shadow-puppet appearance.

Despite their unadorned printing style, the crisp early Holman graphics are quite spirited; depictions of hunting scenes and animals predominate, supplemented by lively depictions of shamanic rites and contests, dancing and games, and interestingly, a number of violent images. Holman has preserved its Copper Inuit traditions, and the distinctive Western Arctic clothing patterns still give a special look to its prints. Helen Kalvak, the doyenne of Holman graphic art, was trained as a shaman, and she recorded hundreds of stories as well as creating the images that reflect her strong interest in mythology and the supernatural (Figure 129).

The "Holman look" persisted well into the 1970s, even after several artists had begun drawing with more vivid colours; it was gradually replaced by more colourful stencil and lithography techniques. Stonecut prints, once the trademark of Holman graphics, were completely discontinued in 1986, in part because it was becoming difficult to quarry the local limestone. Holman now rivals Pangnirtung in the quality of its stencil technique. By the 1990s, younger Holman artists and printmakers had revolutionized the use of pictorial space, filling the paper with figures and landscape in an almost painterly fashion. Notable among the youngest generation of artists and printmakers is Mary Okheena, whose sense of intellectual detachment from traditional life is summed up in this quote from the 1988 Holman print catalogue: "Sometimes I think of all the ways my ancestors used to live. They would make all their tools and equipment from the animals they killed for food. Everything was handmade." *Strange Drummer* (Figure 122) indicates how acculturated young artists like Okheena have become. The stark and mysterious power of Kalvak's images (Figure 130) has been replaced by dramatic composition, theatrical gesture and tour-de-force stencilling technique.

Baker Lake

Drawings collected in the late 1950s and early 1960s convinced government officials that a graphics program would be successful in the Keewatin community of Baker Lake. Several experimental direct printing workshops were held in the community in the mid-1960s, but it was the arrival of the husband-and-wife artist team of Jack and Sheila Butler in 1969, and their encouragement of separate drawing and printmaking programs, that galvanized the community.[21]

The Sanavik Co-operative was incorporated one year after the release of Baker Lake's first print collection in 1970. A disastrous fire in 1977 destroyed the print shop, and with it the archive of drawings and the entire print collection for the next year. The co-op rallied, and

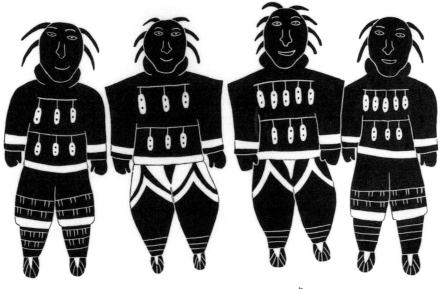

KALVAK

129 (top)
Helen Kalvak (1901–1984),
Holman
Printmaker: Harry Egutak (born 1925)
The Power of Amulets/Atatalgit,
1987 memorial portfolio
Stonecut, 50.0 × 65.0
Musée canadien des civilisations/
Canadian Museum of Civilization

Inuit were careful not to break
taboos and relied on their
shamans to keep them from
harm, but also wore personal
amulets for protection. These
amulets could be small bones
or other animal parts, or carved
figures. This print, part of a
special collection released after
Kalvak's death, is based on a
1965 line drawing.

130 (bottom)
Helen Kalvak (1901–1984),
Holman
Printmakers: Peter Palvik (born 1960)
and Colin Okheena (born 1961)
My Hands, 1982 #11
Lithograph, 28.5 × 38.0
Musée canadien des civilisations/
Canadian Museum of Civilization

Copper Inuit women were tat-
tooed at marriage or before
childbirth, to enhance beauty
and as a form of personal pro-
tection. Lines of tattooing were
made with a needle and sinew,
covered in soot and oil, drawn
under the skin.

Holman, '82 My Hands 35/50 Kalvak RCA/Peter Palvik, Colin Okheena

within a month had begun work on a new collection. After several years of financial difficulties, the print shop was forced to close after releasing the 1990 collection. Beginning in 1996, a program sponsored by Nunavut Arctic College permitted the release of new experimental collections. Baker Lake's best known graphic artists are mostly female, but both men and women were active in the print shop.

The most frequently used printmaking techniques were stonecut and stencil, often in combination, supplemented in later years by serigraphy, linocut and woodcut. The vibrant, unconventional colour sense of Baker Lake drawings has been faithfully translated into the prints: figures are usually outlined in black stonecut and filled in with bright unmodulated areas of stencil, giving the prints a bold expressiveness. Vivid and unusual colour combinations, together with strikingly non-Western spatial organization and mysterious subject matter, are the hallmarks of Baker Lake drawings and prints (Figures 132 and 133).

Because Baker Lake is located inland, the imagery features caribou and muskoxen rather than walrus and whales, the Kiviuk legend rather than the Sedna myth. Although drawings often present isolated single images, many artists attempt to fill the page. Elderly artists like Luke Anguhadluq tend to mix several spatial and temporal perspectives freely in a single image.[22] A former camp leader, Anguhadluq began drawing in his seventies. His handling of spatial relationships is especially noteworthy (Figures 29 and 121); he "orients the world around a central focal point" (Cook 1993:53). Younger artists also may present several episodes of a legend on a single page; their mixing of perspectives, however, is usually for aesthetic reasons (Figure 40).

Jessie Oonark first experimented with drawing in 1959, and her work is remarkable for its vivid colours, its symmetricality, and its synthesis of decoration and symbolism. In *Big Woman* (Figure 131), tattoos, hairsticks, clothing patterns and *ulus* (women's curved knives) are not merely ornamental—they symbolize womanhood. Though a devout Christian, Oonark (whose father was a shaman) frequently explored the realm of the supernatural (Figures 113 and 114).

Younger graphic artists (several of whom are Oonark's children), generally work more narratively and are drawn to a variety of themes: myths and legends (Figure 43), the world of shamanism (Figure 36), spirits and animal-human transformation (Figure 40), and landscape (Figure 112).

Pangnirtung

Printmaking in Pangnirtung was established in 1973 as a territorial government-sponsored co-op project. After several years of financial difficulties, the print shop was forced to close after the release of the 1988 annual collection. That same year, the Uqqurmiut Inuit Artists Association was formed with the intention of bringing art production under the direct control of artists, printmakers and weavers. The group immediately began raising money for the construction of a building to house a new print shop and tapestry weaving studio. The weave shop opened first, and printmaking resumed in temporary facilities in time to release collections in 1992 and subsequent years.

> I've been working at the Print Shop six or seven years, since the printmakers asked me if I'd like to work here. I said yes right away, the same day. My father was proud of me getting a job before I finished school, right here in Pangnirtung, and drawing's been my main goal since I was eight. I started on Marvel comic books, and just kept on practising. I want to show my art, to do what people usually go to art school for, but I never went. Probably now I can do without it.
>
> —ANDREW KARPIK, AGE 23 (Pangnirtung 1987)

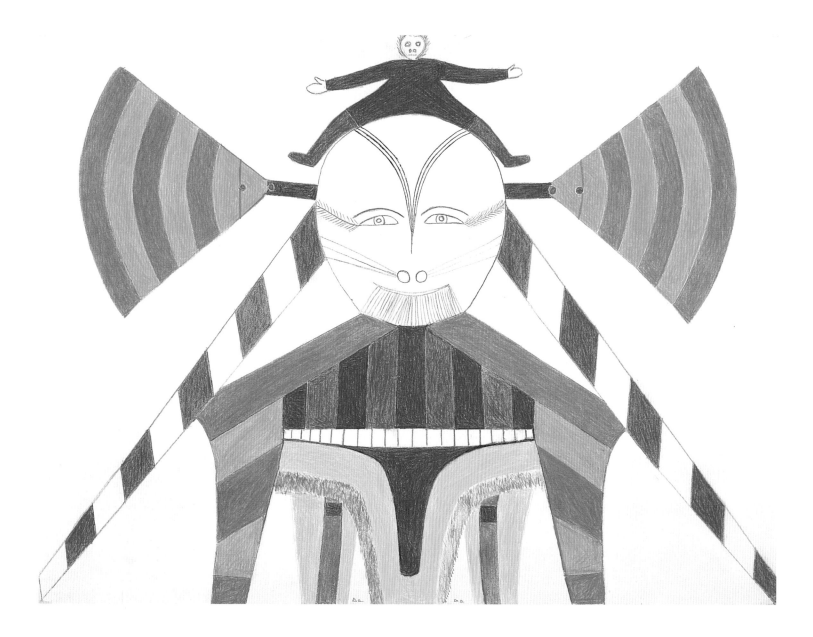

131
Jessie Oonark (1906–1985),
Baker Lake
Big Woman, 1974
Coloured pencil and ink, 56.3 × 76.1
Winnipeg Art Gallery, purchased
through a grant from the McLean
Foundation

The concept of womanhood
pervades Oonark's art. Caribou
Inuit women often wound their
hair around wooden sticks and
wrapped them with strips of
caribou skin. These hairsticks,
the curved *ulu* woman's knife
and women's clothing patterns
are powerful symbols in
Oonark's iconography.

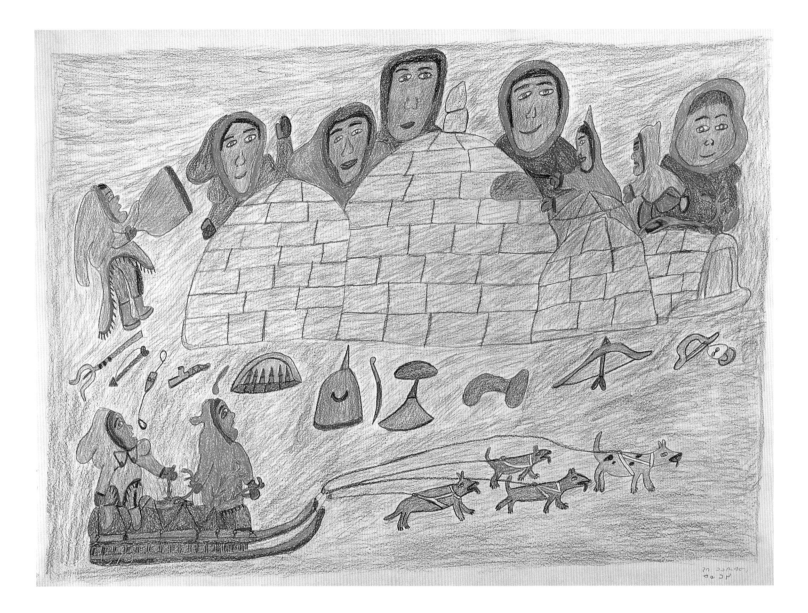

132
Ruth Annaqtuusi Tulurialik
(born 1934), Baker Lake
Christmas, 1982
Crayon and pencil, 58.2 × 80.0
Musée canadien des
civilisations/Canadian Museum of
Civilization

Annaqtuusi depicts the build-
ing of an igloo, various tools,
and the arrival of a great
hunter. Her wide range of
thematic interests includes
mythology, traditional life and
post-contact history. She fills
the page with energetic but
carefully modulated strokes in
blended colours, and some-
times writes speech balloons or
other explanatory text. She
says: "A long time ago all the
people came together during

Christmas month. In those
days they knew about God and
Jesus but did not understand
what it all meant" (Tulurialik
and Pelly 1986).

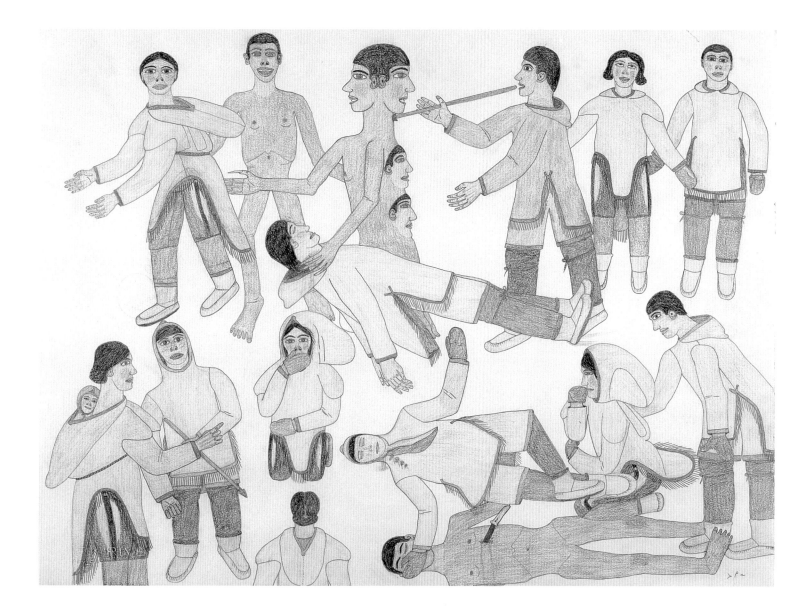

133
Nancy Pukingrnak Aupaluktuq
(born 1940), Baker Lake
Battle with the Green Monsters,
1978
Coloured pencil and graphite,
56.1 × 76.1
Winnipeg Art Gallery, acquired with
funds from the Winnipeg Art Gallery
Foundation Inc.

"These creatures can be killed
through the heart and through
the throat, just as other living
beings are quickly killed in this
way. Even the wolf knows how
to aim at the caribou's throat,"
Pukingrnak says (Driscoll
1982b:73). She invented her
own mythology surrounding
these creatures, which are
inspired by one of her sculp-
tures (Driscoll 1982b:6).

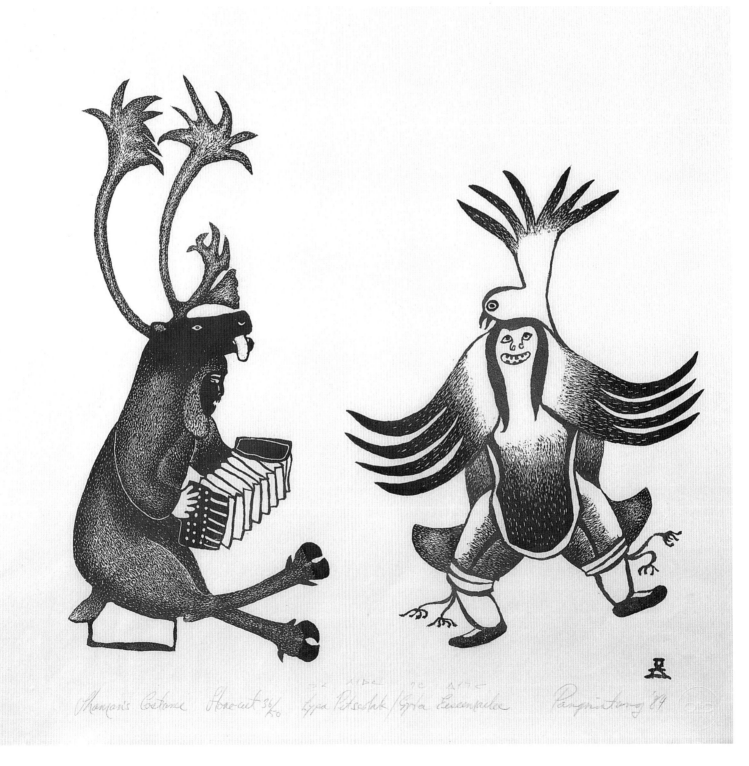

Shaman's Costume Linocut 36/50 Lypa Pitseolak/Gyta Eeseemailee Pangnirtung '84

134 (facing page)
Lipa Pitsiulak m. (born 1943),
Pangnirtung
Printmaker: Gyta Eeseemailie m.
(born 1955)
Shaman's Costume, 1984 #27
Stonecut, 48.5 × 52.0
Musée canadien des civilisations/
Canadian Museum of Civilization

"I do drawings that may not
seem to make any sense at all
to some people because they
are about the really old, old
way of life. My drawings seem
to come from up in the air and
they don't seem to be going
anywhere until I put them on
paper or carve them. The
images might not may sense to
someone who doesn't know
the Inuit way of life," says Lipa
(1983:19).
 Outsiders might be as sur-
prised by the accordion as by
the images of transformation.

The Inuit of Pangnirtung have
been entertaining themselves
with American square dances
and Scottish reels, learned from
the whalers, as long as anyone
can remember.

135
Ekidluak Komoartok m. (1923–
1993), Pangnirtung
Printing: Atelier
Walrus Hunter, 1988 #20
Drypoint etching, 30.0 × 36.5
Musée canadien des civilisations/
Canadian Museum of Civilization

"Not exactly a human, but with
habits somewhat like humans.
The weather is getting worse,
and he is using the storm to
get close to the walrus. From
time to time, things are seen
that cannot be fully explained,
and this was even more likely
to happen in past times. I
imagined this as a sighting of
a spirit hunter of old. This
image is admired by Inuit,
but I wonder if it will be well
thought of in the south," said
the artist (Pangnirtung
1988:28).

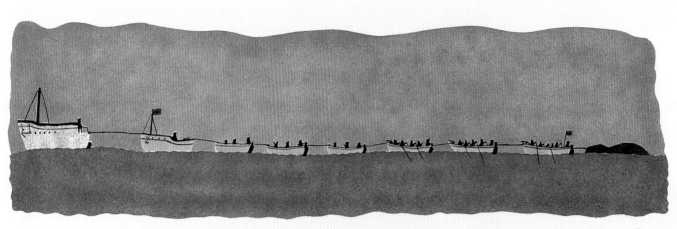

sailing in the Cumberland Sound c.1930's Stencil 37/50 Tommy Novakeel / Kananginaee Toghlile Pangnirtung 1977

"With Open Mind" Lithograph 34/45 Andrew Karpik Pangnirtung 92

136 (top)
Tommy Nuvaqirq (1911–1982),
Pangnirtung
Printmaker: Jacoposie Tiglik m. (born
1952)
*Whaling in the Cumberland Sound:
1930's,* 1977 #10
Stencil, 31.8 × 85.1
Musée canadien des civilisations/
Canadian Museum of Civilization

The last regular Cumberland
Sound whale hunts ended in
the 1920s, with the last suc-
cessful hunt taking place in
1946 (Eber 1989:156–58).
Whaling was replaced by fur-
trapping and trading. The
boats in Nuvaqirq's simple,
evocative image of a bygone
era are beautifully framed by
the wide, richly toned expanses
of sea and sky.

137 (bottom)
Andrew Karpik (born 1964),
Pangnirtung
Printed by the artist
With Open Mind, 1992 #12
Lithograph, 40.0 × 49.0
Musée canadien des civilisations/
Canadian Museum of Civilization

"A shaman would have a cham-
pion animal which he or she
could become . . . Today the
transformation occurs in
humans with an open mind.
You can know so much more
of others' ways of life today,
and learning this, something
you never knew before, this
knowledge becomes part of
you," says Andrew Karpik
(Uqqurmiut 1992:26).

This image would hardly
seem out of place in an old
Arctic travel book, were it not
for a few surprises. The trick is
to find them all. The human
arm is only the most obvious.
The same animal has a caribou
hoof; the other walrus seems to
be sporting a whale's tail. And
the shadow beneath the animal
in front is a tiny dogteam.

Although a few Pangnirtung printmakers quickly mastered the art of the stonecut and have since experimented with etching and lithography, most embraced the stencil technique from the moment they first tried it. Working usually from simple line drawings submitted largely by elders, the printmakers (who are often much younger) must use considerable ingenuity and their own artistic sense to make decisions about colour. In stencil printing, the density of colour application affects not only the brightness of an image but also its sense of volume and perspective. Whereas in Baker Lake prints the stencilled colours are primary, bright and saturated in keeping with the intense colours of many drawings, in Pangnirtung the colour sense is more subtle and muted, with softer blues and earth tones predominating (Figure 41). There is little mixing of techniques; dark outlines, which are generally stonecut in other communities, are often stencilled in Pangnirtung. The stencilled images from this community differ from the technically similar ones of Holman in that they tend to be more isolated on the page and are less likely to be integrated into a Western-style landscape or perspectival context.

Whaling, an important activity in the Historic Period and still remembered by the oldest inhabitants of Pangnirtung, is another popular theme (Figure 136). The many scenes of hunting, camp life and simple pleasures like games, sports and dancing are characterized by a certain innocence, a hint of nostalgia, and a strong sense of community and family (Figure 134). The spirit world, which plays an important role in Pangnirtung sculptural art, inspires more expressionistic graphic approaches (Figure 135). Andrew Karpik, a skilled young printmaker and artist, has developed a strongly naturalistic style honed since childhood. He experiments not only with lithography and intaglio techniques but also with imagery, and his *With Open Mind* (Figure 137) combines meticulously detailed landscape with syncretistic surprises.

■ ■ ■

ANDREW KARPIK is one of only a handful of young Inuit graphic artists (Mary Okheena of Holman is another) who are working in what could be called a post-contemporary approach, expanding the boundaries of their own imagery and styles.[23] Relatively few young Inuit have so far been attracted to the graphic arts, as carving lures many teenagers and young adults with the promise of quick cash and a certain prestige. Graphics programs, on the other hand, still rely heavily on images drawn by a dwindling number of elders. According to Jimmy Manning (1997), assistant manager of Cape Dorset's West Baffin Co-op, many young artists are intimidated by a blank sheet of paper and find it far easier to visualize an image in a piece of raw stone. It remains to be seen if the newest generation of sculptors will be joined by a new generation of artist-printmakers like Karpik.

TEXTILE ARTS

THE TEXTILE ARTS are the domain of Inuit women, a natural extension of their work preparing skins and using them to sew clothing. These were perhaps the most important of an Inuit woman's duties, because survival in the Arctic depended on warm yet breathable and flexible garments. Expertly stitched clothing was a source of pride and even social standing in the community, and techniques were passed down from mother to daughter. Clothes possessed symbolic as well as practical importance. For example, the animals (mostly caribou and seals) who gave up their lives to provide skins for clothing were acknowledged by incorporating anatomical references to them in both the overall design and decoration. In addition, clothing and footwear designs indicated the wearer's regional origin, sex, age, occupation and, for a woman, childbearing status (Hall et al. 1994:xiii). The woman's parka (*amautik*) was made with wide shoulders, a rear pouch and a large hood to accommodate an infant child; the parka's front flap (*kiniq*) was a reference to fertility and birth (Driscoll 1980:14–15). While the clothing created by a particular woman might be identified by characteristic or particularly fine stitching, traditional designs were followed quite closely within each regional group. There was, however, considerable variation between regions, and strangers were instantly recognizable by their clothing (compare the South Baffin styles in Peter Pitseolak's *The Eskimo Will Talk Like the White Man* (Figure 19) with the Western Arctic styles in Helen Kalvak's *The Power of Amulets/Atatalgit* (Figure 129).

As trade increased with outsiders during the Historic Period, Inuit seamstresses began decorating the inner parka (*atigi*) with objects such as glass trade beads and pewter spoon bowls, and using imported cloth for the atigi itself (see Figure 50). Highly decorated, personalized clothing became increasingly important, especially among the Caribou Inuit, where beadwork panels and fringes permitted individual expression for the first time (Figure 139). Today, two forces are at work in Inuit fashion. There is a movement to revive or strengthen traditional sewing techniques and clothing designs; at the same time, many Inuit women have embraced new materials and sewing machines, and are pursuing careers in a fledgling contemporary Inuit fashion industry that blends northern and southern clothing styles.

The design and production of traditional clothing, with its striking arrangements of light and dark fur and skin panels put together with meticulous workmanship, provided Inuit women with the necessary skills to pursue arts and craft production as an economic activity in the early

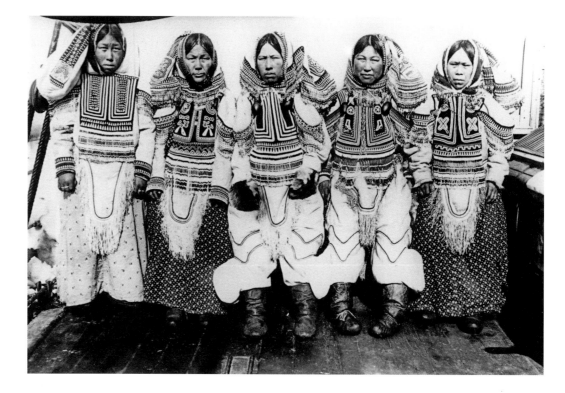

1950s. For example, women on southern Baffin Island, in addition to making parkas, boots, slippers and mitts for sale, produced purses and "skin pictures." Skin pictures were made by arranging scraped sealskin cutouts of animals and objects onto a background of bleached skin; the pieces were generally inset, but were sometimes appliquéd. The graphic artist Kenojuak produced several sealskin bags using this method; one inspired her 1959 print *Rabbit Eating Seaweed*.[1] In Cape Dorset, the making of sealskin pictures was abandoned as women became involved in the graphic arts program.

The art of larger scale textiles developed in Baker Lake (wall hangings) in the 1960s, and in Pangnirtung (tapestries) in the early 1970s. Appliqué wall hangings are currently produced in other Keewatin communities, notably Arviat and Rankin Inlet, in Holman, and to some extent in Nunavik and Labrador. Arviat hangings are especially distinctive, incorporating antler, caribou skin, beads and wool. Various fabric art experiments have been conducted: with weaving in Cape Dorset and Baker Lake for a brief time in the 1960s, with macramé in Taloyoak, and with batik by several Puvirnituq artists in the 1970s.

Doll-making flourished across the Arctic for many decades before commercial production began in the 1960s. Collectors' dolls in traditional skin and fur as well as fabric clothing are generally far more elaborately constructed and sewn than traditional children's dolls, and are made in several communities. Some of the most unusual and best documented dolls come from Taloyoak.[2]

BAKER LAKE WALL HANGINGS

As early as 1950, the Baker Lake graphic artist Jessie Oonark was sewing duffle parkas and other items, some decorated with embroidery figures. When the new government craft officer Gabe Gély saw her drawings and sewing work in 1963, he urged her to produce small wall hangings (Blodgett and Bouchard 1986:30–31). Oonark and a few others sewed the occasional

hanging throughout the 1960s, with the encouragement of Elizabeth Whitton, wife of the local Anglican minister. In the mid-1960s, Oonark's wall hangings were pieced together from duffle, felt, hide and other scraps of material left over from clothing production; they were often decorated with areas of densely stitched embroidery.

Oonark's work set the pattern for future developments in the art form. Her hangings attracted the attention of Sheila Butler, who with her husband, Jack, had successfully revived printmaking in the community. Butler encouraged the serious production of wall hangings by ordering large supplies of cloth and embroidery floss in a variety of colours (Butler 1988). Soon, a government-run sewing shop employed dozens of local women in a successful cottage industry that included the production of wall hangings and clothing.[3]

By the mid-1970s, group and solo shows and major public commissions had established Baker Lake wall hangings as an important Inuit art form, though it took some years before the works completely shed the "crafts" label in the art world.[4] The sewing shop closed down in the 1980s, but wall-hanging production was quickly revived by the private sector.[5] While fabric arts in Baker Lake have undoubtedly been influenced by the advice of southern promoters, their suggestions seem to have been geared towards ensuring technical quality and individuality rather than conformity to outside tastes. Wall-hanging artists pride themselves on their individual styles and sewing techniques.

Like the graphic artists, wall-hanging artists work at home, which gives them flexibility to set their own hours in order to care for their children and grandchildren. Since their homes are not very large, artists have sewn some large hangings without ever being able to spread out the entire work. Baker Lake textile artists (all of them women) employ two quite different techniques, appliqué and embroidery, which they frequently combine in one piece. In appliqué, felt cutouts are arranged on a solid-coloured background cloth (duffle or stroud) and sewn on with a variety of stitches. This method approximates the look, but not the technique, of some traditional clothing panel design. In clothing, skin panels were attached edge to edge, or cutouts were set into corresponding holes in the main panel with no backing material; this traditional inset technique was used occasionally by Jessie Oonark (Butler 1988:97).

The appliquéd hangings are supplemented with outlines, added details or decorative patterns in stranded cotton embroidery thread, either linear (for example, with a running stitch), or with rows of arrowhead stitches, detached fly stitches and sometimes feather stitches.[6] Embroidery can be so dense that it almost obscures the appliqué figure; it can also be used alone on the duffle background in a more "painterly" fashion (Muehlen 1989:10). Embroidery stitching is largely self-taught and experimental.

Although there is some affinity between Baker Lake hangings and graphic art, since several women who sew also draw, the two can also be strikingly different. Most hangings, like drawings and prints, are square or rectangular, but some artists (notably Oonark) have experimented with more unusual shapes. Wall hangings also tend to be considerably larger than drawings; hangings of one to two metres (three to six feet) in height and width are common.[7] Figures in wall hangings are seldom overlapped or superimposed, especially in appliquéd works, and large single figures are rare. Likewise, complex narratives, such as detailed episodes from mythology, are not often depicted in the hangings.

The borders of a wall hanging are clearly defined; while generally delineated with stitching, they can also be incorporated into the design itself (Figure 33). The cloth used for the back-

ground comes in a variety of colours but is usually dark; this means that the understandable but unfortunate equation of white paper background with "snowy wasteland" does not occur.

The Arctic is anything but a wasteland in Baker Lake textile art; it is a riot of colour, an abundance of flora and fauna (Figures 140 and 145). The felt used for cutout figures comes in a range of colours, and two or more colours may be pieced together to form a single figure. In appliqué work, colours are played off each other in striking combinations with little attempt at naturalism (Figure 138), but in embroidery work, subtle and realistic colour combinations are common. The embroidery can and often does create the illusion of depth, thereby enhancing the already three-dimensional quality of textiles.

Some artists arrange and rearrange the appliquéd figures on their background before sewing, while others develop relatively spontaneous compositions (Figure 141). Sometimes one cutout figure will be used as a pattern for others. Many hangings, especially large works, have an ordered, balanced appearance, with symmetrical or tiered compositions (Figure 142).

140
Marion Tuu'luuq (born 1910),
Baker Lake
Untitled (Foliage), 1984–85
Duffle, felt, embroidery floss,
72.2 × 73.9
Musée canadien des civilisations/
Canadian Museum of Civilization

Tuu'luuq switches between fairly organic compositions and structured works; likewise, although most of her work is figurative, she also experiments with symbolic or even semi-abstract designs. The foliage shapes are reminiscent of Kenojuak's designs and Matisse's paper cutouts.

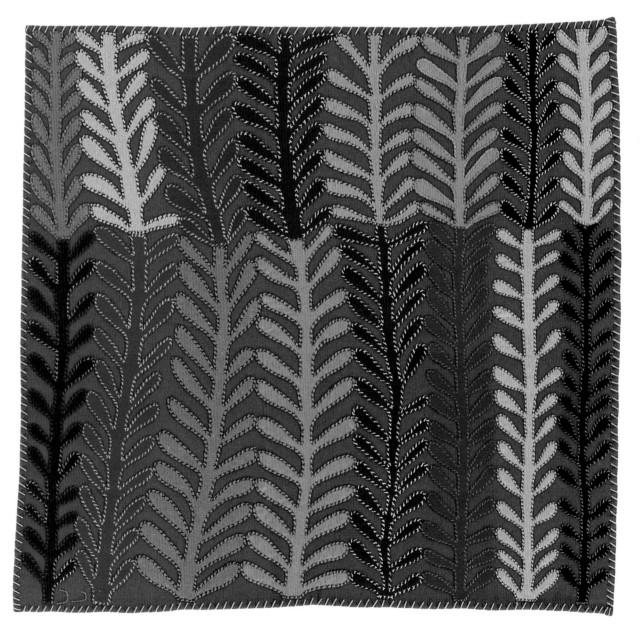

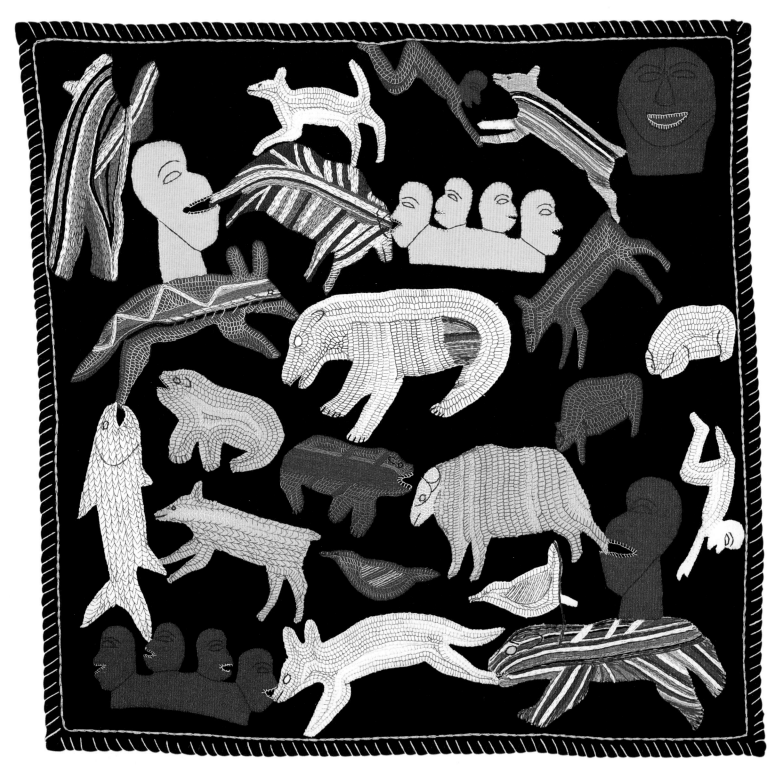

141
Naomi Ityi (born 1928), Baker Lake
Untitled, ca. 1974
Duffle, felt and embroidery floss,
70.5 × 73.0
Winnipeg Art Gallery, Gift of the
Women's Committee

Some Baker Lake hangings have a certain formality of design, but Ityi's are notable for their fluidity and exuberance. Human (or perhaps spirit) figures run around in circles. She makes no attempt to be naturalistic; while the shapes of her appliquéd figures approximate reality, their outlandish colours and patterned embroidery are pure fun.

142

Jessie Oonark (1906–1985),
Baker Lake
*Untitled (What the Shamans Can
Do)*, 1973–74
Duffle, felt and embroidery floss,
185.0 × 177.0
National Gallery of Canada, Gift of
the Department of Indian Affairs and
Northern Development, 1989
Photo courtesy National Gallery of
Canada

Oonark's appliqué hangings
(especially her large ones) are
strikingly ordered composi-
tions, perhaps influenced by
her experience in parka design.
This one has a tiered, almost
processional organization.
That, and the depiction of

shamanic ritual and the inclu-
sion of ulus and other symbols,
give this work the hieratic
quality of an Egyptian frieze.

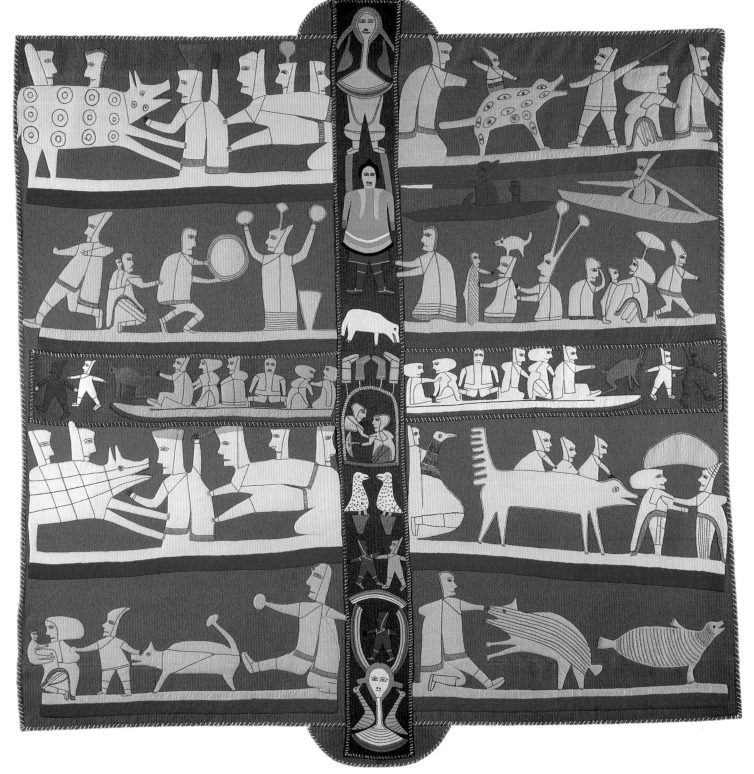

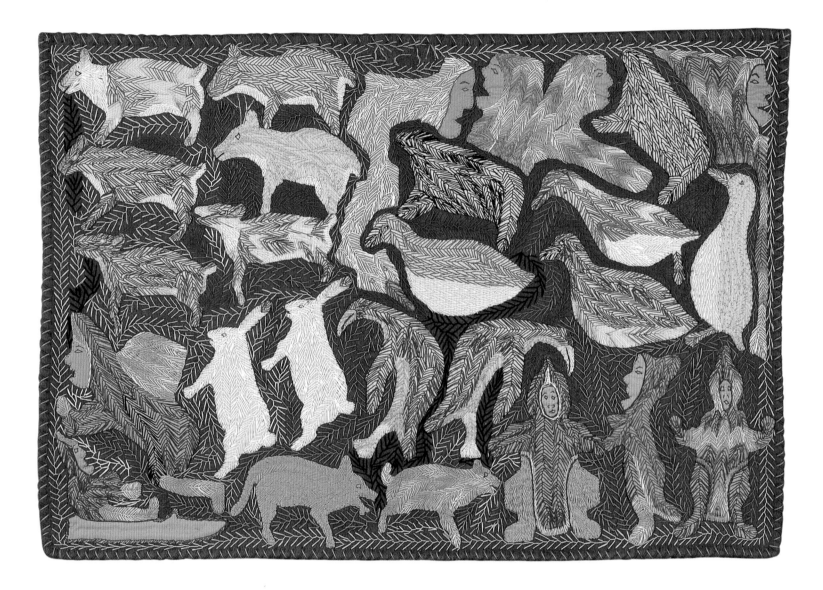

143
Elizabeth Angrnaqquaq (born 1916), Baker Lake
Untitled, 1981
Duffle, felt, embroidery floss and thread, 66.5 × 97.0
Winnipeg Art Gallery

Angrnaqquaq makes heavy use of forward-pointing feather stitching, and here the appliqué figures are embroidered with fur and feather patterns. The entire background is covered with a slightly more open stitch, which has the curious effect of compressing the picture plane. Colour runs wild, and the rustic figures seem trapped in a zany web.

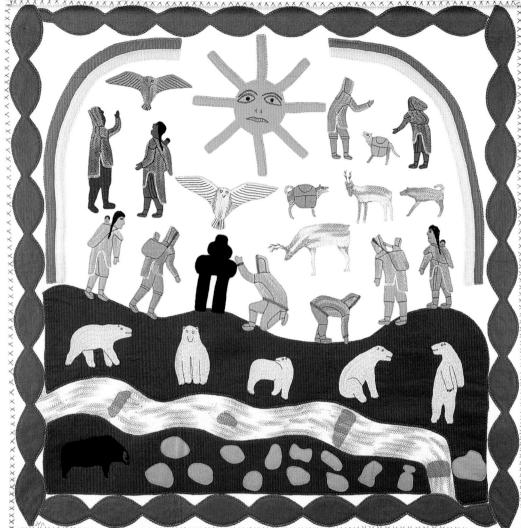

The placement of colour often reinforces this sense of balance.[8] The hangings that are freest in
composition are completely or largely embroidered; they evolve more organically, like drawings
(Figure 143).

The subject matter of wall hangings ranges from narrative or symbolic depictions of tradi-
tional camp life to animals, the spirit world, transformation and mythology; in other words, the
same themes found in Baker Lake women's drawings. Landscape or detailed visions of the land
are particularly important to certain artists (Figures 144 and 145). Curator Bernadette Driscoll-
Engelstad (1994:7) summarizes the strong connection between the artists' femaleness and their
imagery as an "abiding concern with the procreative and transformative powers of people, the
land, animals and nature."

TAPESTRY WEAVING IN PANGNIRTUNG

Shortly after the establishment of the Pangnirtung Eskimo Co-operative in 1968, the federal
government set up an arts and crafts program to foster the development of printmaking, carving
and jewellery making. In 1969, the government contracted a Montreal company to establish a

145
Ruth Qaulluaryuk (born 1932),
Baker Lake
*Four Seasons on the Tundra:
Spring,* 1992
Stroud and embroidery floss, 172.8 ×
119.4
Winnipeg Art Gallery, Gift of the
Volunteer Committee to the Winnipeg
Art Gallery

Long interested in portraying
landscape in her drawings and
textiles, Qaulluaryuk created a
magnificent series of four
hangings depicting the sea-
sons. She developed a special
feather stitch to replicate the
small, delicate foliage of the
tundra. *Spring* shows Arctic
plants flanked by moss- and
lichen-covered rocks.

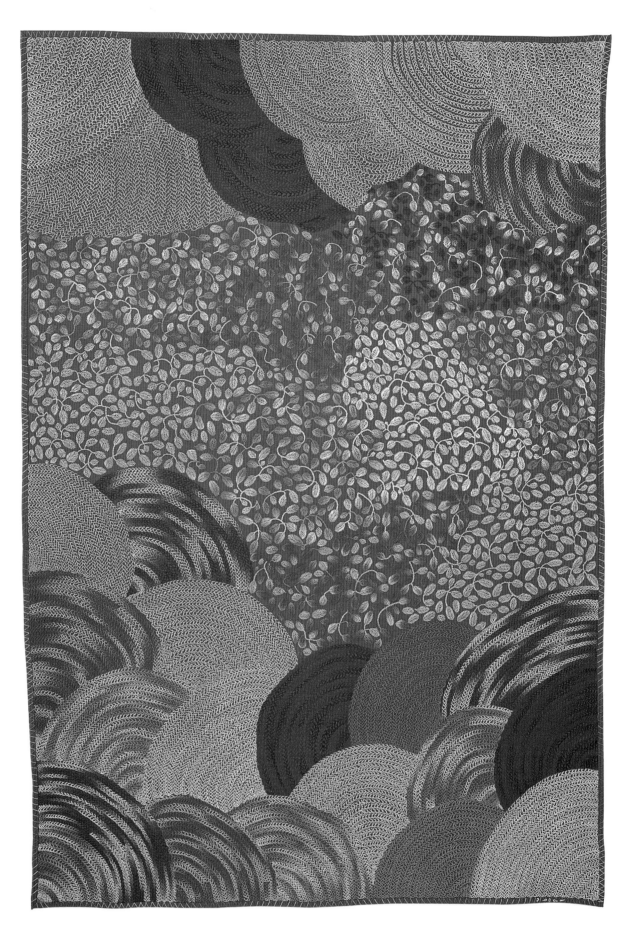

training program in weaving as well.[9] Initially, three women were trained in weaving techniques; interest grew quickly, as there were few employment opportunities for women in the community at the time. Early production items included blankets and sashes, which are still produced by the weave shop, along with sweaters and scarves. In order to recover the high costs of weaving production through the sales of higher priced prestige works of art, the co-op began soliciting drawings from women to be used as designs for tapestries.

The first exhibition of Pangnirtung tapestries was held at the Canadian Guild of Crafts Québec in Montreal in 1972 (Pangnirtung prints did not appear until the following year). Since the late 1970s, annual collections of tapestries have been exhibited all over North America. Discouraged by the closure of their print shop and a lack of secure funding, the artists and printmakers of Pangnirtung voted to take their activities out of the co-op system in 1988, incorporating the Uqqurmiut Inuit Artists Association. The territorial government suggested that the weavers join the association and help raise funds to build a new weaving and print facility in the community. The new weave shop opened in 1991 and has been producing tapestry editions ever since.

The production of tapestries has definite parallels with Inuit printmaking, since weavers, like printmakers, are employees of the shop. Artists submit drawings (graphite, coloured pencil and recently some watercolours) to the weave shop, just as they do to the print studio. The full-scale cartoons for weaving the tapestries are based on drawings selected by the weavers. Artists have a say if they wish, and several have exerted considerable influence, discussing details of an image with the weavers. Nevertheless, weavers generally make the decisions concerning the size, proportions and especially the colours used in images. As well, certain technical limitations in tapestry weaving frequently necessitate the simplification of the artists' lines. In the late 1970s, the co-op decided to create editions of ten to twenty tapestries to capitalize on the more successful images, with different weavers working on subsequent copies according to the original colour schemes.[10] As in Inuit printmaking, there is some question of who should receive more credit for a finished tapestry, especially since the crucial decisions about colour are often made by the weavers.[11] Over the years, Pangnirtung weavers have always had equal, if second, billing.[12]

Like Baker Lake textile art, weaving relies on the patience and dexterity of Inuit women, but the concept and technique of Pangnirtung tapestry weaving is fundamentally different. Unlike the graphic arts and appliqué or embroidery, there is no "background" in that weavers do not apply anything against an empty field; rather, the background and figures develop together as the weaving progresses. Conceptually, this is not unlike traditional Inuit sewing, in which pieces of skin were generally pieced together edge to edge.

Pangnirtung tapestries are created on horizontal floor looms, using a combination of traditional European Aubusson and North American methods.[13] A full-scale cartoon, enlarged from the original drawing, is traced onto the horizontal warp threads, and various colours of wool yarns are used in a discontinuous weft method utilizing several bobbins. Weavers also experiment by twisting together yarns of different colours to create new and subtle combinations, which leads to small differences between tapestries in the same edition. Textured yarns are used sparingly; Pangnirtung weavers pride themselves on simple, clean lines. The tapestries are so carefully woven that they are practically reversible. They generally range in size from less than one to almost two metres (three to six feet) in height and width, though a few larger works have been produced as special commissions.

146
Malaya Akulukjuk f.
(1915–1995), Pangnirtung
Weaver: Olassie Akulukjuk f. (born
1951); original weaver: Kawtysee
Kakee f. (born 1955)
Children at Summer Camp, 1980
Wool, 118.5 × 111.5
National Gallery of Canada, Gift of
the Department of Indian Affairs and
Northern Development, 1989
Photo courtesy National Gallery of
Canada

This tapestry is indicative of
the level of complexity of
weaving imagery and of the
refined weaving technique in
Pangnirtung. Kawtysee has
brought a delicate colour sense
to Malaya's line drawing. The
soft blues and greys of the
patchwork tents, and slightly
more contrasting figures, are
set against warm landscape
tones.

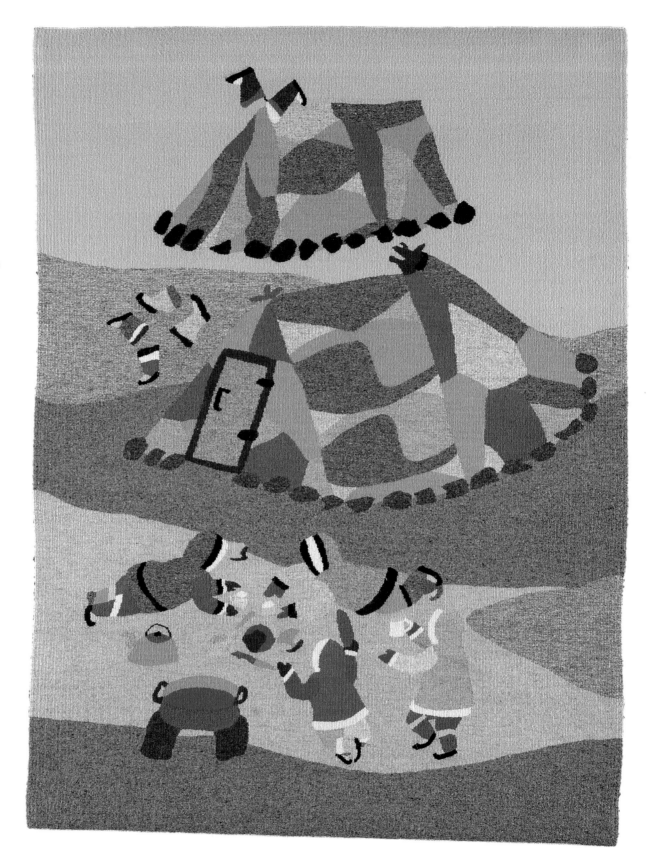

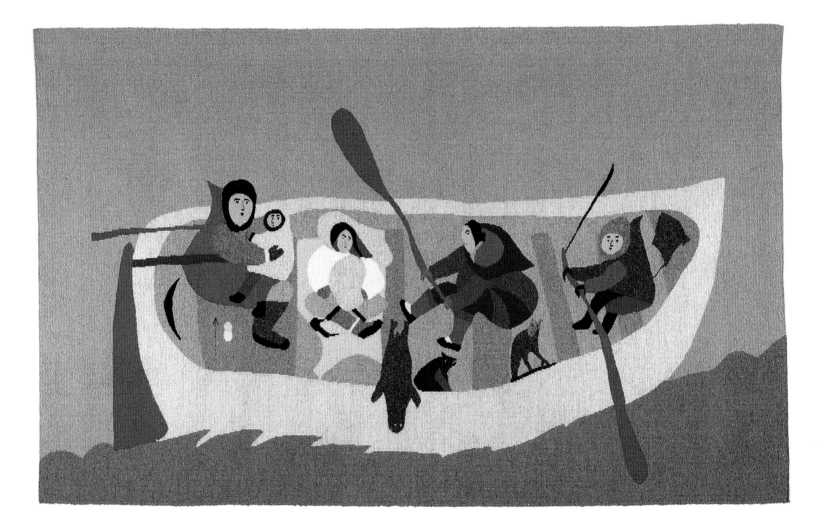

147
Annie Kilabuk (born 1932)
Pangnirtung
Weaver: Kawtysee Kakee f. (born 1955)
Umiaktuqtu—Boating, 1981
Wool, 114.0 × 187.5
National Gallery of Canada, Gift of the Department of Indian Affairs and Northern Development, 1989
Photo courtesy National Gallery of Canada

Kilabuk manipulates the picture plane to present simultaneous aerial, profile and frontal views of the boat and its occupants. The effect is humorous, as it makes the boat appear to be capsizing. The beautifully modulated colour by weaver Kawtysee almost approaches the sensitivity of stencil prints (Figure 136).

With her drawings, Malaya Akulukjuk laid much of the groundwork for both the Pangnirtung tapestry and print programs, truly dominating the development of tapestry imagery. Malaya, who was also a shaman, contributed ten bold drawings of spirit creatures to the first tapestry collection alone. The earliest tapestries consisted mostly of single, striking images, but by the late 1970s had shifted to the depiction of larger, more complex scenes with animal and human subjects, often set in simple landscapes. Occasionally, single animal and spirit creatures, and more recently, pure landscapes are depicted. The fact that the weavers are all women has influenced their choice of imagery, which usually revolves around narrative or descriptive camping and family themes (Figure 146).[14] Pangnirtung's long association with the sea also provides inspiration for tapestries (Figure 147).

Pangnirtung tapestries resemble Baker Lake hangings in one respect; their "backgrounds" are only rarely white, and even then, the shades of white are modulated. Weavers take advantage of the choice of yarn colours and blending techniques to create subjects and settings which conform to the natural colours of animals and the environment: blues, greys, browns, greens and whites predominate. As in Pangnirtung prints, there is an atmosphere of nostalgia: colours are somewhat muted and blended, complementing rather than contrasting with each other.[15]

■ ■ ■

WHILE TEXTILE ARTISTS are experimenting and expanding their range of imagery, wall hangings and tapestries are more conservative art forms than sculpture and the graphic arts in terms of technique. The textile art of Baker Lake, especially, is rooted in women's traditional sewing and design skills. The women who create these works, and those who love and buy them, appreciate the old-fashioned qualities of patience and attention to detail that perhaps do not necessarily fit with "modern" ideas of innovation. The question is whether or not the newest generation of Inuit women will have the desire or skills to carry on these traditions.

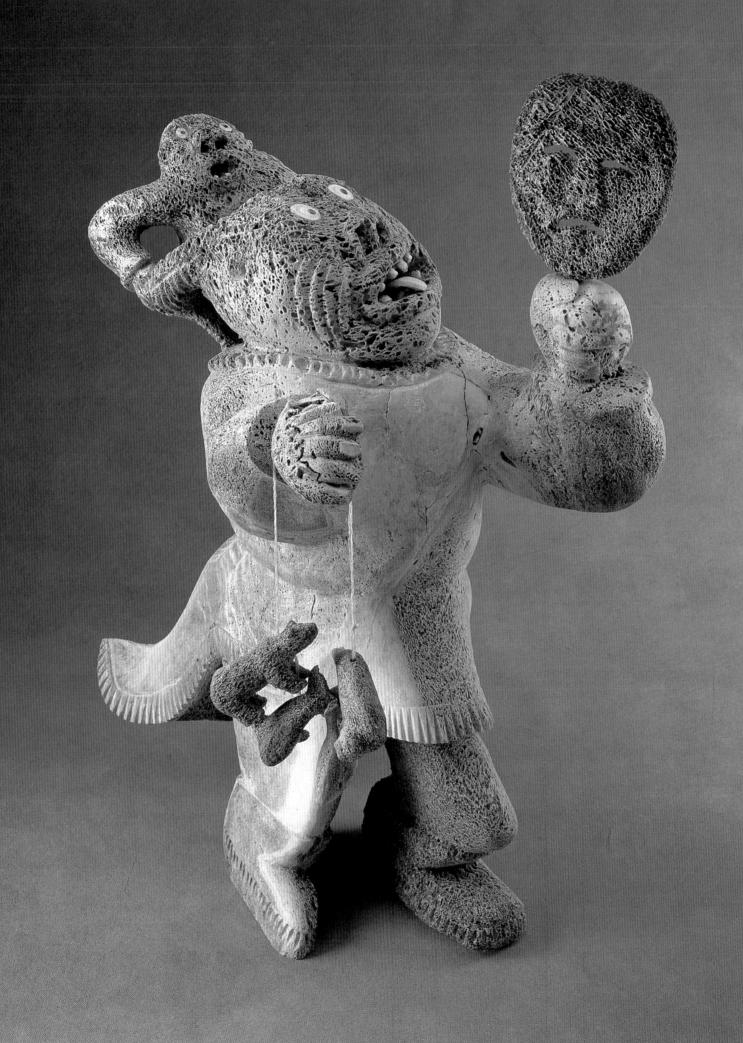

ART AND INUIT IDENTITY

We have to keep our language, our stories, and our identity alive . . . The world has to learn about the Inuit and their culture and traditions, so that they will not be forgotten.

—URIASH PUQIQNAK, GJOA HAVEN[1]

COMPARED TO COLONIAL EXPANSION in southern Canada, the move into the Arctic by Europeans and Canadians has been remarkably peaceful. But while government policies toward Inuit have been relatively benign, there has never been any doubt about who was in control. Inuit have been forced to adapt to extremely rapid and far-reaching changes.

Contemporary Inuit art is, in a sense, a visual record or reportage of Inuit life in the twentieth century, a compendium of ideas regarding traditional beliefs, spirituality, values and cultural change. Although Inuit art was never meant to be a vehicle for culture preservation or affirmation, it has become a powerful means of recording and transmitting traditional culture and traditions. The cultural legacy of Inuit art was not widely appreciated in the first twenty years of the contemporary period. Only in the past two decades have Inuit artists and southern art specialists realized that, in the absence of a large body of recorded music, poetry, literature and historical writing by and for Inuit, the visual arts have preserved an enormous amount of cultural information. Because the art of the Inuit so strongly reflects their traditions and beliefs, much of what is known about Inuit culture has been directly related to the interpretation of works of art.

Like Uriash Puqiqnak, many visual artists strive to convey as much cultural information as they can, as a way of preserving traditions for their children—even though, paradoxically, most Inuit works of art end up in the south, never to be seen again.[2] Perhaps displaying their culture through their art has afforded Inuit a way to hang on to the past in the face of rapid cultural change.[3] In the early years, when they had no clear sense of the outside world, what else could they have portrayed? The old Inuit customs must still seem more "real" than some of the new southern ways, so arbitrarily imposed by outsiders. It is only recently that Inuit have come to understand southern culture, largely through television, and even then only a very few meet it completely on its own terms. Through their exposure to many outside influences—commercial, governmental, educational and aesthetic—Inuit have invented a new kind of art, one made for export but culturally relevant and truly communicative.

148
Judas Ullulaq (born 1937), Gjoa Haven
Shaman with Amulets and Ceremonial Mask, 1985
Whalebone, antler, grey stone, sinew, 30.0 × 54.2 × 36.3
Art Gallery of Ontario, Gift of Samuel and Esther Sarick

Ullulaq, having absorbed and modified his nephew Karoo's style, is the Kitikmeot's pre-eminent carver. Here, the subject, style and material (carved and assembled masterfully) fuse to give a striking depiction of shamanic ritual, tempered with humour. The shaman-mother chants and dances, her parka flap flying, while her child hangs on for dear life.

The question is how Inuit will choose to use their art. There is little record of Inuit art in the north itself. Not only are the artworks themselves mostly in southern collections, but the majority of written and visual resources concerning Inuit art are housed in southern archives. This is not, however, a case of exploitation, theft, or misappropriation on the part of outsiders; it is simply a logical outcome of the peculiar history of Inuit art production, marketing and research.[4] It will be up to Inuit and other Canadians to decide what Inuit themselves can learn from Inuit art. As one group of Inuit, the residents of the new territory of Nunavut, move to control their political destiny, it will be interesting to see if they view Inuit art as an important expression of their culture.

THE PLACE OF INUIT ART

Contemporary Inuit art, like traditional and contemporary First Nations art, has been officially and unofficially embraced as a shining example of Canadian culture, both at home and on the world stage. Canada, a young country with an ongoing identity crisis, has adopted Inuit art as its cultural symbol of the north, which plays an important role in the nation's mythology.[5] Anthropologist Nelson Graburn (1986) has suggested that the desire to distinguish Canadian from American culture, a growing confidence after the Second World War, and the need to assert sovereignty in the Arctic during the Cold War (when the U.S. was building DEW Line stations on Canadian soil) all added impetus to the Canadian government's promotion of Inuit art in the 1950s.[6] The combination of an art form with a "northern" flavour, clever promotion and marketing, and political and bureaucratic support has resulted in a high degree of acceptance (though not any great understanding) of Inuit art as a quintessentially Canadian symbol.

Is Inuit art then part of Canadian art? A glance through any survey of Canadian art will show that Inuit art is seldom represented as part of the mainstream. Although Inuit art was embraced by the Winnipeg Art Gallery and the Canadian Museum of Civilization (then the National Museum of Man—a history and ethnology museum) in the 1960s, it took another two decades for other major institutions like the National Gallery of Canada and the Art Gallery of Ontario to follow suit. The fact that there are separate curators of Inuit art in these institutions may be an indication of Inuit art's importance, or it may demonstrate that mainstream curators are so far unable or unwilling to deal with it.

Inuit art has always been very much a "popular" art. Few contemporary art forms can claim such wide acceptance. The reasons are perhaps obvious: it has the lure of the exotic or "other"; its materials and variety of forms are aesthetically pleasing; much of it has undeniable emotional impact and spiritual content; and most of its subject matter is understandable and universal. In short, unlike much modern contemporary art, it is accessible, as most people can relate to some aspect of it.[7] Inuit art has few pretensions—it does not attempt to be intentionally profound; it is made by folks, for folks. It is not self-referential like so much of modern art, it is not elitist, and only rarely political.[8] Inuit art's initial success was no doubt due largely to its "primitive" look and clever promotion, but its other attributes have maintained its status over five decades.[9] Benefiting from generous government assistance over that period (much to the envy and consternation of its critics), Inuit art has developed from anonymous curio in the early 1950s to an art form created by celebrated Canadian artists and hailed as one of Canada's cultural treasures.

Almost from the beginning, however, Inuit art has been dogged by the criticism that the whole enterprise is one giant government welfare project and the nagging fear that somehow the art form is not really "authentic," in either its ethnicity or its artistic merits. The anthropologist Edmund Carpenter (1973:194), one of Inuit art's most vociferous critics, wrote: "Can the word 'Eskimo' legitimately be applied to this modern stone art? I think not. Its roots are Western; so is its audience." There are, however, numerous historical examples of peoples making art and artistic objects for export. Moreover, there is the physical evidence of the artworks themselves and the many gifted and inspired Inuit artists who live their culture through their work. The work could hardly be *more* "Eskimo."[10] Some critics (and even some Inuit) hold the view that only artists of the older generation are "true" Inuit artists, that younger artists, talented though they may be, lack the essential life experiences of their grandparents. The young artists themselves will have to prove these people wrong.

The fact that Inuit carvings are marketed in airport gift shops as well as housed in major public galleries has added to this uncertainty; it is difficult to accept that some Inuit art is "fine" art and some is mundane souvenir art.[11] This dilemma would resolve itself if we chose not to treat Inuit art as a single body. With its wide range of regional, community and personal styles, its various media and themes, and the different life experiences of three generations of artists, it in fact involves several overlapping categories: fine art, folk art, tourist art, ethnic art (and perhaps Canadian art). The greatest examples of Inuit art outgrew their "ethnic" label long ago; like much so-called ethnic art, the work that relies most heavily on ethnicity for its appeal is often fairly mediocre. For their part, Inuit artists make few distinctions, and would probably be surprised at these quibbles over categories.[12]

While Inuit art has been embraced (some would say appropriated) as part of Canadian culture, it is treated quite differently from "southern" art in museum and academic settings. Inuit art objects are rarely exhibited or discussed in complete isolation; there is generally an effort to explain the objects in the context of traditional or contemporary Inuit culture, often by interviewing the artists themselves.[13] Since Inuit art is *not* a Western art form, it should be treated by different aesthetic and other criteria, but given today's ideological minefields, curators choose a course at their peril. To discuss Inuit art in terms of Western concepts of style and art history is to be accused of ethnocentrism and cultural assimilation; yet to treat Inuit art separately from Canadian art is to be accused of ghettoizing it and pandering to political correctness. The issues are further complicated since Inuit art is more or less a contemporary art form and not a "traditional" one, and since it is created almost purely for the consumption of the culture that studies it.[14]

The relationship of Inuit art to anthropology is an uneasy one, perhaps because of attitudes like Edmund Carpenter's. And anthropologist Nelson Graburn, who has devoted much of his career to studying contemporary Inuit art, has been criticized for his "social science approach" in attempting to come to grips with Inuit aesthetics. Graburn (1976:55) suggests that many works of Inuit art have "risen above souvenir art and [have] become works of a 'commercial fine art.'" Inuit art historians, however, feel very strongly that the best of Inuit art is fine art, period.[15]

Almost every aspect of Inuit art challenges preconceived notions and definitions of "art" and "artist," forcing us to rethink our positions on the meaning of art traditions, artistic motivation and freedom, and creativity and innovation.

The status of the individual artist is not entirely clear, either. The Inuit artist is not a "primitive" and not an anonymous craftsperson. There are many hundreds of good and ordinary talents, and a surprising number of great ones. The majority of Inuit artists are known by name, although unfortunately in the early years, indifference and poor record-keeping resulted in many works being unattributed. To add further confusion, because of the nature of the Inuit art "experiment," there exist many single outstanding works made by artists who discontinued their efforts for one reason or another.

The social status of the individual Inuit artist has also evolved over the years. In the south, where individual achievement is paramount, certain Inuit artists have become stars. In the north, the best artists sometimes enjoy a status roughly equivalent to that of good hunters or seamstresses; they are seen as highly skilled and excellent providers for their families, and do not necessarily view art as a special vocation.[16] Other artists feel acute embarrassment at their inability to hunt or find a "real job." And because the Inuit tradition of sharing is still strong, even the most successful artists do not have an appreciably higher standard of living than their relatives. Certain of the younger artists, however, especially post-contemporary artists, do see art as a vocation, much as southern artists do.

> You have asked many questions. Now if I may, I have something to ask you, and I will ask you only the one question. What type of carving do people in the south want to buy?
> —ROMEO EEKERKIK, ARVIAT (Driscoll 1982b:29)

This question, posed by carver Romeo Eekerkik, is one that has been asked of almost every researcher who has talked with Inuit artists. Inasmuch as many Inuit artists make art because they enjoy it and have something to communicate, they *all* produce it to earn a living. Art-making has brought more money into the pockets of Inuit than any other industry in the north; although it may not always be lucrative, it is a relatively steady source of part- or full-time employment in a region where "real jobs" are scarce. Perhaps 20 per cent of the adult population is employed to some extent in the Inuit art industry; in some communities, the percentage is considerably higher.

Inuit art is essentially a cultural export commodity; it has been so for some two hundred years, and particularly in the past fifty. Although some artists stubbornly follow their own creative path, most are keenly aware that outside tastes and markets directly affect their livelihood, and they want some feedback. Inuit artists are eminently pragmatic; most do not produce work that they know will have difficulty in selling. At the bottom end of the scale, the infamous quickly made "bingo" carvings[17] are still being made, but even the most celebrated carvers will produce a work they know is easily salable if they need money urgently. Carvers, especially, know the value of their work and often create one or more major pieces with the purchase of a new snowmobile or outboard motor in mind. While immediate need is the motivation behind many artworks, Inuit art-making is not a purely venal activity. The late Margaret Uyauperq of Arviat put it quite eloquently: "When I began carving I used to think of my children, how they were going to get food and clothing . . . Also I looked at other carvers, and really loved them because they were trying to do the same thing . . . I think of my family, that they need something, they need food, they need to survive . . . I have to help them . . . I do not carve only for money, but to help the family."[18]

The "economic" importance of art-making to Inuit is best seen in that light. Inuit existence has always been about survival. Uyauperq's generation vividly remembers starvation and deadly epidemics. Life is more secure for her children and grandchildren, but it is still hard. Perhaps some day Inuit artists will have the luxury to think about making money for their own sake, and making art for art's sake; in the meantime, the two remain inextricably bound together for the vast majority of Inuit.

In the final analysis, it should not be important if the immediate motivation behind Inuit art-making is monetary or artistic; it is the result that counts.

THE FUTURE: TRADITION OR INNOVATION?

If images of the past continue to be a powerful attraction for both Inuit artists and the outside market, then change will come slowly to the art. While Inuit culture might seem anachronistic to some, to others it remains a powerful tradition. Younger artists are caught in a difficult situation, as their attachment to the past is more tenuous.

Art history can be a boon or a burden. Early contemporary Inuit artists, participating in the creation of a new kind of art, made choices that determined how the art would develop. Younger artists, following fifty years of modern art-making, and increasingly under southern influence, must also make choices. Will they choose the path of tradition or the path of innovation? Will they reaffirm old ideas or simply mimic them? Or will they shift more towards Western ideas and ideals? And having recognized the cultural importance of their art, will new generations of Inuit continue to make art only for export, or will they begin to make art for themselves?

149
Eegyvudluk Pootoogook m.
(born 1931), Cape Dorset
Dog Spirit, 1960–65
Black stone, 20.8 x 31.6 x 12.4
Winnipeg Art Gallery, Twomey
Collection, with appreciation to the
Province of Manitoba and the
Government of Canada

"These creatures have been seen mostly by shaman people . . . I myself have seen a seadog that was black. It came up through a crack in the ice. It sat on the ice for a while and moved like any other ordinary dog . . . I'm not trying to put down the Fish and Wildlife Officers, but the Fish and Wildlife Officers have never heard of these creatures," says Lipa Pitsiulak (1983:13–14).

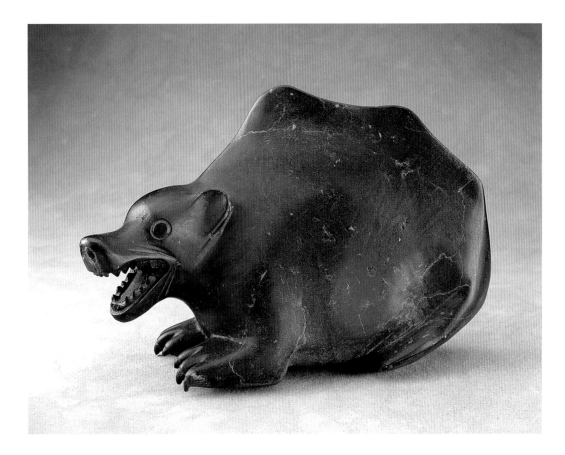

CHAPTER 1
THE ARCTIC AND THE INUIT

1 For a frank discussion of the "colonization of the Arctic" from an Inuit perspective, see Ipellie (1992) and Tagoona (1975).

2 The Inuit (Eskimos) of Greenland and Alaska have had similar experiences, and are more assimilated than Canadian Inuit. They, too, have traditional and contemporary art forms, but these are beyond the scope of this book. For discussions of Greenlandic and Alaskan Eskimo art, see Kaalund (1979) and Ray (1977, 1981, 1996).

3 This area constitutes about a third of the land mass of Canada, or an area about the size of Argentina. Baffin Island alone is larger than California and is almost the size of France. The Inuit community of Baker Lake (Qamanittuaq), 2500 kilometres (1554 miles) northwest of Toronto, is actually the geographical centre of Canada. On April 1, 1999, the Northwest Territories will be divided in two. The eastern portion, where most Inuit live, will be renamed the Territory of Nunavut ("Our Land"). By virtue of population dominance, Nunavut's Inuit will have de facto political control of their homeland.

4 It is possible that John Cabot met Inuit if he landed in Labrador in 1497, and Portuguese fishermen may have had contact with Inuit in the early sixteenth century.

5 See Eber (1989) for a fascinating look at Arctic whaling from the perspective of Inuit oral history.

6 Qallunaaq (plural qallunaat) is the Inuktitut term for Europeans and other non-Inuit, derived from the word qallu, which means "eyebrow" and "body hair." Possibly the Inuit were impressed by the bushy eyebrows and greater hairiness of the Europeans. Other spellings include kadlunak and kabloona.

7 Culturally distinct from Indians, Inuit do not fall under the jurisdiction of Canada's Indian Act of 1876. However, in 1939 the Supreme Court of Canada ruled that Inuit were entitled to the same government health, education and social services as Indians. The federal government began acting upon this ruling after the Second World War. Inuit were given the right to vote in 1950.

8 Polio, tuberculosis and other diseases ran rampant in the Arctic throughout the 1930s, 1940s and 1950s. For a time the mortality rate among Inuit was twenty times the national average. In 1953 almost 3,000 Inuit were living in tuberculosis sanatoria in the south; the average stay was twenty-eight months (Staples et al. 1993:5–7).

9 Canada's Inuit population reached an all-time low of about 8,000 in the 1930s due to starvation and disease. Today, Inuit have one of the highest birth rates in Canada, and modern medicine has drastically reduced infant mortality as well as eliminating the scourges of influenza and tuberculosis.

10 The late Cape Dorset artist Pitseolak Ashoona said: "I don't remember the drum dances; I only remember the accordion dance" (Eber 1971:unpag.).

CHAPTER 2
ART OF THE PREHISTORIC PERIOD

1 The usual English pronunciation of the Danish name is Too-lee.

2 Archaeological remains of the "Skraelings" encountered in Greenland by the Norseman Eirik the Red circa A.D. 982 very likely belonged to the Dorset culture. It is possible that the Angmassalik Eskimos of nineteenth-century southeastern Greenland were descended from Dorset culture survivors.

3 Taylor and Swinton both advance this proposition in Taylor and Swinton (1967). It is in effect two articles written in parallel: "The Silent Echoes of Culture" by Taylor and "The Magico-Religious Basis" by Swinton.

4 McGhee (1996:155) disputes this theory, arguing that the average Dorset person would have possessed a high level of technical competence.

5 Swinton (Taylor and Swinton 1967:45) compares them to similar tubes found in Northwest Coast cultures. Indeed, the sucking tube and "arrows of sickness" are part of shamanic healing in many different cultures.

6 For some interesting observations concerning the possible symbolic attributes of Thule art, see Swinton (1992:117–18) and McGhee (1977; 1988a).

7 Thule culture survived intact in Labrador and southwestern Greenland until well into the Historic Period (McGhee 1977:141).

CHAPTER 3
ART OF THE HISTORIC PERIOD (1770s TO 1940s)

1 For a brief account of Moravian mission activities, see Crowe (1974:96–99).

2 Bernadette Driscoll (in Hoffmann 1988:215) divides the art of the Historic Period into two types: the "art of function" (traditional arts) focussing largely on tradition and innovation in clothing design, and the "art of memory" (art communicating to outsiders). Unfortunately, Driscoll's article does not appear in the English translation of Hoffmann's book.

3 *Drawings by Enooesweetuk of the Sikosilingmiut Tribe, Fox Land, Baffin Island,* 1915.

4 See Bellman (1980) and Pitseolak and Eber (1975) for the remarkable story and images by Peter Pitseolak.

5 For an excellent description of Historic Period art, see Blodgett (1988b).

CHAPTER 4
THE DAWN OF CONTEMPORARY INUIT ART (1949 TO 1955)

1 Houston went on to become a designer for Steuben Glass in New York and the author of many books for adults and children, including *The White Dawn*. His lively memoir (Houston 1995) recounts his personal discovery of Inuit art, his subsequent involvement with it, and his many years in the Arctic.

2 Now the Department of Indian Affairs and Northern Development. By the late 1940s, the federal government was eager to fund any projects that might help Inuit to diversify its economy, which had been based for many years on the (by then) failing white fox fur market. Some civil servants had in fact seen potential specifically in the market for (ivory) carvings. The partnership between the federal government, the Canadian Handicrafts Guild and the Hudson's Bay Company lasted for several years. See Goetz (1993) for a discussion of federal government involvement.

3 Houston supplemented this with $500 of his own money, which the Guild subsequently repaid (Houston 1995:31–32).

4 The Guild instructed Houston to purchase mostly clothing and crafts articles, but it seems that he disregarded those instructions to a large extent. It had been hoped that Houston would find additional work in the neighbouring community of Povungnituk, but his first trip there was a disappointment (Wight 1991b:54–62).

5 The Winnipeg Art Gallery's 1990 exhibition "The First Passionate Collector" featured the collection of Ian Lindsay, who had purchased many works at the first Guild show. Curator Darlene Wight published a detailed account of developments in Inuit art from 1948 to 1953 (Wight 1991b).

6 It is clear that 1949 marked the beginning of the "export market" for Inuit art. Without that export market, Inuit art production would have remained sporadic, and the art might have languished in obscurity.

7 Watt (1988b) gives an account of the Houstons' trip.

8 According to Graburn (1987b:3–4), the style of the booklet was based largely on Alaskan government publications of the 1940s. The booklet encouraged work that was still very much in the "crafts" vein: thirty illustrated suggestions for grass baskets, sealskin mitts and bags, carved ivory and stone figures, and games were annotated with descriptions or advice. Here is an excerpt from the introduction: "This pamphlet . . . is the first of a series to be published in Eskimo for the people of the Canadian Arctic, to encourage them in their native arts. It is hoped that these illustrations will suggest to them some of their objects which are useful and acceptable to the white man. Although the articles illustrated are not produced in all regions of the Arctic they are purely Eskimo . . . These suggestions should in no way limit the Eskimo. He should be encouraged to make variations and introduce new ideas into his handicrafts" (Houston 1951). By the late 1950s, the department decided that it was no longer appropriate for the federal government to issue such explicit directives to artists or artisans.

9 Eugene Power's nonprofit company, Eskimo Art, Inc. of Ann Arbor, Michigan, promoted Inuit art in the United States for over thirty years.

10 See Watt (1989) for a discussion of the London exhibition and reviews in the press.

11 James Houston was by no means solely responsible for stimulating and promoting Inuit art during this period. For accounts of some of the other people involved, see Watt (1987; 1988a; 1991) and Wight (1991b).

12 See Department of Northern Affairs and National Resources (1955).

13 See Wight (1991b) for illustrations of works from 1949. See also Canadian Guild of Crafts Québec (1980) for works from the early years. The Guild exhibits a permanent collection.

14 Letter from Jack Molson of the Canadian Handicrafts Guild to James Houston (Wight 1991b:73).

15 "The introduction of wood, cloth, and metals into his art destroys the true Eskimo quality and places him in competition with craftsmen elsewhere who have a complete mastery of the materials" (Houston 1951).

16 This "question that will not die" is discussed in the last chapter.

17 "From a pseudo-traditional activity, already much influenced by White contact, he [Houston] and they [Inuit artists] created a splendid new art of acculturation" (Martijn 1967:14). This article (as well as Martijn 1964) presents an excellent, frank discussion of the challenges and dilemmas facing artists and promoters in the 1950s. See also Butler (1991) and Zepp (1986).

18 There has been some controversy over the impact of Houston's 1951 booklet *Sanajasak Eskimo Handicrafts*. Most observers feel that Inuit artists quickly moved on to highly original concepts and styles.

19 Hudson's Bay Company traders strongly favoured "realistic" scenes and styles, which is not surprising, since they were not trained in art. Their influence seems to have been especially strong in Puvirnituq; the realistic style of that community has since spread across much of Arctic Québec.

CHAPTER 5
THEMES AND SUBJECTS IN
INUIT ART

1 This is especially true for the pieces made for the tourist and souvenir market, which favours realistically carved wildlife art.

2 For a more detailed discussion of animals in Inuit art, see Driscoll (1985) and Nelda Swinton (1993).

3 As early as 1771 in Nain, Labrador, and as late as the 1950s in certain parts of the Central Arctic.

4 See Blodgett (1979) for an excellent and well-illustrated study of Inuit shamanism.

5 In Labrador, Moravian missionaries (beginning in the late eighteenth century) and the Grenfell medical missions at the turn of the century encouraged Inuit to produce carvings and other souvenirs, which were sold abroad to raise funds. It does not appear, however, that they particularly encouraged work with Christian themes.

6 For more information on Christian imagery in Inuit art, see Blodgett (1988a).

7 For more information on the sea goddess, including different versions of the myth, see Nelda Swinton (1980).

8 The exploits of Kiviuk are illustrated and described in University of Alberta (1986).

9 Some Inuit, even elders, feel they do not remember enough to accurately pass on oral history. The renowned graphic artist Kenojuak said: "I stay away from trying to use the old-fashioned stories from the oral tradition in my work because I only have a kind of smattering or superficial knowledge of those stories and I don't want to put something down which would not really be true or accurate" (Blodgett 1985:35).

On the other hand, see Nungak and Arima (1988) for a fascinating illustrated anthology of myths and stories told and illustrated by Puvirnituq artists.

CHAPTER 6
SCULPTURE: TRADITION
AND NEW DIRECTIONS

1 See Nasogaluak (1996).

2 "What is most obviously distinctive in Eskimo carving is the way life moves outward from inside the material, forms and part-forms of animality and humanity emerging from unshaped bone and stone, and the multiplicity of vital forms in a single piece of stuff" (Sparshott 1980).

3 The market has rejected imported stone for two reasons. First, there is the sense that imported stone is somehow "inauthentic." A large part of the appeal of Inuit sculpture involves the use of native materials. Second, collectors have become used to identifying certain types of stone closely with particular regions or commu-

nities. Artists, on the other hand, want a steady supply of material regardless of the source, although they resent having to pay by the pound for imported stone.

4 The term "whalebone" has traditionally referred to baleen, a black horny substance that grows in the mouths of certain species. Baleen has been used extensively in Alaskan Eskimo art, but very little in Canada. In Canadian Inuit art, "whalebone" and "whale bone" are used interchangeably to refer to the actual bones of whales. Fresh whalebone is not suitable for carving, hence artists never hunt whales for raw materials. Since whalebone takes fifty to a hundred years to age, artists scavenge for it along beaches and (unfortunately) at Thule archaeological sites.

5 In the 1970s the U.S. Congress passed the Endangered Species Act and other acts severely restricting the importation of goods derived from whales and other species. In addition, the Convention on International Trade in Endangered Species regulates the trade of marine mammal products around the world.

6 There are some *qallunaat* (outsiders) who are very interested in subject matter and Inuit culture, and Inuit artists for whom a beautiful object is important.

7 Graburn began discussing the term in conferences in 1967. See Graburn (1976:49–55) for an outline of his thoughts on Inuit aesthetics. His analysis has particular validity in relation to the sculpture of Nunavik (Arctic Québec).

8 Some ten years ago, Marie Routledge, curator of Inuit art at the National Gallery of Canada, and I developed a framework that attempted to synthesize regional and community styles in Inuit sculpture with an examination of major artists in each region (Routledge and Hessel 1988; 1990; 1993). The analysis here is based largely on that framework.

9 Although the Inuit art market values the achievements of "classic" 1950s Nunavik art, it very much encourages and rewards innovation today. This has led to difficulties for Nunavik artists, who are considered "old-fashioned." In addition, the minor forms of Nunavik tourist carving are often copied by the purveyors of cheap imitations, to the detriment of the reputation of Nunavik carvers. Two surveys of contemporary Nunavik art are Saucier and Kedl (1988) and Noël (1992).

10 For a discussion of Inukjuak sculpture, see Winnipeg Art Gallery (1977a) and Roberts (1978).

11 This is especially true when compared with the people of Puvirnituq. Myers (1977a:18) received this insight from Peter Murdoch, who worked with Inuit artists first as a Hudson's Bay agent and then as general manager of the Fédération des Co-opératives du Nouveau-Québec.

12 Myers (1977b:7–18) suggests that the rise of the co-operative spirit in the late 1950s influenced Puvirnituq's overall confidence and, indirectly, its art. The Povungnituk Sculptors' Society of 1958 became the Povungnituk Co-operative in 1960. A strong boost to the community's pride and sense of purpose, the co-op prompted Puvirnituq Inuit to become involved in politics and the larger co-operative movement of the 1960s. Outsiders encouraged these activities and had their own influence on Puvirnituq's carving style. Notable among these were Peter Murdoch and Father André Steinmann, an Oblate missionary.

13 See Swinton (1977:21–24) and Graburn (1976:49–55) for a discussion of the sulijuk concept in Puvirnituq sculpture.

14 Surrealist works resulted from a contest sponsored in the community in 1967 by University of California anthropologist Nelson Graburn; without being given any specific instructions, carvers were encouraged to produce work inspired by dreams, visions and imagination that might have otherwise met with disapproval. Graburn was conducting research on Inuit aesthetics at the time. The more grotesque forms of surrealism flourished for a few years but in the end did not meet with general market acceptance. See Trafford (1968) for details of the contest.

15 Erotic and even pornographic art was encouraged by some outsiders, but is not particularly prevalent today.

16 Ian Lindsay in *La Fédération des Co-opératives du Nouveau-Québec* (1977). See also Saladin d'Anglure (1978).

17 For discussions of Salluit sculpture and artists, see Art Gallery of Windsor (1992) and Roberts (1976).

18 The Baffin Region, a large administrative region that includes Baffin Island, also extends south to Sanikiluaq in southern Hudson Bay, north to Grise Fiord on Ellesmere Island, and west to Igloolik, which is on an island off Melville Peninsula.

19 In 1955 Houston moved to Cape Dorset as the government's first northern service officer for the region. Houston helped develop the graphics program in 1957, and remained in Cape Dorset until 1962; he was succeeded by Terry Ryan, who has managed the co-op ever since. The West Baffin Eskimo Co-operative began marketing art in the 1970s through its southern subsidiary, Dorset Fine Arts, and is regarded as the most successful and independent art-producing co-op. Demand for the works of the most famous sculptors is high, and the co-op must compete with several companies and private entrepreneurs.

20 The original Cape Dorset stone was a coarse granitelike rock (see Figure 22). Later, the more luscious jadelike deposits were found near Kamadjuak and at Markham Bay. The latter quarry is shared with carvers in Kimmirut; Iqaluit artists find it worthwhile to travel there as well. As if Cape Dorset were not blessed enough, a large vein of high-quality marble has been discovered nearby.

21 All of the islands in Hudson Bay, James Bay and Hudson Strait belong to the Baffin Region of the Northwest Territories. Cultural and family ties between the Belcher Islands and southern Nunavik are strong, however.

22 Farley Mowat published his versions of the famine of the late 1940s and early 1950s in his books *People of the Deer* (1952) and *The Desperate People* (1959).

23 Norman Zepp (1986) highlighted the work of seven artists whom he felt epitomized the Keewatin aesthetic with their "strength and purity of vision."

24 Swinton (1998) states that virtually no archaeological artifacts that could be classified as "art" have so far been discovered in the Keewatin. He suggests that Keewatin Inuit, without an art "tradition," were working with a "clean slate" when it came to carving production.

25 See Winnipeg Art Gallery (1981) for a discussion of Rankin Inlet sculpture.

26 Tiktak has the distinction of being the first Inuit artist to be honoured with a solo exhibition, in 1970, some twenty years after Inuit sculpture hit the Canadian art scene (Swinton 1970).

27 Cape Dorset artists also experimented with ceramics in the mid-1960s, but their works were never marketed. See Nagy (1967) and Sutherland (1994) for a discussion of the Rankin Inlet ceramics project.

28 For a discussion of the Arviat style, see Winnipeg Art Gallery (1982) and Hessel (1990). For the Inuit perspective on developments, see Kalluak (1993).

29 Chesterfield Inlet had both a hospital and a home for the aged, operated by Roman Catholic missionaries, similar to the one run in Pangnirtung by the Anglicans. Ivory carving production thrived here for some time, but the community is no longer a major art centre.

30 The Repulse Bay Inuit are also related to the inhabitants of Coral Harbour on Southampton Island. The Sallirmiut, original inhabitants of the island, were wiped out by disease introduced by the whalers early this century. The whalers then moved a group of Aivilingmiut from the Wager Bay-Repulse Bay area to resettle the island in the 1920s.

31 Houston wrote (Winnipeg Art Gallery 1978:21) that the Repulse Bay ivories he saw during his brief visit in 1950 "showed considerable skill but not much passion or invention. . . . Why? A result of mid-Victorian whalers' tastes, perhaps."

32 Father Franz Van de Velde, the Roman Catholic missionary in Pelly Bay, commissioned a bust of Christ in 1945. A 1952 portrait of Christ is illustrated in Brandson (1994:186), along with Christian images by other artists.

33 Because Pelly Bay was accessible only by air and not by ship, it made economic sense to limit artwork to a small scale. A number of very fine works ended up in the collection of the Eskimo Museum (founded by Oblate missionaries) in Churchill, Manitoba.

34 Pelly Bay is discussed here again because its miniature tradition and large-scale sculpture are very different.

35 In a letter to the editor of *Inuit Art Quarterly* (Vol. 8, No. 1, Spring 1993, p. 61), John McGrath wrote that the British sculptor Henry Moore, upon hearing of Karoo's death, had sent a telegram to Canada's Prime Minister expressing regret at the loss of Canada's foremost artist.

36 Roald Amundsen, the first person to successfully navigate the Northwest Passage, arrived here on August 28, 1903, and spent two winters living with the Netsilingmiut before continuing his journey westward.

37 The Copper Inuit were studied extensively by anthropologist Diamond Jenness during Vilhjalmur Stefansson's Canadian Arctic Expedition of 1913–1918.

38 Both Alaskan mask traditions and Greenlandic *tupilak* spirit carvings also have grotesque tendencies. According to Meldgaard (1960:35), with tupilaks, "the more fantastic and distorted the better."

39 Their forms also resemble those of some Makonde ebony *shetani* spirit figures from Tanzania. Contemporary Makonde sculpture, like Inuit sculpture, is an art form largely encouraged by outsiders in the 1950s; there are many interesting parallels between Makonde and Inuit tourist and fine arts.

40 Swinton's "fantastic art" (1972a) includes the Puvirnituq works, other works that are horrifying in content or form, the whimsical and grotesque, and the extravagant or baroque in form.

41 This is also true for the other approaches discussed above, and the sulijuk sensibility as well. While there may not be a "universal aesthetic," differing individual aesthetic tendencies can manifest themselves at any time and in any place, even within the confines of a fairly traditional style. These approaches could lead to a personal style or direction which might be adopted by others, or they could be completely idiosyncratic, and either tolerated by or scorned by peers.

42 For an interesting discussion of three "post-contemporary" sculptors, see Wight (1991a).

43 And as with any mannerist tendency, there is always the danger of going too far, of getting carried away with elegance, virtuosity and emotion.

44 See Anghik (1991) and Piqtoukun (1994) for artist interviews in *Inuit Art Quarterly*, and Wight (1989).

45 Wight (1991a:10) notes that Manasie told her that in Arctic Bay, he would only be an Arctic Bay carver; in Toronto, he is "Manasie."

46 See Akpaliapik (1993) for an artist interview in *Inuit Art Quarterly*.

47 See Marion Scott Gallery (1994; 1996) and Leroux et al. (1994) for critical and autobiographical writings.

CHAPTER 7
GRAPHIC ARTS: DRAWINGS AND PRINTS

1 Pauloosie Karpik, quoted in a letter from Phyllis Worsley to H. G. Jones in "Pauloosie Karpik's First Drawings," *Inuit Art Quarterly* (Summer 1991, p.30). Worsley was Karpik's nurse while he was recovering from hepatitis in hospital. Unable to supply him with carving materials, she gave him paper and pencil instead, and he drew eight pictures for her.

2 See McDougall (1992) for a discussion of Jenness's writings on Inuit drawings. The article quotes one of Jenness's "prophetic" 1946 comments on the drawings of the Copper Inuit: "I cannot believe that they lack talent, or that the second or third generation from today will not show as much proficiency in drawings as other Eskimo."

3 John Ayre, who has checked federal government memos, discovered that Houston had discussed the introduction of printmaking with bureaucrats as early as 1955 (Ayre 1996). That does not necessarily contradict Houston's story of Osuitok; perhaps it was the impetus needed to finally begin.

4 In the article "Japanese Artists on Inuit Printmaking: Challenge and Response" in *Inuit Art Quarterly* (Vol. 1, No.1, Spring 1986), two Japanese printmakers expressed their opinions on the Inuit use of the ukiyo-e method. Naoko Matsubara laments that Houston "switched" from the early experimental stage of the *sōsaku hanga* method (a modern tradition imported from Europe early this century, in which the artist is also the printmaker) to what she referred to as the old "assembly-line," "commercial" ukiyo-e method. Noboru Sawai, on the other hand, sees the collective ukiyo-e tradition as appropriate "given the closely knit nature of Inuit society." He notes that it took the Japanese printmaking tradition over two hundred years to evolve, and assumes that the Inuit tradition will continue to evolve as well.

5 For operational reasons, print shops often pulled complete editions of prints before submitting them to the Canadian Eskimo Arts Council. Its refusal to approve prints (sometimes more than half of an annual collection) was a considerable financial blow, not to mention a bitter disappointment to artists and printmakers, who often did not understand the reasons behind seemingly arbitrary decisions. Some co-ops quietly marketed unapproved prints locally at cut-rate prices. Baker Lake, which consistently produced more "difficult" images, was often forced to market them outside regular channels. For examples of prints that were never officially released, see Canadian Arctic Producers (1993) and Gustavison (1994).

6 A few stone blocks have been saved for archival and exhibition purposes or have found their way into private collections, but they are never reused.

7 The Inuktitut syllabics on the Canadian Eskimo Arts Council's blind stamp translate literally as "it is alright," meaning genuine. The Council was "an entity that has no parallels in the international art world at any time in history" (Gustavison 1994:87). Gustavison gives a historical account of this controversial body which for almost thirty years acted as artist agent, arts advisor, jury, exhibition sponsor, copyright agent and advisor to the Minister of Indian and Northern Affairs.

8 Complexity is a major factor in techniques like stonecut and stencil, where it is difficult to reproduce fine lines or intricate patterns. The advent of lithography has reduced the importance of complexity as a limiting factor.

9 For more on the relationship between drawing and print, see Blodgett (1991), Winnipeg Art Gallery (1983) and LaBarge (1986).

10 See Blodgett (1976) and Driscoll (1982a), both on shows at the Winnipeg Art Gallery. Notable among the commercial galleries have been the Innuit Gallery of Eskimo Art (now the Isaacs/Innuit Gallery), Toronto, and the Upstairs Gallery, Winnipeg. See also Eber (1971).

11 Jackson and Nasby's 1987 show at the Macdonald Stewart Art Centre in Guelph, Ontario, was a turning point in the study of Inuit drawings (Jackson and Nasby 1987).

12 Two Inuit who tried painting in the 1960s were featured in the *The Beaver* magazine (Autumn 1967). Terry Ryan gave the artist Kingmeata Etidlooie some watercolours in the late 1960s; she produced about two dozen works.

13 For an account of the developments in painting in Cape Dorset, see Gustavison (1996). Toronto artist Kate Graham worked with Cape Dorset artists from 1973 to 1977.

14 Terry Ryan suggests that the "strange" look of many of the earliest Cape Dorset drawings is the result of artists making corrections and ad hoc decisions because of their lack of proficiency in the medium (Blodgett and Gustavison 1993:9). This publication is interesting in that many of the artists included in it did not become major print artists. But even some who went on to become famous artists maintain a free-form, experimental attitude. Kenojuak approaches a drawing without a preconceived plan and makes decisions as she goes along (Blodgett 1985:36).

15 Kenojuak Ashevak: "For my subject matter I don't start off and pick a subject as such; that's not my way of addressing a drawing. My way of doing it is to start without a preconceived plan of exactly what I am going to execute in full, and so I come up with a small part of it which is pleasing to me and I use that as a starting point to wander into, through the drawing. I may start off at one end of a form not even knowing what the entirety of the form is going to be; just drawing as I am thinking, thinking as I am drawing. And that's how I develop my images" (Blodgett 1985:36).

16 Swinton (1972a:8) had already used the term "synchretistic [*sic*]" in his discussion of Inuit "fantastic art."

17 For a fascinating glimpse of Pitseolak's life and art, see Eber (1971).

18 While more women than men submit drawings, printmaking is a male-dominated profession in Cape Dorset, with a small group of about a dozen men producing most of the community's over 2,500 prints. Many of the printmakers are also carvers.

19 In 1957, George Swinton collected drawings in Puvirnituq, illustrated in Winnipeg Art Gallery (1977b:86–99). The look of Puvirnituq art evolved quite differently from the styles suggested by these early examples.

20 For a discussion of "outsider art" see Maclagan (1991:32–49).

21 Gabe Gély began the first printmaking experiments in 1963. He was also largely responsible for the development of sculpture in Baker Lake. He was followed by Roderick McCarthy, Robert Paterson and Boris Kotelowitz.

22 Jackson's "two-generation" theory is based on her analysis of Baker Lake drawings (see Jackson 1987).

23 For early work in a clearly post-contemporary vein, see Tagoona (1975).

CHAPTER 8
TEXTILE ARTS

1 For illustrations of two bags by Kenojuak, see Blodgett (1985: 33–34). For examples of skin pictures, see Department of Northern Affairs and National Resources (1955:23–24).

2 See the "Crafts from Arctic Canada" catalogue (Canadian Eskimo Arts Council 1974) for examples of various types of Inuit textile arts from the early 1970s . See also Strickler and Alookee (1988).

3 The federal government had opened a sewing shop in the mid-1960s. It closed in 1970, but was re-opened under the auspices of the Government of the Northwest Territories.

4 The 1974 competition and exhibition "Crafts from Arctic Canada" sponsored by the Canadian Eskimo Arts Council did much to promote Baker Lake textile arts, but placed them in the same category as dolls, toys, clothing and jewellery. The Art Gallery of Ontario's 1976 exhibition "The People Within" helped to elevate the status of textile arts when it exhibited Baker Lake wall hangings together with drawings and sculptures from that community.

5 Baker Lake Fine Arts and Crafts, founded and operated by Marie Bouchard, purchased and promoted not only wall hangings but also drawings by selected artists who had nowhere to sell their work after the closure of the print shop. The business was recently sold to an Inuk, Sally Qimmiu'naaq Webster.

6 See Fernstrom and Jones (1993) for detailed descriptions of stitching techniques; the authors provide a history of wall-hanging production as well as an analysis of artists' styles and themes.

7 Oonark is especially famous for her large, imposing, highly structured and symmetrical compositions of the early to mid-1970s. Her 1973 untitled commission for the National Arts Centre in Ottawa measured about four by six metres (12 by 19 feet).

8 The influence of parka design may have had an influence here (Driscoll-Engelstad 1994:6).

9 The company, Karen Bulow Ltd., hired Don Stuart to manage the project in 1970. That year, responsibility for the development of arts and crafts shifted to the Government of the Northwest Territories, which carried on federal government initiatives in Pangnirtung and elsewhere. Subsequent consultants and managers included Charlotte Lindgren, Janet Senior, Kordula Depatie, Megan Williams and Deborah Hickman.

10 Because of the labour involved in tapestry weaving, additional copies in an edition are produced on demand, not in advance. The decision to use different weavers was made to relieve the original weaver of repetitive labour; one weaver will produce no more than two or three copies of a single image. Kawtysee Kakee, who is highly respected for her colour sense, is credited with establishing the colour schemes of both of the tapestries in this book, as well as weaving the first one of each edition and one of the actual tapestries illustrated.

11 In recent years, as artists have submitted more drawings in full colour, the work of the weavers has evolved. Rather than making basic colour decisions, they are now working to render images faithfully. This requires even more subtlety in the blending of colours.

12 Articles on Pangnirtung tapestries written by southern advisers (who are weavers themselves) tend to stress the skill and contribution of the weavers (see Lindgren and Lindgren 1988). Art historians tend to stress the imagery and give more credit to the artists who provided the drawings.

13 The original low warp Aubusson-type looms were designed for fabric weaving, not tapestry, but they have been used with considerable success. Recently, a large Gobelin high warp loom was acquired for larger commissions (Deborah Hickman, personal communication, 1997).

14 Janet Senior in Goldfarb (1989: 17). Most of the advisors and managers have been women; they have no doubt had an influence as well.

15 The weavers have not always had a wide choice of colours. A few of the early weavings were somewhat garish, and for many years weavers had to make do with one shade of say, blue, whereas now they have six (Deborah Hickman, personal communication, 1997).

AFTERWORD
ART AND INUIT IDENTITY

1 Quotation from the video *Keeping Our Stories Alive: The Sculpture of Canada's Inuit* (Indian and Northern Affairs Canada 1993).

2 This is one of the great challenges facing Inuit artists, especially carvers and textile artists. Their work is often sold within hours of being completed, and since few artists photograph their work, they are left with only a memory. This must make it extremely difficult for them to keep a sense of continuity and progression; it is perhaps also one reason that many artists "copy themselves." Nick Sikkuark has said: "The carvings are taken away from here; it's like my creation has left me behind" (Sikkuark 1997:14).

3 "It is perhaps in the midst of catastrophic change, or in a time of anguished endings and beginnings, that artists have the greatest opportunity to offer something of crucial value to the culture around them, by seeking, through the image, ways to deal with the destruction of an old identity and to begin to shadow forth a new one" (McEvilley 1992:124).

4 There is no real case for the "repatriation of artifacts" or other political action, but southern institutions will be under pressure to share their resources and information. So far, Inuit political and cultural organizations have shown surprisingly little interest in the visual arts.

5 The Canadian idea of the "true North strong and free" is often highly romantic. In Peter Millard's words (1987:24), it can be "a nostalgic yearning for a romantic north of organic simplicity and pre-industrial innocence—a kind of frozen pastoral."

6 The construction of a string of twenty-two DEW (Distant Early Warning) Line sites along Canada's Arctic coast was completed in 1957 at the height of the Cold War. The cost was borne by the United States, but Canada retained ownership of the stations.

7 Hal Opperman (1986:2) posed and answered the following question: "What accounts for the appeal or relative lack of appeal at certain times of a given body of work? . . . I think there is one simple answer: because they communicate more completely than others."

8 Sculptor Abraham Anghik (1991:23) feels that many Inuit *are* making subtle political statements with their art. He calls them "positive" rather than "negative" political statements; they affirm Inuit identity and show "the way things are and should remain."

9 Joan Vastokas (1987:16) suggests that Inuit (and First Nations) art offers a deeply appealing and satisfying alternative to the " 'empty' formalism of mainstream western art."

10 Granted, the audience is Western, but the roots of contemporary Inuit art are definitely not. While it would be wrong to suggest that Inuit art is a natural evolution from traditional forms, or even from Historic times, it is equally wrong to suggest that the whole idea is simply recently "planted." Opperman (1986) has some interesting comments on this question. Also, further questions about authenticity have arisen. Some suggest that drawings, prints and textiles are less "authentic" than carvings, because these media and their materials were all introduced by outsiders, but the work done in these media speaks eloquently for itself.

11 The federal government's "Igloo Tag" program, instituted in 1959, created new problems while attempting to solve old ones. Designed to differentiate genuine Inuit sculpture from imitations (and to ensure that all Inuit sculpture would be deemed "original fine art" and thus be duty-free), the "Igloo Tag" helped to instill the wrong-headed notion that all Inuit art is created equal (i.e., that it is all "fine art"). This has brought on the backlash opinion that because of some mediocre work touted as "fine art," *no* Inuit art is worthy of the description. Toronto art dealer Harold Seidelman (1986:15) wrote an interesting commentary in which he voiced the growing anxiety among gallery owners that there was not enough clear separation between Inuit fine art and "gift trade" production.

12 As Millard (1995:41) has observed, in our culture "intellectual endeavour is concerned, to a large extent, with analysis and taxonomy—examining things minutely and identifying them as discrete entities." Those intellectual passions usually serve us well, but they weigh us down with a lot of cultural baggage when we try to come to grips with traditions outside our immediate experience.

13 There has been much interviewing of Inuit artists, but most of it has been relatively unsatisfying for researchers and artists alike. The language and cultural gaps are wide, and researchers usually do not have the time to build up rapport and trust. "The Artists Speak" series of interviews in *Inuit Art Quarterly*, following an Inuit art conference at the McMichael Canadian Art Collection in 1992, highlighted this dilemma dramatically.

14 The fact that there are not yet any Inuit trained as curators and art historians complicates the issue still further. But even when that happens, there will still be much to be gained from the perspective of highly trained and passionately committed "outsiders." See also Hessel (1991:6–15), Fry (1987) and McEvilley (1992).

15 Graburn (1987a) tends to try to put everything into discrete categories but realizes that Inuit art does not fit into just one. Questions of aesthetics are far more problematic. In an anthropological sense, however, he is absolutely right in studying Inuit art together with other Fourth World arts: art by aboriginal peoples "whose lands fall within the national boundaries and techno-bureaucratic administrations of the First, Second and Third Worlds" (Graburn 1976:1).

16 Kenojuak Ashevak, a member of the Royal Canadian Academy and a Companion of the Order of Canada, has said: "I do not really consider myself a drawer, or an artist, or a sculptress, or whatever. I wouldn't say that of myself except in conjunction with the other things that I do. I would say, well yes, I draw and I sculpt, and I do appliqué, embroidery and needlepoint . . . Tomorrow I want to go out and go jigging [a type of ice fishing]; I want to do that because I have fond memories of having done that in the past . . . I don't put any aspects of my experience first as the main thing. Being able to do embroidery and being able to go out on the land and all those other things are not secondary to being an artist" (Blodgett 1985:74).

17 The nickname given to small works made for quick cash to be used immediately (for that evening's bingo game, for example).

18 Personal communication, August 1989.

BIBLIOGRAPHY

Adams, Amy. (1994). Surrealism and Sulijuq: Fantastic Carvings of Povungnituk and European Surrealism. In *Inuit Art Quarterly*. Vol. 9, No. 4, Winter 1994. (4–10).

Akpaliapik, Manasie. (1993). Carving is Healing to Me: An Interview with Manasie Akpaliapik. In *Inuit Art Quarterly*. Vol. 8, No. 4, Winter 1993. (34–42). (Interview by John Ayre).

Akpaliapik, Manasie. (1998). Personal communication.

Anghik, Abraham. (1991). An Interview with Abraham Anghik. In *Inuit Art Quarterly*. Vol. 6, No. 2, Spring 1991. (18–23).

Art Gallery of Windsor. (1992). *Sugluk: Sculpture in Stone 1953–1959.* Windsor: Art Gallery of Windsor.

Ashevak, Kenojuak. (1993). Foreword. In West Baffin Eskimo Cooperative. *1993 Cape Dorset Annual Graphics Collection.* (Annual catalogue).

Ashoona, Mayoreak. (1994). My Life at Shatureetuk. In Leroux et al. (1994:199–219).

Ayre, John. (1996). Review of *Confessions of an Igloo Dweller* by James Houston. In *Inuit Art Quarterly*. Vol. 11, No. 1, Spring 1996. (42–43).

Balikci, Asen. (1970). *The Netsilik Eskimo.* New York: Natural History Press.

Bellman, David, ed. (1980). *Peter Pitseolak (1902–1973): Inuit Historian of Seekooseelak: Photographs and Drawings from Cape Dorset, Baffin Island.* Montreal: McCord Museum.

Berlo, Janet. (1993). Autobiographical Impulses and Female Identity in the Drawings of Napachie Pootoogook. In *Inuit Art Quarterly*. Vol. 8, No. 4, Winter 1993. (4–12).

Blodgett, Jean. (1976). *Tuu'luq/Anguhadluq.* Winnipeg: Winnipeg Art Gallery.

Blodgett, Jean. (1979). *The Coming and Going of the Shaman: Eskimo Shamanism and Art.* Winnipeg: Winnipeg Art Gallery.

Blodgett, Jean. (1985). *Kenojuak.* Toronto: Firefly Books.

Blodgett, Jean. (1986). *North Baffin Drawings.* Toronto: Art Gallery of Ontario.

Blodgett, Jean. (1988a). Christianity and Inuit Art. (Reprinted from *The Beaver* Autumn 1984). In Houston, Alma (1988:84–93).

Blodgett, Jean. (1988b). The Historic Period in Canadian Eskimo Art. (Reprinted from *The Beaver* Summer 1979). In Houston, Alma (1988:21–29).

Blodgett, Jean. (1991). *In Cape Dorset We Do It This Way: Three Decades of Inuit Printmaking.* Kleinburg: McMichael Canadian Art Collection.

Blodgett, Jean, and Marie Bouchard. (1986). *Jessie Oonark: A Retrospective.* Winnipeg: Winnipeg Art Gallery.

Blodgett, Jean, and Susan Gustavison. (1993). *Strange Scenes: Early Cape Dorset Drawings.* Kleinburg: McMichael Canadian Art Collection.

Brandson, Lorraine E. (1994). *Carved from the Land: The Eskimo Museum Collection.* Churchill: Diocese of Churchill Hudson Bay.

Brody, Hugh. (1987). *Living Arctic: Hunters of the Canadian North.* London: Faber and Faber.

Bromfield, Abjon. (1969). Operation Whalebone. In *North.* Vol. 16, No. 6., November–December 1969. (1–7).

Butler, Sheila. (1988). Wall Hangings from Baker Lake. (Reprinted from *The Beaver* Autumn 1972). In Houston, Alma (1988:94–99).

Butler, Sheila. (1991). Inuit Art, an Art of Acculturation. In Wight (1991b:33–43).

Canadian Arctic Producers. (1993). *The Prints Never Seen: Holman 1977–1987.* Winnipeg: Canadian Arctic Producers.

Canadian Eskimo Arts Council. (1971). *Sculpture/Inuit: Masterworks of the Canadian Arctic.* Toronto: University of Toronto Press.

Canadian Eskimo Arts Council. (1974). *Crafts from Arctic Canada.* Ottawa: Canadian Eskimo Arts Council.

Canadian Guild of Crafts Quebec (1980). *Canadian Guild of Crafts Quebec: The Permanent Collection, Inuit Arts and Crafts c. 1900–1980.* Montreal: Canadian Guild of Crafts Quebec.

Canadian Museum of Civilization. (1993). *In the Shadow of the Sun: Perspectives on Contemporary Native Art.* Hull: Canadian Museum of Civilization.

Cape Dorset. (1978). *Dorset 78.* (Annual catalogue). Toronto: M. F. Feheley Publishers.

Carpenter, Edmund. (1973). *Eskimo Realities.* New York: Holt, Rinehart and Winston.

Christopher, Robert. (1987). Inuit Drawings: 'Prompted' Art-Making. In *Inuit Art Quarterly*. Vol. 2, No. 3, Summer 1987. (3–6).

Cook, Cynthia. (1993). *From the Centre: The Drawings of Luke Anguhadluq.* Toronto: Art Gallery of Ontario.

Crowe, Keith J. (1974). *A History of the Original Peoples of Northern Canada.* Kingston/Montreal: McGill-Queen's University Press.

Department of Northern Affairs and National Resources. (1955). *Canadian Eskimo Art.* Ottawa: Department of Northern Affairs and National Resources. (Text by James Houston).

Driscoll, Bernadette. (1980). *The Inuit Amautiq: I Like My Hood To Be Full.* Winnipeg: Winnipeg Art Gallery.

Driscoll, Bernadette. (1982a). *Baker Lake Prints and Print-Drawings 1970–1976.* Winnipeg: Winnipeg Art Gallery.

Driscoll, Bernadette. (1982b). *Inuit Myths, Legends & Songs.* Winnipeg: Winnipeg Art Gallery.

Driscoll, Bernadette. (1985). *Uumajut: Animal Imagery in Inuit Art.* Winnipeg: Winnipeg Art Gallery.

Driscoll, Bernadette. (1988). Zwischen Konvention und Innovation: die historische Periode der Inuit-Kunst 1800–1950. In Hoffmann (1988:215–22).

Driscoll-Engelstad, Bernadette. (1994). A Woman's Vision, A Woman's Voice: Inuit Textile Art from Arctic Canada. In *Inuit Art Quarterly*. Vol. 9, No. 2, Summer 1994. (4–13).

Eber, Dorothy, ed. (1971). *Pitseolak: Pictures Out of My Life.* Montreal: Design Collaborative Books/Toronto: Oxford University Press.

Eber, Dorothy. (1989). *When the Whalers Were Up North: Inuit Memories from the Eastern Arctic.* Kingston/Montreal: McGill-Queen's University Press.

Eber, Dorothy. (1993) Talking with the Artists. In Canadian Museum of Civilization (1993:425–42).

Etook, Tivi. (1980). Artist's Statement. In *Povungnituk 1980.* Montreal: La Fédération des Co-opératives du Nouveau-Québec.

Fernstrom, Katharine W., and Anita E. Jones. (1993). *Northern Lights: Inuit Textile Art from the Canadian Arctic.* Baltimore: Baltimore Museum of Art.

Flaherty, Robert J. (1915). *Drawings by Enooesweetuk of the Sikosilingmiut Tribe, Fox Land, Baffin Island.* Toronto: privately printed.

Fry, Jacqueline. (1987). Contemporary Inuit Art and Art from other "Tribal" Cultures. In *The American Review of Canadian Studies.* Vol. XVII, No. 1, Spring 1987. (41–46).

Goetz, Helga. (1993). Inuit Art: A History of Government Involvement. In Canadian Museum of Civilization (1993:357–81).

Goldfarb, Beverly. (1989). Artists, Weavers, Movers and Shakers. In *Inuit Art Quarterly*. Vol. 4, No. 2, Spring 1989. (14–18).

Graburn, Nelson, ed. (1976). *Ethnic and Tourist Arts.* Berkeley and Los Angeles: University of California Press.

Graburn, Nelson. (1986). Inuit Art and Canadian Nationalism. In *Inuit Art Quarterly*. Vol. 1, No. 3, Fall 1986. (5–7).

Graburn, Nelson H. H. (1987a). Reflections of an Anthropologist: Inuit Drawings: The Graphics behind the Graphics. In Jackson and Nasby (1987:21–28).

Graburn, Nelson H. H. (1987b). The Discovery of Inuit Art. In *Inuit Art Quarterly*. Vol. 2, No. 2, Spring 1987. (3–5).

Gustavison, Susan. (1994). *Arctic Expressions: Inuit Art and the Canadian Eskimo Arts Council 1961–1989.* Kleinburg: McMichael Canadian Art Collection.

Gustavison, Susan. (1996). *Imaak Takujavut: The way we see it: Paintings from Cape Dorset.* Kleinburg: McMichael Canadian Art Collection.

Hall, Judy, Jill Oakes and Sally Qimmiu'naaq Webster. (1994). *Sanatujut: Pride in Women's Work: Copper and Caribou Inuit Clothing Traditions.* Hull: Canadian Museum of Civilization.

Hessel, Ingo. (1990). Arviat Stone Sculpture: Born of a Struggle with an Uncompromising Medium. In *Inuit Art Quarterly*. Vol. 5, No. 1, Winter 1990. (4–15).

Hessel, Ingo. (1991). Contemporary Inuit Art. In Earth Spirit Festival. *Visions of Power: Contemporary Art by First Nations, Inuit and Japanese Canadians.* Toronto: Earth Spirit Festival. (6–15).

Hickman, Deborah. (1997). Personal communication.

Hoffmann, Gerhard, ed. (1988). *Zeitgenössische Kunst der Indianer und Eskimos in Kanada.* Stuttgart: Cantz Verlag.

Hoffmann, Gerhard. (1993) The Aesthetics of Inuit Art: Decoration, Symbolism, and Myth in Inuit Graphics; Material, Form, and Space in Inuit Sculpture; The Context of Modernism and Postmodernism. In Canadian Museum of Civilization (1993:383–423).

Holman Eskimo Co-operative. (1987). *Holman 1987 Prints/Estampes.* (Annual catalogue).

Houston, Alma, ed. (1988). *Inuit Art: An Anthology.* Winnipeg: Watson & Dwyer.

Houston, James. (1951). *Sanajasak: Eskimo Handicrafts.* Montreal/Ottawa: Canadian Handicrafts Guild and Department of Resources and Development.

Houston, James. (1952). In Search of Contemporary Eskimo Art. In *Canadian Art.* Vol. 9, No. 3, Spring 1952. (99–104).

Houston, James. (1971). *Eskimo Prints.* Don Mills: Longman Canada Ltd.

Houston, James. (1977). Port Harrison, 1948. In Winnipeg Art Gallery (1977a:7–11).

Houston, James. (1978). Repulse Bay 1950. In Winnipeg Art Gallery (1978:17–22).

Houston, James. (1979). Cape Dorset 1951. In Winnipeg Art Gallery (1979:9–11).

Houston, James. (1995). *Confessions of an Igloo Dweller.* Toronto: McClelland & Stewart.

Iksiraq, Thomas. (1986). 1986–87 Art Work. In Sanavik Co-operative Association. *Baker Lake 1986 Prints.* (Annual catalogue).

Indian and Northern Affairs Canada. (1993). *Keeping Our Stories Alive: The Sculpture of Canada's Inuit.* Hull: Indian and Northern Affairs Canada. (Video: 24 min.).

Inuit Art Quarterly. (1992). The Artists Speak—Iyola Kingwatsiak On Being Patronized; Kananginak Pootoogook On Educating Young Artists; Jimmy Manning On the Changing Art Scene in Cape Dorset. In *Inuit Art Quarterly.* Vol. 7, No. 2, Spring 1992. (25–34).

Ipellie, Alootook. (1992). The Colonization of the Arctic. In McMaster, Gerald, and Lee-Ann Martin, eds. *Indigena: Contemporary Native Perspectives.* Vancouver/Toronto: Douglas & McIntyre and Hull: Canadian Museum of Civilization. (39–57).

Ipellie, Alootook. (1997). Land, Spirituality, and Mythology in Inuit Art. In Nortext Multimedia Inc. *The 1998 Nunavut Handbook: Travelling in Canada's Arctic.* Iqaluit: Nortext Multimedia Inc. (97).

Jackson, Marion. (1987). Contemporary Inuit Drawings: Reflections of an Art Historian. In Jackson and Nasby (1987:7–19).

Jackson, Marion, and Judith Nasby. (1987). *Contemporary Inuit Drawings.* Guelph: Macdonald Stewart Art Centre.

Jackson, Marion, Judith Nasby and William Noah. (1995). *Qamanittuaq: Where the River Widens: Drawings by Baker Lake Artists.* Guelph: Macdonald Stewart Art Centre.

Jenness, Diamond. (1922a). Eskimo Art. In *Geographical Review.* 12 (2). (161–74).

Jenness, Diamond. (1922b). *The Life of the Copper Eskimos: Southern Party 1913–16.* Vol XII of *Report of the Canadian Arctic Expedition 1913–18.* Ottawa: King's Printer.

Jenness, Diamond. (1946). *Material Culture of the Copper Eskimo: Southern Party 1913–16.* Vol XVI of *Report of the Canadian Arctic Expedition 1913–18.* Ottawa: King's Printer.

Kaalund, Bodil. (1979). *The Art of Greenland: Sculpture, Crafts, Painting.* Berkeley: University of California Press.

Kalluak, Mark, ed. (1993). *From Pelts to Stone: A History of Arts & Crafts Production in Arviat.* Hull: Indian and Northern Affairs Canada.

Kasadluak, Paulosie. (1977). Nothing Marvelous. In Winnipeg Art Gallery (1977a:21–23).

LaBarge, Dorothy. (1986). *From Drawing to Print: Perception and Process in Cape Dorset Art.* Calgary: Glenbow Museum.

La Fédération des Co-opératives du Nouveau-Québec. (1977). *Davidialuk 1977.* Montreal: La Fédération des Co-opératives du Nouveau-Québec.

La Fédération des Co-opératives du Nouveau-Québec. (1980). *Things Made By Inuit.* Montreal: La Fédération des Co-opératives du Nouveau-Québec.

La Fédération des Co-opératives du Nouveau-Québec. (1989). *Povungnituk 1988–89.* (Annual catalogue).

Lalonde, Christine. (1995). How Can We Understand Inuit Art? In *Inuit Art Quarterly.* Vol. 10, No. 3, Fall 1995. (6–14).

Leroux, Odette, Marion E. Jackson and Minnie Aodla Freeman, eds. (1994). *Inuit Women Artists: Voices from Cape Dorset.* Vancouver/Toronto: Douglas & McIntyre; Hull: Canadian Museum of Civilization; Seattle: University of Washington Press.

Lindsay, Ian. (1974). From the bottom of the kudlik. In Canadian Arctic Producers Ltd. *From the bottom of the kudlik: Carvings and artifacts from Gjoa Haven 1974.* Ottawa: Canadian Arctic Producers Ltd.

Lindgren, Charlotte, and Edward. (1988). The Pangnirtung Tapestries. (Reprinted from *The Beaver* Autumn 1981). In Houston, Alma (1988:112–17).

Maclagan, David. (1991). Outsiders or Insiders? In Hiller, Susan, ed. *The Myth of Primitivism.* London and New York: Routledge. (32–49).

Manning, Jimmy. (1997). Personal communication.

Marion Scott Gallery. (1994). *Oviloo Tunnillie.* Vancouver: Marion Scott Gallery.

Marion Scott Gallery. (1996). *Oviloo.* Vancouver: Marion Scott Gallery.

Martijn, Charles A. (1964). Canadian Eskimo Carving in Historical Perspective. In *Anthropos.* Vol. 59, 1964. (546–96).

Martijn, Charles A. (1967). A Retrospective Glance at Canadian Eskimo Carving. In *The Beaver.* Autumn 1967. (4–19).

McDougall, Anne. (1992). Jenness on Eskimo Art. In *Inuit Art Quarterly.* Vol. 7, No. 1, Winter 1992. (22–29).

McEvilley, Thomas. (1992). *Art and Otherness: Crisis in Cultural Identity.* Kingston, N.Y.: McPherson & Company.

McGhee, Robert. (1977). Ivory for the Sea Woman: The Symbolic Attributes of a Prehistoric Technology. In *Canadian Journal of Archaeology.* No. 1, 1977. (141–49).

McGhee, Robert. (1978). *Canadian Arctic Prehistory.* Toronto: Van Nostrand Reinhold.

McGhee, Robert. (1988a). Material as Metaphor in Prehistoric Inuit Art. In *Inuit Art Quarterly.* Vol. 3, No. 3, Summer 1988. (9–11).

McGhee, Robert. (1988b). The Prehistory and Prehistoric Art of the Canadian Inuit. (Reprinted from *The Beaver* Summer 1981). In Houston, Alma (1988:12–20).

McGhee, Robert. (1996). *Ancient People of the Arctic.* Vancouver: University of British Columbia Press.

Meldgaard, Jørgen. (1960). *Eskimo Sculpture.* London: Methuen.

Millard, Peter. (1987). Contemporary Inuit Art—Past and Present. In *The American Review of Canadian Studies.* Vol. XVII, No. 1, Spring 1987. (23–29).

Millard, Peter. (1995). Baker Lake Drawings. In Jackson et al. (1995:40–51).

Mowat, Farley. (1952). *People of the Deer.* Toronto: McClelland & Stewart.

Mowat, Farley. (1959). *The Desperate People.* Toronto: McClelland & Stewart.

Muehlen, Maria. (1989). Baker Lake Wall-hangings: Starting from Scraps. *Inuit Art Quarterly.* Vol. 4, No. 2, Spring 1989. (6–11).

Myers, Marybelle. (1977a). In the Wake of the Giant. In Winnipeg Art Gallery (1977a:13–20).

Myers, Marybelle, ed. (1977b). *Joe Talirunili: A Grace Beyond the Reach of Art.* Montreal: La Fédération des Co-opératives du Nouveau-Québec.

Myers, Marybelle. (1977c). The People of Povungnituk, Independent through a Common Effort. In Winnipeg Art Gallery (1977b:7–18).

Nagy, Hendrika G. (1967). Pottery in Keewatin. In *The Beaver.* Autumn 1967. (60–66).

Nasogaluak, Bill. (1996). Focus: Bill Nasogaluak: Getting Past the Oral Tradition. Interview in *Inuit Art Quarterly.* Vol. 11, No. 3, Fall 1996. (28–35).

National Museum of Man. (1977). *The Inuit Print/L'estampe inuit.* Ottawa: National Museum of Man.

Noah, William. (1995). Starvation on the Land and My Experience in Baker Lake. In Jackson et al. (1995:16–22).

Noël, Michel. (1992). *Nunavimiut: Art Inuit=Inuit Art.* Pointe-Claire: Roussan en collaboration avec l'Institut culturel Avataq.

Nungak, Zebedee, and Eugene Arima. (1988). *Inuit Stories: Povungnituk=Légendes inuit: Povungnituk.* Hull: Canadian Museum of Civilization.

Nutaraluk Aulatjut, Elizabeth. (1989). Personal communication.

Opperman, Hal. (1986). The Inuit Phenomenon in Art-Historical Perspective. In *Inuit Art Quarterly.* Vol. 1, No. 2, Summer 1986. (1–4).

Pangnirtung Eskimo Co-operative. (1987). *Pangnirtung 1987 Prints.* (Annual catalogue).

Pangnirtung Eskimo Co-operative. (1988). *Pangnirtung 1988 Prints.* (Annual catalogue).

Piqtoukun, David Ruben. (1989). Artist's statement. In Wight (1989).

Piqtoukun, David Ruben. (1994). Artists Speak: David Ruben Piqtoukun. In *Inuit Art Quarterly.* Vol. 9, No. 3, Fall 1994. (17–22). (Interview by John Ayre).

Pitseolak, Peter, and Dorothy Eber. (1975). *People from our side: A life story with photographs by Peter Pitseolak and oral biography by Dorothy Eber.* Edmonton: Hurtig Publishers.

Pitsiulak, Lypa (Lipa). (1983). My Ideas Come from Up in the Air. In Winnipeg Art Gallery (1983).

Pootoogook, Kananginak. (1973). Foreword. In West Baffin Eskimo Co-operative. *1973 Cape Dorset Prints/Estampes.* (Annual catalogue).

Pootoogook, Kananginak. (1976). Statement. In *Inuit Today.* Vol. 5 (December) 1976 (31).

Pootoogook, Kananginak. (1979). A Story about Carvers and Hunters. In Winnipeg Art Gallery. (1979:33–34).

Pudlat, Pudlo. (1991). An Interview with Pudlo Pudlat. In *Inuktitut.* #74, 1991. (38–49).

Ray, Dorothy Jean. (1977). *Eskimo Art: Tradition and Innovation in North Alaska.* Seattle/London: University of Washington Press and Vancouver/Toronto: Douglas & McIntyre.

Ray, Dorothy Jean. (1981). *Aleut and Eskimo Art: Tradition and Innovation in South Alaska.* Seattle: University of Washington Press and Vancouver/Toronto: Douglas & McIntyre.

Ray, Dorothy Jean. (1996). *A Legacy of Arctic Art.* Seattle: University of Washington Press and Vancouver/Toronto: Douglas & McIntyre.

Roberts, A. Barry. (1976). *The Inuit Artists of Sugluk, P.Q.* Montreal: La Fédération des Co-opératives du Nouveau-Québec and Ottawa: Department of Indian and Northern Affairs.

Roberts, A. Barry. (1978). *The Inuit Artists of Inoucdjouac, P.Q.* Montreal: La Fédération des Co-opératives du Nouveau-Québec and Ottawa: Department of Indian and Northern Affairs.

Robertson, R. Gordon. (1960). The Carving Industry of Arctic Canada. In *The Commerce Journal.* Spring 1960. (49–54).

Roch, Ernst, ed. (1974). *Arts of the Eskimo: Prints.* Montreal: Signum Press and Toronto: Oxford University Press.

Routledge, Marie. (1979). *Inuit Art in the 1970s/L'art inuit actuel 1970–79.* Kingston, Ontario: Agnes Etherington Art Centre.

Routledge, Marie, and Ingo Hessel. (1988). Die zeitgenössische Skulptur der Inuit: Eine Einführung in das Medium, die Künstler und ihr Werk. In Hoffmann (1988:419–36).

Routledge, Marie, and Ingo Hessel. (1990). Regional Diversity in Contemporary Inuit Sculpture. In *Inuit Art Quarterly.* Vol. 5, No. 3, Summer 1990. (10–23).

Routledge, Marie, and Ingo Hessel. (1993). Contemporary Inuit Sculpture: An Approach to the Medium, the Artists, and their Work. In Canadian Museum of Civilization (1993:443–77).

Routledge, Marie, with Marion E. Jackson. (1990). *Pudlo: Thirty Years of Drawing.* Ottawa: National Gallery of Canada.

Saladin d'Anglure, Bernard. (1978). *La parole changée en pierre: Vie et oeuvre de Davidialuk Alasuaq, artist Inuit du Québec Arctique.* Québec: Gouvernement du Québec.

Saucier, Céline, and Eugene Kedl. (1988). *Image inuit du Nouveau-Québec.* Québec: Musée de la civilisation.

Seidelman, Harold. (1986). Fine Art or Giftware? Marketing Inuit Art. In *Inuit Art Quarterly.* Vol. 1, No. 3, Fall 1986. (15).

Seidelman, Harold, and James Turner. (1993). *The Inuit Imagination.* Vancouver/Toronto: Douglas & McIntyre.

Sikkuark, Nick. (1997). Nick Sikkuark: "I do love the carvings themselves." In *Inuit Art Quarterly.* Vol. 12, No. 3, Fall 1997. (Interview by Simeonie Kunnuk, 1994).

Sparshott, Francis. (1980). Spence Bay Sculpture: 'An Expressive Force.' In The Innuit Gallery of Eskimo Art. *Spence Bay Sculpture: 'An Expressive Force.'* Toronto: The Innuit Gallery of Eskimo Art.

Staples, Annalisa R., Ruth L. McConnell and Jill Oakes. (1993). *Soapstone and Seed Beads: Arts and Crafts at the Charles Camsell Hospital, a Tuberculosis Sanatorium/The Charles Camsell Garment Collection.* Edmonton: Provincial Museum of Alberta.

Strickler, Eva, and Anaoyok Alookee. (1988). *Inuit Dolls: Reminder of a Heritage.* Toronto: Canadian Stage and Arts Publications.

Sutherland, Dave. (1994). In Retrospect: The Sad Tale of the Rankin Inlet Ceramics Experiment—1963–1965. In *Inuit Art Quarterly.* Vol. 9, No. 2, Summer 1994. (52–55).

Swinton, George. (1965). *Eskimo Sculpture/Sculpture Esquimaude.* Toronto/Montreal: McClelland and Stewart.

Swinton, George. (1966). Artists from the Keewatin. In *Canadian Art.* Vol. XXII, No. 2, April 1966. (32–34).

Swinton, George. (1970). *Tiktak: Sculptor from Rankin Inlet, N.W.T.* Winnipeg: Gallery One One One, University of Manitoba.

Swinton, George. (1972a). *Eskimo Fantastic Art.* Winnipeg: Gallery 111, University of Manitoba.

Swinton, George. (1972b). *Sculpture of the Eskimo.* Toronto: McClelland and Stewart.

Swinton, George. (1977). The Povungnituk Paradox: Typically Untypical Art. In Winnipeg Art Gallery (1977b:21–24).

Swinton, George. (1978). Repulse Bay Folk Art. In Winnipeg Art Gallery (1978:27–30).

Swinton, George. (1982) Memories of Eskimo Point 1967–1979. In Winnipeg Art Gallery (1982:13–19).

Swinton, George. (1992). *Sculpture of the Inuit.* Toronto: McClelland and Stewart. (Revised edition of *Sculpture of the Eskimo* 1972).

Swinton, George. (1998). Personal communication.

Swinton, Nelda. (1980). *La déesse inuite de la mer/The Inuit Sea Goddess.* Montreal: Montreal Museum of Fine Arts.

Swinton, Nelda. (1993). *Arctic Wildlife: The Art of the Inuit.* Montreal: Montreal Museum of Fine Arts.

Tagoona, William. (1975). *Shadows.* Ottawa: Oberon Press.

Tasseor Tutsweetok, Lucy. (1989). Personal communication.

Taylor, William E., and George Swinton. (1967). Prehistoric Dorset Art. In *The Beaver.* Autumn 1967. (32–47).

Thomson, Jane Sproull, and Callum Thomson. (1991). Prehistoric Eskimo Art in Labrador. In *Inuit Art Quarterly.* Vol. 6, No. 4, Fall 1991. (12–18).

Trafford, Diana. (1968). Takushurnaituk [Things Never Seen Before]. In *north.* March-April 1968, Vol. 15. (52–55).

Tulurialik, Ruth Annaqtuusi, and David Pelly. (1986). *Qikaaluktut: Images of Inuit Life.* Toronto: Oxford University Press.

University of Alberta. Ring House Gallery. (1986). *Keeveeok Awake!: Mamnguqsualuk and the Rebirth of Legend at Baker Lake.* Edmonton: Boreal Institute for Northern Studies.

Uqqurmiut Inuit Artists Association. (1992). *Pangnirtung 1992 Prints.* Pangnirtung: Uqqurmiut Inuit Artists Association.

Vastokas, Joan. (1971/72). Continuities in Eskimo Graphic Style. In *artscanada.* 162/163, (1971–1972). (69–83).

Vastokas, Joan. (1987). A Reply to Nelson Graburn. In *Inuit Art Quarterly.* Vol. 2, No. 1, Winter 1987. (15–16).

Watt, Virginia. (1987). In Retrospect. In *Inuit Art Quarterly.* Vol. 2, No. 4, Fall 1987. (18–20).

Watt, Virginia. (1988a). In Retrospect. In *Inuit Art Quarterly.* Vol. 3, No. 2, Spring 1988. (27–29).

Watt, Virginia. (1988b). In Retrospect. In *Inuit Art Quarterly.* Vol. 3, No. 4, Fall 1988. (36, 39).

Watt, Virginia. (1989). In Retrospect. In *Inuit Art Quarterly.* Vol. 4, No. 2, Spring 1989. (42–44).

Watt, Virginia. (1991). Alice M. S. Lighthall: 1891–1991. In *Inuit Art Quarterly.* Vol. 6, No. 4, Fall 1991. (46).

Wight, Darlene. (1989). *Out of Tradition: Abraham Anghik/David Ruben Piqtoukun.* Winnipeg: Winnipeg Art Gallery.

Wight, Darlene. (1991a). Inuit Tradition and Beyond: New Attitudes Toward Art-Making in the 1980s. In *Inuit Art Quarterly.* Vol. 6, No. 2, Spring 1991. (8–15).

Wight, Darlene Coward. (1991b). *The First Passionate Collector: The Ian Lindsay Collection of Inuit Art.* Winnipeg: Winnipeg Art Gallery.

Wilford, Nigel. (1974). Spence Bay: Whalebone Carvings. In *North/Nord.* Vol. 21, No. 2, March-April 1974. (22–25).

Winnipeg Art Gallery. (1977a). *Port Harrison/Inoucdjouac.* Winnipeg: Winnipeg Art Gallery.

Winnipeg Art Gallery. (1977b). *Povungnituk.* Winnipeg: Winnipeg Art Gallery.

Winnipeg Art Gallery. (1978). *Repulse Bay.* Winnipeg: Winnipeg Art Gallery.

Winnipeg Art Gallery. (1979). *Cape Dorset.* Winnipeg: Winnipeg Art Gallery.

Winnipeg Art Gallery. (1981). *Rankin Inlet/Kangirlliniq.* Winnipeg: Winnipeg Art Gallery.

Winnipeg Art Gallery. (1982). *Eskimo Point/Arviat.* Winnipeg: Winnipeg Art Gallery.

Winnipeg Art Gallery. (1983). *Baffin Island.* Winnipeg: Winnipeg Art Gallery.

Zepp, Norman. (1986). *Pure Vision: The Keewatin Spirit.* Regina: Norman Mackenzie Art Gallery.